Artists
of
World War II

**Recent Titles in
Artists of an Era**

Artists of the Middle Ages
Leslie Ross

Artists of Colonial America
Elisabeth L. Roark

Artists of the Renaissance
Irene Earls

Artists
of
World War II

BARBARA McCLOSKEY

Artists of an Era

GREENWOOD PRESS

Westport, Connecticut • London

Library of Congress Cataloging-in-Publication Data

McCloskey, Barbara
 Artists of World War II / Barbara McCloskey.
 p. cm. – (Artists of an era, ISSN 1541-955X)
 Includes index.
 ISBN 0-313-32153-1
 1. World War, 1939-1945—Art and the war. 2. Artists—Biography. I. Title. II. Series.
N9160.M33 2005
940'.54/88—dc22 2004026938

British Library Cataloguing-in-Publication Data is available.

Library of Congress Catalog Card Number: 2004026938

ISBN: 0–313–32153–1
ISSN: 1541–995X

First published in 2005

Greenwood Press, 88 Post Road West, Westport, CT 06881
An imprint of Greenwood Publishing Group, Inc.
www.greenwood.com

Printed in the United States of America

(∞)™

The paper used in this book complies with the
Permanent Paper Standard issued by the National
Information Standards Organization (Z39.48–1984).

10 9 8 7 6 5 4 3 2 1

Copyright Acknowledgment

Contents

Acknowledgments

Imagining a world war through the art of its time is a daunting challenge. My attempt to do so in this book would not have been possible without the outstanding work of those many scholars on whose research and writing I have relied. My first debt of gratitude is to them. I hope to have done justice to their thinking on the subject of art and its complex relationship to the events of World War II. References to their publications appear in the endnotes and bibliography.

I would also like to thank Debra Adams and Robert Kirkpatrick of Greenwood Press for their helpful editorial advice. Thanks also to Elizabeth Kincaid who saved me countless hours of work by tracking down reproduction rights for illustrations. The University of Pittsburgh generously supplied me with a Faculty of Arts and Sciences summer research grant at a crucial moment in the development of this project. The staff, students, and faculty of the University of Pittsburgh's Department of the History of Art and Architecture have also been graciously supportive. My thanks to them all.

I am especially grateful to those who read my work and from whose expansive knowledge I benefited in the writing of this book. Paul Jaskot shared with me his expertise on the cultural policies of Germany during World War II; Katheryn Linduff, a scholar of Chinese art and archeology, helped me to understand the complexities of China's art and history; and Thomas Rymer and Mayu Tsuruya, both scholars of Japanese art, gave me generous assistance for the section of this book on Japan. Sabine Hake patiently read through and commented insightfully, as always, on many of the chapters. And David Wilkins provided rigorous editorial advice that greatly improved the manuscript. My thanks also to Fred Nutt who supplied me with several outstanding sources on art and history during the World War II era.

Last, but certainly not least, I want to thank Fred Evans for reading every line

and commenting helpfully on each turn in the text. He has fought this world war with me every step of the way with love, good humor, and unflagging support. I can't thank him enough.

My father, Joseph, enlisted the day after the bombing of Pearl Harbor and married my mother, Bernadette, before departing for service in Europe. Their recollections of those years wove in and out of my life as I was growing up. Through my research and writing, I have appreciated coming to understand them and the world they faced in the earliest days of their lives together. I dedicate this book to them, and especially to the memory of my father, who was himself an historian of World War II. His immense pleasure in seeing his youngest daughter retrace some of the steps he and my mother took during those dramatic years will remain in my memory always.

Timeline

1933 January 30: Hitler appointed chancellor in Germany
March 4: Roosevelt becomes President of the United States; New Deal enacted
Reichs Chamber of Culture formed in Germany
Mario Sironi publishes his "Manifesto of Mural Painting" in Italy
Giuseppe Terragni begins work on the Casa del Fascio in Como, Italy

1934 Mao's "Long March" in China
German artist Käthe Kollwitz begins her lithographic series "On Death"
Exhibit of Italian futurist Aeropittura in Germany
Adalberto Libera submits an architectural design for Italy's Palazzo del Littorio competition
Socialist Realism made the official art of the state in the Soviet Union

1935 October 3: Mussolini invades Ethiopia
Li Hua produces woodcut, "Roar, China," in protest of the Japanese invasion
Italian artist Giorgio de Chirico paints "Visit to the Mysterious Baths"
Imperial Academy of Fine Art and Teiten exhibits reorganized in Japan

1936 March 7: Hitler reoccupies the Rhineland in violation of the Treaty of Versailles
May 9: Mussolini's Declaration of Empire
July 18: Civil war begins in Spain
October 25: Germany and Italy form Axis Alliance
November 25: Germany and Japan sign Anti-Comintern pact against the Soviet Union
Gao Jianfu publishes "My Views on Contemporary National Painting" in China
The Olympic Games take place in Berlin, Germany
All-Union Committee for Art Affairs (KDPI) established in the Soviet Union
Spanish artist Alberto joins the agitprop division of the Communist Party's Fifth Regiment in the Spanish Civil War
Salvador Dalí featured on the cover of "Time" magazine in the United States
Founding of the American Artists' Congress in New York

1937 April 26: Hitler's Condor Legion bombs the Spanish town of Guernica
May 25: *The Paris World's Fair opens; Picasso's "Guernica" unveiled*
July 7: Japan attacks China on the Marco Polo Bridge
July 19: *Degenerate Art Exhibition unveiled in Germany*
Formation of the National Salvation Propaganda Corps in China
Adolf Ziegler's painting "The Four Elements" serves as centerpiece for first Great German Art Exhibition
Italy's Ministry of Popular Culture reorganized
Japan's Ministry of Education publishes "The Cardinal Principles of the Nation"

Beginning of the Great Purge in the Soviet Union
Vera Mukhina sculpts "Worker and Collective Farm Worker" for the Soviet pavilion at the Paris World's Fair
José Renau's photomontages appear in the Spanish pavilion at the Paris World's Fair

1938 March 13: Germany annexes Austria
May: Hitler's state visit to Italy
September 29: Munich Agreement; Germany annexes the Sudetenland in Czechoslovakia
October 1: *The Lu Xun Academy of Arts and Literature opens in Yan'an, China*
November 9–10: *Kristallnacht* (Night of the Broken Glass) pogrom against the Jews in Germany
December: *Marinetti leads protest in Rome against anti-Semitic attacks on modern art*
Aristide Maillol creates his antiwar sculpture, "The River (Sorrows of War)," in France
Japan signs cultural exchange treaty with Germany
Japanese war artist Fujita Tsuguji travels to battlefront in central China
Yokoyama Taikan lectures in Japan to a visiting group of Hitler Youth
"Exhibition of 20th Century German Art" staged in Great Britain
Aleksander Gerasimov paints "Stalin and Voroshilov in the Kremlin"

1939 March 10: Hitler seizes all of Czechoslovakia
March 28: Franco defeats the Spanish Republic
September 1: Hitler attacks Poland
September 3: France and Great Britain declare war on Germany
Feng Zikai publishes "A Mother's Head Severed" in protest of Japanese bombing of Jiaxing in China's Zhejiang Province
Jiang Feng becomes instructor at the Lu Xun Academy in Yan'an, China
War Artists' Advisory Committee formed in Great Britain
Premio Cremona and Premio Bergamo instituted in Italy
Army Art Association founded in Japan
Stalin Prize instituted in the Soviet Union
Picasso's "Guernica" installed in the Museum of Modern Art in New York

1940 January: *Stanley Spencer begins his series "Shipbuilding on the Clyde" for Great Britain's War Artists' Advisory Committee*
May 10: Germany invades Belgium, the Netherlands, and Luxemburg
May 10: Winston Churchill becomes prime minister of Great Britain
June 10: Italy declares war on France and Great Britain
June 14: The fall of France; German troops enter Paris

June 23: Hitler tours Paris with Arno Breker and Albert Speer

July: Germany launches Battle of Britain

August: *Varian Fry of the Emergency Rescue Committee arrives in France*

September 7: German Blitzkrieg of London begins

September 27: Japan joins Axis Alliance with Germany and Italy

September: *"The Jew and France" exhibit opens at the Institute for the Study of Jewish Questions in Paris*

United Front alliance between China's nationalists and communists ends

Cabinet Information Bureau established in Japan

Fernand Léger flees France for the United States

Henri Matisse refuses Varian Fry's offer to assist him to escape from France

1941 January: *Henry Moore made an official war artist by Great Britain's War Artists' Advisory Committee*

April: *Matsumoto Shunsuke publishes his essay "The Living Artist" in Japan*

May: *"Britain at War" exhibit at the Museum of Modern Art in New York*

May: *André Masson flees France for the United States*

June 22: Germany attacks the Soviet Union

October: *French artists go on propaganda tour of Germany*

December 7: Japan attacks the United States at Pearl Harbor

December 8: The United States declares war on Japan

December 11: Italy and Germany declare war on the United States

Graham Sutherland records the effects of the German Blitz on London for Great Britain's War Artists' Advisory Committee

Aleksander Deineka documents the German siege of Leningrad

Artists for Victory forms in the United States

U.S. artist Thomas Hart Benton begins his "Year of Peril" series

1942 January 20: Wannsee Conference for the destruction of the European Jews takes place in Berlin

February 19: Japanese-Americans interned in the United States

May 15: *German sculptor Arno Breker's exhibit at Paris's Orangerie Museum*

June–August: Japan defeated in Battles of Midway and Guadalcanal

June 13: Office of War Information (OWI) established in the United States

November 11: Germany seizes all of France

November: Allies land in North Africa

December: German military reversals in the Battle of Stalingrad

Mao's Rectification Campaign in China

Hitler's state architect, Albert Speer, appointed Germany's Minister

of Armaments
British artist Paul Nash publishes his essay "The Personality of Planes"
Peggy Guggenheim opens her Art of This Century gallery in New York
George Biddle chairs U.S. War Department's Art Advisory Committee
Ben Shahn's "This is Nazi Brutality" rejected by the U.S. Office of War Information

1943 July 25: Mussolini arrested by Allied forces
September 12: German forces rescue Mussolini, roll back Allied advance
Yan'an Conference on Literature and Art in China
Burning of "degenerate" art at Jeu de Paume Museum in Paris
Patriotic Society of Japanese Art established
Japanese artist Kikuchi Keigetsu paints "Welcoming the Imperial Carriage"
Norman Rockwell's "Four Freedoms" used in U.S. government War Loan campaign

1944 June 6: D-Day, Allied forces land at Normandy
August 9: *German-Jewish artist Felix Nussbaum and his wife, Felka Platek, are murdered in Auschwitz*
October: *Staging of the Liberation Salon in Paris*
Japanese occupation authorities ban display of Jiang Zhaohe's "Refugees" in Shanghai, China
Spanish artist Joan Miró completes antiwar lithographic series, "Barcelona"

1945 April 12: Roosevelt dies
April 28: Mussolini executed
April 30: Hitler commits suicide
May 8: Germany surrenders, end of war in Europe declared
July–August: Potsdam Conference between Truman, Churchill, and Stalin
August 6 and 9: United States drops atomic bombs on Hiroshima and Nagasaki
August 10: Japan surrenders
November: War crimes trial begins in Nuremberg, Germany
U.S. photographer Margaret Bourke-White photographs liberated concentration camp victims at Buchenwald

1947 *USSR Academy of Arts established*

1949 End of China's civil war; founding of the People's Republic of China

1953 Stalin dies

1975 Franco dies

1981 *Picasso's "Guernica" installed in the Casón del Buen Retiro, Madrid*

2004 May 29: *World War II memorial dedicated on the Washington Mall*

Introduction

World War II claimed the lives of more than 50 million people. Between 1939 and 1945, civilians the world over were burned, gassed, and starved to death, while grenades and bombs cut down a whole generation of soldiers. Cities, towns, ports, and countrysides in North Africa, Asia, Europe, the Soviet Union, the United States, and elsewhere lay in ruins by war's end. Those who didn't die faced rebuilding their shattered lives and broken homes from the deathly stench and rubble left behind.

The creation of art amidst such cataclysmic destruction assumes a terrible strangeness. We tend to think of art as the antithesis of war, as an embrace of the beautiful and transcendent that bears little or no connection to atrocity, death, and the tawdriness of armed combat. How could—and did—art exist in such conditions? Astonishingly, artists continued to paint, photograph, build, sketch, and sculpt in the shadow of worldwide destruction. How were their perceptions shaped by their experiences? And how did their work shape the wartime perceptions of the public at large? We have to ask, finally, what insight their art gives us a half century later into the values, ideas, and attitudes that provoked, fought, and died in the most destructive moment in modern world history. These and other questions are taken up in this international survey of artists during the World War II era.

The following chapters consider the activities of artists in China, France, Germany, Great Britain, Italy, Japan, the Soviet Union, Spain, and the United States during this fateful period.[1] For each country, I begin with a short synopsis of its political and artistic culture in the years leading up to World War II. A discussion of each nation's institutional framework for the production of art during the war then follows. The chapters end with biographical accounts of four to five artists from each country. Some are best known for their work

in architecture, painting, or sculpture, while others made their careers in photography, illustration, and advertising. The biographies explore their art and different levels of engagement in the events unfolding around them. The book concludes with a discussion of postwar attempts, at times controversial, to create appropriate monuments to this traumatic period. English-language references for further research on the subject of artists in World War II are contained in the bibliography and endnotes for each chapter.

A study such as this prompts us to ask when and why World War II began. Part of the answer lies in the escalating competition for resources and territory that accompanied the Industrial Revolution and the emergence of modern nation-states in the nineteenth century. France, Great Britain, and Japan were among those countries that engaged in aggressive programs of colonialism and imperial conquest in Africa, East Asia, and elsewhere. The expansion of international trade, meanwhile, created an increasingly interdependent world economy. Growing tension between nations erupted in 1914 with the outbreak of World War I; that conflict ended four bloody years later. The victorious Allied powers, led by France, Great Britain, and the United States, forced Germany to agree to the stringent terms of the Versailles Treaty concluded in 1919. Crippling reparations payments and the disbanding of its army fostered a culture of resentment in Germany that soon gave rise to Hitler's National Socialist Party.

Modernization contributed to international tensions while dramatically accelerating the rate of exchange between countries and cultures from the nineteenth century onward. Artists enjoyed ready access as never before—through travel, publications, and exhibits—to the achievements of their counterparts in far-flung reaches of the world. Such exposure and exchange gave rise to productive artistic cross-fertilizations. "Modern" artists became recognized as those who produced art that challenged deeply rooted aesthetic traditions in their respective countries. The most cutting-edge, or "avant-garde" among them frequently courted hostile public response to their work through their deliberately provocative and innovative approaches to form, color, and subject matter.

By the late 1920s, modern artists and the avant-garde confronted growing nationalist sentiment in each of the countries explored in this book. In 1929, with the collapse of the New York Stock Exchange and the spread of economic depression throughout the industrialized world, many countries began to look negatively on international exchange and interdependency as the root cause of their current predicament. Under the circumstances, modern art became associated with pernicious erosion of national self-sufficiency, cultural tradition, and, in the cases of Germany and Japan in particular, a loss of "racial purity."

By the early 1930s, many governments regarded the arts as a means for generating a spirit of national renewal and providing an antidote to the economic downward spiral of the Great Depression. After Hitler came to power in Germany in 1933, he also looked to war and imperialism as another avenue for national recovery and the realization of his grandiose schemes of world domination. Japan and Italy, whose leaders shared many of Hitler's ambitions, soon became Germany's partners in the Axis alliance.

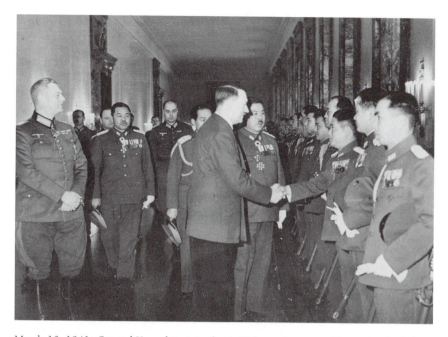

March 10, 1941: General Yamashita introduces Hitler to Japanese officers, Reichschancel-
lery, Berlin. © Ullstein, Bild, Berlin.

Artists in these and in the other countries that became engulfed in World
War II were charged with formulating new national cultures. In the premodern
era, national cultures were fashioned by and remained the preserve of society's
elites. From the nineteenth century onward, by contrast, national cultures have
functioned to create mass legitimacy for modern nation-states that rely more
heavily than ever before on their ordinary citizens to labor in their interests
and to fight and die in their wars. In such circumstances, artists and their
work become crucial instruments for the creation of signs and symbols used
to mobilize the people and foster patriotic loyalty. During World War II, art-
ists who participated in their countries' programs of national renewal found
their work accordingly "massified" through wide public distribution in the
form of postcards, films, and photographic reproductions. As art thus became
harnessed to the imperatives of war and nationalist fervor, distinctions between
art on the one hand, and propaganda on the other, became harder and harder
to discern.

Western scholars tend to date the outbreak of World War II to September 1,
1939. On that day, Hitler attacked Poland, drawing France and Great Britain
into a Europe-wide conflict immediately thereafter. A view taking into account
the unfolding of war in the Asian Pacific, however, requires an earlier beginning
date. The year 1936 more appropriately marks an escalation of belligerence and
militarist aggression that established many outlines of the later war in Asia and
in Europe. In 1936, Hitler defied the Treaty of Versailles by rearming Germany

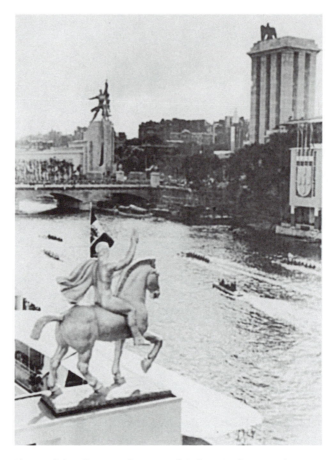

Photo of the German, Soviet, and Italian pavilions at the Paris World's Fair of 1913. © 2005 Artists Right Society (ARS), New York.

and reoccupying the Rhineland. He and Mussolini then joined forces with Franco in 1936 in order to overthrow the democratically elected government of Spain. Italy and Germany also entered into military alliances with Japan in 1936, which emboldened the island nation to pursue its military conquest of China in 1937 and other reaches of the Asian Pacific in the coming years.

In 1937, many of the nations discussed in this book participated in the Paris World's Fair. Organizers of the fair billed the event as a peaceful demonstration of national achievements in the areas of arts and technology. My treatment of artists in Germany, the Soviet Union, Italy, and Spain highlights their participation in this important event and the manner in which the fair became a cultural staging ground for the militarist confrontations that were then beginning to unfold. Japan launched its full-scale attack on China in 1937, followed two years later by Hitler's march into Poland. With Germany's assault on the Soviet Union and Japan's bombing of Pearl Harbor in 1941, the Soviet Union and the United States entered the conflict. The Allied powers, led by the United States,

the Soviet Union, and Great Britain, defeated Germany, Italy, and Japan four bitter years and 50 million lives later.

Writing on the art and artists of World War II poses special problems for the researcher. In the ravages of war many documents and works of art were destroyed, stolen, or lost. In some countries, moreover, discussion of the World War II period remains taboo. In those cases, ready access to archival materials is restricted. Subtler, however, are the limits imposed on serious exploration of World War II by a persistent tendency in art history to dismiss much of the art produced during this period as mere propaganda. As a result, surprisingly few studies take up the subject of the many soldier-artists who fought at the front and filled the ranks of war art programs that sprang up in many, but not all of the countries covered in this book. I discuss some of these soldier-artists in the following biographies. Most of the artists I consider, however, are those with established artistic reputations who often remained on the home front and used their work to either contribute to or resist the militarist nationalism that consumed their respective countries. Whether battlefront or home front, taken individually or together, it is my hope that the lives and works of the artists treated in this book shed light on the cultural conditions that variously created, enabled, and condemned this most pivotal and destructive moment in our world's modern history.[2]

Notes

1. For other surveys of art and artists during World War II, see Dawn Ades, Tim Benton, David Elliott, and Iain Boyd Whyte, eds., *Art and Power: Europe Under the Dictators, 1930–45,* exhibition catalogue (London: Thames and Hudson, 1995); Stephanie Barron and Sabine Eckmann, eds., *Exiles and Émigrés : The Flight of European Artists from Hitler,* exhibition catalogue (Los Angeles: Los Angeles County Museum of Art, 1997); Igor Golomstock, *Totalitarian Art in the Soviet Union, the Third Reich, Fascist Italy and the People's Republic of China,* trans. Robert Chandler (London: Collins Harvill, 1990); and Ken McCormick and Hamilton Darby Perry, eds., *Images of War: The Artist's Vision of World War II* (New York: Orion Books, 1990).

2. Due to copyright restrictions, some of the images discussed in this book have, regrettably, not been reproduced. Readers will find endnote references to other sources where illustrations of works may be found.

CHAPTER 1

Artists in China: Between War and Civil War

China's World War II era lasted a long and bloody two decades. Civil war between the country's nationalist government and Mao Zedong's (1893–1976) communist insurgents complicated China's war of resistance against Japan from 1931 to 1945. Many records and works of art from this time were lost or destroyed. Moreover, after communist triumph and the founding of the People's Republic of China in 1949, much of the history of this period was rewritten to downplay Mao's[1] political opponents, and the artists and institutions associated with them. Scholars have lately begun to reevaluate this distorted history. Their research sheds new light on the seismic cultural transformations that redefined China's artistic legacy during World War II.

Beginning in the mid-nineteenth century, vital art centers emerged in Shanghai, Canton, and China's other coastal port cities where a thriving and cosmopolitan merchant class became the major source of patronage. But, as civil war engulfed China and the Japanese seized control of major centers on the country's eastern seaboard, many artists and intellectuals joined the mass exodus from China's urbanized coast to the rural interior. The trauma of war challenged all artists—those who remained in Japanese-occupied territories, as well as those who fled to the interior—to evaluate the meaning and function of their work under dramatically changed circumstances.

Those artists who joined the war effort confronted a wholly new audience for their art, namely China's masses of illiterate peasantry, whose support for the struggle against Japan became vital to the country's survival. War artists turned to cartoons, woodcuts, prints, and other popular art forms in order to reach this new audience, rapidly and dramatically transforming China's peasant culture in the process. The growing importance of such media during the war years also raised serious questions about the relevance of China's centuries-old

official traditions of art not only to the current struggle, but also to the country's cultural future.

China and Its Art World before World War II

China has been one of the world's most advanced societies throughout much of its 2,000-year history. Many technological and cultural innovations originated in China—including the trace harness and plow for use in agriculture and the crossbow and gun weaponry, as well as the decimal system, medicines, printed books, and movable type machines—in some cases centuries before such developments occurred in the West. After generations of feudalism and imperial expansion, China was conquered in 1644 by the Manchus, descendents of nomadic tribes in Manchuria located on China's northeastern border. The Manchu emperors of the Qing Dynasty (1644–1912) exercised authoritarian control over the country's vast territories. They also set about transforming China into the most wealthy, populous, and powerful nation in the world. In the eighteenth century, European Enlightenment thinkers and philosophers looked to China's advanced arts, learning, and secular form of government as models for the development of the modern nation-state.

Throughout its long history, art played a crucial role in unifying China's numerous ethnic groups and regions under a single, cohesive, and official cultural identity. From the Song Dynasty in the tenth century well into modern times, this national artistic culture remained the preserve of court artists, literate elites, and scholar-bureaucrats who occupied the highest ranks in Chinese society. With a deep reverence for artistic tradition, these elite artists portrayed over and over again certain time-honored motifs, including idealized depictions of birds, flowers, bamboo, imaginary landscapes, and historical subjects. Their work, considered a mode of intellectual refinement linked to the pursuits of poetry, philosophy, and religion, emphasized nuance of touch in the application of gentle washes of ink and mineral pigments to silk or paper. In the nineteenth and early twentieth centuries, this largely unchanging and tradition-bound art, and the aristocratic culture to which it was tied came under assault by the forces of modernization and war.

The nineteenth century, known as China's "century of humiliation," marks a period of catastrophic decline in the country's standing in the world. Convulsed by internal uprisings and the encroachments of foreign imperialism, China was forced in 1842 to sign the Treaty of Nanjing, which ceded Hong Kong to Britain and opened its coast to foreign exploitation. By the end of the nineteenth century, Britain, France, and the United States had established concession zones in China's prosperous coastal cities. These concessions were under foreign governance and exempt from Chinese law. Artists living in Shanghai (China's "Paris of the East"), Canton, and other port cities with foreign concessions were some of the first to encounter new creative impulses from abroad. Those foreign impulses, in turn, began to erode the authority of traditional Chinese art.

Sun Yat-sen's nationalist revolutionaries overthrew China's corrupt Qing Dynasty in 1912. Sun became president of the new republic of China and initiated policies of democratic reform and modernization. Cai Yuanpei, the republic's Minister of Education, carried this reformist spirit into China's art world. He instituted far-reaching programs that resulted in the founding of China's first public museums and galleries. He also opened the art world to outside artistic influences. Cai saw such openness as part of a larger official effort to renew the country's national culture through contact with Western modernization.

In 1929, Cai presided over the government's first National Art Exhibition, which took place in the nation's capital, Nanjing. Works displayed in the show included painting, photography, sculpture, and design. Critical attention focused on artists such as Jiang Zhaohe and the Lingnan School—Gao Jianfu, Gao Qifeng, and Chen Shuren—whose work combined aspects of traditional Chinese painting with contemporary subject matter and strategies of pictorial realism picked up from studies of Western art. As testament to heightened nationalist sentiment in China on the eve of its war with Japan, some objected to the presence of non-Chinese, foreign influences in the work of the country's contemporary artists.

China's Artists in World War II

Japan's first bold move into China took place in 1931 with its seizure of Manchuria. Chiang Kai-shek, who succeeded Sun Yat-sen as the Nationalist Party leader and head of the republic after Sun's death in 1925, used the Japanese invasion as a pretext for suppressing the country's communist insurgency led by Mao Zedong. In what became known as the Long March of 1934–1935, Chiang's military drove 400,000 troops of the Communist Party's Red Army some 6,000 miles northwest into Shaanxi Province. Only 40,000 survived the ordeal. The Red Army made the Shaanxi village of Yan'an their capital for the remainder of the war.

In July 1937, Japan's attack on the Marco Polo Bridge, just ten miles west of Beijing, prompted a temporary United Front between the nationalists and the communists. By the end of the month, the Japanese had taken Beijing; in December their forces captured Shanghai, killing 250,000 Chinese. Japan's armies then moved on to Nanjing, the country's capital, and what became known as the "Rape of Nanjing," where Japanese troops committed heinous atrocities of rape, torture, and murder against 200,000 of China's civilians and soldiers. Feng Zikai, one of the country's most acclaimed cartoonists, was among those who used their art to record Japanese brutality and the horror of modern, mechanized warfare during these months. The nationalist government retreated from Nanjing to Chongking in the province of Sichuan for the remainder of the war. Schools, universities, and art academies closed down and moved to the interior in advance of Japan's invading forces. By late 1938, the Japanese held control of most of the coastal cities and major railways.

Under the United Front, Guo Moruo, a leading Communist Party intellectual, was appointed to the Military Affairs Commission, where he was put in charge of coordinating the United Front's war propaganda. Shortly after the Marco Polo Bridge incident, the National Salvation Cartoon Association formed in Shanghai. The association soon came under the direction of the Military Affairs Commission, at which point it was renamed the National Salvation Propaganda Corps. The corps published its own journal, *National Salvation Cartoons*, with caricatures urging patriotic resistance to the Japanese. They also disseminated resistance cartoons in newspapers, posters, and other media. Adapting the works of George Grosz, David Low, and other Western satiric illustrators to their own illustration traditions, corps cartoonists produced images intended to dehumanize the enemy by portraying the Japanese as monstrous apes, pigs, and dogs. Other cartoons drew damning parallels between the Japanese and German governments and assailed traitors complicit with the invading Japanese. The corps fled Shanghai for the interior when Japan's forces invaded the coastal city in 1937.

The Military Affairs Commission confronted a lack of mass media resources (including the film industry, which ceased operations between 1937 and 1945) for its propaganda efforts, as well as a breakdown of travel and communication between China's urban centers and its vast rural countryside. The commission resorted to using propaganda teams, including artists from the National Salvation Propaganda Corps, which it attached to battalions of communist and nationalist forces. These propaganda teams produced posters, brochures, books, exhibitions, banners, and performances in China's towns and villages in order to educate the country's illiterate peasantry about the war effort. Due to a wartime scarcity of materials, artists improvised by using scrap pieces of wood, discarded newsprint, or whatever else they could find.

In 1940, the United Front alliance between China's nationalist government and Mao's Communist Party came to an end. Communist intellectual Guo Moruo was removed from his propaganda post in the Military Affairs Commission. The nationalist leadership also cut further funding for the National Salvation Propaganda Corps after some corps artists produced cartoons critical of government corruption. While simultaneously attempting to hold back Japanese advances, Chiang Kai-shek waged another large-scale offensive against the communists.

With the bombing of Pearl Harbor in 1941 and the United States' entry into the war, Japan's imperialist drive soon suffered military setbacks. In China's civil war, meanwhile, the nationalists began to lose ground to Red Army forces as the Communist Party expanded its influence in both Japanese and nationalist held areas. Mao's supporters rallied the peasantry to the Communist Party cause by introducing land reform and improved education. They also harnessed popular culture as a vitally important propaganda tool.

On October 1, 1938, a school for the exploration of popular culture and communist propaganda opened in the communist stronghold of Yan'an in Shaanxi Province. Called the Lu Xun Academy of Arts and Literature, it occupied a former Catholic church in the center of the village. The Academy was named after

the revered leader of the Creative Print Movement, Lu Xun, whom Mao praised as an early driving force in China's cultural revolution.

Lu Xun, a writer and educator, was involved in national educational reform through his work with Cai Yuanpei in the Ministry of Education beginning in 1913. He became an avid collector of woodcut prints in the 1920s, purchasing works by artists from Japan, the United States, Europe, and the Soviet Union. Woodcut entails carving a design into a block of wood, applying pigment to the remaining surface, and pressing it on paper in order to make an image. The earliest examples of woodcut come from China's Tang Dynasty of the seventh century when it was used to produce book illustrations. Throughout its long history in China, woodcut was considered a craft, not an art form, and was carried out by groups of craftworkers who divided the labor of designing, carving, and printing the wood block. Many prints could be made from a single block, thus making woodcuts—unlike one-of-a-kind paintings—relatively inexpensive and capable of wide distribution.

Though never a member of the Communist Party, Lu Xun gravitated toward the Marxist artistic left in the 1920s. Woodcuts represented for him a new radicalized national art. He saw woodcut as deeply rooted in an indigenous Chinese culture expressive not of China's aristocratic elite, but rather of its masses of common people. Lu Xun actively promoted the works of those Western and Soviet artists whose critiques of capitalism and imperialism provided dissident Chinese artists with a model of socially engaged subject matter. He favored above all the works of the German Expressionist Käthe Kollwitz, with whom he established a personal correspondence and whose prints he often exhibited and published. Kollwitz's powerful images of the 1920s depicted downtrodden workers and wounded soldiers in protest of capitalist exploitation and resurgent militarism in Germany. Lu Xun looked on Kollwitz's art as an important international example of social protest dedicated to the lives and struggles of the people. Lu Xun wrote:

> Chinese who have not had the opportunity to travel abroad often have the idea that all white people are either preachers of Christianity, or well-dressed, well-fed managers of business firms given the habit of lecturing people…But the works of Käthe Kollwitz show that there are others "injured and insulted" like us in many places of the earth, as well as artists who mourn, protest and struggle on their behalf…[and portray] a different kind of people, not "heroes" perhaps, but more approachable and sympathetic. The longer you look at them, the more beauty you find in them, and the more their power attracts you.[2]

Creative Print Movement artists such as Lu Xun's friend, Li Hua, frequently modeled their propaganda prints during the World War II years on Kollwitz's protest imagery of the 1920s.

The Lu Xun Academy in Yan'an featured departments devoted to literature, music, drama, and art. Instructors at the school upheld Lu Xun's commitment to the creation of art engaged with the masses. Mao condemned a cartoon show

held in Yan'an in 1942, however, in which artists associated with the Lu Xun Academy emulated Western modes of socially critical art and satiric illustration. Works by Hua Junwu, Zhang E, and Cai Ruohong included in the exhibit not only assailed Chiang Kai-shek's nationalists and the Japanese, but also drew attention to problems within the Communist Party and persistent social inequities in Yan'an.

Mao responded with a Rectification Campaign that enforced party discipline and brought the arts under centralized control. Under his command the Lu Xun Academy abandoned the cosmopolitan sophistication of satiric illustration and Western examples of socially critical art. Instead, Mao exhorted artists to learn from the popular arts of China's peasantry and to subordinate their creative activity to the interests of the masses.

Mao summarized his views in a series of lectures in Yan'an that outlined his desire to form a "cultural army" in the interests of communist revolution. Mao rejected any notion of art as mere "slogan style" propaganda. Art, he insisted, should provide the peasantry with positive images of the coming egalitarian society under communism. As part of his larger aim to found a new national art under communist control, Mao demanded that artists also use a style that served to raise the aesthetic and educational standards of the peasantry:

> What we demand [...] is a unity of politics and art, a unity of content and form, a unity of revolutionary political content and the highest artistic form possible. Works of art that lack artistry, however progressive politically, are nevertheless ineffectual. We are therefore equally opposed to works of art with a harmful content and to the tendency toward the so-called "slogan style," which is only concerned with content and not with form; we should carry out a struggle on both fronts in questions of literature and art.[3]

The Lu Xun Academy put Mao's principles into practice. Students were sent out into the countryside to learn various folk arts, especially the popular tradition of *nianhua* or New Year's prints. *Nianhua* were multicolored woodblock prints typically made in honor of the New Year, but used as decoration and hung in peasant homes year-round. They contained auspicious symbols—healthy children, bountiful harvests, folk gods, and the like—for good luck in the coming year. Communist artists learned the *nianhua* technique from the peasants. They used the prints, in turn, as tools to educate the peasantry by teaching them how to read slogans incorporated into *nianhua* images and introducing them to the ideals of the communist revolution. *Nianhua* portrayals of Red Army soldiers replaced folk gods as the new heroes of the people; healthy children and bountiful harvests similarly became affirmative harbingers of the coming communist triumph.

China's civil war came to an end in 1949 with Mao's declaration of the People's Republic of China in Beijing's Tiananmen Square. Chiang Kai-shek fled to Taiwan, where he ruled over the nationalist government in exile until his death in 1975. After 1949, the cultural principles set forth in Mao's lectures at Yan'an

became extended to the whole country. Lu Xun Academy instructors Jiang Feng, Zhang Ding, Hu Yichuan, Chen Tiegeng, Hua Junwu, and Cai Ruohong became leading figures in China's Maoist art world. Under their stewardship, woodblock prints, cartooning, and the wartime legacy of other popular arts became the cornerstone of China's new "people's culture." In the early 1950s, with the development of ties to the Soviet Union, China's revolutionary-era popular culture began to yield to the Soviet-styled socialist realism for which Mao's cultural legacy is best remembered today.

Chinese Artist Biographies

Gao Jianfu (1879–1951)

Gao Jianfu was born in 1879 in the prosperous port city of Canton, located in Guangdong Province. He became the lead theorist and spokesperson for the Lingnan School of painting, named for the Lingnan region of his native Guangdong. Other members of the Lingnan School were Gao Jianfu's brother, Gao Qifeng, and Chen Shuren. All three became involved in the anti-Manchu revolutionary movement that culminated in the overthrow of the Qing Dynasty in 1912. Gao Jianfu subsequently led the Lingnan School's efforts to modernize China's traditional painting as a "new national art" under Sun Yat-sen and Chiang Kai-shek's nationalist governments.

Gao Jianfu began formal artistic training at age 13 when he entered the studio of the traditional Cantonese painter Ju Lian. In 1906, he left for Japan where he met his friend Chen Shuren, and was later joined by his brother, Gao Qifeng. While pursuing studies in Tokyo, all three were exposed to the heated nationalist debates then raging in the Japanese art world over the modernizing impact of Western art on Japan's local artistic traditions. Gao Jianfu and the other members of the Lingnan School became interested in the syntheses of Western and traditional approaches characteristic of work in the contemporary Japanese art world, which they looked upon as a viable model for a revitalized and modern national art.

These Lingnan School painters, politically radicalized in Japan, joined Sun Yat-sen's anti-Manchu, revolutionary nationalist movement. With the overthrow of the Manchus in 1912, Gao Jianfu and Gao Qifeng moved to Shanghai where they began publishing *Zhen xiang huabao* (The True Record). They also opened the Aesthetic Bookstore, which became one of the nation's first public galleries for the exhibit and sale of art works. Their journal featured articles on art and politics and published essays for the promotion of a new, modernized national art in China. They also advocated a system of government support for the arts, similar to what they had encountered in Japan.

Gao Jianfu's art of the 1920s combined elements of realism derived from Western art with traditional Chinese ink and brushwork. His landscape paintings of this period achieved greater volume and depth through subtle washes

of pigment and the use of light, shade, and perspective. His subject matter, too, underwent change. He addressed themes derived from contemporary reality instead of flowers, birds, and landscapes of traditional art.

In 1927, the connection between Gao Jianfu's new national art and the nationalist political cause to which he had dedicated himself was made explicit with the unveiling of his new airplane paintings in an exhibit in Canton. In works such as *Flying in the Rain* (undated), Gao Jianfu used atmospheric washes of pigment and calligraphic brushwork reminiscent of traditional art to depict a squadron of biplanes soaring in the sky over a placid landscape of meandering streams and delicate trees. The propagandistic importance of the show was made plain by the banner carrying Sun Yat-sen's slogan "Aviation to Save the Country," which was used to announce the exhibit's theme. During the war years, Gao Jianfu produced similar works with titles such as *New Battlefield* and *Air Defense*.

By the late 1920s, however, Gao Jianfu's combined use of Japanese and Western stylistic impulses and themes began to encounter a rising tide of antiforeign sentiment. Under the direction of the Minister of Education, Cai Yuanpei, Gao Jianfu was the chief organizer in 1929 of the government's first National Art Exhibition held in Nanjing. The Lingnan School was prominently represented in the exhibit, which met with hostile critical response for its inclusion of non-Chinese artistic tendencies.

In 1936, Gao Jianfu began teaching at Sun Yat-sen University in Canton. He published articles during this period in which he defended his concept of a new national art. In "My Views on Contemporary National Painting" from 1936, he insisted on the importance of adhering to Chinese traditions while allowing those traditions to absorb selectively from Western approaches in the interests of maintaining a vital and living art. Echoing more politicized artistic tendencies of the war years, Gao Jianfu also insisted that national painting must abandon the elitism of traditional art and dedicate itself to engaging more directly with the Chinese public.

Gao Jianfu left such populist efforts for reform of China's art to a younger, more radicalized generation of artists, however. As the war years progressed, he retreated more and more from the political struggles of the nationalists and the communists. He also turned away from using Japanese and Western influences in his art and returned to traditional painting, which he came to regard as China's only genuine national art.

With the Japanese occupation of Canton in 1938, Gao Jianfu fled to the island of Macao. There, in 1938, he produced a morbid allegorical commentary on current events in a work titled *Skulls Crying over the Nation's Fate*. The image depicts a pile of skulls abandoned in a field of grass. After Japan's defeat in 1945, he returned to teaching in Canton. When Mao came to power in 1949, he retreated once again to the relative isolation of Macao. His refusal to participate in the building of a new communist art world after 1949 earned him the vilification of Maoist cultural functionaries. Gao Jianfu died in Macao in 1951.

Jiang Zhaohe (1904–1986)

Jiang Zhaohe was born into a poor family in Luxian, Sichuan in 1904. Jiang began at an early age to earn money by drawing portraits in charcoal and ink. He later worked for a department store in Shanghai producing portraits of clients while he studied oil painting and sculpture in his spare time. His breakthrough in the established art world came in 1929 when he exhibited *Rickshaw Coolie* at the first National Art Exhibition in Nanjing. He then took a teaching post for two years at the National Central University in Nanjing, returning thereafter to Shanghai.

Jiang made a name for himself during this period for his portraits of officials and military figures. He also traveled the slums of Nanjing, Shanghai, and Beijing to record the lives of the downtrodden and the suffering of refugees displaced by war. Jiang combined the calligraphic line of traditional Chinese brushwork with a Westernized pictorial realism, which he developed through subtle washes of ink and pigment to suggest three-dimensional, modeled form.

In 1935, Jiang moved to Beijing where he remained until 1945. In 1943, during the Japanese occupation of the city, he painted a large-scale hand scroll (2 meters high by 26 meters long). Titled *Refugees,* the work depicts displaced men, women, elderly, and children carrying with them their meager possessions. Jiang communicates the refugees' exhaustion through their emotionless expressions and slumped shoulders. Figures collapse by the wayside; in vignettes reminiscent of Käthe Kollwitz's social protest art of the 1920s, mothers hold their dead and dying children in their arms and cradle their own tired and despairing faces in their hands. The file of refugees makes its way from left to right in the composition. Jiang highlights their uncertain future and lack of secure destination, however, by the aimless manner in which figures break off from the file, move in the opposite direction, and gather in motionless clusters by the roadside. Though their dire predicament has reduced them to an anonymous, dispossessed mass, Jiang individualizes each figure with a portraitlike realism and quiet dignity of character.

When the scroll went on view in the Imperial Ancestral Temple in Taimiao, Japanese soldiers removed the work and closed down the show. Jiang took *Refugees* to Shanghai in 1944 for exhibition in the French concession. The Japanese once again confiscated the work and banished it to a warehouse in Shanghai where it remained until 1953. By then, the second half of the hand scroll was lost and the rest was in poor condition.

After Mao came to power in 1949, Jiang taught at the Central Academy of Fine Arts, which became a model institution for arts instruction throughout the country. His life and art were celebrated under Mao as an example of an artist who came from humble circumstances and dedicated his work to sympathetic portrayals of the poor and oppressed. When *Refugees* was unearthed from a Shanghai warehouse in 1953, it was acclaimed as a precursor to the socialist realism then recognized as China's official art. Jiang Zhaohe died in 1986.

Li Hua (1907–1994)

Born in Panyu, Guangdong Province in 1907, Li Hua studied Western oil painting at the Canton Academy where he graduated from in 1925. The governor of Guangdong Province opposed Chiang Kai-shek's authoritarian nationalist government. His sympathy for political dissidence made Guangdong a haven for radicalized woodcut artists whose suspected communist ties made them a target of nationalist repression in the late 1920s and early 1930s. Li became active in the woodcut movement in 1930. After a year of study in Japan between 1931 and 1932, he returned to Canton where he founded the Modern Woodcut Society at Canton Academy, which became a powerful center of woodcut art.

In 1934, Li held a one-man exhibition of his work, which led to the formation of a small group that lasted from 1934 to 1937 called the Modern Creative Print Study Society. The society worked to popularize woodcuts through the publication of their own illustrated journal, *Modern Prints,* and by holding exhibitions and conducting workshops on woodcut technique.

In 1935, Li carried on a correspondence with Lu Xun, where the two debated the question of what constituted the "Chinese spirit" in art.[4] Li Hua's art during this period reflected Lu Xun's belief that authentic Chinese art could only emerge from those artists willing to establish direct contact with—and share in the struggle and hardship of—the ordinary masses of Chinese people at war.

In *Roar, China,* a woodcut of 1935, Li Hua adopts allegory for a portrayal of China's struggle under the impact of Japanese imperialism and civil war.[5] Drawing on the emotional intensity of German Expressionist art, Li's stark composition depicts a man whose nude and contorted body struggles against thick ropes that lash him to a wooden post. Captive and blindfolded, yet undefeated, the man's muscular body begins to wrestle loose from his imprisoning ropes as he reaches for a dagger lying at his side. The work suggests China's present torment but also predicts its awakening power and strength to prevail. In other woodcuts, such as *Arise!,* Li patterned the style and content of his work directly on Käthe Kollwitz's print series titled *Peasants' War* (1899–1908). *Arise!* depicts the heroic solidarity of peasants and soldiers who join together and rush headlong with determination and resolve to face down the enemy in battle.

As an official war artist after 1937, Li covered the southern China battlefronts, during which time he produced anti-Japanese propaganda. In works such as *Conscript Soldiers of the Guomindang* (undated), Li began to register his growing opposition to the recruitment tactics of Chiang Kai-shek's nationalist government. The work portrays a nationalist soldier leading off to battle a group of village men, whose hands have been tied behind their backs. Women and children from the village mourn and cry out in despair as their husbands and brothers are forcibly taken off to war. In *Two Generations* (undated), Li suggests his sympathy with the communist cause in a woodcut that portrays a fraternal alliance between a peasant and a soldier of Mao's Red Army. The peasant and soldier stand side by side, with their arms around each other's shoulders in a gesture of equality and camaraderie. The image affirms Mao's Red Army as a

"People's Army" dedicated to the struggle not solely against Japanese imperialism, but also against the class oppression of China's peasant masses.

Beginning in 1949 under the Maoist regime, Li taught graphic arts in the Central Academy of Arts in Beijing. He also became chair of the Chinese Wood Engravers Association and a powerful figure in the communist Chinese art world. During and after Mao's rule in China, Li became outspoken in his hostility toward modernist tendencies in the arts. History now remembers Li Hua as a bastion of the old order for his refusal to condone artistic experiment among his students at the Central Academy, where he continued to teach until shortly before his death in 1994.

Feng Zikai (1898–1975)

Born in Shimenwan, Zhejiang Province in 1898, Feng Zikai is best known for elevating the cartoon to the status of a respected art form. Feng studied art and music under Li Shutong in 1915. In 1920, he, along with Liu Zhiping, founded the Shanghai Private Arts University. He spent 1921 in Japan studying oil painting. Throughout the 1920s and 1930s, Feng published influential treatises on art theory and taught courses in cartooning. He contributed his own cartoons, many of them depictions of innocent and fun-loving children, to prominent literary journals. Feng's artistic sensibility was profoundly imbued with his Buddhist beliefs, which shaped his pacifism and deep reverence for life.

Unlike other cartoonists of his generation, who styled their work on the artistic precedent of George Grosz, David Low, and other Western satiric illustrators, Feng favored traditional Chinese brushwork. He typically accompanied his cartoons with a poem, linking his illustrations to the high-art, literary status of poetry. Feng also characteristically refrained from overt political comment in his art.

Feng's attitude changed dramatically, however, when Japan marched into China. In 1937, Japanese bombers attacked his hometown, Shimenwan. He and his family joined the thousands of refugees who fled to the interior in advance of Japan's armies. Feng did not participate in any of the cartoon propaganda corps attached to the United Front armies in 1937. In March 1938, however, he joined the All-China Resistance Association of Writers and Artists and became a member of the editorial board for the association's official publication, *Resistance Literature and Art*. Feng published several cartoons in the association's journal and elsewhere during this period that condemned Japanese brutality. His works contrasted the horror of Japanese bombs and mechanized warfare with the innocence of Chinese children, mothers, and the defenseless. In one cartoon, titled *Bombing*, two Japanese bombs descend from the sky toward their target destination: a school for blind and mute children unable to see or warn one another of their impending fate. In another cartoon, which appeared in the *China Weekly Review* in 1939, Feng made reference to an event that took place in 1937 in Jiaxing, Zhejiang Province. Titled *A Mother's Head Severed*, Feng depicts

a mother—her head just blown off—seated on a low bench, holding her nursing child to her breast.[6] Blood spurts from her headless torso as two more bombs descend from the sky above. Feng included a poem with the image:

> In this aerial raid,
> On whom do the bombs drop?
> A baby is sucking at its mother's breast,
> But the loving mother's head has suddenly been severed.
> Blood and milk flow together.[7]

Feng and his family settled in Chongqing until 1945. In 1954 he became director of the Chinese Artists Association and, in 1960, president of Shanghai Art Academy. In 1962 he served as vice chair of the Joint Federation of Literature and Arts in Shanghai. Feng Zikai died in 1975.

Jiang Feng (1910–1983)

Jiang Feng was born in 1910 into a working class family in Shanghai. He became involved in left-wing politics in his late teens when he worked as a bookkeeper for a railroad company and participated in labor strike activities. At age 19, he began evening art classes at the White Swan Western Painting Club in Shanghai. In 1931, Jiang became involved with a group of dissident students. He joined them in launching the Shanghai Eighteen Art Society Research Center (plans for the organization had begun in 1929, the 18th year of the republic, after which the group was named). The Eighteen Art Society developed close ties to the League of Left-Wing Artists and other communist-affiliated groups. They published and spread anti-imperialist propaganda among Chinese workers. Lu Xun, who supplied them with funds, woodcuts, and books, supported their efforts. Lu Xun also put Jiang and the Eighteen Art Society in charge of selecting students for the workshop on woodcut technique in 1931 that Lu Xun organized in Shanghai.

In 1931, Jiang produced his woodcut titled *Kill the Resisters*. He used the stark woodcut style of German expressionist art to depict a group of flag-waving demonstrators fleeing in advance of gunfire from a phalanx of armed nationalist troops. In 1932, Jiang formally joined the Communist Party and was elected to the executive of the League of Left-Wing Artists in that year. Shortly thereafter, the nationalist government arrested eleven members of the Eighteen Art Society, including Jiang. He spent two years in prison where he organized a school and led hunger strikes. He was rearrested in 1933, two months after his release, and jailed for another two years. Lu Xun sent Jiang a portfolio of Käthe Kollwitz's prints while he was serving his sentence.

In 1935, Jiang returned to Shanghai where he remained involved in dissident political activity. He also worked for a publication called *Iron Horse Prints,* for which he produced several woodcuts inspired by Soviet constructivism. After

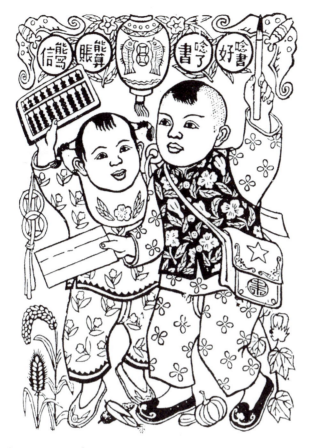

Jiang Feng, *Studying is Good*, 1942.

the Japanese attacked Shanghai in 1937, Jiang fled to the Red Army stronghold in Yan'an.

In 1939, Jiang became an instructor at the Lu Xun Academy of Literature and Art in Yan'an. He was made director of the art department the following year and put in charge of the art factory responsible for producing *nianhua* prints for Red Army propaganda. In the wake of Mao's Rectification Campaign of 1942, Jiang, for reasons that remain unknown, was jailed for one year.

One of his works from 1942, titled *Studying is Good*, infuses *nianhua* with positive and uplifting communist content. In line with communist espousal of gender egalitarianism and the party's commitment to bettering the lives of the peasantry through education, Jiang depicts happy and healthy children and a bountiful harvest familiar from traditional *nianhua* prints. In this case, however, the children are a boy and girl who hold aloft an abacus and a writing brush while squash and grain spring up from the ground beneath their feet. The slo-

gans depicted in the canopy of paper lanterns above their heads read: "Studying is good. After you study, you can do accounts and write letters."

Between 1945 and 1949, Jiang dedicated his work to the war of liberation against the nationalists. In 1946, he served as head of the art department at the Huabei United Revolutionary University. Jiang became vice-chairman of the Chinese Artist's Association in 1949 under the Maoist regime. He later held the offices of vice-president of the Zhejiang Academy of Fine Arts in Hangzhou and president of the prestigious Central Academy of Fine Arts in Beijing. Jiang enjoyed significant power and authority between 1949 and 1957 as a leading figure in Mao's project of cultural reform in the Chinese art world. Jiang Feng died in 1983.

Notes

1. Chinese names traditionally present the surname or family name first, followed by the first or given name. The first full reference to an individual's name in the text will follow Chinese order. All subsequent references will use the family name. "Mao Zedong" thus becomes "Mao" in the following discussion.

2. Lu Hsun (Xun), "Written in Deep Night," *Chinese Literature* 9 (1961). Cited in Lisa E. Rotondo, *Chinese Revolutionary Woodcuts 1935–1948* (Middletown, CT: Davison Art Center, 1984), 6.

3. Bonnie S. McDougall, *Mao Zedong's "Talks at the Yan'an Conference on Literature and Art": A Translation of the 1943 Text with Commentary* (Ann Arbor: Center for Chinese Studies, The University of Michigan, 1980), 78.

4. Lu Hsun (Xun), "Letter to Li Hua," *Chinese Literature* 8 (1978): 105–6.

5. See illustration of Li Hua's Roar, China in Iris Wachs and Chang Tsong-zung, Half a Century of Chinese Woodblock Prints: From the Communist Revolution to the Open-Door Policy and Beyond, 1945-1998 (Ein Harod, Israel: The Museum of Art Ein Harod, 1999), page 83, figure A2.

6. See illustration of Feng Zikai's A Mother's Head Severed in Chang-Tai Hung, War and Popular Culture: Resistance in Modern China, 1937-1945 (Berkeley: University of California Press, 1994), figure 9.

7. See Chang Tai-Hung, trans. *War and Popular Culture: Resistance in Modern China, 1937–1945* (Berkeley: University of California Press, 1994), 101.

Bibliography

Andrews, Julia F. *Painters and Politics in the People's Republic of China, 1949–1979.* Berkeley: University of California Press, 1994.

Andrews, Julia F., and Kuiyi Shen. *A Century in Crisis: Modernity and Tradition in the Art of Twentieth-Century China.* Exhibition catalogue. New York: Guggenheim Museum, 1998.

Andrews, Julia F., Claudia Brown, David E. Fraser, and Kiuyi Shen. *Between the Thunder and the Rain: Chinese Paintings from the Opium War through the Cultural Revolution, 1840–1979.* Exhibition catalogue. San Francisco, CA: Echo Rock Ventures, 2000.

Croizier, Ralph. *Art and Revolution in Modern China: The Lingnan (Cantonese) School of Painting, 1906–1951*. Berkeley: University of California Press, 1988.

Hung, Chang-Tai. *War and Popular Culture: Resistance in Modern China, 1937–1945*. Berkeley: University of California Press, 1994.

Kao, Mayching, ed. *Twentieth-Century Chinese Painting*. Oxford: Oxford University Press, 1988.

Rotondo, Lisa. *Chinese Revolutionary Woodcuts, 1935–1948*. Exhibition catalogue. Hamilton, NY: The Picker Art Gallery, Colgate University, 1984.

Sullivan, Michael. *Art and Artists of Twentieth-Century China*. Berkeley: University of California Press, 1996.

Wachs, Iris, and Chang Tsong-zung. *Half a Century of Chinese Woodblock Prints: From the Communist Revolution to the Open-Door Policy and Beyond, 1945–1998*. Exhibition catalogue. Ein Harod, Israel: The Museum of Art Ein Harod, 1999.

CHAPTER 2

Artists in France: Between Collaboration and Resistance

Adolf Hitler realized one of his long-held ambitions when German troops entered into Paris on the morning of June 14, 1940. Since the reign of King Louis XIV (1643–1715), the French capital had ruled as Europe's undisputed center of art and culture. Hitler was not alone in his admiration for Paris's outstanding works in architecture, painting, and sculpture and its world-class museums, whose collections had been augmented by the spoils of Napoleonic conquest in the early nineteenth century. The Franco-Prussian War of 1870 had sown the seeds of bitter national enmity between France and Germany, however. That enmity had grown all the more acute with Germany's defeat in World War I and France's role in forcing German compliance to the humiliating terms of the Versailles Treaty in 1919. With the invasion of France in 1940, Hitler proceeded to subjugate Germany's erstwhile enemy and appropriate its cultural riches for the greater glory of the Third Reich. Between 1940 and 1944, German occupying forces stripped tens of thousands of artworks from French private and public collections. Many of the looted objects were packed on trains for delivery to the homes of the German leadership. Many more, however, were destined for a new colossal museum, located in Hitler's childhood hometown of Linz, Austria, that was to serve as a showcase for the cultural spoils of Nazi world conquest.

France was also home to leading members of the international avant-garde, including Pablo Picasso, Georges Braque, Henri Matisse, and other luminaries, whose pathfinding work set the terms for some of the most provocative artistic movements of the twentieth century. Inside Germany, Hitler banned modernist art and persecuted modern artists as "degenerate." Works by Picasso, Braque, Matisse, and others appeared in defamatory exhibits held in Germany from 1933 onward. Nazi cultural functionaries also systematically purged their paintings and sculptures from German art collections.

Inside occupied France, however, Nazi policy tolerated a surprising degree of creative freedom. While art containing anti-Nazi political commentary was forbidden, artists nonetheless continued to produce and exhibit works of a formally experimental and innovative nature that would have exposed them to harsh recrimination in Germany.

Relative leniency thus made it possible for vanguard artists in France to continue their work. It also posed serious and abiding questions, however, about "artistic freedom" in time of war and repression. What did it mean for Picasso, Braque, Matisse, and others to create avant-garde works under these circumstances? Was their pursuit of innovative art a gesture of defiance against the creative oppression exercised inside Nazi Germany? Or did these artists simply affirm the status quo of the Occupation by abstaining from involvement in current events and continuing to immerse themselves in the formal problems of their own art? Did they—in short—resist Nazi cultural repression, or collaborate with it? Such questions haunted not only France's artists, but also the country as a whole in the postwar years. Debates on the wartime role of France's art, artists, and the public at large consumed the country's political and cultural life after 1945 as it confronted the tormented history of its ambiguous relationship to Germany during World War II.

France and Its Art World before World War II

With the establishment of the Royal Academy of Painting and Sculpture in Paris under King Louis XIV in 1648, France rose to prominence as the center of European cultural achievement. From 1737 onward, the French government sponsored annual academy exhibits, known as Salons. These Salons became major events that attracted the attention of artists, critics, and art patrons from around the world. France's museums, including the Louvre and Jeu de Paume among many others, also drew international admiration and boast to this day some of the most impressive art collections ever assembled.

By the mid-nineteenth century, France also played host to the first flowerings of the avant-garde. Avant-garde artists began to form artistic movements that broke with the stylistic norms promoted by the Royal Academy. Among the first vanguardists were the French impressionists, including Claude Monet, Berthe Morisot, and Auguste Renoir, whose sketchy, sun-drenched images of bourgeois leisure caused public controversy when they were unveiled to the Parisian public at the group's first exhibit in 1874.

Following in the wake of the impressionists were artists whose names are now synonymous with Western modernism itself: Vincent Van Gogh, Paul Gauguin, and Paul Cézanne of the post-impressionist generation; Henri Matisse and André Derain of the fauvist group; Pablo Picasso and Georges Braque, founders of cubism; and Marcel Duchamp, an international leader of the antiart

Dada movement of the World War I era. In 1924, André Breton founded the surrealist group in Paris, drawing to the city an array of artists and writers who dominated the avant-garde well into the 1930s, including André Masson, Alberto Giacometti, Yves Tanguy, Max Ernst, Salvador Dalí, Joan Miró, and Meret Oppenheim. Some of these leading figures of artistic modernism were born in France, but many others, like Van Gogh from Holland, Picasso from Spain, and Ernst from Germany, gravitated toward Paris as the cosmopolitan heart of the international avant-garde art world.

After Hitler's appointment as German chancellor in 1933, Paris's vibrant cultural scene swelled with vanguard artists and intellectuals fleeing Nazi persecution. In 1935, Hitler announced his intention to rearm Germany in violation of the Versailles Treaty of 1919. In line with Stalin's effort to form a popular front pact between the Soviet Union and Western democracies against Hitler, France elected a Popular Front government in 1936. Headed by Léon Blum, the Popular Front coalition of communist and socialist parties attempted to quell growing political polarization between the country's fascist militants, on the one hand, and increasingly radicalized workers, on the other. Staging a series of debilitating labor strikes in the early and mid-1930s, France's workers demanded sweeping social and economic reform in response to the crippling effects of the Great Depression. The Popular Front government's attempts at reform were hobbled by the growing need to rearm in the face of mounting German militarist aggression. In March 1936, Hitler occupied the Rhineland in flagrant violation of the Treaty of Versailles; he also began to provide military support to General Francisco Franco's fascist insurgency in Spain.

Darkening international relations were much on display at the Exposition internationale des Arts et des Techniques appliqués à la Vie moderne (International Exposition of Arts and Applied Technics in Modern Life), more commonly known as the Paris World's Fair. Opened to the public on May 25, 1937, the fair, located on the banks of the Seine near Paris's landmark Eiffel Tower, was intended to promote peaceful economic exchange and competition between nations through the display of the latest international achievements in art, design, and technology. Reflective of the current climate of world crisis, however, the fair became instead a showdown of prewar visual propaganda between countries soon to be combatant enemies. Towering over all the other national pavilions at the fair were those of Germany and the Soviet Union, whose bombastic, large-scale structures squared off across from one another on the main fairway. The physical confrontation of these two structures reminded the fair-going public of the political and military conflict then brewing between Germany and the Soviet Union. In late 1936, Stalin had decided to aid the Spanish Republic in its struggle against Franco's rebel forces, who enjoyed the support of Hitler's Condor Legion. By the opening of the fair in summer 1937, Spain's civil war had thus evolved into a war between Germany and the Soviet Union on Spanish soil.

The Paris World's Fair is most remembered today as the setting for the unveiling of Picasso's *Guernica,* one of the most celebrated works of art in the twentieth century. A Spanish expatriate who had made Paris his home since 1904, Picasso

donated his mural-sized work to the Spanish pavilion, a modest three-story steel and glass structure dwarfed by the German and Soviet pavilions located nearby. Using a cubist fragmentation of form to suggest the ravages of death and destruction, Picasso's mural drew world attention to the brutal aerial bombing of the civilian town of Guernica, located in northern Spain, by Hitler's Condor Legion in April 1937. *Guernica* worked in concert with other displays in the Spanish pavilion to protest the civil war and plead for international help in the Spanish Republic's struggle against Franco's rebel forces.

The following year, conservative factions gained the upper hand in France with the election of the cabinet of Édouard Daladier on April 10, 1938. Daladier broke with communists and socialists in the French government and dismantled the Popular Front coalition. In September 1938, France, along with Great Britain, signed the fateful Munich Agreement that attempted to appease Hitler by granting him annexation of German-speaking territories in Czechoslovakia. By March 1939, Hitler had taken control of all of Czechoslovakia. With war imminent, French cultural officials closed museums in Paris and other northern cities. Plans were also readied to evacuate the country's art collections to the south of France for safekeeping in the event of a German invasion. Blackouts were ordered in Paris in August 1939 as a precaution against German air raids. Two days after Hitler's invasion of Poland on September 1, 1939, France and Britain declared war on Germany, igniting World War II in Europe.

France's Artists in World War II

In May 1940, German forces invaded the Netherlands, Belgium, and Luxemburg; by June, Hitler's troops had arrived in France, occupying Paris on June 14, 1940. French tricolor flags were removed from their standards throughout the city and replaced with swastika banners. French premier Marshal Philippe Pétain quickly capitulated. Under the terms of the armistice, Germany took control of the north of France, including Paris, and the country's Atlantic seaboard. The French government relocated from Paris to the provincial town of Vichy. Hitler (disingenuously) promised Pétain a role for France in the new Europe soon to be realized through Nazi conquest. In exchange, Pétain agreed to collaborate with Germany while maintaining nominal control over the unoccupied southern regions of the country. In reality, however, the Vichy government amounted to little more than a puppet of German dictatorial authority.

On June 23, 1940, one day after the armistice was signed, Hitler visited Paris for the first time. Propaganda photos, including one of Hitler and his entourage silhouetted against a backdrop of the Eiffel Tower, captured the Führer's triumphal tour through the city. Guiding Hitler on this visit was his favorite sculptor, Arno Breker, who, having lived in Paris in the 1920s and through his active contacts with the art scene there, knew the city well. Albert Speer, Hitler's architect, was also in attendance. Speer was then engaged in realizing Hitler's plans for the

grandiose reconstruction of Berlin as a city of world conquest. Hitler had toyed with the idea of destroying Paris altogether. After his visit, however, he instead ordered the French capital be left to stand as a diminished and humiliated relic soon to be surpassed by the grandeur of the new Berlin.

After the armistice, the Nazis moved immediately to secure control over French artistic patrimony and the country's art world. On June 30, 1940, Germany placed under its "protection" all public and private art collections in France. The following month, collections of leading Jewish art dealers in Paris were confiscated and Jews were soon forbidden to display their work in public exhibitions. In August 1940, Josef Goebbels' German Propaganda Ministry began to oversee all cultural activity in the occupied zone, including the content of art exhibitions. Exercising tight control over the French press, the ministry allowed the continued publication of art periodicals and journals, which now featured regular reports on events in the German art world. Celebratory articles on the art of Breker and Hitler's other favored artists combined with cinema newsreels also approved by the ministry to foster the image of Germany as a land of proud and enduring culture now triumphant over that of a defeated France.

Included in the armistice agreement between France and Germany was a stipulation that all German refugees who had sought asylum in France after 1933 were to be surrendered to German authorities on demand. The "surrender on demand" clause suggested to many that broader persecution of artists, intellectuals, Jews, and other "undesirables" was soon to follow. In the United States, an Emergency Rescue Committee (ERC) formed, which undertook securing safe passage for threatened artists and intellectuals to the United States. Assisted by Alfred H. Barr, director of the Museum of Modern Art in New York, the ERC drew up a list of some 200 names, including those of Pablo Picasso, Wassily Kandinsky, Max Ernst, Marc Chagall, Henri Matisse, and others who were to be rescued from occupied France. The ERC faced several challenges, not the least of which was the moral dilemma involved in its decision to rescue "valued persons" over and above the masses of others who were now similarly imperiled. The committee also confronted tightly restricted immigration quotas in the United States, public resistance to aiding foreign nationals, and, given that many on the list were Jewish, anti-Semitic hostility to its efforts.

The ERC selected Varian Fry, a former editor who was fluent in French and German, to travel to the south of France in August 1940. Fry set up a relief bureau in Marseilles, located on France's Mediterranean coast, where he forged passports and arranged safe passage for refugees, among whom he hoped to include prominent avant-garde artists. Many—including Picasso and Matisse—refused to leave given the continued viability, however restricted, of their artistic careers under the German occupying forces. Meanwhile, Fry's staff quarters at Villa Air Bel (a retreat located just outside Marseilles) became refuge to leading surrealists and other artists, including André Breton and his family, Marcel Duchamp, Max Ernst, André Masson, and Tristan Tzara, whose provocative works encountered dwindling public tolerance and opportunities for sales under the Occupation. Breton raised money through art auctions at Villa Air Bel, relying

on the patronage of collectors such as Peggy Guggenheim, who purchased many avant-garde works for her Art of This Century Gallery in New York. Breton, Ernst, and Masson were among those that Fry eventually helped to reach the United States. By the time he was expelled from France in September 1941, Fry's modest list of 200 had swelled to 2,000 artists, intellectuals, and political refugees whom he helped find safe passage out of the country.

Fry's rescue operations in France took place against the backdrop of an increasingly radicalized Nazi art policy of confiscation and anti-Semitic restrictions. In September 1940, a month after Fry's arrival, Hitler empowered the Einsatzstab Reichsleiter Rosenberg (Special Staff of Reich Leader Rosenberg, or ERR) to seize all art objects belonging to state museums, institutions, and private individuals in Paris and in the provinces. The army was directed to help the ERR transport the confiscated art to Germany for "safekeeping," while "degenerate" works by Picasso, Braque, Léger, Rouault, and others were sold to buy works deemed more artistically valuable. Pétain's Vichy government protested the seizures, but to no avail. Fernand Léger, one of France's leading modernist artists during this period, was among those who chose the uncertainty of exile over submission to the country's increasing cultural repression. Having fled Paris for the south of France in advance of invading German forces, Léger now departed for Lisbon, Portugal, and eventually made his way to the United States, where he remained until the end of World War II. By October 1940, the Vichy regime, in compliance with Nazi policy in occupied France, stripped Jews of their rights, ordered the seizure of all art from Jewish homes and businesses, and authorized the internment of Jews in concentration camps.

In November 1940 confiscated art was collected together at the Louvre and then assembled for exhibit at the Jeu de Paume Museum. There the works were inspected by Nazi leader Hermann Göring, who possessed a legendary and insatiable passion for building his private art collection—by whatever means. Göring divided the works into those reserved for Hitler, those set aside for himself (including old masters as well as works by "degenerate" modernists such as Renoir, Degas, Monet, Sisley, Cézanne, and Van Gogh), and those intended to be sent on to German museums. Rose Valland, curator at the Louvre, was retained to work alongside German curators who were brought in to inventory the works. In touch with the French Resistance, Valland passed information to General Charles de Gaulle's Free French movement headquartered in London on the whereabouts of the country's national treasures. Through her clandestine efforts, she helped the Resistance to track the destination of some of the tens of thousands of objects that were shipped to Germany between 1941 and 1944.

In 1941, Pétain's project of Révolution Nationale (National Revolution) inside Vichy France began to make itself felt in the French art world. A movement of national regeneration intended to restore France to its glorious past, Pétain's Révolution Nationale closely mirrored Nazi ideology in its emphasis on "travail, famille, patrie" (work, family, nation). The Pétain government looked on France's political democracy, urbanism, industrialism, declining birth rate, and changing gender roles of the 1920s—in short, all aspects of the country's modernization

since World War I—as the root cause of France's decline in the 1930s and its current subjugation to Germany. Pétain's policies sought to roll back the effects of modernity through economic incentives that promoted agrarian life through subsidies to small farmers. He also attempted to revive traditional gender roles by extending economic reward to women in exchange for leaving the workplace and returning home to bear children.

In the eyes of the Vichy government, modern art was also responsible for France's decadence of the 1920s. Rejecting the individualism, elitism, and internationalism associated with modern art, Vichy cultural functionaries promoted instead the production of clearly legible, easily understood, and idealized portrayals of the French nation and Pétain as its leader. Similar to Nazi imagery that rejected the "degenerate" effects of modern industrialism and urban life, Vichy propaganda images extolled the virtues of France's landscape and preindustrial traditions of agrarian life. Pétain's Révolution Nationale also promoted the values of handcraftsmanship over modern mass production by fostering a revival of French folk and decorative arts traditions.

Artists working in a limited range of styles from classicism to romantic realism and, in some instances, restrained forms of modernism, found favor—and increased access to exhibitions and sales—under Pétain's government. Aristide Maillol, a leading modernist sculptor of the pre-World War I years, garnered increasing official favor for his harmoniously proportioned portrayals of the nude female form. Such works now became enlisted in propagandistic notions of the beautiful body and physical perfection as hallmarks of French racial purity. The Vichy government staged major exhibitions devoted to themes of healthy youth, sport culture, and provincial agrarian lifeways and values. Pétain also ordered sculptures in public spaces throughout the country to be replaced by statues of politicians and those military and cultural figures now deemed important to the image of the new France.

In September 1941, the anti-Semitic Institut d'Etudes des Questions Juives (Institute for the Study of Jewish Questions) staged an exhibition titled "Le Juif et la France" (The Jew and France) at the Palais Berlitz in Paris. The pro-Nazi and rabidly anti-Semitic French art critic Lucien Rebatet handled the art section of the show. In his published writings, Rebatet insisted on the urgent need to "aryanize," or racially purify, the arts of allegedly corrosive Jewish cultural influence. He also drew a direct connection between such influence and the excesses of abstraction, figural distortion, and nonnaturalistic use of color that characterized the avant-garde art that Rebatet now condemned as foreign and non-French:

> It is necessary to aryanize the fine arts. It is an essential task, that which must precede all others. For it is Jews who through their excessive number [...] like parasite insects, threaten the beautiful plant [of current art]...
>
> Jews, painters or sculptors propagating the most pernicious example, Jewish dealers with their hideous speculations, critics praising [...] with unstoppable enthusiasm the mores and works from this vast ghetto, their presence must be

forbidden. And they must be told why they are condemned, and how their in-
fluence has been devastating [...] for us, and even if some of them have talent,
that talent is completely foreign to the spirit of our country and only serves to
contaminate our artists.[1]

Artists (none of them since recognized as significant in the history of art)
contributed sculptures, posters, and drawings to the show in which they por-
trayed Jewish "types" with distorted and misshapen physiognomies. The propa-
gandistic purpose of the exhibit was made plain by the manner in which such
negative portrayals were contrasted with works that emphasized the healthy,
idealized faces and bodies of the "true" French people under Pétain's Révolution
Nationale. Picasso was among those who faced mounting attacks from Rebatet's
critical cohort during this period who were quick to equate avant-garde art
with political subversion and "Jewishness." He endured searches of his private
bank vault and regular visits to his studio by German authorities who suspected
Picasso of harboring members of the Resistance.

Louis Hautecoeur, the Vichy government's General Secretary of Fine Arts,
attempted to institute strict government regulation over all the country's artists
and the form and content of their work. His aim was to establish a centralized
regulatory ministry on the order of the Reichs Chamber of Culture in Germany
to which all practicing German artists were compelled to belong. Such efforts
in France ultimately failed, however. Hautecoeur's plan lost out to a long and
deeply cherished French tradition, especially within the modernist art scene,
of artistic autonomy and a firmly held belief that "true" art had little to do with
political propaganda.

Picasso, Matisse, and others—particularly those artists whose international
stature insulated them from overt political repression—were thus able to main-
tain a measure of creative independence. Picasso, whose work was officially
condemned and censored under the Occupation, was nonetheless able to move
freely in public and show his art to visitors and collectors—including art enthu-
siasts among the German occupiers—who streamed into his studio during this
period. His work, furthermore, continued to command top prices in a thriving
art market. Indeed, the number of art galleries nearly doubled in 1941 as art
became a relatively secure financial investment during the war years. Gallery
shows also became an increasingly valued source of leisure activity during a time
of growing material scarcity.

By thus allowing "degenerate" art to continue flourishing in the French art
world, the German occupying forces and the collaborationist Vichy government
maintained a semblance of normalcy in French life that aimed to distract French
citizens from the atrocities unfolding daily in their midst. For Hitler, it appears
that the continued vitality of the French avant-garde only confirmed his belief
in the irredeemable degeneracy of the French as a people. When told of the
continuing public display of vanguard art in French exhibits, Hitler shrugged
dismissively: "Are we to be concerned with the intellectual soundness of the
French people? Let them degenerate if they want to, all the better for us!"[2]

Active collaboration between the German and Vichy art worlds escalated in 1941 and 1942. In October and November 1941, the German Ministry of Propaganda arranged an art tour of Germany for selected French artists. Maillol was among those who declined an invitation to go. Most of those who did participate were friends and colleagues of Hitler's sculptor, Arno Breker. Thirteen artists in all were included, among them the former fauvists Maurice de Vlaminck, André Derain, and Kees Van Dongen, whose work had become more traditional in recent years, and the figurative sculptors Charles Despiau and Paul Belmondo. Some claimed later that they participated in the art tour in exchange for a promise that several French artists who had been interned in concentration camps would be released.

The art tour galvanized the formation of a Resistance group of artists, known as the Front Nationale des Arts (National Front of Arts), who published a clandestine newsletter titled *L'art français* (French Art). *L'art français* raised money for the Resistance while informing readers about persecution and deportations as well as threats to France's artistic patrimony through German plundering raids. The group placed less emphasis on formal innovation and artistic achievement than it did on the production of propagandistic works useful to the political struggle against the German occupiers. Edouard Pignon and André Marchand were among the first members of the Front Nationale des Arts; they were later joined by the more established artists André Lhote, Pierre-Paul Montagnac, and Maurice Denis.

On May 15, 1942, a major exhibition of Arno Breker's sculptures was unveiled at Paris's Orangerie Museum. The opening included a lavish reception at Paris's famed Ritz Hotel, underscoring the exhibit as a high society event. At the same time, newsreels, which were widely distributed shortly after the opening, made the event accessible to the broad masses of the French public. Some 2,000 people visited the show daily during its three-month run. A lavish catalogue with color plates of Breker's work was also made available for sale. The collaborationist journal *Signal* ran a feature on the large-scale studio that Hitler had ordered and put at Breker's disposal for the creation of his colossal sculptures. *Signal* noted the presence in Breker's studio of French artists and workers who had been released from forced labor camps in order to assist Hitler's favorite sculptor in his work. *Signal* touted the relationship between Breker and his assistants as indicative of positive and harmonious German-French "collaboration." Such collaboration in the art world was mirrored by the steady supply of laborers and economic assistance that the Vichy government provided to Germany throughout the remainder of the Occupation.

While Breker was being celebrated at the Orangerie, Jews were compelled for the first time to identify themselves publicly in occupied France by wearing a yellow Star of David stitched to their clothing. The first systematic deportations of foreign-born Jews to death camps in the east also commenced. Between 1941 and 1942, some 30,000 Jews were interned in concentration camps in the Occupied zone, along with communists and other "undesirables."

On November 11, 1942, collaboration between France and Germany became undisguised subjugation. German troops moved into the unoccupied zone on that day, seized control from Pétain's Vichy government, and brought all of France

under German rule. Hitler immediately ordered the arrest and deportation from France of all Jews and other enemies of the German Reich. Deportations to concentration and death camps escalated while food and material shortages inside France increased. The Resistance also experienced devastating setbacks during this period as a number of its leaders were arrested, tortured, and murdered by German forces. Modern artists, including Picasso, were now forbidden to exhibit their works. According to Rose Valland, the French curator who passed information to the Resistance during the Occupation, works by Masson, Miró, Picabia, Klee, Ernst, Léger, and Picasso were burned by Nazi cultural functionaries in the garden of the Jeu de Paume Museum on May 27, 1943.

Political repression within France corresponded in time, however, with dramatic reversals in Hitler's campaign of world conquest. In late 1942 and early 1943, German troops experienced humiliating defeat at the hands of the Soviet army in their fruitless attempt to take Stalingrad. Allied forces also landed in North Africa and began the first phases of the liberation of Europe. State-sponsored French art exhibitions began to feature work that deviated from traditional, romantic realism during this period, promoting instead "degenerate" artists whose canvasses filled once again with abstraction, intense colors, distorted forms, and flat pictorial space. Known as "bleu-blanc-rouge" (blue-white-red) tricolor painting in reference to the colors of the French flag, the prominent display of such works in the later months of the Occupation was celebrated in the postwar years as a first inkling of imminent national liberation from Nazi rule. Critics and the art public showed special interest in the work of Matisse, Vlaminck, Braque, Rouault, and others whose fauve works of brilliant color and exotic subject matter had led France's vanguard art scene in the years before World War I. To the anti-Semitic art critic Lucien Rebatet this turn of events signaled an alarming resurgence of Jewish influence in French art. Incensed by a display of tricolor painting in 1943, Rebatet, in a last sputtering gasp of pro-Nazi vitriol, dismissed the works on view as "the most remarkable collection of mistakes, a laborious rehashing of Cézanne, Picasso, Rouault, Lhote, a bunch of aborted deadheads, full of arbitrariness and impotence."[3]

Allied forces landed at Normandy on D-Day, June 6, 1944; on August 25, they liberated Paris. Marshal Pétain was sentenced to life in prison and General Charles de Gaulle was brought back from exile in London and made head of the provisional government. The painful process of rooting out collaborators in and beyond the French art world then commenced. Those artists who had participated in the anti-Semitic "Juif et la France" exhibit of 1941 or traveled to Germany that same year at the behest of the German Propaganda Ministry were among the first to experience public condemnation as traitors to France. They, along with other artists who were judged to be collaborators, were forbidden to exhibit or sell their work for periods ranging from several months to two years after the liberation.

In October 1944, the French government renamed its annual Salon d'Automne (Autumn Salon) the Liberation Salon as a programmatic tribute to those artists whose work was now to be celebrated as a symbol of resistance to Nazi

oppression. Foremost among them were not the artists of the Front Nationale des Arts who had risked their lives by producing and disseminating anti-Nazi and anti-Vichy propaganda. Honored instead were Picasso, Léger, and other vanguard artists who, while abstaining from political involvement, nonetheless maintained their commitment to producing aesthetically challenging art. Seventy-four of Picasso's semiabstract cubist and surrealist paintings were put on view along with five of his sculptures, each work a testament to his unabated creative activity under the Occupation. The following day, Picasso joined the Communist Party in acknowledgement of the Party's heroic efforts in the French Resistance and antifascist struggle against the Franco insurgency in Spain. In 1945, he completed a work titled *Charnel House* that, unlike his art of the Occupation years, responded directly to the atrocities of the Nazi concentration and death camps.

Léger, Masson, Chagall, and Ernst were among the many artists and intellectuals to return to France soon after the country's liberation in 1944. They left behind a legacy of profound and enduring impact on the art worlds of their host countries—most especially the United States—where their example spawned the development of new vanguard artistic tendencies. As France's illustrious artistic culture revived once again after the war, it therefore contended with an art scene in which Paris no longer held unquestioned preeminence in the international avant-garde. It now found itself instead in competition with New York and other centers that had benefited from the presence of France's exiled artists during the war years.

Within France, classical and realist styles of art, which had enjoyed the patronage of Vichy's Révolution Nationale, were condemned as deplorable vestiges of the Nazi-Pétain era. The French art world renewed its commitment in the postwar years to the promotion of some of the most vanguard tendencies of the time, beginning with the abstraction of the Art Informel (Informal Art) group of the 1950s and continuing on to later developments in minimalism, conceptualism, and performance art that dominated the internationalized art world of the latter half of the twentieth century.

French Artist Biographies

Fernand Léger (1881–1955)

Fernand Léger, whose family raised livestock in Normandy (located in northwest France), was born in 1881. Léger began his artistic career by working as an architect's apprentice in Caen, Normandy from 1897 to 1899. In 1903, he settled in Paris in order to begin serious study of painting. Léger was admitted to Paris's École des Arts Décoratifs (School of Decorative Arts). He also worked at the Académie Julian (Julian Academy) and with instructors from the École des Beaux-Arts (School of Fine Arts). With the death of Paul Cézanne in 1906

and the ensuing critical attention to his creative legacy, Léger became interested in the formal lessons of Cézanne's art. In 1907, he began to show his work in the state-sponsored Salon d'Automne (Autumn Salon); by 1909, he emerged as part of the Parisian avant-garde.

Léger's work during this period emulated the prismatic forms of Pablo Picasso and Georges Braque's newly launched cubist aesthetic. In 1911, he exhibited along with other cubists at the Salon des Indépendents (Salon of the Independents). Two of his works were exhibited at the landmark Armory Show, which went on view in New York City in 1913. The Armory Show introduced the latest in international avant-garde art to the United States. As a sign of Léger's art world ascendancy, Daniel-Henry Kahnweiler, who also represented Picasso during this period, became Léger's dealer in 1913. Along with Robert and Sonia Delaunay, Francis Picabia, and Marcel Duchamp, Léger formed the Orphist Group in the months before the outbreak of World War I. In line with the Orphists' pursuit of nonobjective art, he produced a series of abstract canvasses titled *Contrastes de Formes* (Contrasts of Forms), consisting of rhythmically arranged and brilliantly colored flat and rounded forms.

Léger was mobilized as part of an engineer's regiment in World War I and served on the Western front as a stretcher-bearer. In the postwar years, he abandoned abstract painting and devoted his art to the rendering of contemporary life. Léger adapted his earlier cubism to the depiction of urban scenes in a distinctive aesthetic of machine-inspired, tubular forms. In his *Three Women (Le Grand Déjeuner)* of 1921, he took the classical and timeless theme of the female nude and wedded it to a semiabstract formal vocabulary of smooth, volumetric forms reminiscent of modern technology. The three women, two reclining and one seated on the edge of a divan, appear in a brightly colored interior of geometric-patterned rugs and wallpaper. The women stare out from the canvas with emotionless, robotic expressions. In this and other works of the 1920s, Léger's aesthetic of machine-tooled precision presents modern, urban life as a new reality in which the human and the technological merge.

In the mid-1920s, Léger became associated with André Breton's surrealist group and its left-wing politics. His life and art became increasingly committed to reconciling the elitism of avant-garde art (particularly the semiabstract sort of work for which he had gained art world notoriety) with a social utility that would render art meaningful to workers and the common people. Several of his paintings during this period dealt with issues of working class life; he also sought out public forms of art making, such as mural art, in an effort to remove his work from the exclusive environment of the museum and the gallery. As economic crisis and political polarization gripped France in the 1930s, Léger became a staunch supporter of Léon Blum's Popular Front government, a coalition of communist and socialist parties that was voted into office in 1936.

In 1937, Léger did several large-scale mural works for the Paris World's Fair, each celebrating the achievements of France's Popular Front government. In one, titled *Travailler* (Work), which decorated the Education building at the fair, Léger emphasized the benefits of modern technology harnessed to human

control. The image depicts a male worker operating a conveyor belt; the rest of the composition is a collagelike catalogue of various technological instruments—belts, pulleys, high-tension cables, and pylons—each rendered with Léger's characteristic machinelike precision. In a collaborative mural undertaken with Charlotte Perriand for the Agriculture pavilion, however, Léger used images and themes that suggested the growing impact in the French art world of nationalist traditionalism and antimodernism on the eve of the Occupation. Dedicated to the leisure policies of the Popular Front government, the work depicts three women from Brittany, a provincial region in northwest France, in traditional embroidered dresses symbolic of a preindustrial, premodern, agrarian way of life. The work also included a celebration of France's landscape as a verdant site of leisure filled with flowers, animals, and sunshine.

With the outbreak of World War II on September 1, 1939, the question of the relationship between art and life became all the more acute for Léger. In a letter of September 11, 1939, to his friends in Paris, he wondered if the formal beauty and escapist themes of recent art had not been, in the end, simply socially irresponsible. Had such work made people ill-prepared to confront the crises that now lay before them? Could a new art be developed, Léger asked, that would maintain its status as "art" (as opposed to mere propaganda) while nonetheless proving its social utility by addressing the pressing realities of the day?

> In the face of a war like this, where the map of Europe changes every morning, what can one expect?...For 25 years art has been "an escape" from life, a retreat in the face of great social, moral and political problems...Sitting in front of a beautiful picture people turn their back on the truth [...] which young artist will be forceful enough to solve the problem [of art's relationship to life], in both the formal and the human sense?[4]

Léger fled Paris in advance of the German occupying forces who took control of the city on June 14, 1940. He migrated to the south of France and eventually made his way to New York City in November 1940. After his arrival, he quickly installed himself in the New York art world where he lectured, taught, exhibited his work, and contributed essays to émigré journals.

Léger's immigration to the United States was celebrated with the unveiling of his painting titled *Composition with Two Parrots* in 1940 at the Museum of Modern Art in New York. A portrayal of circus acrobats, *Composition with Two Parrots* was similar to other work of Léger's exile period in which he addressed themes of work, sport, and leisure. Léger's machine-inspired style underwent subtle change in his new environment. His art took on an added coloristic vigor and further streamlining of form, due, Léger maintained, to his encounter with the raw vitality and quickened pace of life in the United States.

Though he avoided any overt artistic commentary on current events, Léger nonetheless supported the anti-Nazi, anti-Vichy cause by participating in the cultural projects of France Forever, an American support organization for the French Resistance. Léger saw his work condemned as "degenerate" inside Nazi

Germany during this period. His work also suffered the same fate as that of Picasso and other avant-garde artists when it was burned by Nazi cultural authorities in a bonfire outside Paris's Jeu de Paume Museum in 1943.

Léger's work was celebrated along with Picasso's at the Liberation Salon of 1944 as an example of France's new national art after the defeat of Hitler and the eradication of Vichy cultural politics from French life. In 1945, he produced one of his first artistic commentaries on the events of the war. Titled *France Reborn*, Léger painted the work as a poster for the Container Corporation of America, which was involved in European reconstruction efforts. The image depicts five semiabstract human figures with their arms raised in jubilation and hands holding aloft blooming flowers. The figures, reminiscent of his robotic humans of the 1920s, are bisected by abstract swathes of orange, red, blue, and green that emphasize the painting's two-dimensional decorative surface.

On his return to France in 1945, Léger, like Picasso, joined the Communist Party. He also renewed his commitment to the creation of an art devoted to working class themes and socially relevant subject matter. In 1946, he provided illustrations for Eugène Guillevic's poems about the concentration camps; he later illustrated poems by Paul Eluard, a lead poet of the French Resistance during the war years. As a Communist Party member during the Cold War, Léger also became active in the peace movement by joining in protests, signing manifestos, and undertaking several large-scale collaborative projects. In May 1948, he received a commission to create decorations for the Congrès Internationale des Femmes (International Congress of Women), dedicated in part to the heroic acts of women in the French Resistance and their growing presence and militancy within the labor movement on behalf of workers' rights. Léger was honored with a retrospective in 1949 at the Musée National d'art Moderne (National Museum of Modern Art). Fernand Léger died in 1955 at the age of 74.

Aristide Maillol (1861–1944)

Born in 1861 in the town of Banyuls, located in the south of France, Aristide Maillol began his artistic career as a painter. At age 20 he moved to Paris. In 1884, he was accepted at the École des Beaux-Arts (School of Fine Arts), where he studied under the successful Salon painter Alexandre Cabanel. He soon became interested, however, in the avant-garde work of Paul Gauguin. In 1894 he joined the Nabis, a group of artists including Émile Bonnard and Maurice Denis, whose work emulated Gauguin's use of flat, decorative color and organic form. Maillol also derived inspiration during these years from Gothic tapestries on display at the Musée de Cluny in Paris. He set up a tapestry workshop in Banyuls, which, due to an eye condition, he was forced to close down in 1900.

Maillol began to experiment with ceramic and bas-relief sculpting at this time. His early work in sculpture revealed the influence of art nouveau in his organic, curvilinear rendering of form. He also began sculpting nude figurines from terra-cotta. Maillol's approach to sculpture rejected the neoclassical and

Fernand Léger, *France Reborn*, 1945. © Smithsonian American Art Museum, Washington, D. C./Art Resources, NY.

traditional styles of modeling that were promoted at the French academies and in the annual state-sponsored Salons. In 1902, his dealer, Ambrose Vollard, gave Maillol his first exhibit in which he unveiled his works in tapestry along with several of his figurative sculptures cast in bronze. His art garnered the praise of Auguste Rodin, France's most revered avant-garde sculptor at the turn of the century.

Maillol exhibited his first major sculpture, titled *La Méditerranée* (The Mediterranean) at the Salon d'Automne (Autumn Salon) of 1905. Maillol's wife, Clotilde Narcisse, posed for the sculpture and his lifelong friend, Henri Matisse, helped him with the casting. The large-scale work, depicting a seated female nude, firmly established Maillol's departure, in both form and content, from traditional sculpture. Unlike Salon and academy renderings that typically cloaked portrayals of the nude female body in mythological themes, Maillol's sculpted female nudes of this period reject literary or mythological reference and focus attention instead on the inherent beauty and grace of the body itself. Composed of smooth surface, sleek contour, and voluptuous, volumetric form, Maillol's

La Méditerranée combines attention to the human figure with a semiabstract approach to form. Critics applauded Maillol's modernist sculptures as a "new classicism" of timeless beauty and calm repose.

Maillol also garnered critical success in Germany in the years before the outbreak of World War I in 1914. Harry Count Kessler of Weimar, Germany, became an active collector and patron of his work. Such success proved costly to Maillol during the war, however. An angry crowd accused Maillol of being a German sympathizer and set fire to his workshop; Maillol produced no more work for the duration of the war.

After the war, Maillol sculpted several war memorials. His *Grief* of 1921, avoids the patriotic bombast and triumphalism of earlier monuments to war. The work emphasizes the psychological interiority of a woman, who sits cradling her bowed head in her hand, isolated and alone in a moment of quiet mourning. Though Maillol's work of the 1920s continued to command positive critical assessment, his approach to sculpture was soon eclipsed in avant-garde circles by the work of cubist and constructivist artists. Cubists and constructivists rejected figurative sculpture during this period in favor of abstract works composed of geometric forms and untraditional sculpting materials such as sheet metal, wire, and glass.

In the 1930s, however, Maillol once again enjoyed prominence and acclaim as the French art world began to reflect the mounting conservatism and traditionalism that characterized France's political culture on the eve of World War II. Credited with inspiring a return to realist figuration in sculpture, Maillol was celebrated with a major exhibit of his work in 1937 at the Petit Palais in Paris.

In 1938 Maillol received a commission from Frantz Jourdain to commemorate Henri Barbusse, author of the famed World War I antiwar novel *Le Feu (The Fire)*. Titled *The River* (also known as *The Sorrows of War*), the work departs from the emotional restraint of his earlier war memorials such as *Grief* of 1921. *The River* draws on the convention of the reclining female nude but rejects calm repose in favor of helpless agitation. The figure lies awkwardly on her side atop a low platform while her arms and legs twist and struggle as though attempting to escape from being swept along in a watery deluge. Commentators of later years looked on Maillol's *River* as an allegory of France's torment in the face of Occupation and world war.

Such torment did not characterize Maillol's artistic career under the Nazi Occupation and Vichy regime, however. The pro-Nazi, anti-Semitic critic Lucien Rebatet was among those who actively promoted his restrained depictions of the female nude as harbingers of cultural renewal. For Rebatet, Maillol's sculpted figures served as artistic symbols of the beauty, youthful perfection, and racial purity of a new France purged of undesirable Jewish, international, and modernizing influences. His work was prominently displayed in exhibits throughout the Occupation years as a preeminent example of state-sanctioned art.

Maillol also enjoyed great popularity in the German art world, where his art found favorable comparison to that of his longtime friend, Arno Breker. Maillol openly expressed his admiration for German culture and welcomed German

Aristide Maillol, *The River,* 1938–1943. © Superstock.

collectors and soldiers of the Occupation to visit his studio. His son, moreover, worked with the German Gestapo in rounding up Jews and apprehending members of the French Resistance.

Maillol was also among those artists invited by the German Ministry of Propaganda on a propaganda tour of Germany's cultural sites in 1941. Though he declined the invitation, Maillol nonetheless served the following year on the honorary committee that sponsored a major exhibit of Arno Breker's work. Publicity photos capture him in the company of Breker, the French figurative sculptor Charles Despiau, and Vichy's General Secretary of Fine Arts, Louis Hautecoeur, at the opening of the show, which was unveiled to the public at Paris's Orangerie Museum in May 1942. Breker reciprocated the honor of Maillol's appreciation by sculpting a bust of his longtime friend in 1943.

After Hitler's defeat and the establishment of a free France, Maillol was among those who were denounced as Nazi collaborators. His work was excluded from the Liberation Salon of 1944 and other public shows in the immediate postwar years. Maillol's son was arrested and jailed for his complicity with Nazi repression during the war. The sculptor attempted unsuccessfully to intercede on his son's behalf. Aristide Maillol died in September 1944 from injuries sustained in a car crash.

André Masson (1896–1987)

Born in 1896, André Masson began formal study at the precocious age of 11 when he was admitted to the Académie Royale des Beaux-Arts et l'École des Arts Décoratifs (Royal Academy of Fine Arts and School of the Decorative Arts) in Brussels. In 1912 he relocated to Paris to continue his training and to study the outstanding collections of Paris's museums. Masson joined the French infantry in 1915 and was gravely wounded in combat. Suffering from profound psychological trauma, he was confined to a mental hospital for a time. Critics often trace the source of Masson's later artistic meditations on violence, torment, and inhumanity to the trauma of his World War I experience.

After the war, Masson began to build his reputation in the French avant-garde art scene. His paintings of brightly colored, semiabstract, forested landscapes in the early 1920s revealed the impact of André Derain and fauvism on his work. He also experimented with the faceted, prismatic forms of cubism. Daniel-Henry Kahnweiler organized his first solo show in Paris at the Galerie Simon in 1924. His work came to the attention of André Breton, founder of the surrealist movement, who invited Masson to join the group. Along with the Spanish surrrealist Joan Miró, Masson began to experiment with automatic drawing, a spontaneous approach to art making designed to allow for direct and uninhibited expression of the creative unconscious.

In late 1924, Breton published his "First Manifesto of Surrealism" in which he outlined surrealism's interest in Freudian psychoanalytic theory. He also declared the group's ambition to inaugurate a revolution of the unconscious mind for which "automatism" (the automatic drawing practiced by Masson and Miró) was to be surrealism's primary means of psychic liberation and artistic expression. Two of Masson's automatic drawings appeared in the first issue of the surrealist group's journal, *La Révolution surréaliste* (The Surrealist Revolution), in December 1924.

In 1926 and 1927, Masson experimented with using nonart materials, such as sand, to achieve automatist effects in his painting. For one such work, titled *Battle of the Fishes* (1927), Masson randomly applied adhesive to the canvas and sprinkled sand over it. The patches of bonded sand provided suggestive forms and shapes that evoked for Masson an aquatic theme, which he enhanced further by adding drawings of fish to the composition. Masson continued to experiment with similar chance approaches to drawing and painting.

Masson, who prized art's autonomy from politics, became increasingly estranged from the surrealist group after Breton and other members joined the Communist Party in 1927. He drifted away from Paris and spent most of his time between 1930 and 1937 in the south of France and in Spain, where he witnessed the outbreak of the Spanish Civil War. Masson's work registered, in highly personal terms, the effects of the current European crisis—the Great Depression and the rise of fascism and war on the continent—through his explorations of Greek mythological themes in which murder, brutality, and tormented eroticism predominated.

Masson returned to Paris in 1937 and once again became involved in Breton's surrealist group. His work during this period became more figurative and less abstract. He continued to explore mythic themes and Freudian concepts in his art. Many of his works concentrated on the minotaur from Greek mythology. Half man and half bull, the minotaur served as a defiantly erotic symbol of a bestial and instinctive virility repressed by the normative demands of society at large. The surrealists published a journal titled *Minotaure* in the early 1930s, and several artists, including Picasso, took up the theme as a symbol of avant-garde revolt.

As the political situation darkened in France on the eve of the German invasion, friends urged Masson to go into exile. In 1938, Masson's patron in the United States, Sadie May, offered to facilitate his relocation to America, but Masson refused. He remained in France through the beginnings of the German occupation in June 1940. When anti-Jewish decrees were imposed in October 1940, however, Masson, whose wife was Jewish, readied himself and his wife to leave the country. His own association with the surrealist movement and its political affiliation with communism also put Masson and his wife in jeopardy. At Breton's suggestion, the two relocated to Villa Air Bel outside of Marseilles, the staff quarters of Varian Fry's Emergency Rescue Committee. With Fry's assistance, Masson and his wife left Europe at the end of March 1941 and arrived in New York on May 29, 1941. They settled in New Preston, Connecticut.

During his exile in the United States, Masson frequently exhibited his art in shows devoted to surrealism and the work of exiled artists. He also defended freedom of expression in print and in public lectures where he insisted on the necessity of art's independence from politics. He denounced dictatorial attempts to reduce art to mere propaganda and characteristically avoided direct political references in his art. Much of his work nonetheless continued to register—however indirectly—the impact of current crises on his artistic sensibility. In *Pasiphaë* (1943), Masson tapped into the violence of the period in a work that hovers on the brink of total abstraction. His painting engages the Greek myth of the minotaur's origins in the violent sexual union between the woman Pasiphaë and a bull. Combining automatic drawing with a bold, expressionist approach to color, Masson depicts biomorphic shapes, fragmented body parts, and sexual organs caught in a claustrophobic space of fevered torment.

Masson's interest in repressed instinctual drives of sexuality and aggression, combined with his spontaneous, automatist approach to image making, profoundly influenced young artists in the New York art world who were beginning to coalesce around the abstract expressionist movement. Jackson Pollock, leader of the abstract expressionists, also took up the theme of Pasiphaë in 1943. More significantly, he derived from Masson and other exiled surrealists the spontaneous, automatic approach to art that resulted in his famed abstract "drip-paintings" of the 1950s.

Masson's painting titled *The Resistance* (1944) is one of the few works from his exile period that alludes directly to current events. The work commemorates the massacre of the population of Oradour-sur-Glane by German forces

on June 10, 1944, in retaliation against the French Resistance. Working with a palette of deep oranges, browns, and blacks, Masson's somber image consists of semiabstract vignettes describing the horrors of the Oradour massacre. A figure with fists clenched and its mouth open in a scream dominates the upper portion of the composition. Below appears another figure, kneeling and with head bowed in mourning, over a body lying prone on the ground. A third vignette shows yet another figure, its arm severed from its body, awaiting burial in the aftermath of the atrocity.

Masson returned to Paris in 1945, settling the following year in Aix-en-Provence. His art of the postwar period tended away from the mythological themes that had dominated his earlier work. He turned increasingly to landscape studies and began to employ the sketchy brushstroke typical of the work of the British nineteenth-century painter, J.M.W. Turner, and the French impressionists. Many of his paintings and drawings also reflected his deepening interest in the spiritual calm of Zen Buddhism. André Masson died in Paris in 1987.

Henri Matisse (1869–1954)

Art historians frequently rank Henri Matisse alongside Pablo Picasso as one of the most important artists working in France in the early twentieth century. Born in 1869, Matisse studied law in Paris between 1887 and 1889, during which time he took occasional drawing classes. In 1889, he decided to become a painter. He enrolled in the Académie Julian (Julian Academy) in 1891, where he studied with the successful Salon artist William-Adolphe Bouguereau. In 1895, he enrolled in the École des Beaux-Arts (School of Fine Arts). Matisse pursued traditional academic study at the École, but became more interested in the aesthetic innovations of the French avant-garde.

In 1904 and 1905, Matisse traveled the Mediterranean where he began to work in a palette of light, sun-drenched colors. He, like many artists of the French avant-garde, also became interested during this period in tribal artifacts that had been plundered by French colonial expeditions in Africa and installed in Paris's ethnographic museums. Matisse began to incorporate the formal character and "primitivist" sensibility of African art into his own. He introduced angular planes and an aggressive, gestural application of intense color into his painting in an attempt to emulate the rough-hewn creative vitality of tribal works.

When Matisse exhibited his latest work at the annual Salon d'Automne (Autumn Salon) of 1905, a critic branded his art, along with that of several others including André Derain and Maurice de Vlaminck, as fauve (a term meaning "wild beast" in French) for their savage, uninhibited use of color. In a portrait of his wife, titled *The Green Stripe* (1905), Matisse liberated color from any obligation to describe the face of his wife in naturalistic terms, rendering her hair, face, eyes, and mouth in nonnaturalistic shades of blue, green, yellow, and pink. Color takes on a value of its own, independent of the motif, in Matisse's fauve

works and became subject solely to the creative interests of the painter. The 1905 Salon d'Automne launched Matisse's avant-garde career; his work soon began to be collected by wealthy and influential patrons, including Gertrude and Leo Stein and Sergei Shchukin.

In 1908 Matisse published his "Notes of a Painter" in which he expressed his enduring credo concerning the relationship between art and life. For Matisse, art should be about art first and foremost and provide a pleasing refuge from the realities of the day:

> What I dream of is an art of balance, of purity and serenity, devoid of troubling or depressing subject-matter, an art which could be for every mental worker, for the businessman as well as the man of letters, for example, a soothing, calming influence on the mind, something like a good armchair which provides relaxation from physical fatigue.[5]

His most famous works of this period, including *The Joy of Life* (1905–1906) and *Blue Nude: Memory of Biskra* (1907) emphasize decorative rhythms and harmonious color. *Joy of Life* and *Blue Nude* portray images of the nude female in nature, reclining and uninhibited in her nakedness, a symbol of sensuous pleasure far removed from the cares of modern life. In the years leading up to the outbreak of World War I, Matisse traveled to Morocco and Spain where he encountered Moorish decorative impulses, which he soon integrated into his own art.

When World War I broke out in 1914, Matisse volunteered for service but was rejected because of his age (he was 45). He relocated to Nice in the south of France in 1917 and eventually lived there on a permanent basis while making regular visits to Paris. After the war, Matisse's art became less flat and decorative and more naturalistic in line with a general return to artistic tradition that characterized the French art world in the postwar years. In 1929, he turned from painting to work in graphic media, including etching, drypoint, and lithography. Several monographs written about Matisse in the 1920s confirming his role as a leader of the French art world.

In the early 1930s, Matisse traveled abroad to Tahiti and the United States. In 1930, he received a commission to produce a mural on the subject of the dance for the main hall of the Barnes Foundation in Merion Station, Pennsylvania. At the time of the German Occupation of France beginning in June 1940, Matisse was staying in St.-Jean-de-Luz in the southwest of France, which fell under German control. He immediately made his way back to Nice in the southeast of France, which remained for the time being under the jurisdiction of Marshal Pétain's Vichy government. Varian Fry of the Emergency Rescue Committee approached Matisse about going into exile, but he refused. Matisse's statements to friends and family during this period make plain his deep love of France and belief in the country's superior cultural tradition. In a private letter written to his son Pierre, he also suggested his feelings of obligation, as a carrier of that illustrious tradition, to remain: "if everyone who has any values leaves France" he wrote, "what remains of France?"[6]

In 1941, Matisse underwent an operation for a tumor, which left him an invalid and unable to travel. During his convalescence he returned to drawing. He illustrated several books during this period, including an edition of Charles Baudelaire's *Les Fleurs du Mal* (*The Flowers of Evil*). In 1942 he received a commission to produce an illustrated color album titled *Jazz*, which appeared in 1947. *Jazz* involved Matisse's first use of the paper cutout as an aesthetic medium in its own right. For his earlier compositions, he frequently painted pieces of paper, cut them out into shapes and attached them to the canvas surface merely as an aid in working out his decorative designs. While working on *Jazz*, Matisse used the cutouts for the first time as an end in themselves, to serve directly as the basis for stenciled prints.

Given Matisse's lifelong commitment to pleasurable art-for-art's sake and avoidance of imagery related to political commentary or current events, his uncontroversial paintings and drawings continued to be exhibited regularly in state-sponsored Salons and gallery shows throughout the Occupation period. When early fauvism once again began to command critical attention in 1942–1943, Matisse granted several interviews, some of which were broadcast on radio, confining his comments strictly to his artistic process. Though Matisse avoided political involvement, his wife and daughter were active in the French Resistance.

After liberation, Matisse, along with Picasso and other modern artists, was now celebrated as a leader of a renewed French national culture. Over the next 10 years, he continued to produce his lyrical cutouts, even when confined to his bed in the last years of his life. For his last major commission, the decoration of a Dominican chapel in the French Mediterranean town of Vence in 1951, Matisse used his brightly colored and fanciful cutouts for the design not only of the chapel's stained glass windows and interior décor, but for the priests' vestments as well. Henri Matisse died in 1954 at the age of 85.

Notes

1. Lucien Rebatet, "Entre le juif et le pompier" [Between the Jew and the Pompier], *Je suis partout* (February 14, 1941). Cited and translated in Michèle C. Cone, *French Modernisms: Perspectives on Art Before, During, and After Vichy* (Cambridge: Cambridge University Press, 2001), 73–74.

2. Albert Speer, *Inside the Third Reich: Memoirs* (New York: The Macmillan Company, 1970), 184. Cited in Michèle C. Cone, *French Modernisms*, 94.

3. Lucien Rebatet, "Les Révolutionnaires d'arrière garde," *Je suis partout* (October 29, 1943). Cited and translated in Michèle C. Cone, *French Modernisms*, 93.

4. Fernand Léger, letter dated 11 September 1939. Cited in Sarah Wilson, "Fernand Léger, Art and Politics 1935–1955," in *Fernand Léger: The Later Years*, exhibition catalogue, 61 (London: Whitechapel Art Gallery, 1987).

5. Henri Matisse, "Notes d'un peintre" [Notes of a Painter], in *Art in Theory, 1900–1990,* ed. Charles Harrison and Paul Wood, 72–78 (Oxford: Blackwell, 1992). Originally published in *La Grande Revue* (December 25, 1908).

6. Henri Matisse to Pierre Matisse, 1 September 1940. Cited and translated in Michèle C. Cone, *Artists under Vichy: A Case of Prejudice and Persecution* (Princeton, NJ: Princeton University Press, 1992), 51.

Bibliography

Berman, Elizabeth Kessin. "Moral Triage or Cultural Salvage?: The Agendas of Varian Fry and the Emergency Rescue Committee." In *Exiles and Emigrés: The Flight of European Artists from Hitler,* edited by Stephanie Barron and Sabine Eckmann, 99–112. Exhibition catalogue. Los Angeles: Los Angeles County Museum of Art, 1997.

Cone, Michèle C. *Artists under Vichy: A Case of Prejudice and Persecution.* Princeton, NJ: Princeton University Press, 1992.

———. "Decadence and Renewal in the Decorative Arts under Vichy." In *Fascist Visions: Art and Ideology in France and Italy,* edited by Matthew Affron and Mark Antliff, 239–62. Princeton, NJ: Princeton University Press, 1997.

———. *French Modernisms: Perspectives on Art Before, During, and After Vichy.* Cambridge: Cambridge University Press, 2001.

Golan, Romy. *Modernity and Nostalgia: Art and Politics in France between the Wars.* New Haven, CT: Yale University Press, 1995.

Hirschfield, Gerhard, and Patrick S. Marsh, eds. *Collaboration in France: Politics and Culture during the Nazi Occupation, 1940–44.* London: Berg, 1989.

Lottman, Herbert. *The Left Bank: Writers, Artists, and Politics from the Popular Front to the Cold War.* Boston: Houghton Mifflin, 1982.

Nash, Steven A., ed. *Picasso and the War Years, 1937–1945.* Exhibition catalogue. San Francisco: The Fine Arts Museum of San Francisco, 1998.

Nicholas, Lynn H. *The Rape of Europa: The Fate of Europe's Treasures in the Third Reich and the Second World War.* New York: Alfred A. Knopf, 1994.

Peschanski, Denis, Yves Durand, Dominique Veillon, Pascal Ory, Jeanne-Pierre Azéma, Robert Frank, Jacqueline Eichart, and Denis Maréchal. *Collaboration and Resistance: Images of Life in Vichy France, 1940–1944.* Trans. Loy Frankel. New York: Harry N. Abrams, 2000.

Silver, Kenneth E., and Romy Golan. *The Circle of Montparnasse: Jewish Artists in Paris, 1905–1945.* New York: Universe Books, 1985.

CHAPTER 3

Artists in Germany: Constructing the "Thousand-Year Reich"

Adolf Hitler's forces marched into Poland on September 1, 1939, igniting World War II. Through coercion and terror, Hitler (1889–1945) transformed Germany's highly civilized society into a barbarous machinery of death within the space of 12 short years. The Nazi regime claimed the lives of millions during World War II not only on the battlefield, but also—and most horrifically—in the gas chambers of the death camps. Six million Jews and five million others, including communists, homosexuals, and gypsies, were murdered in the camps with chilling efficiency. Scholars continue to puzzle over how one of the most modern, educated, and technologically sophisticated countries in the world could have descended into the irrationality of such atrocity and genocide. Indeed, much writing on World War II continues to focus on Germany and the incomprehensibility of the Nazi phenomenon.

The arts, we now realize, played an important role in disciplining and militarizing German society for Hitler's genocidal and imperialist ambitions. Acutely aware of art's ability to shape public perception and opinion, Hitler maintained firm control over the arts throughout his regime. After his appointment as German chancellor in January 1933, he gave Germany's art world four years' time to reform itself and to begin producing work appropriate to the ideals and aspirations of the new Third Reich. Hitler gave no firm idea in 1933 of what such art should look like, nor did he suggest what might happen if artists failed to fulfill their mandate within the allotted time. His hostility to modern, avant-garde art soon became clear, however. So, too, did the realization that expressionism, Dadaism, and other vanguard movements that had brought Germany international attention in the 1920s would find no place in Hitler's project of national renewal.

41

Modern art, in Hitler's view, attested not to Germany's cultural achievement, but rather to a social decay that needed to be stamped out. He demanded instead the development of a new artistic culture rooted in the German imperial past yet expressive at the same time of the country's future. That future, following Hitler's grandiose notion of a Thousand-Year Reich, foresaw an enduring Germany both racially pure and triumphant in world conquest. Artists unwilling to adapt their work to Hitler's vision faced suppression, imprisonment, and, in some cases, death. Many, including some of Germany's most illustrious artists, fled into exile.

Exploiting the full range of new mass media technologies at its disposal—including film, photography, and radio—the Third Reich saturated German society to an unprecedented degree with sounds and images that permeated not just the work place and public life, but also leisure time and the privacy of the home. Such images and sounds were created by the regime's state-sanctioned painters, sculptors, photographers, filmmakers, and musicians. Their creative endeavors eroded the distinction between "art" and "propaganda" as their work became harnessed to the construction of Hitler's Thousand-Year Reich.

Germany and Its Art World before World War II

Hitler's artistic tastes and policies looked back to the German art world as it was fashioned under Wilhelm II, who reigned as Germany's emperor from 1888 to 1918. Kaiser Wilhelm took a special interest in the arts and insisted on strict standards for what constituted legitimate art under his rule. His views were made policy by Anton von Werner, Wilhelm II's court painter, who became head of the Royal Academy of Art and also exercised control over independent arts organizations in the country.

Germany's Royal Academy of Art schooled students in the great artistic traditions of the past, above all those of ancient Greece and Rome and the Italian Renaissance. They were trained to emulate those traditions through rigorous drawing and copying from original works and plaster casts. Academy students also took courses in chemistry that introduced them to the properties of pigments as well as anatomy lessons that taught them the underlying structure of the human body. They were expected to turn out works that were clear in form and didactic in content. Academy paintings, sculptures, and drawings exhibited, in other words, an exacting naturalism of detail and mastery of illusionistic space while providing ennobling scenes of history and everyday life. Most prized were works that extolled the glories of Germany, its imperial leaders, triumphs in battle, and achievements in culture.

The authority of the imperial art world began to crumble, however, as Germany began its process of rapid modernization in the late nineteenth century. With industrialism came expanded trade, commercial competition, and dip-

lomatic relations with other countries. This contact also made German artists increasingly aware—through exhibits, publications, and their own travels abroad—of some of the latest achievements in art. Of most interest were the innovations taking place in France, the recognized leader of modern art throughout the nineteenth century. From the 1880s onward, German artists kept pace with developments in French realism, impressionism, post-impressionism, fauvism, and beyond. Their new vanguard work placed them on a collision course with Kaiser Wilhelm, who attempted by various means to bar modern artists from exhibits and positions of cultural authority. Rejecting the realistic style and positive imagery advocated by the Academy, these modern artists challenged government-sanctioned art through the use of nonnaturalistic color, fragmented pictorial space, and distorted forms. Moreover, their subject matter frequently deviated from accepted taste with works that criticized social injustice, imperial authority, and the sexual mores of the time.

One of Germany's earliest and most vibrant vanguard art movements was expressionism, which began in 1905 with the founding of the artists' group Die Brücke (The Bridge). Under the leadership of Ernst Ludwig Kirchner, Brücke artists rejected the materialism of modern, urban life. They found inspiration instead in non-European tribal cultures from Africa and Oceania, whose arts they used as models for the development of their crudely rendered and frequently sexually explicit "primitivist" paintings and sculptures. The Russian-born artist Wassily Kandinsky launched a second expressionist group when he founded the Blaue Reiter (Blue Rider) in 1911 with Paul Klee and Franz Marc. On the eve of World War I, Kandinsky's art moved toward total abstraction with canvasses given over to nonfigurative plays of expressive color and line. Uncomprehending critics of the time denounced Kandinsky's abstractions as nonsensical childish scribbling and the workings of an insane and degenerate mind.

With Germany's defeat in World War I and the abdication of Kaiser Wilhelm in 1918, the country's imperial art world collapsed. A period of revolution and civil upheaval ensued, followed by the founding of the German Weimar Republic in 1919 (which lasted until 1933) and the institution of a constitutional government. Marginalized under the imperial arts administration before 1918, vanguard artists in Germany found themselves for the first time appointed as professors at the nation's art schools and elevated to positions of cultural leadership. Traditional, academic artists, who had earlier benefited from imperial largesse, found themselves eclipsed during the Weimar Republic by their modernist counterparts.

During the Weimar years, the efflorescence of modernism took place in all areas of production, including painting, sculpture, and architecture as well as design, film, photography, and theater. Artists such as Otto Dix, George Grosz, Kurt Schwitters, Käthe Kollwitz, Max Beckmann, Paul Klee, Hannah Höch, and Wassily Kandinsky established international reputations as leaders of the German expressionist, Dada, and New Objectivity movements of the 1920s. Dix, Grosz, and Kollwitz produced politically controversial paintings and drawings that assailed persistent militarism and class injustice under the Weimar Repub-

lic. Hannah Höch, meanwhile, drew attention to the erosion of traditional gender roles in German society of the time with collages that satirized stereotypical male and female behaviors.

In 1919, Walter Gropius set about revolutionizing architecture in Germany with the founding of the Bauhaus (House of Building). Bauhaus directors Gropius (1919–1928), Hannes Meyer (1928–1930), and Ludwig Mies van der Rohe (1930–1933), fostered an approach to architecture that abandoned building styles of the past and favored instead the exploitation of modern materials and construction techniques. Bauhaus buildings featured flat roofs, ribbon windows, and unornamented walls that emulated the sleek surfaces and streamlined, modular forms of the modern machine. Such work set the international standard for an aesthetic of steel, glass, and concrete that is still with us today.

Despite its cultural vitality, the Weimar Republic suffered from chronic instability throughout much of its existence. In 1919, Germany was compelled to sign the Versailles Treaty, which demanded the country's admission of war guilt, the disbanding of its army, and the payment of reparations. Germany's inability to meet reparation payments resulted in crippling inflation in 1922–1923. Political and economic instability bred a culture of resentment that gave rise to Hitler's National Socialist (Nazi) Party during these years.

Hitler and others who shared his views held the new democratic republic responsible for accepting defeat and agreeing to hold Germany to the stringent demands of the victorious powers. In 1923, he attempted to overthrow the Weimar government and install a military dictatorship. While serving a jail sentence in 1924, Hitler wrote *Mein Kampf (My Struggle)* in which he began to set out his genocidal plans for the Jews as well as his intention to create a greater Lebensraum (living space) for the German people through military conquest. *Mein Kampf* also included his views on art. Modern art, he fulminated, was nothing short of an artistic swindle foisted off on the German people by Jewish art dealers. He denounced Dada and cubism above all as "artistic Bolshevism," "morbid excrescences of insane and degenerate men," and symptoms of "cultural decay."[1] The Weimar government's support of such art was yet another indication for Hitler of the republic's utter bankruptcy.

The collapse of the New York Stock Exchange in 1929 and the onset of the Great Depression in the Western industrialized world facilitated Hitler's rise to power. Unemployment rates in Germany soared between 1929 and 1932, jumping from 3 million jobless in 1930 to nearly 5 million in 1931. Numbers peaked at 6 million in 1932 with over 30 percent of the working population out of work.

Germany's electorate became increasingly polarized and distrustful of a democratic system of government that appeared incapable of reversing the country's downward spiral. More and more voters turned to political extremes, with the German Communist Party and Hitler's National Socialists registering the greatest parliamentary gains in the elections of the early 1930s. Hitler came to power in January 1933 when President General von Hindenburg appointed him chancellor.

Germany's Artists in World War II

After Hitler's rise to power in 1933, the Bauhaus was one of the first institutions to be closed down. Modern artists were also summarily removed from their teaching posts at the nation's academies of art. Suspending the constitution soon after his appointment in 1933, Hitler further solidified his authoritarian rule in 1934 as Reich Chancellor and Führer by combining the office of the chancellor with that of the president after President Hindenburg's death.

Hitler set about fashioning Germany into a strong, modernized nation that would also present itself as legitimate heir to Germany's imperial glory of the past. This process included building up the country's industrial and military capability. Such efforts were combined with a series of government programs designed to reverse Depression-era unemployment by putting men back to work. Women, on the other hand, were encouraged to return to the home and to bear children for the Reich. Nazi policy represented a dramatic reversion to traditional gender roles as the leadership attempted to halt the declining birthrate and growing presence of women in the workforce that had characterized the Weimar years. Most perniciously, the Nazi regime embarked on cleansing German society of all "foreign," especially Jewish, influence.

Hitler intended the arts to play a crucial role in his nationalist program. In March 1933, he appointed Josef Goebbels as Minister for the Peoples' Enlightenment and Propaganda. Administration of the arts came under Goebbels's charge. In September 1933 he became head of the Reichskulturkammer (Reichs Chamber of Culture, or RKK). Consisting of subchambers devoted to film, architecture, the visual arts, literature, and music, the RKK centralized government control over the arts. All artists who wished to pursue their careers, including, the exhibition and selling of their work, were required to belong to the RKK. In 1933, as one of the earliest manifestations of Hitler's anti-Semitic policy, Jewish artists were forced to register under a separate government-controlled organization known as the Jüdische Kulturbund (Jewish Culture Union). The Union's exhibits and performances were restricted to the Jewish community. The foundation of the Jüdische Kulturbund was one of the first steps in a genocidal process that began with the cultural segregation of Jews from society, followed by their ghettoization, and ending with their murder in the death camps.

After 1933, party commentators frequently recalled Hitler's early ambition to be an artist and his brief apprenticeship in an architectural office before World War I. News reports carried photos of Hitler poring over plans with his architects, likening the activity of the strong leader to that of an architect giving shape to the new regime. As testimony to the centrality of the arts to his program, the House of German Art, intended from the beginning as a "temple" for the new art of the Third Reich, was the first structure Hitler commissioned after his appointment as chancellor in January 1933. The building was designed by Paul Ludwig Troost, a Nazi Party member since 1924, who came to Hitler's attention through his redesign of the party'sheadquarters in 1931. The cornerstone for the House of German Art was laid in October 1933.

The construction and design of the House of German Art set the standard for monumental architecture under the Third Reich. Rejecting the steel, glass, and concrete "flimsiness" of Bauhaus architecture, Troost modeled his museum on German imperial architecture of the nineteenth century that, in turn, had emulated architectural styles of classical antiquity. Though the House of German Art employed modern construction in its steel frame, Troost designed the façade with a traditional cladding of cream-colored limestone. A severe, unornamented, two-story colonnade reminiscent of a Greek portico commands the front of the structure. Recessed mortar between the blocks of limestone on the façade stress the building's monumentality and solidity. Like the ruins and monuments of ancient Greece, the architecture of the Nazi regime was meant to endure as an eternal and awe-inspiring testament to Hitler's Thousand-Year Reich.

In pointed rejection of the typically machine-made, low-cost, prefabricated building units of glass, steel, and concrete used in modernist architecture of the Weimar era, construction of the House of German Art was deliberately carried out by traditional hand labor. Well aware that the building trades had been among the hardest hit during the Depression, Hitler chose to demonstrate his commitment to putting the populace back to work by elevating manual labor over the machine. The heavy limestone, taken specifically from German quarries, was hewn and shaped by hand and transported to the site. In later years, the hewing and shaping of heavy stone for Hitler's monumental building projects was undertaken by concentration camp victims who were worked to death in the process.

After Troost's death in 1934, Albert Speer assumed the role of Hitler's state architect. Speer's earliest work for Hitler involved organizing the all-important Nazi Party rallies that took place at Nuremberg. The purpose of these rallies was to solidify in ritual terms the relationship between Hitler as Führer and his subjects. Speer developed innovative lighting techniques for these events, which involved the use of searchlights pointed heavenward to create a "cathedral of light" over the rally grounds. Flags, music, and plumes of smoke from pans of burning coals combined with parade pageantry and Speer's lighting to cast the party rally in the guise of Christian ritual. The savior in this case was Hitler himself, who appeared above and before the rally participants on an elevated podium. In 1934, Hitler commissioned the filmmaker Leni Riefenstahl to create a documentary of the party rally for that year. *Triumph of the Will,* released in 1935, is now recognized as a classic of twentieth-century film history. Riefenstahl's camera lingers on the regimented ranks of party members whose uniforms and drill-like parade maneuvers ritually enacted a human architecture of mass conformity and submission to the Führer.

While the nature of monumental architecture under the Third Reich was well established from the outset of the regime, the character of the new painting and sculpture remained a matter of debate among party cultural officials between 1933 and 1934. Goebbels, who favored modern art, pushed for expressionism as the art of the Third Reich. He regarded as distinctly German the introspectiveness and spiritualism that characterized much expressionist painting and

sculpture. Several expressionist artists, moreover, had served with honor during World War I. Goebbels was opposed by Alfred Rosenberg, head of the Kampfbund für deutsche Kultur (Fighting League for German Culture). A leading party ideologue, Rosenberg advocated a popular or "völkisch" art, characterized by a realist style and easily legible themes from everyday life. At the Nuremberg Party Rally of 1934, Hitler intervened, ruling out modernism, including expressionism, as well as völkisch art, which he dismissed as old-fashioned, nostalgic, and insufficiently ennobling of the new Germany.

Modern artists who refused to adapt their work to Hitler's idea of art and its function fled into exile as did George Grosz in 1933, followed in later years by Mies van der Rohe, Gropius, Beckmann, and many others. Still others remained in Germany in a state of "inner emigration," or forced suppression. Käthe Kollwitz, who became famous for her antiwar imagery of the 1920s, was dismissed from her teaching post at the Prussian Academy in 1933. After Hitler came to power, she faced Gestapo (Geheime Staatspolizei; Secret State Police) surveillance of her activities and searches of her studio to ensure that she was not producing work hostile to the regime. Others, such as Otto Dix, who, like Kollwitz, was a noted pacifist artist of the Weimar years, was banned from exhibitions. Dix remained in Germany throughout the Third Reich. He ceased producing overtly antiwar imagery, however, and turned instead to mythic themes and landscapes that continued in some cases to be subtly encoded with dissident content.

While modern artists thus found their activities profoundly curtailed, many traditional, academic artists whose careers had been overshadowed by the success of modernism during the Weimar years found renewed favor after 1933. For those artists who accommodated themselves to the regime, their works—predictably rendered in a clearly legible, naturalistic style—received state approval for the propagandistic function of glorifying Hitler and fostering the image of the "new German" under the Third Reich. Their art appeared in state-sponsored exhibits devoted to themes such as work, family, and the German land. Among the most successful was Werner Peiner, who replaced Paul Klee as an instructor after Klee's dismissal from the Düsseldorf Academy in 1933. Peiner's paintings include *German Earth* from the early 1930s, which depicts a farmer guiding his horse-drawn plow with ease across an expansive and carefully cultivated field. Such works celebrated the fecundity of the German countryside and the value of agricultural labor. Adolf Wissel produced images such as *The Kahlenberg Farm Family,* which extolled rural life, the values of the traditional family unit, and racial purity. In Wissel's painting, a grandmother, father, mother, and children, each exhibiting distinctly "Aryan"[2] facial features (including high foreheads, squared jaws, fair complexions, and aquiline noses), share a quiet moment together on a porch that opens out into farmland beyond. Image after state-approved image similarly elided the effects of modernity by foregrounding the virtues of family, German rural life, and the value of hand labor, despite the fact that Germany continued to develop under Hitler as an urban, technologized, and, in many senses, thoroughly modern society.

A significant percentage of paintings and sculptures produced under the Third Reich featured the mythic image of the healthy Aryan body. Such works were often patterned (according to Nazi claims of descent from the glories of ancient Greece) on the idealized portrayal of the body as seen in ancient Greek art. Adolf Ziegler, who served as president of the Reichs Chamber of Visual Arts between 1936 and 1943, became famous for renderings of the female nude, as did Ivo Saliger, Sepp Hilz, and Paul Matthias Padua. These artists typically depicted women in the role of Greek goddesses, but with distinctly Aryan features and healthy, athletic bodies that spoke to contemporary notions of physical beauty. Such images not only served as models for the ideal of German womanhood, but also, through their reference to Greek antiquity, asserted the timeless validity of that ideal.

In 1935 and 1936, Hitler's militarist aims became apparent to the world at large. In flagrant violation of the Treaty of Versailles, he reintroduced military conscription and began to rearm the country. In 1936, he formed the Axis Alliance with Italy (later joined by Japan) and intervened in the Spanish Civil War on the side of General Francisco Franco. Such actions belied the claims to peaceful cooperation and coexistence that comprised Nazi rhetoric on the occasion of the Olympic Games, which were held in Berlin in the summer of 1936. While Hitler thus began to project his power beyond Germany's borders, he also exerted ever more stringent control over the German populace—and its art world—at home. In 1936, he instructed Goebbels to introduce a ban on art criticism. From that point forward, only "art reporting" was allowed, which, in practice, resulted in adulatory, superficial discussions of state-approved art.

In 1937, Hitler's mandate for the reform of the German art world within four years' time (which he issued immediately after coming to power in 1933) was now called to account. Two major exhibitions, which took place in the summer of 1937, spelled out this decisive turning point in Nazi Germany's artistic culture. The first of these exhibits was unveiled on July 18, 1937, in Troost's House of German Art in Munich. Called the Grosse Deutsche Kunstausstellung (Great German Art Exhibition), the show formally presented to the German people the new art of the Third Reich. It included works by Peiner, Ziegler, and 555 other state-approved artists, all of whom were registered with Goebbels's RKK. Nearly 1,200 paintings, sculptures, and prints were put on display, some of which were purchased by Hitler, members of the party leadership, and the state. Several of the works were also exhibited in the German pavilion designed by Albert Speer for the Paris World's Fair of summer 1937, where they announced to the world the new cultural direction of the Third Reich.

State-sponsored excursions brought people from the provinces to Munich for a week of parades, festivals, and celebrations that accompanied the opening of the Great German Art Exhibition. Such mass spectacles, which were a common feature of the Third Reich, were designed to reinforce the notion of Volksgemeinschaft, or people's community, that clearly identified those who belonged to the new regime, namely Aryan Germans, and those who did not, most especially Jews. Jews were ostracized, persecuted, and otherwise barred from participation

in such events. A glimpse of the opening festival and the works displayed in the Great German Art Exhibition was also made available to people throughout the country in the form of postcards, press reports, newsreels, and films.

Hitler gave an address at the opening of the 1937 Great German Art Exhibition that drew a clear and unmistakable distinction between "modern" and "German" art. Modern art was mere incoherent fashion, Hitler maintained, practiced by swindlers and the mentally disturbed. German art, by contrast, possessed timeless value, confirmed by its intelligibility to the public at large and its rootedness in the life and history of the healthy German people:

> Art can in no way be a fashion. As little as the character and the blood of our people will change, so much will art have to lose its mortal character and replace it with worthy images expressing the life-course of our people in the steadily unfolding growth of its creations. Cubism, Dadaism, Futurism, Impressionism, etc., have nothing to do with our German people. For these concepts are neither old nor modern, but are only the artifactitious stammerings of men to whom God has denied the grace of a truly artistic talent, and in its place has awarded them the gift of jabbering or deception. I will therefore confess now, in this very hour, that I have come to the final inalterable decision to clean house, just as I have done in the domain of political confusion […] "Works of art" which cannot be understood in themselves but, for the justification of their existence, need those bombastic instructions for their use, finally reaching that intimidated soul, who is patiently willing to accept such stupid or impertinent nonsense—these works of art from now on will no longer find their way to the German people.[3]

Great German Art Exhibitions took place annually up until 1944. Each show featured a new, honorific portrait of Hitler and a reinterpretation of the German state symbol, the eagle. All works adhered to a prescribed academic style of naturalistic portrayal, with a clear and didactic content that stringently instructed the German populace in the ideal of Aryan racial purity and systematically excluded from view any representations of Nazi Germany's unwanted "others."

The second major exhibit of summer 1937 opened on July 19, 1937, the day after the unveiling of the Great German Art Exhibition. Called the Entartete Kunst Ausstellung (Degenerate Art Exhibition), the show was the culmination of a series of locally sponsored defamatory exhibits of modern art that began to be held in various towns and cities throughout Germany from 1933 onward. With titles like "Mirror Images of Decay" and "Government Art, 1918–1933," these exhibits featured modern works from public collections that were held up for public ridicule as "evidence" of the degeneracy and indulgence of the Weimar years. The Degenerate Art Exhibition was the first official state-sponsored defamatory show of modernism—and it was intended to be the last. The exhibit was staged not in a museum, but rather in an archeological institute in Munich; works on display were not to be regarded as "art," therefore, but instead as artifacts of a dead culture. Paintings by Kandinsky, Klee, Grosz, and others were hung haphazardly on temporary partitions while sculptures by Kirchner and other modernists were carelessly scattered around the galleries. Even Emil

Nolde, who was a member of the Nazi Party, found many of his expressionist canvasses held up for pillory in the Degenerate Art Exhibition. Organizers of the show scrawled graffiti-like slogans on the surrounding walls that castigated the works on view as "An Insult to German Womanhood," "Deliberate Sabotage of National Defense," "Crazy at Any Price," and "Nature as Seen by Sick Minds."

The exhibit traveled throughout Germany and its impact was disseminated on a wider scale through postcard reproductions and newsreels. Some 2 million people (as opposed to the 420,000 estimated for the 1937 Great German Art Exhibition) came to see the show. On view were over 600 works from 32 collections produced by some 120 leading modernists, including Kollwitz, one of the few women artists to be so represented. The Degenerate Art show announced the Nazi regime's final rejection of the values of internationalism, aesthetic innovation, and social and cultural critique that had come to define the art of the German avant-garde in the years before 1933. An unknown number of "degenerate" works were subsequently burned, while others were sold in 1939 to international buyers at an auction in Lucerne, Switzerland.

In 1938, Hitler commissioned Albert Speer to design a new Reichschancellery building whose size and opulence would give visual expression to Hitler's unfolding vision of military conquest. With the assistance of 8,000 workers and made of precious marbles, Hitler's new chancellery building was completed within the space of one year. Arno Breker, Hitler's favorite sculptor, assisted Speer in the embellishment of the vast structure with imposing sculpted reliefs and statuary that emphasized themes of war and Aryan invincibility. In its every detail, the Reichschancellery was designed to intimidate those who entered its spaces seeking an audience with Hitler. While carrying out the Reichschancellery commission, Speer also moved ahead on orders from Hitler to transform the capital into a city of world conquest. The unrealized plan called for the construction of an enormous Volkshalle (People's Hall) where conquered peoples would come and assemble in supplication before the Führer.

In March 1938, Hitler began to realize his aims with the annexation of Austria; in September of that year German troops marched into Czechoslovakia, incorporating the country's German-speaking territory known as the Sudetenland into the "Greater Reich." And on September 1, 1939, Hitler attacked Poland, touching off World War II.

Luitpold Adam, who served as a war artist in World War I, headed up Hitler's official war art program after 1939. Adam's Division of Visual Arts eventually numbered some 80 soldier-artists, whose lives and art have yet to receive extended treatment in the art historical literature on this period. Their works were described in the government-controlled art press as derived from the artists' immediate experience of the war, though none, predictably, drew attention to the actual blood and death of the battlefront. Paintings and drawings by Elk Eber, Fritz Erler, Franz Eichhorst, Wolf Willrich, Rudolf Hengstenberg, and other soldier-artists instead glorified Germany's war effort and the heroic self-sacrifice of those who served. Emil Scheibe was among those artists who turned out images that affirmed Hitler's role as Führer. His work titled *Hitler at the Front* from 1942

depicts Hitler surrounded by an adoring group of soldiers who take strength from their Führer's commanding presence. Such war art paintings and drawings belonged to the government and were circulated in home front exhibits organized around themes such as "The Invasion of Poland in Pictures," "German Greatness," and "Painters at the Front." Images of war also began to displace the nudes and landscape paintings that had dominated the Great German Art Exhibitions up until 1939. Hitler himself promoted the continued production of art throughout the duration of the war as a testament to Germany's power to endure militarily and to flourish culturally. In his art report of the Great German Art Exhibition of 1940, critic Robert Scholz described the war as a "defensive war" and likened the artist's role to that of the soldier inspired by Hitler's example and fighting in defense of the nation:

> The opening of the "Great German Art Exhibition" during a war forced upon us, is the strongest demonstration of our cultural need and our cultural strength [...] The fact that Germany continues its cultural mission, undeterred and protected by its glorious weapons, is part of the miraculous inner renewal of the people. A philosophy has brought out creative forces. The part the visual arts play in this process of cultural renaissance is the miracle of all miracles...War, which a Greek philosopher called "the father of all things," is a great challenger. German visual arts have met the challenge. This exhibition is proof of the strong impulses that our Führer's ingenious willpower and his ingenious creative strength have brought to the arts. His example spurs every creative force to the highest.[4]

In June 1940, France fell to Hitler's invading forces and German bombers launched an aerial assault on Great Britain that September. Arno Breker and Albert Speer accompanied Hitler on a tour of occupied Paris as Hitler contemplated the future disposition of France's illustrious cultural patrimony. The previous year, Hitler had charged his chief advisor on art collecting, Hans Posse, to create an art collection for what became known as Sonderauftrag Linz (Special Project Linz). Posse proceeded to amass a collection of art for a "Führer Museum" to be located in Hitler's childhood hometown of Linz, Austria. Hitler developed plans for the Führer Museum as early as 1925. He envisioned it as a cultural capital for a European continent under his dictatorial control. It was to include concert halls, theaters, cinemas, libraries, and a museum containing the most outstanding treasures in all of Europe. Hitler's henchmen looted artworks from France and other conquered territories over the next several years, confiscating pieces earmarked for eventual display in the Führer Museum. The museum was never realized.

In 1942, the Wannsee Conference took place in the quiet suburb of Wannsee in Berlin, where the Nazi leadership drew up a blueprint for the extermination of the European Jews. A system of death camps was established, most of them in Poland, where Jews and others were systematically gassed to death and incinerated. Felix Nussbaum, a German-Jewish artist who enjoyed a growing reputation in the German art world in the late 1920s, was among the 6 million Jews whose lives were extinguished in the camps. The year 1942 also marked

a turning point in the war with Germany experiencing a series of military reversals. The most devastating took place at Stalingrad when the Soviet Union was able to thwart Hitler's campaign of eastward expansion. All monumental building projects, including the redesign of Berlin, were brought to a halt as labor and materiel were diverted to the war effort. Albert Speer ceased his role as state architect and became Hitler's Minister of Armaments in 1942.

The war raged on for another three years until April 30, 1945, when Hitler committed suicide in an underground bunker in Berlin. On May 8th Germany surrendered and the European phase of World War II came to an end. Interim authority was vested in an Allied control council of Great Britain, France, the United States, and the Soviet Union, each taking control of a sector of the Berlin capital. On November 20, 1945, a war crimes trial of Nazi leaders opened at Nuremberg.

With Germany's defeat in 1945, Speer's Reichschancellery was reduced to rubble by invading Soviet forces. Troost's House of German Art, which still stands in Munich today, has been transformed into a museum dedicated to the modernist art that had been suppressed under the Nazi regime. The German populace was put through a protracted process of denazification in an effort to rid the country of its notorious past. Many who had occupied positions of power in Hitler's art world were given light sentences, however.

Some artists who had churned out works supportive of the Third Reich kept their posts as teachers at the nation's academies, and their works continued to be publicly exhibited. Similarly, dealers and museum officials who had been involved in looting artworks from Jews and collections in Germany's conquered territories continued to ply their trade in the postwar years. Museums in the United States and elsewhere that built up their collections by purchasing stolen art during this period remained quiet about the manner in which such works were acquired.

In the late 1960s and early 1970s, within the context of the Vietnam War and social protest movements of those years, a younger generation of Germans confronted their country's painful past and demanded a frank reckoning, even of those who continued to exonerate themselves as "innocent" artists. Recent years have also seen greater efforts to restore looted works of art to their rightful owners. In the United States, a government commission has been formed to trace the origins of looted works now housed in public collections in an effort to further the ongoing work of restitution for the atrocities of Hitler's 12-year Reich.

German Artist Biographies

Arno Breker (1900–1991)

Arno Breker was born in 1900 near Düsseldorf in the town of Elberfeld. An intimate of Hitler and the Nazi regime's most celebrated sculptor, Breker

received some of his earliest artistic training from his father, who was also a sculptor and stonemason. During World War I, he attended an arts and crafts school and took private lessons in drawing. In 1920, Breker began formal artistic training at the State Art Academy in Düsseldorf where he studied sculpture with Hubertus Netzer and architecture with Wilhelm Kreis. During the early phase of his career, his work betrayed the influence of Auguste Rodin, the leading French avant-garde sculptor at the turn of the century. Portrait heads that Breker produced during this period emulate the textured, impressionistic surfaces and psychological penetration of Rodin's approach to the human form.

In 1926, Breker went to study in Paris where he stayed on and off until 1932. He became well-known in French art circles and his work began to garner international acclaim. Like that of his French counterparts, Aristide Maillol and Charles Despiau, Breker's work abandoned earlier experiments with expressive handling during this period and tended more toward an idealizing classicism in his portrayals of the harmoniously proportioned, nude human body. In 1932, he was given the coveted Rome Prize by the Prussian Academy of Arts as testament to his growing stature within his native country. This allowed Breker six months of study in Rome in 1932–1933. After Hitler was appointed German chancellor in 1933, Nazi Propaganda Minister Josef Goebbels visited Breker at the Academy in Rome. He exhorted Breker and other German artists to return to Germany in order to lend their talents to the building of Hitler's Thousand-Year Reich.

After his return, Breker faced criticism from some quarters that his work was too indebted to foreign influence. Soon, however, he adapted his art to meet the demands for greater monumentality and was given a steady supply of work creating sculpted embellishments for new building construction throughout the Reich. In 1936 he contributed two sculptures, *Victory* and *Decathlete,* to the Olympic Stadium in Berlin for which he received a silver medal from the Olympic Arts commission.

In 1937, Breker joined the Nazi Party and was named the regime's Official State Sculptor. Hitler lavished upon him a giant studio for the production of his colossal sculptures destined for Hitler's monumental building projects. Included with the studio was a small staff of professional sculptors who worked as Breker's assistants and a steady supply of forced labor provided by the head of the SS (Schutzstaffel or Guard Squadron), Heinrich Himmler. Himmler facilitated the transfer of concentration camp detainees to Breker's studio.

Breker was appointed professor at Berlin's School for Fine Art in 1937 and later taught at the Prussian Academy of Arts. Along with fellow sculptor Josef Wackerle, he was put in charge of selecting sculptures for the first Great German Art Exhibition, unveiled in summer 1937 in Paul Ludwig Troost's House of German Art. Some of Breker's pieces appeared in the show. His work was also presented to the world at large as an example of Hitler's "new German art" at the Paris World's Fair in 1937. Soviet Premier, Joseph Stalin, was reportedly so impressed by Breker's monumental statuary that he attempted (unsuccessfully) to commission works from him.

Breker's sculptures became a regular feature in subsequent Great German Art Exhibitions. In 1939, his work titled *Readiness* was unveiled in that year's show, where it served as an allegory of German preparedness for war.[5] Drawing on the tradition of Greek statuary and Michelangelo's *David* (1501–1504), Breker's over life-size work portrays a nude male warrior whose squared shoulders, coiled musculature, and commanding gaze project an assured strength capable of facing down any oncoming challenge. His powerful right hand grasps the hilt of his sword, which he stands ready to unsheathe from its scabbard. The state-sponsored art periodical, *Die Kunst im Dritten Reich* (Art in the Third Reich) lavished adulatory "art reporting" on this and other works by Breker as quintessential representations of Aryan perfection and invincibility.

After the war broke out in 1939, Breker's supply of forced labor came to include French and Italian prisoners of war. He received numerous commissions to produce portrait busts of the party leadership during this period, including those of Hitler and Hitler's state architect, Albert Speer. Breker and Speer began to collaborate on Hitler's monumental building projects, including the design for the new Reichschancellery constructed in 1938–1939. Breker's sculptures of muscular male nudes titled *Torch Bearer* and *Sword Bearer* (later renamed *Party* and *Army* by Hitler) flanked the entryway from the chancellery's ceremonial Court of Honor into a series of adjoining rooms that culminated in Hitler's sumptuously appointed office. Eight times larger than life size, *Party* and *Army* served as allegorical symbols of the indomitable strength and enduring legitimacy of the Third Reich. In 1940, Hitler himself bestowed on Breker the Golden Badge of the Nazi Party.

Breker, along with Speer, accompanied Hitler on his tour of Paris in June 1940 after the fall of France to German forces. Given his intimate knowledge of the city and his connections to the art world there, Breker became a key figure in the occupation and the orchestrated plundering of France's cultural patrimony. Breker himself appropriated the Paris townhouse of the Jewish-American cosmetics manufacturer, Helena Rubenstein. He was also the only German artist to have an exhibit in occupied France. The display of his sculptures was unveiled at Paris's Orangerie Museum in 1942. The event included a lavish reception at the Ritz Hotel and the broadcasting of the festivities to the French public at large through newsreels, journalistic reports, and an expensive catalogue with color plates of Breker's statuary. Breker continued to receive awards, commissions, lavish gifts, and favored treatment from Hitler and the Nazi leadership throughout the war years.

After the fall of Berlin to Allied forces, Breker went through a perfunctory denazification hearing and was never tried for war crimes. He remained unrepentant about his activities in the Third Reich and continued to consort with former Nazis in the postwar years. His career flourished with commissions for portrait busts, particularly from corporate clients, and occasional civic sculpting projects. Arno Breker died in 1991 after a decade of mounting public resistance to the continued positive evaluation of this work.

Käthe Kollwitz (1867–1945)

Käthe Kollwitz (born Käthe Schmidt) ranked alongside Otto Dix and George Grosz as one of the most outstanding and socially committed German artists of the early twentieth century. Born in Königsberg, Germany in 1867, Kollwitz grew up in a politically left-wing family. Her brother was a friend of Friedrich Engels, who, with Karl Marx, wrote the *Communist Manifesto* in 1848.

In 1881, at the age of 14, Kollwitz began drawing lessons with Rudolf Mauer in Königsberg. Four years later, in 1885, she moved to Berlin. Because women were barred from studying at the Royal Academy, she enrolled instead in a private women's art school for instruction under Karl Stauffer-Bern, who encouraged the development of her talent in drawing. Kollwitz's emergence on the modern art scene at this time coincided with a revival of printmaking in Germany, led first and foremost by the Munich artist Max Klinger, whose art deeply impressed her. In 1888, she relocated to Munich, where she studied under Ludwig Heterich. By 1890, she had given up her earlier interest in oil painting and dedicated herself to developing her skills in graphic arts, including etching, lithography, and, later, woodcuts. After her marriage to Karl Kollwitz, a health insurance doctor, she returned in 1891 to Berlin where her husband set up a medical practice in a working-class district, they had two sons: Hans, born in 1892, and Peter, born in 1896.

In 1898, Kollwitz and her art became the center of a decisive confrontation between Germany's growing modern movement and Kaiser Wilhelm's entrenched imperial taste. Her portfolio of three lithographs and three etchings titled *A Weaver's Revolt* was put on display at the Great Berlin Art Exhibition in that year. Inspired by Gerhard Hauptmann's socially critical play, *The Weavers,* Kollwitz's series vividly evoked the poverty and desperation of the oppressed working class. These images set the tone for Kollwitz's future works in which she returned time and again to the injustices of a class-stratified society. Frequently using her husband's working-class patients as her models, Kollwitz rendered her downtrodden subjects with care-worn faces, darkened eyes, and sunken cheeks. She also endowed them with powerful hands, however, and a sculptural solidity that suggested a bent, but unbroken power to endure.

Somber in its mood and subject matter, Kollwitz's *A Weaver's Revolt* raised the specter of working-class insurrection during a period in Germany's history where such confrontations inflamed the country's political culture. The jury of the Great Berlin Art Exhibition voted to award Kollwitz a gold medal for her achievement. *A Weaver's Revolt* was a far cry from the ennobling academic work supported by Kaiser Wilhelm, however. He therefore demanded retraction of Kollwitz's gold medal. Her experience of imperial intolerance had the consequence, certainly unintended, of establishing Kollwitz as one of the leading vanguard artists of the day. Her conflict with Kaiser Wilhelm was also a main catalyst for the foundation of the Berlin Secession in 1898, one of the many organizations of artists that sprang up during this period and that seceded from

the imperial art world. She joined the secession and was soon appointed to teach graphic arts and life drawing at the Berlin Künstlerinnenschule (School of Art for Women).

In 1904, Kollwitz visited Paris for study at the Académie Julian (Julian Academy) where she learned the basic principles of sculpture. One of her most moving sculptural pieces is a low-relief work titled *The Parents,* which she completed in 1916 as a monument to her son Peter, who was killed in action during World War I. The work portrays Kollwitz and her husband kneeling before their son's grave, their heads bowed and hands gently resting on the ground where his body lay. The loss of her son solidified Kollwitz's commitment to pacifism and her desire to make her art accessible and meaningful to a broad audience. Themes of grief and of mothers protecting their children began to enter her work at this time.

In 1919, after the collapse of the Imperial monarchy and the end of World War I, Kollwitz became the first woman elected to a professorship at the Prussian Academy of Art in Berlin. Throughout the 1920s, she continued to produce socially engaged work in order to raise money for various workers' causes. Several of her images, which attempted to raise public consciousness about the starving in Soviet Russia, the plight of German workers, women's issues (including abortion rights), and the resurgence of militarism in Germany, were adapted for agitational placards, used in public demonstrations, and featured in protest exhibitions. In 1933, she signed a petition opposing the Nazis in upcoming parliamentary elections. After Hitler came to power, she was forced to resign her post at the Prussian Academy of Art and compelled to join the Reichs Chamber of Culture. She was then 66 years old.

Though an American collector urged Kollwitz to come to the United States, she remained in Germany throughout the years of Nazi dictatorship. In 1934, she began a series titled *On Death* that conveyed her growing fatalism. Returning to her pacifist subject matter of the early Weimar years, the eight lithographs in the series pit a mother's desperate and unsuccessful attempt to protect her children against the overpowering force of encroaching death. Kollwitz includes herself in the series, in an image titled *The Call of Death.* With deft strokes of the lithographic crayon, she renders her aged and careworn features in a manner that links her plight to that of the mothers and workers she rendered throughout her career. Her powerful hands are idle and contrast with the skeletal finger of death that touches her left shoulder. Kollwitz depicts herself not recoiling from death, but rather leaning towards it as death's shadow begins to enshroud her sunken features. Here and throughout *On Death,* Kollwitz exploits the lithographic medium's dramatic contrasts of white and black to heighten the series' profound sense of pathos.

By 1936, Kollwitz was restricted from putting her work on public display. In that same year, she was questioned by the Gestapo for an interview she had granted to a Soviet newspaper. She and her husband began to carry vials of poison with them at all times, for use in the event of imprisonment or internment

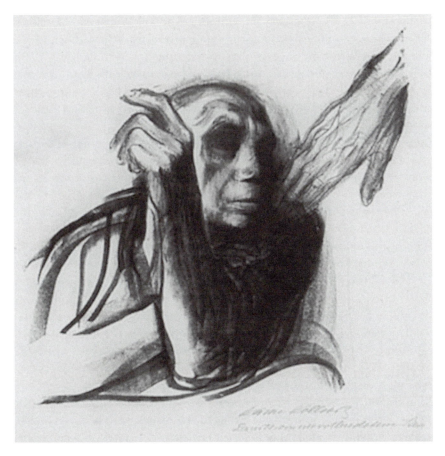

Käthe Kollwitz, *The Call of Death*, 1934. © 2005 Artists Rights Society (ARS), NY/VG Bild-Kunst, Bonn.

in a concentration camp. The Gestapo periodically searched Kollwitz's studio to ensure that her art refrained from dissident content. Her work was also subject to removal from local art exhibitions. In 1937, she was one of 167 artists whose art was held up for public ridicule in the Degenerate Art show.

Hitler invaded Poland in September 1939. The next year, Kollwitz's husband died. In October 1942, she relived the personal trauma and loss of her son Peter in World War I, when her grandson, also named Peter, was killed on the Russian front. Kollwitz fled Berlin in summer 1943 and retreated to an estate near Dresden. Her Berlin home was bombed shortly thereafter. Käthe Kollwitz died of heart failure on April 22, 1945, shortly before the end of World War II.

Felix Nussbaum (1904–1944)

In 1904, Felix Nussbaum was born into a family of assimilated Jews in Osnabrück, Germany. In 1922, he enrolled in the Staatliche Kunstgewerbeschule

(State School of Arts and Crafts) in Hamburg. The following year, he relocated to Berlin, where he took up private study under the artist Willi Jaeckel. In 1924, he attended the Vereinigte Staatschulen für freie und angewandte Kunst (United State Schools of Free and Applied Art), where he studied with Cesar Klein, one of the leading modern artists of the November Group. His first paintings, mostly landscape studies and portraits, were inspired by the work of Karl Hofer and Vincent Van Gogh.

Nussbaum established his reputation as an artist during a period of escalating anti-Semitism in Germany. His works from the mid-1920s began to trace the tension within Germany's Jewish community between the desire for assimilation into secular Germany society, on the one hand, and, on the other, growing calls for the renewal and preservation of Jewish traditions that were now under increasing threat. One such work, titled *Two Jews* (1926), presents a view of the interior of the Osnabrück synagogue. In the synagogue's main apse, a cantor performs services before the Torah shrine. Appearing on the wall above him is the Star of David surrounded by an aura of golden light. Orthodox Jews, depicted in the white robes traditionally worn on the Day of Atonement or Yom Kippur, fill the pews of the synagogue. They stand alongside assimilated Jews, identified by their dark suits, top hats, and narrow prayer scarves. In the foreground of the composition, Nussbaum depicts the Osnabrück cantor Elias Abraham Gittelsohn holding a liturgical book in his hands. Next to him appears Nussbaum himself wearing a traditional prayer shawl. Confronting the viewer with an intent and somber gaze, Nussbaum's self-portrait suggests something of the artist's internal conflict as he weighed the relationship between assimilation and a growing awareness of his own Jewishness in a period when such an identity had become increasingly perilous.

In the late 1920s, Nussbaum followed in Van Gogh's footsteps by traveling to the south of France. By 1929, he began to receive a measure of critical success. He had two solo exhibits during this period, and his art was included in group shows in Berlin and elsewhere. He moved into his own studio in Berlin along with the Polish-Jewish artist Felka Platek in 1929. Platek and Nussbaum married in 1937.

As Nussbaum's work began to garner greater acclaim and visibility in the German art world, it also came increasingly under attack by anti-Semitic detractors. Many of his paintings from this period, such as *The Cheerless Road* (1928) and *The Pessimist* (1930), suggest Nussbaum's mounting sense of gloom and foreboding as Germany edged toward dictatorship and war.

In 1932, Nussbaum moved to Rome as a guest student at the German Academy, which was housed in the Villa Massimo. While there, he continued to paint. He also produced illustrations, which were published in the popular German journal *Querschnitt* (Cross-Section). Arno Breker occupied the studio next to Nussbaum's at the Villa. In April 1933, shortly after Hitler's appointment as chancellor, Propaganda Minister Josef Goebbels visited the German Academy in Rome to encourage German artists to return to the Reich.

The following month, Nussbaum was expelled from the villa after getting into a fight with another painter. Rather than return to Germany, however, he remained in northern Italy. In 1935, with the help of Belgian artist, James Ensor, Nussbaum and Felka Platek immigrated to Belgium. Nussbaum began to adapt Ensor's characteristic carnival imagery of masking and disguise to a series of self-portraits and other works during this period. After *Kristallnacht* (Night of the Broken Glass), the nationwide pogrom against the Jews that took place in Germany in 1938, such imagery took on a special urgency in Nussbaum's art.

In *Masquerade* of 1939, Nussbaum constructed a carnivalesque image based on several of his earlier self-portraits. He recast his self-images as participants in a masquerade that unfolds in a desolate urban setting. At the center of the composition, Nussbaum's likeness appears disguised in a woman's dress and jewelry. While such inversions of gender identity are common to traditions of carnival and masquerade in general, Nussbaum's attire in this case acquires added significance in its reference to the Jewish festival of Purim. During Purim, male Jews dress as women to honor Esther, the Jewish wife of the Persian King Ahasuerus of antiquity, who saved the Jews from persecution. Nussbaum's feminine clothing thus commemorates Esther, while also highlighting the issue of Jewish persecution throughout history. It also refers to his own sense of persecution at an historical moment in which growing anti-Semitism made the concealment of Jewish identity a matter of life and death. Nussbaum holds his hand over his mouth, further underscoring his need to keep quiet as an unwanted Jew. After Hitler's march into Poland in September 1939, Nussbaum began to make copies of his paintings in an effort to ensure their survival.

On May 10, 1940, German forces entered Belgium. Belgian authorities arrested all German males over the age of 15 then residing in the country. Nussbaum (Felka Platek remained behind in Brussels) was among some 7,000 German nationals who were transported from Belgium to a concentration camp located in Saint-Cyprien in the south of France. They joined tens of thousands of refugees from the Spanish Civil War, along with 15,000 Germans and Austrians then living in France, who had similarly been rounded up as foreign nationals. In an effort to escape the hellish conditions of the camp, Nussbaum asked to be returned to Germany. While in transit back to the Reich, he escaped with a friend to Brussels aboard a Red Cross train.

After his return to Belgium, Nussbaum produced a number of paintings and drawings devoted to the despair and desolation of his internment. *Camp Synagogue* dated 1941, suggests the growing importance that the Jewish faith assumed for Nussbaum and other Jews under the extremity of their imprisonment. In a somber palette of blacks and browns, Nussbaum depicts a simple hut with a corrugated metal roof situated in a barren landscape. Weak rays of sun barely penetrate a darkening sky. Moving toward the hut are five figures dressed in brilliant white prayer shawls. Stooped in prayer, the figures' white robes stand out in high relief against the unrelieved gloom of their surroundings. Nussbaum's work recalls a specific event that took place at the camp while he

was there. Three Jews from Antwerp deliberately had themselves arrested near the camp so that they could bring a Torah scroll and shawls for fellow Jews in preparation for the feast of Shavu'ot.

On October 28, 1940, Nazi racial policy against the Jews was enforced in occupied Belgium. Nussbaum was compelled to register as a Jew with Brussels city authorities on December 24, 1940. In 1942, he hid his paintings in the home of his friends, Dr. Grosfils and Dr. Lefèvre. After the first transport carrying Jews to their imminent deaths left for Auschwitz in early August 1942, Nussbaum fled his studio. He and Felka went into hiding in the home of their sculptor friend Dolf Ledel. They hid there for six months during which Nussbaum produced painted porcelains and other commercial works, which the Ledels sold under their own name. In March 1943, the Ledels fled Brussels, at which point Nussbaum and Felka moved to an attic provided for them by a member of the Belgian Resistance.

In mid-1943, Nussbaum completed his work titled *Organ Grinder,* a bleak and darkly pessimistic image of the street in which he and Felka hid during this period. The organ grinder, with no one left to play for, rests his elbows on an organ whose pipes are made of bones. Behind him appears a desolate street, lined with the darkened windows of uninhabited apartments. Façades crumble and human bones litter the avenue's paving stones. Above, hanging on broken flagpoles suspended from empty windows, black tattered flags flap against a storm-filled sky.

In late 1943, Nussbaum completed *Self-Portrait with Jewish Identity Card,* referring to the clandestine nighttime walks that he sometimes took. Such walks were in violation of strict curfew laws that forbade Jews to move about the city streets between sunset and sunrise. Nussbaum portrays himself wearing a hat and coat. His coat's upturned collar reveals the yellow Star of David he and other Jews were compelled to wear on their clothing. Nussbaum looks fearfully towards the viewer, while displaying to us his Jewish identity card, which he holds in his left hand. His eyes fixed on us, Nussbaum places his fate in our hands. Will we keep his identity a secret? Or will we deliver him into the hands of murderous authorities? In his last known work, titled *Death Triumphant,* Nussbaum surrendered to despair. Completed in April 1944, the work envisioned the collapse of Western civilization in a macabre dance of death.

In June 1944, German military police discovered Nussbaum and Felka in their attic hideaway. The two were put on a transport to Auschwitz. They arrived at the death camp on August 2, 1944, and were gassed seven days later.

Albert Speer (1905–1981)

Albert Speer's architectural grandiosity suitably matched Hitler's world ambitions. Born in Mannheim, Germany in 1905, Speer trained at several technical universities. He eventually worked for the architect Heinrich Tessenow, from 1927 to 1929 at his office in Berlin, and from 1929 to 1932 as his assistant at the Technische Hochschule (Advanced Technical School) in Charlottenburg.

Speer joined the Nazi Party in 1931, and in 1932 the party commissioned him to remodel its headquarters in Berlin. In 1933, at the age of 28, he became the commissioner for the technical and artistic organization of Nazi Party rallies, under the aegis of Goebbels's propaganda bureau.

His first major architectural project for the Third Reich was the design of structures for the party rally grounds at Nuremberg. An interlinked set of stadiums and parade grounds, the Nuremberg Rally Grounds was the largest architectural complex envisioned under the Third Reich. Speer managed to see two of the intended structures, the Zeppelin Field Tribune and rally ground, designed to accommodate some 200,000 people, through to completion. Speer's architectural style took its cue from that of Paul Ludwig Troost, Hitler's state architect until his death in 1934. The Zeppelin Field Tribune, similar to Troost's House of German Art, used antique reference in the colonnade and excluded decorative ornament from the façade. Unlike Troost, however, Speer built on a colossal scale, which aligned his projects not with Greek antiquity, but rather with the awe-inspiring structures of ancient Rome. Speer's architecture thus programmatically linked the aspirations of the Third Reich to that of Rome's great empire of the past.

With the beginning of German rearmament in 1936, steel and iron used for building were diverted toward armaments production. It was within this context that Speer developed his "Theory of Ruin Value," which advocated the exclusive use of stone, instead of steel, iron, or reinforced concrete, in the creation of monumental government buildings. According to Speer's theory, structures made of stone would provide in perpetuity, again on the precedent of ancient Greece and Rome, architectural ruins that would stand as eternal testament to the achievements of the Third Reich. Because such a vision required enormous amounts of quarried stone, Speer became intimately involved in the location and design of concentration camps near quarrying sites as well as the allocation of forced labor needed to supply sufficient amounts of stone for his grandiose projects.

His need for stone accelerated in 1937, when Hitler charged Speer with the redesign of Berlin. Hitler gave Speer wide latitude in forming urban policy and using the resources of the police and forced labor in order to transform the old capital city into the city of world conquest envisioned by Hitler. Speer presented his plans to Hitler on April 20, 1937, Hitler's birthday. What stood in the way of Speer's vision was not only old building stock located at the center of the city, but also a sizable population of resident Jews. Speer used and broadened Nazi anti-Semitic policy by developing and enforcing a plan in 1938 for the removal of Berlin's Jews. Jews were deprived of their housing rights and concentrated in alternative areas, which served as a prelude to their removal to the death camps. Speer's actions were part and parcel of the radicalization of Nazi policy against the Jews that was signaled in 1938 by the nationwide *Kristallnacht* (Night of the Broken Glass) pogrom.

Based on ancient Roman city planning, Speer's vision for Berlin involved the creation of an east–west and north–south axis. These axes were intended not only to facilitate movement to and from the city center. They were also to serve

Albert Speer, *Plan for Reconstruction of Berlin*, 1942. © Ullstein Bild, Berlin.

as symbolic links between Berlin, the rest of the Reich, and, eventually, the world. Following Hitler's increasingly megalomaniac schemes for world domination, Speer's design placed Berlin at the functional and symbolic center of mass demonstrations and parades that would ritually reenact popular submission to the Führer.

The main railway station, located at the terminus of the southern axis, was intended to deliver the masses to the city center. From there, they would walk north along an avenue lined with cannons and the severe monumental façades of government buildings. Included along the north–south avenue as the ritual entry to the city was to be a colossal Arch of Triumph designed by Hitler himself. From ancient Roman times, such triumphal arches were erected to commemorate the victorious return of a leader from battle. Intended to be 325 feet tall and 285 feet wide, Hitler's triumphal arch was to surpass in size all preceding triumphal arches, including the Arc de Triomphe in Paris and Berlin's own Brandenburg Gate. Indeed, it was intended to dwarf even Paris's Eiffel Tower, then

the tallest structure in the world. In line with Hitler's claim to vindicate those heroes who fought in World War I, the walls of the Arch of Triumph were to be inscribed with their names. Arno Breker, Hitler's favorite sculptor, was to adorn it with sculpted reliefs.

Passing through the Arch of Triumph, supplicants were intended to proceed along the north–south axis toward the northern terminus, which was to be crowned by a massive Volkshalle, or People's Hall. Speer's plan included a large-scale plaza located in front of the Volkshalle, called Adolf Hitler square, for popular celebrations and parades. The hall itself was to rise 1,050 feet and to be larger than the Pantheon in Rome on which the design was based, thereby surpassing in size and grandeur its Roman imperial precedent. The dome was to be covered in patinated copper intended to shimmer like a radiant jewel in the Berlin skyline. Speer's design crowned the dome with a 100-foot-tall, sculpted German eagle grasping the world in its talons. Flanking the entryway to the structure were to be two colossal male nude figures, one carrying on his shoulders the globe of the heavens and the other, the globe of the earth.

The interior of the Volkshalle was envisioned as a three-tiered circular gallery, with 100 rectangular marble pillars lining the walls and separated by recessed gold mosaics. Located over the Führer's podium was to be another sculpted eagle, 46 feet tall and gilded, this time grasping a swastika in its claws. The Führer's podium occupied the north side of the interior space, and was thus the ultimate destination of the long axial procession of the populace to the center of power. No seats were included in the interior, only an open floor and three tiers of galleries designed to hold 180,000 people. The People's Hall was not intended to be a hall of and for the people in any meaningful political sense of their consensual support of the regime. It visualized instead the reduction of the people to a powerless spectacle of mass submission to Hitler's untrammeled authority.

With Germany's attack on the Soviet Union and its military reversal at Stalingrad in 1942, Speer's reconstruction plans came to a halt. Only part of the east–west axis of the Berlin plan was realized. Indeed, few of Speer's building projects were ever completed. In addition to the Zeppelin Field Tribune at Nuremberg, he also realized the German pavilion at the Paris World's Fair of 1937 and the new Reichschancellery in Berlin (1938–1939). With the virtual halt on new building in 1942 and the need to direct more resources to the war effort, Speer was put in charge of transportation, industrial allocations, and forced labor, this time not in the interest of carrying forth Hitler's grandiose building projects, but rather as Minister of Armaments and War Production.

In 1945, Speer was found guilty of war crimes at the Nuremberg trials and sentenced to twenty years in Spandau prison in Berlin. In 1969 he released his memoirs, which were translated into English the following year under the title *Inside the Third Reich*. Speer attempted to gloss over much of his involvement with the Third Reich, describing himself as an architect whose activities were first and foremost devoted to art and not politics. But Speer's use of forced labor

and anti-Semitic policy to realize Hitler's architectural ambitions demonstrate how deeply intertwined art had become with politics and building with human destruction. The imposing monumental façades of his realized structures projected Hitler's authority not only in ideological terms, but also in the cost of the many human lives that were extinguished in the process. Albert Speer died in London in 1981.

Adolf Ziegler (1892–1959)

One of Hitler's most trusted cultural functionaries, Adolf Ziegler was born in 1892 the son of an architect. He received artistic training at academies in Weimar and Munich. In his early career, Ziegler was attracted to developments in the modern art scene, in particular expressionism. He admired most specifically the work of Franz Marc, who, with Kandinsky and Klee, founded the Blue Rider group in 1911. None of Ziegler's works from this early phase of his career survive.

In the 1920s, Ziegler gravitated toward the National Socialist Party, and in 1925 he met Hitler for the first time. By then Ziegler had abandoned his interest in modernism. His new artistic outlook now corresponded closely enough with Hitler's that Hitler appointed him the party's expert on art. After Hitler came to power in 1933, Ziegler assumed a professorship at the Academy of Fine Arts in Munich, where he remained through 1934. Between 1936 and 1943, he served as president of the Reichs Chamber of Visual Arts (a subchamber of Goebbels's Reichs Chamber of Culture devoted to painting, prints, and sculpture).

As President of the Reichs Chamber of Visual Arts, Ziegler took the lead role in organizing the first Great German Art Exhibition and the Degenerate Art Exhibition of summer 1937. For the Great German Art Exhibition, Hitler entrusted Ziegler to solicit from Aryan German artists, both within Germany and abroad, submissions for this first government display of the new German art under the Third Reich. With imput from Hitler, Ziegler selected the paintings to be put on view while Arno Breker and Josef Wackerle chose the sculptures.

Ziegler's own painting, an allegorical work titled *The Four Elements*, served as the exhibit's centerpiece and was given pride of place in the well-lighted main gallery of Troost's House of German Art. Greatly admired by Hitler, the work portrays four female nudes, each of whom symbolizes one of the four elements, seated on pedestals atop a low bench. The nude representing fire holds aloft a flaming torch, while the figure of water rather obviously holds a bowl of water in her hand. Earth, rendered as an older, more maternal figure at the center of the painting, cradles stalks of grain. The fourth element, air, appears in the guise of the nude with windswept hair at the far left of the composition. Ziegler rendered his nudes with exacting, indeed photonaturalistic, detail. Each of the allegorical four elements possess Aryan facial features and

the healthy, athletic body type prized as a racial ideal under the Third Reich. The painter also—and somewhat shockingly—included pubic hair on his female nudes, a detail that rendered his figures both real and ideal, contemporary and timeless at the same time. Ziegler became known during this period as "The Master of German Pubic Hair" for such works.

Ziegler's photonaturalistic painting was widely reproduced in the form of postcards and in the state-regulated art press. It became a model for the portrayal of German womanhood that was widely emulated by other state-approved artists of the time. Hitler purchased *The Four Elements* and hung it over the fireplace in his Munich residence. It was recreated as a tapestry and displayed in Albert Speer's German pavilion for the Paris World's Fair of 1937, where it won the grand prize for painting and tapestry.

Hitler also put Ziegler in charge of purging German art collections of degenerate art and organizing the Degenerate Art Exhibition, which opened the day after the Great German Art Exhibition of summer 1937. Aided by art historians and curators, Ziegler seized some 5,000 works of modern art from collections throughout the Third Reich. Pieces by German artists were included along with many works by such non-Germans as Pablo Picasso, Henri Matisse, and Vincent van Gogh, whose art was similarly branded "degenerate." In his speech at the opening of the Degenerate Art show, Ziegler announced:

> Our patience with all those who have not been able to fall in line with National Socialist reconstruction during the last four years is at an end. The German people will judge them. We are not scared. The people trust, as in all things, the judgment of one man, our Führer. He knows which way German art must go in order to fulfill its task as the expression of German character...What you are seeing here are the crippled products of madness, impertinence, and lack of talent...I would need several freight trains to clear our galleries of this rubbish...This will happen soon.[6]

Ziegler's fortunes took a dramatic turn in 1943 when he was arrested by the Gestapo and imprisoned in the Dachau concentration camp for six weeks. He stood accused of behavior detrimental to the state. While the details of his arrest remain sketchy, it appears that Ziegler may have wavered in his convictions regarding Germany's ability to prevail in the later years of the war. He was reportedly sympathetic to an artist who did not want to send his work to the Great German Art Exhibition in 1943 for fear it would be damaged in Germany's floundering war effort. He evidently was also part of a traitorous plan to put out feelers for a peace initiative.

Ziegler was released from Dachau and allowed to retire. Newspapers were henceforth forbidden to make mention of him or to publish his work. He lived quietly near Hannover until apprehended by occupation authorities in 1947. Ziegler was put through denazification and charged a fine, which he was later not required to pay. In the 1950s, he tried unsuccessfully to be reinstated at the Academy of Fine Arts in Munich. Adolf Ziegler died in 1959.

Notes

1. Adolf Hitler, *Mein Kampf* [My Struggle] (Munich: Verlag Franz Eher Nachfolger, 1927).

2. In an effort to bolster their claims to the timeless validity of the Nazi regime, Hitler and his party ideologues insisted on an historical link between "racially pure" Germans of the present and Aryan (or Indo-European) culture of the past, whose greatest flowering was thought to have taken place in ancient Greece. The visual arts under the Nazi regime, including architecture, painting, and sculpture, as well as parades and demonstrations, accordingly made reference to Greek as well as Roman cultural precedents. This was done in order to solidify this ideological connection between the celebrated origins of Western civilization and Hitler's regime.

3. Adolf Hitler, "Der Führer eröffnet die Grosse Deutsche Kunstausstellung 1937," in *Theories of Modern Art: A Source Book by Artists and Critics,* ed. Herschel B. Chipp, 479 (Berkeley: University of California Press, 1968). Originally published in *Die Kunst im Dritten Reich* (July–August, 1937).

4. Robert Scholz, *Die Kunst im Deutschen Reich* [Art in the German Reich] (September 1940): 236. Cited in Peter Adam, *Art of the Third Reich* (New York: Harry N. Abrams, Inc., 1992), 157–58.

5. See illustration of Arno Breker's Readiness in Peter Adam, *Art of the Third Reich* (New York: Harry N. Abrams, 1992), page 149.

6. Adolf Ziegler, speech opening the Degenerate Art Exhibition, *Mitteilungsblatt der Reichskammer der bildenden Künste* (August 1, 1937). Cited in Peter Adam, *Art of the Third Reich,* 123.

Bibliography

Adam, Peter. *Art of the Third Reich.* New York: Harry N. Abrams Inc., 1992.

Barron, Stephanie, ed. *Degenerate Art: The Fate of the Avant-Garde in Nazi Germany.* Exhibition catalogue. Los Angeles: Los Angeles County Museum of Art, 1991.

Barron, Stephanie and Sabine Eckmann, eds. *Exiles and Émigrés: The Flight of European Artists from Hitler.* Exhibition catalogue. Los Angeles: Los Angeles County Museum of Art, 1997.

Hinz, Berthold. *Art in the Third Reich.* New York: Random House, 1979.

Holz, Keith. *Modern German Art for Thirties Paris, Prague and London: Resistance and Acquiescence in a Democratic Public Sphere.* Ann Arbor: University of Michigan Press, 2004.

Jaskot, Paul B. *The Architecture of Oppression: The SS, Forced Labor and the Nazi Monumental Building Economy.* London: Routledge, 2000.

Lane, Barbara Miller. *Architecture and Politics in Germany, 1918–1945.* Cambridge, MA: Harvard University Press, 1968.

Petropoulos, Jonathan. *Art as Politics in the Third Reich.* Chapel Hill: University of North Carolina Press, 1996.

———. *The Faustian Bargain: The Art World in Nazi Germany.* New York: Oxford University Press, 2000.

Scobie, Alex. *Hitler's State Architecture: The Impact of Classical Antiquity.* University Park: The Pennsylvania State University Press, 1990.

Steinweis, Alan E. *Art, Ideology, and Economics in Nazi Germany: The Reich Chambers of Music, Theater, and the Visual Arts.* Chapel Hill: University of North Carolina Press, 1993.

Taylor, Robert R. *The Word in Stone: The Role of Architecture in the National Socialist Ideology.* Berkeley: University of California Press, 1974.

CHAPTER 4

Artists in Great Britain: Creating Art as Propaganda during the "Blitz"

Between September 1940 and May 1941, German pilots pounded Great Britain's capital city of London with repeated bombing raids in what became known as the Blitz (short for Blitzkrieg, the German term meaning lightning war). World War I, which raged mostly on French soil, left British shores largely untouched. In World War II, however, Hitler's Blitzkrieg erased distinctions between home front and battlefront as Nazi fighter-bombers and submarine blockades threatened to force Britain to its knees. British artists, several of whom had served as government combat artists in France during World War I, now confronted the horrors of war in their own towns and cities. Most signed on to produce paintings and drawings as part of the Ministry of Information's War Artists' Advisory Committee (WAAC), whose guiding spirit was the renowned art historian and connoisseur, Kenneth Clark. The WAAC sent artists to the front to record the British campaigns in Europe, North Africa, and the Middle and Far East between 1939 and 1945. Many more, however, were asked to remain at home in order to document the country under siege and provide a visual account of British wartime resolve.

In an effort to harness art for distinctly propagandistic purposes, most World War II era war art campaigns restricted the style and content of pictures produced by their commissioned artists. The British war art program was no exception to this rule. The WAAC required its artists to work in a style readily accessible to the public; it also demanded images that would foster patriotic defense of the nation. Due to Kenneth Clark's efforts, however, the WAAC distinguished itself from other war art campaigns. Clark solicited contributions from some of Britain's most avant-garde artists and encouraged them to create works of art, not mere propaganda, whose high quality, meaning, and significance would outlast the immediate realities of war. WAAC images sometimes

indulged in semiabstract and surrealist interpretations of the war that challenged the conventional tastes of the military authorities and popular audiences that the WAAC's war art program was intended to serve. For Clark, the production of such art *was* propaganda—propaganda designed to ensure the survival and continuation of Britain's long and illustrious cultural heritage and to elevate the aesthetic standards of the public. Clark's elitist vision of art and its wartime role transformed the defense of British culture into a matter of urgent importance not solely for the country, but also, and more importantly, for the future of a world civilization threatened by the spread of dictatorship and war.

Great Britain and Its Art World before World War II

Britain's avant-garde of the World War II years traced its lineage back to the early nineteenth century when England played a key role in the origins of Western modernism. In the early 1800s, Romantic landscape painters John Constable and J.M.W. Turner produced works whose innovative style broke with the idealized realism promoted by the government-sponsored Royal Academy of Art. They created unconventional landscape images through the use of un-mixed pigments applied to the canvas in short, choppy brushstrokes. Unlike artists at the Royal Academy, who were trained to turn out polished and illu-sionistically detailed paintings and drawings, Constable and Turner preserved the visible "touch" of the artist's hand in the turbulent, textured surfaces of their finished works. Their landscape paintings asserted the value of the artist's emotional interiority and personal response to the motif over and above any obligation to document, in realistic fashion, the outside world. Constable and Turner's subjective approach to art was emulated by other leading artists of the nineteenth-century avant-garde, most famously Claude Monet who evolved his sketchy, impressionist style after encountering an exhibit of Turner's work in London in 1870.

From the mid-nineteenth century until the outbreak of World War I in 1914, British artists built on their country's legacy of modernist innovation, but they also looked increasingly to France as the center of the international vanguard. Successive waves of French impressionism, fauvism, and cubism exercised con-siderable influence on Britain's art world well into the twentieth century.

The outbreak of war in 1914 suspended exchange within the international avant-garde as France, Britain, and the other Allies became engulfed in war against Germany. Caught up in patriotic fervor, many British artists signed on to their government's newly inaugurated war art program. The program supplied artists with needed patronage in a time of scarcity while enlisting them in one of the first mass media propaganda wars of the modern era.

The new field of commercial advertising was an important model for Britain's war artists as they looked for ways in which to create persuasive images urg-

ing home front support and Allied resolve in the war against Germany. Many produced patriotic films, posters, photographs, calendars, and cigarette cards with patriotic messages for mass distribution. Others put their talents to use making camouflage, signage, diagrams, and maps for combat purposes. In 1916, Britain's War Office allowed artists access to the front in France for the first time in an effort to provide an increasingly image-hungry British audience at home with eyewitness testimonies to the war. Several prominent artists, including Paul Nash, Muirhead Bone, and Stanley Spencer (all of whom were later involved in the WAAC during World War II), produced paintings and drawings that were placed in war art exhibits and mass reproduced in illustrated journals and as postcards. In March 1917, the Imperial War Museum was founded in London to house examples of Britain's war art along with medals, maps, books, photos, and other documents of the World War I campaign.

Between the two World Wars, Henry Moore, Ben Nicholson, Barbara Hepworth, and Paul Nash produced abstract and surrealist paintings and sculptures that reinvigorated Britain's standing in the international vanguard art world. But, with the collapse of the New York Stock Exchange in 1929, nearly four million Britons thrown out of work during the Great Depression, and the increasing threat of war announced by Hitler's accession to power in Germany in 1933, such internationalist and experimental tendencies were soon eclipsed by a rising tide of nationalism and calls for a return to tradition in the British art world.

In March 1936, Hitler's troops marched into the Rhineland in defiance of the Versailles Treaty of 1919. Beginning in July 1936, Hitler violated yet another international agreement by providing military backing to General Francisco Franco's rebel insurgency in the Spanish Civil War. In summer 1937, the Nazi regime staged its infamous Degenerate Art Exhibition in Munich, where modernist art was held up for pillory in one last defamatory display before its formal eradication from Germany. In March 1938, Britain looked on with the rest of the world while Hitler annexed Austria as part of an accelerating program of territorial conquest.

In summer 1938, a group of exile artists fleeing Nazi persecution staged an exhibit of modern German art at London's New Burlington Galleries. Included among the prominent patrons and sponsors of the show were Kenneth Clark and Pablo Picasso. Originally titled "Banned German Art," the exhibit was intended to protest Hitler's Degenerate Art Exhibition of the previous summer. On display were works by some of Germany's leading modernists—Max Beckmann, George Grosz, Ernst Ludwig Kirchner, and Käthe Kollwitz among others—now proscribed by the Nazi regime.

Before the show opened, however, its title was changed from "Banned German Art" to the less incendiary "Exhibition of 20th Century German Art." The British Foreign Ministry dictated the change as part of its ongoing effort to suppress anti-German propaganda. British Prime Minister Neville Chamberlain adopted an appeasement policy during this period, hoping to avoid a wider war by (erroneously) trusting Nazi claims to limited territorial ambitions in Europe. Chamberlain signed the infamous Munich Agreement in September 1938, in

which Britain consented—following its ill-conceived policy of appeasement—to Hitler's annexation of the German-speaking areas of Czechoslovakia.

Britain's Artists in World War II

By March 1939, Hitler had overrun the entire Czechoslovakian state; on September 1, 1939, German troops marched into Poland. Two days later, on September 3rd, Britain and France declared war on Germany, formally commencing World War II. Within a matter of days, Kenneth Clark approached Britain's Ministry of Information about establishing a government-sponsored war art commission modeled on the country's World War I art program. A critic, connoisseur, museum curator, and art historian, Clark was an established scholar of Italian Renaissance art. He was also known for his encouragement and patronage of younger artists. From 1934 to 1939, he served as director of the National Gallery and Keeper of the King's Pictures.

With the outbreak of war, Clark went to work for the Ministry of Information in its film division. He also set about establishing the WAAC as a means for supplying economic relief to artists in wartime and protecting them from combat service. Above all, Clark, who firmly believed in art as the highest testament to advanced civilized society, sought to save Britain's art from becoming another casualty of war. In October 1939, he published his views in the British journal *The Listener.* The artist's patriotic role, Clark maintained, was to create great art—as artists had done in World War I—in order to ensure the survival of Britain's superior cultural legacy. Unlike photographs which remained limited to documenting individual events, paintings and drawings had shown their capacity to extract larger significance from details in ways that served to imbue the war effort with profound meaning:

> The first duty of an artist in wartime is the same as his duty in peace: to produce good works of art…As a fireman he will be of very little use to his country, but if he is a good artist he may bring it international renown, and even as a mediocre artist he will help to create that body of images through which a country exists for the rest of the world … [The artists of the First World War] did leave a record of the war which the camera could not have given. There are certain things in life so serious that only a poet can tell the truth about them.[1]

Clark's preference for the aesthetic qualities of art over the documentary nature of photography would eventually surface as a point of contention between him and military officials who also participated in the WAAC. The WAAC met for the first time on November 23, 1939, at the National Gallery in London. It included representatives from branches of the armed services (the Air Ministry, War Office, and Admiralty) and from various home front governmental agencies. Also present were Muirhead Bone, Walter Russell, and P.H. Jowett of the arts community.

The committee established certain parameters for WAAC commissions, including the demand that all work be based on eyewitness experience. Such a stipulation appeared to privilege documentary reportage over the more aesthetic concerns championed by Clark in his *Listener* essay. The committee did not exclude from consideration, however, those vanguard artists whose work of the 1930s had begun to move away from abstraction to a restrained modernism based on more conventional, figurative approaches to image making. In its first meeting, the WAAC drew up a list of 50 eligible artists, some of whom were leading modernists. Several were women, including Laura Knight, Vanessa Bell, and Eve Kirk. It then matched artists to ministries and designated the range of subject matter, such as portraits, action scenes, airplanes, and factories, that the artists were expected to depict for their commissions.

The WAAC also outlined three different support arrangements for its artists. Some were hired as full-time salaried employees on six-month contracts. Others received direct commissions from the committee. The WAAC occasionally encouraged still others to submit specific works for purchase consideration. Their salaried artists were spared active military service and received stipends to help pay for supplies and transportation costs associated with their work. All received modest fees for their services. Most artists came to look on the WAAC as a welcome and vitally important source of income as nongovernment patronage sources began to dry up as a result of the war.

Among the most celebrated paintings from the early months of the WAAC program was Charles Cundall's *Withdrawal from Dunkirk* produced in June 1940. Rendered in a realist style, the work portrays with visual accuracy the chaotic withdrawal of 250,000 British troops routed from the beaches of Dunkirk by advancing German forces in May 1940. By focusing attention on the wide variety of sailing craft that hastily pitched in to assist the evacuation, Cundall's work fulfilled its propagandistic purpose by transforming defeat into a testament of national resourcefulness and resolve in the face of adversity.

Withdrawal from Dunkirk was put on display at the first National Gallery exhibit of war art in July 1940. When the National Gallery's permanent collections were removed to slate quarries in Wales for safekeeping during the later phases of the war, such war art shows, which continued until 1945, became the only public art exhibits that continued to be held in London. National Gallery war art exhibits were thus important venues not only for government propaganda efforts but also for popular entertainment amidst a wartime shortage of opportunities for leisure activity. Works by WAAC artists were reproduced and disseminated as posters, pamphlets, postcards, and prints sold at the Gallery. Some war art exhibits toured throughout the country to provincial museums, villages, and army camps.

In August 1940, German Luftwaffe (air force) pilots launched an attack on Britain's Royal Air Force (RAF) bases and strategic targets. The bombing raids announced the beginning of Hitler's plan for full-scale invasion of the island nation. During the Battle of Britain, RAF fighter pilots became national heroes for their courageous defense against the German onslaught. The WAAC assigned

the World War I combat artist Paul Nash to the RAF with a commission to produce works commemorating the air corps' valorous service.

Nash produced a series of watercolors for the RAF that incorporated surrealist tendencies from his earlier work as a member of the modernist avant-garde in the 1930s. Titled *Aerial Creatures,* the watercolors explored Nash's interest in what he described as the "animal-like personalities" of planes. His images depicted unmanned bombers and fighter aircraft as technological weapons metamorphosed into aggressive, predatory animals independent of human control. RAF officials objected not only to Nash's inattention to the heroic men who were defending the country in the Battle of Britain, but also to his less-than-documentary approach to the rendering of fighter aircraft. The RAF fired Nash, much to the dismay of his supporter Kenneth Clark, who then and in years to come praised Nash's work as some of the finest ever produced in time of war. The RAF subsequently went outside the WAAC program to acquire conventional, realistic works deemed more appropriate to its interests. Nash was assigned directly to the WAAC where he continued to produce war art on a freelance basis.

With the beginning of the Blitz in September 1940, Clark's desire to foster greater public (and military) acceptance of innovative art through the WAAC program began to gain ground. The German Blitzkrieg targeted civilian populations, bombing the city of London nightly from September 7, 1940, to January 1, 1941. Bombing raids continued throughout Britain until May 1941, at which point the German Luftwaffe was diverted to the Russian front. Sporadic targeting persisted until the end of the war, claiming the lives of nearly 14,000 people and injuring another 18,000.

In the first two months of the Blitz, some 100,000 Londoners took nighttime refuge in the London Underground, the city's deep, subterranean subway system. Henry Moore, one of Britain's leading avant-garde sculptors of the 1920s, moderated his earlier highly abstract, surrealist approaches to the rendering of the human form in order to capture the experience of Londoners coping with the Blitz in the city's subway shelters. His shelter figures, rendered in cocoonlike layers of sketched line, take on the monumentality of ancient statuary as they crowd together, sit, sleep, and simply endure. Other artists, such as Graham Sutherland and John Piper, drew on nineteenth-century traditions of British Romantic landscape painting in works that registered their bleak emotional responses to the blasted-out buildings and charred streets of London under siege. Sutherland and Piper's somber imagery appeared along with Moore's shelter drawings in war art exhibitions at London's National Gallery, where their poignant subject matter and moderate vanguard style popularized modernist art among the British public as never before. In an eight volume series of war art images published in 1942, the WAAC acclaimed Moore, Sutherland, and Piper as "national" artists whose World War II paintings and drawings were now fully acknowledged as part of Britain's revered cultural patrimony.

As the Blitz wore on, the WAAC redoubled efforts to prove its relevance in the face of threats from the treasury to cut the program as a frivolous expenditure in time of war. It turned its attention to positive images of the home front,

designed to encourage civilian participation in and support for various volunteer emergency programs in agriculture and industry. Stanley Spencer produced a celebrated series of paintings titled *Shipbuilding on the Clyde* (1940–1945) showing riveters, welders, and other shipyard laborers pitching in together to produce ships for Britain's war at sea.

Women artists attached to the WAAC program addressed in particular women's changing social role during this period. Conscripted into home front service, women assumed a variety of traditionally male jobs. Ethel Gabain's lithographs of the Women's Voluntary Services recorded women performing manual labor, filling sandbags, and clearing debris from Britain's rubble-strewn streets. Evelyn Dunbar documented the activities of Britain's so-called Land Girls. Her works, including *A Canning Demonstration, Milking Practice with Artificial Udders,* and *A Land Girl with the Bail Bull,* captured women's volunteer activities on farms throughout the country.

In May 1941, Kenneth Clark arranged for an exhibit of British war art at the Museum of Modern Art in New York. Since assuming the post of prime minister in May 1940, Winston Churchill pursued a policy of forging international alliances with the Soviet Union and the United States in the struggle against Hitler. Clark's "Britain at War" exhibit arrived in New York in the midst of ongoing negotiations between Churchill and President Franklin Roosevelt to end U.S. isolationism. The show's 110 paintings and 200 photographs of Britain under siege attempted to shift U.S. public opinion in favor of coming to Britain's aid in the war.

Beginning in 1943, the Ministry of Information began to exercise more stringent control over the WAAC as the program's overall budget was reduced. Britain, France, the United States and other Allied nations began to gain the upper hand in 1943 against Hitler's devastating campaign of submarine warfare that had raged throughout the previous year. Ministry of Information authorities, meanwhile, sought to maintain morale and compliance among a civilian population grown increasingly disillusioned by continued war.

Government authorities censored several WAAC works during this period, including Richard Eurich's *Survivors of a Torpedoed Ship,* which was removed from a war art display in 1943. Eurich's painting depicts three sailors, one black and two white, who cling desperately to the hull of an overturned lifeboat floating helplessly in a desolate and unending sea. Censors deemed his somber portrayal of a submarine attack "bad for recruitment." Barnett Freedman's *Interior of a Submarine* was also swiftly withdrawn from a show at the National Gallery in 1943 on the grounds that it revealed too much information about Britain's submarine technology.

Ministry officials also encouraged WAAC artists to produce honorific portraits of production workers in an effort to counteract worker discontent and labor strikes in the closing months of the war. Most popular was Laura Knight's picture dedicated to a hard-working female machinist, Ruby Loftus, from the Royal Ordnance Factory in Newport, Monmouthshire. Titled *Ruby Loftus Screwing a Breech-Ring,* Knight's painting became famous nationally and internation-

ally through its circulation in the press and mass reproduction in poster and postcard form. Showing a woman "sacrificing" her normative role as mother and homemaker in the name of the war effort, posters of Ruby Loftus were hung in factories throughout Britain. In a propagandistic use of patriotism, the government promoted such images in an effort to solicit similar selflessness from the country's increasingly restive work force.

On June 6, 1944 (D-Day), British and U.S. forces landed on the beaches of Normandy. Allied forces liberated France and swept into Belgium and Holland, forcing German troops back across the Rhine. On May 8, 1945, after Hitler's death in an underground bunker during the Battle of Berlin, President Harry Truman of the United States and British Prime Minister Churchill declared the end of war in Europe. WAAC artists accompanied British troops as they began the heartrending process of liberating prisoners from Nazi concentration and death camps. Leslie Cole, who had served as a war artist at the front in Greece, was sent to record the women's concentration camp at Belsen, the first camp to be entered by British troops at the end of the war. In *Belsen Camp: The Compound for Women,* he depicts the emaciated and wraithlike victims of Nazi atrocity who stagger aimlessly, collapse, and lie together in dying heaps on the muddy, rock-strewn ground. Cole's images recorded the fate of some of the more than 60,000 women who died of typhus and starvation at Belsen by the hundreds each day.

The WAAC held the last of its weekly meetings on December 28, 1945. During its six years of existence, the WAAC had commissioned 5,570 pictures from hundreds of artists, traditional and modernist, prominent and relatively unknown. After the war, the WAAC's allocations committee distributed the war pictures to Britain's major museums, including the National Gallery, the Tate Gallery, and the Imperial War Museum, to be preserved as significant works of art and enduring testaments to Britain's role in World War II. Kenneth Clark, whose efforts at the WAAC helped to popularize innovative, modernist art among the British public, went on to teach at Oxford after World War II. He became best known in the postwar years for his publications that built on his early scholarly interest in Italian Renaissance art, including *Landscape into Art* (1949), *The Nude* (1956), and *Rembrandt and the Italian Renaissance* (1966). In 1969, he hosted the popular British Broadcasting Corporation television series on world culture titled *Civilization.*

Henry Moore, Graham Sutherland, Barbara Hepworth, Francis Bacon, and Lucian Freud were among those artists who represented Britain's contribution to the international avant-garde during the years of Europe's reconstruction. Figurative art, which had eclipsed modernist abstraction during the war, continued to develop as a powerful force in British vanguard art of the postwar period. Francis Bacon attracted special international attention for incorporating the brilliant color and graffiti-like brushstrokes of early twentieth-century expressionism into his figurative paintings of the 1950s. Succeeding generations of critics have come to regard his psychologically tormented portraits from this

period as universal icons of human tragedy and the enduring trauma of the World War II years.

British Artist Biographies

Henry Moore (1898–1986)

Henry Moore was born into a mining family in the small industrial town of Castleford near Leeds in 1898. He is widely renowned today as one of Britain's most important sculptors of the twentieth century. Moore, who first studied to become a teacher, worked in an elementary school in 1915–1916. In 1917, at the age of 18, he joined the army, enlisting in the 15th London Regiment. He was gassed in the Battle of Cambrai while serving at the front in France. After Moore was demobilized in February 1919, he returned to teach at Castleford. Between 1919 and 1921, he began formal art training at the Leeds School of Art, followed by study at London's Royal College of Art beginning in 1922. In London, Moore was inspired by his visits to the British Museum where he pored over examples of African, Oceanic, and pre-Columbian art. His early stone and wood sculptures reflect his interest in the direct carving methods, rough-hewn textures, and semiabstract forms of these artistic cultures.

In 1928, the Warren Gallery in London unveiled Moore's first solo show of sculptures and drawings. The exhibit was a critical success and launched his career in the British avant-garde. In the early 1930s, Moore began sculpting images of the reclining female nude, which became his signature subject matter throughout his subsequent career. He was one of three sculptors whose work represented Great Britain in 1930 at the Venice Biennale. Museums around the world began to collect his work soon thereafter. The following year, the eminent British art critic and promoter of surrealism, Herbert Read, featured Moore as a leader of Britain's artistic vanguard in his book titled *The Meaning of Art*.

Moore's work of the mid-1930s reflected his deepening interest in the organic, biomorphic forms that were beginning to appear in the surrealist work of Pablo Picasso, Hans Arp, and Alberto Giacometti during this period. Working with biomorphic shapes, Moore introduced holes into his reclining nude sculptures, transforming his human figures into hilly, rounded forms and cavernous openings reminiscent of a semiabstract landscape. In works such as his *Four-Piece Composition: Reclining Figure* of 1934, Moore's art verged toward total abstraction in a sculpture whose various biomorphic parts allude to a dismembered body of head, torso, and legs. In 1936, he served on the organizing committee of the International Surrealist Exhibition held at the New Burlington Galleries in London. The exhibit established surrealism as Britain's main vanguard movement of the 1930s.

With the outbreak of war in 1939, Moore, like other British artists of the period, was forced to reckon with the relationship between his art and unfolding events.

Kenneth Clark, chair of the War Artists' Advisory Committee established in 1939, urged him to lend his services to the government war art program. Moore initially resisted Clark's entreaties, seeing little connection between his abstract sculptural aesthetic and a program that required artists to address contemporary reality in a style broadly intelligible to the public. The growing scarcity of sculpting materials, the bombing of his London studio, and the experience of the Blitz soon changed Moore's mind, however. His prewar subject matter of reclining nudes took on new and urgent meaning as he entered into the London Underground subway system one night during a German air raid:

> One evening after dinner in a restaurant with some friends we returned home by Underground taking the Northern Line to Belsize Park...for the first time that evening I saw people lying on platforms at all the stations we stopped at. When we got to Belsize Park we weren't allowed out of the station for an hour because of the bombing. I spent the time looking at the rows of people sleeping on the platforms. I had never seen so many reclining figures and even the train tunnels seemed to be like the holes in my sculpture. And amid the grim tension, I noticed groups of strangers formed together in intimate groups and children asleep within feet of the passing trains.
>
> After that evening I traveled all over London by Underground...I never made any sketches in the Underground. It would have been like drawing in the hold of a slave ship. I would wander about sometimes passing a particular group that interested me half a dozen times. Sometimes, in a corner where I could not be seen, I would make notes on the back of an envelope.[2]

Turning from sculpture to drawing, Moore produced 65 large-scale works in which he adapted his reclining figures to depictions of the thousands of desperate Londoners who sought refuge in the city's Underground during the air raids of 1940–1941. Moderating the abstraction of his earlier work, Moore endows his Londoners with a simplified, volumetric form reminiscent of the archaic statuary he had studied at the British Museum in the early 1920s. Rendered in cocoonlike layers of pencil, chalk, wax crayon, and ink, his figures assume an eerie, mummified stillness and timeless monumentality as they lie side by side, crowded against one another in the Underground's inhospitable, cavernous spaces.

After presenting his drawings to the War Artists' Advisory Committee, Moore was made an official war artist in January 1941. Four of his shelter drawings were included in the May 1941 "Britain at War" exhibition organized by Kenneth Clark for the Museum of Modern Art in New York. In 1942, Clark also arranged a widely acclaimed display of Moore's drawings in London's National Gallery. Moore's new, modernist renderings of the home front war experience popularized his art outside the rarified confines of the avant-garde art scene.

Moore returned to sculpture in 1943, when he was commissioned by Reverend Walter Hussey of St. Matthew's Church in Northhampton to produce a Madonna and Child for the church. In the postwar years, he continued to sculpt images of reclining women and, after the birth of his daughter in 1946, fre-

quently returned to portrayals of mothers and children. He carried out numerous public art commissions, including one of his largest pieces in 1963–1965, a bronze *Reclining Figure,* for Lincoln Center in New York. In 1974, the Henry Moore Sculpture Centre, possessing the largest public collection of his work, opened in the Art Gallery of Ontario in Toronto, Canada. In 1977, the Henry Moore Foundation opened in Much Hadham, north of London. Henry Moore died in Much Hadham in 1986.

Paul Nash (1889–1946)

Born in 1889 in London to a wealthy family, Paul Nash studied at the Slade School of Fine Arts and the University of London. He had his first solo exhibition in 1912 at London's Carfax Gallery. Nash's landscape paintings during this period registered little interest in the latest post-impressionist tendencies coming out of France at the turn of the century. His earliest works looked instead to the figurative and illustrative traditions of British nineteenth-century art, including the work of Britain's pre-Raphaelite painters.

Nash served as an officer on the Western front in France during World War I. In 1917–1918 he became an official war artist, sent to record the experience of battlefields where tens of thousands German, French, and British soldiers lost their lives. Expected to produce propagandistic images inspiring patriotic support for the war, Nash's exposure to the front left him profoundly disturbed. He began to question the function of his art and his purpose as a war artist:

> The rain drives on, the stinking mud becomes more evilly yellow, the shell-holes fill up with green-white water, the roads and tracks are covered in inches of slime, the black dying trees ooze and sweat and the shells never cease. They alone plunge overhead, tearing away the rotting tree stumps, breaking the plank roads, striking down horses and mules, annihilating, maiming, maddening, they plunge into the grave, and cast up on it the poor dead. It is unspeakable, godless, hopeless. I am no longer an artist interested and curious, I am a messenger who will bring back word from the men who are fighting to those who want the war to go on forever. Feeble, inarticulate, will be my message, but it will have a bitter truth and may it burn their lousy souls.[3]

Nash's World War I combat imagery broke with simplistic glorifications and sanitized propaganda to confront British audiences instead with the reality of war's bitter tragedy and loss. His works depicting obliterated landscapes, mud, and destruction were put on view at an exhibit titled *Void of War* that was held in May 1918 at the Leicester Galleries in London. The government subsequently acquired two of his somber war paintings, *We Are Making a New World* and *The Menin Road,* for permanent display in the Imperial War Museum.

Nash worked on a series of conventional landscape paintings in the early 1920s. By the late 1920s and early 1930s, however, he had become a member of the British avant-garde. On a trip to Paris and the south of France in 1930, Nash

encountered the latest in contemporary French art, including surrealism. After his return to England, he published a series of articles that established him as a leading advocate of modernist art in Britain. In 1933, he was the driving force behind Unit One, a short-lived artists' group that sought to enhance the status of the British vanguard in the international art scene. Britain's leading abstract and surrealist artists who participated in Unit One, included Henry Moore, Ben Nicholson, Barbara Hepworth, and other prominent painters, sculptors, and architects.

In the mid-1930s, Nash gravitated toward surrealism. Works such as *Landscape from a Dream* (1936–1939) adopt the unsettling illusionism and dreamlike juxtapositions typical of the work of the contemporary Italian painter Giorgio de Chirico, whose work was long admired by adherents of the surrealist movement. In 1936, Nash worked with Henry Moore and other British surrealist artists on the landmark International Surrealist Exhibition that took place in London.

Shortly after the outbreak of World War II, Nash founded the Arts Bureau for War Service, an organization intended to provide support for artists during the war. His Arts Bureau was soon superceded by the government's War Artists' Advisory Committee (WAAC), which met for the first time in November 1939. The WAAC's guiding spirit, Kenneth Clark, was Nash's friend and supporter. Clark recommended him for hire by the WAAC program.

In March 1940, Nash was assigned to produce images for the Air Ministry. A severe bronchial condition (that claimed his life in 1946) barred Nash from firsthand experience of airforce missions. His watercolor series titled *Aerial Creatures,* which he produced for the Air Ministry, focused not on authentic depictions of air combat, but rather on surrealistic renderings of bombers and fighter planes. One of the works, titled *Follow the Führer,* transforms air into sea in an image that depicts a squadron of German planes soaring high over a bank of clouds that double surrealistically in Nash's portrayal as an ocean floor.[4] The planes become a school of fish led by a giant shark with menacing, jagged teeth and a face reminiscent of Hitler's. In March 1942, Nash wrote an essay titled "The Personality of Planes" for the British journal *Vogue,* in which he explained his anthropomorphic view that planes, and not people, were the real protagonists in the war.

Royal Air Force officials objected to this and other works by Nash for taking artistic liberties with reality. The conflict underscored latent problems in the WAAC between Kenneth Clark's desire to foster art and creative innovation and the desires of the Air Ministry that preferred conventional, easily understandable, documentary works. Nash defended his desire (honed from his firsthand experiences during World War I) to use his work not to glorify militarism, but rather to awaken in viewers an admonitory sense of war's "dreadful fantasy."

> In all my work I aim at something more than a picture to be exhibited in the [National Gallery]. Wherever possible I should like pictures to be used directly or indirectly as propaganda...Although I know how terrifyingly gay and decora-

Paul Nash, *Totes Meer,* 1940–1941. © Tate Gallery, London/ Art Resource, NY.

tive war and especially war in the air, *can* look, I would like to give a feeling of *dreadful fantasy* something suave but alarming. It's difficult. I know how difficult and I do not flatter myself I have succeeded except now and then. But I would get *inside* this business and frighten someone or burst![5]

Nash was removed from his commission at the Air Ministry and placed directly under the WAAC. In 1940–1941, he produced his most acclaimed works of the war years, *The Battle of Britain* and *Totes Meer* (Dead Sea). In *The Battle of Britain,* Nash relied on allegory, not literal depiction, to capture the enormity of Britain's first defensive struggle against the Germans in World War II. Rather than portray a specific event, the work catalogues those features that Nash regarded as constants of Britain's air war: bleak landscapes of clouds, earth, and water filled with downed aircraft, vapor trails, and menacing fighter squadrons scrambling for attack.

Nash's work titled *Totes Meer* resulted from a WAAC commission to record the wreckage of German planes downed in combat. His rendering transforms the enemy aircraft into a dark and churning sea of twisted and broken forms. Clark regarded Nash's *Battle of Britain* and *Totes Meer* as some of the finest paintings produced by any artist during the war. Both were honored with display at the National Gallery and widely disseminated as postcard reproductions.

Nash soon thereafter gave up his WAAC commission, claiming a lack of suitable subjects for his art. He also became increasingly uncomfortable about the privileged and protected life that his WAAC commission had allowed him to

enjoy. In the closing months of the war, Nash gave up art making altogether and enlisted for service as a Major in the Royal Marines. Paul Nash died in 1946.

Stanley Spencer (1891–1959)

Born in Cookham, Berkshire in 1891, Stanley Spencer enrolled in 1907 at Berkshire's Maidenhead Technical Institute. Between 1908 and 1912 he attended the Slade School in London. In 1912, he produced a prize-winning painting and early example of his lifelong interest in Christian spiritualism. Titled *Nativity,* the work combined Spencer's study of Renaissance art with the expressive form and color of late nineteenth-century French post-impressionism. Spencer drew special inspiration from Paul Gauguin's art of the 1890s, in which Gauguin used his tropical, sun-drenched colonial retreat in Tahiti as the setting for portrayals of the Virgin Mary, Christ Child, and other biblical figures. In his pre-World War I work, Spencer similarly used his hometown of Cookham as a setting for biblical events.

Spencer enlisted in the Royal Army Medical Corps in 1915. In 1918, the Ministry of Information requested that Spencer, who was then serving at the front in Macedonia, be appointed an official war artist. After his demobilization, Spencer returned home in 1919 and began to produce his war art pictures. One, a large-scale oil painting titled *Travoys arriving with Wounded at Dressing Station,* hangs in the Imperial War Museum.

Though Spencer returned thereafter to biblical themes, his war experience continued to haunt him. In the early 1920s, he made plans to produce a large-scale mural about the war modeled on Giotto's famous fourteenth-century frescoes in the Arena Chapel located in Padua, Italy. Mr. and Mrs. J.L. Behrend provided Spencer with a private chapel, which they had constructed in the village of Burghclere, Hants. The Behrends dedicated Sandham Memorial Chapel, as it was called, to the memory of Mrs. Behrend's brother, a lieutenant killed in the Macedonian campaign. Spencer worked from 1927 to 1932 decorating the chapel with his murals, which emphasize themes of war and salvation. The side walls illustrate Spencer's World War I experiences working in a military hospital at the Macedonian front. The cycle of frescoes culminates in his *Resurrection of the Soldier* on the eastern wall, which depicts fallen soldiers rising from the earth. As an emblem of their sacrifice and redemption, the resurrected soldiers place white cross markers from their graves on an altar.

Spencer produced saleable, illusionistic landscape paintings during the 1920s and 1930s as a ready source of income. His interest focused increasingly, however, on figure compositions, whose explicit erotic content courted censorship by the Director of Public Prosecutions. Working in isolation throughout most of the 1930s, Spencer found himself in dire financial straights in 1939. With Britain's declaration of war on Germany, it became all but impossible to find buyers for the landscapes on which he depended for economic survival.

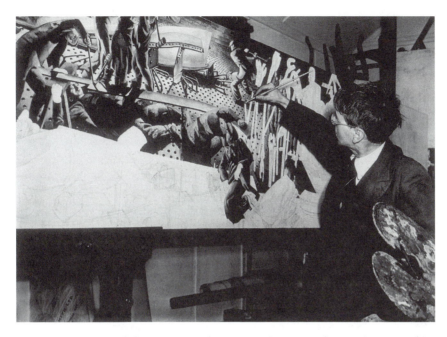

January 30, 1943: English artist Sir Stanley Spencer (1891–1959) at work on one of his giant panels depicting work in the shipyards on Clydeside, Scotland, where he is working as an official war artist. © Harry Shepherd/Getty Images.

Spencer's dealer put him in touch with Kenneth Clark and the War Artists' Advisory Committee (WAAC) in January 1940. Spencer proposed to the committee that he produce a crucifixion scene to symbolize the German invasion of Poland in 1939. Insisting that all works be based on eyewitness experience, the WAAC rejected the idea and assigned Spencer instead to paint shipbuilding in the Lithgow shipyards of Port Glasgow. Spencer developed a grandiose plan to produce some 70 separate canvasses titled *Shipbuilding on the Clyde* that would eventually be assembled in the form of a multipaneled Renaissance altarpiece. He completed 14 of the canvasses, averaging 2 feet in height and covering altogether some 137 feet in length. His crowded compositions depict the bustle of shipyard welders, riveters, riggers, and burners solemnly engaged in home front defense work. The rounded, volumetic form of Spencer's Giotto-esque shipbuilders lend his imagery the sacred dignity and timeless monumentality of fourteenth-century religious art. The commission, which served to encourage home front support for Britain's defense industry, occupied Spencer until the end of the war.

After the war, Spencer returned in his art to themes of redemption and modern spiritualism. In 1955, the Tate Gallery held the first retrospective of his work. The year before his death in 1959, Spencer was knighted by the British monarchy. In 1980, the British Royal Academy, with whom he had strained

relations throughout much of his career, honored Stanley Spencer with a comprehensive exhibit of his work.

Graham Sutherland (1903–1980)

Born in 1903, Graham Sutherland studied at Goldsmith's College of Art in London from 1921 to 1926. He established his early artistic reputation as an engraver and printmaker. He also became known for producing works that looked back to the tradition of Britain's early nineteenth-century Romantic landscape painters. From 1926 to 1940, Sutherland taught at the Chelsea School of Art where Henry Moore also served as an instructor.

In the early 1930s, Sutherland took up painting. His painted landscape compositions possessed psychological qualities that made his work compatible with recent tendencies in surrealist art. In 1936, some of his pieces were included in the landmark International Surrealist Exhibition held in London at the New Burlington Galleries. Sutherland became best known during this period, however, as a leader of the Romantic revival in the arts. Kenneth Clark was a patron of Sutherland's and wrote the introduction to the catalogue for his first solo show, which was held in 1938.

After the outbreak of war in 1939, Sutherland, like other artists, found dwindling opportunity for teaching and sale of his works. In order to provide financial assistance, Clark invited Sutherland and his family to live with him in 1939 and 1940 at his house in Gloucestershire. In 1941, Clark prompted Sutherland to submit work for consideration to the War Artists' Advisory Committee (WAAC). Between 1941 and 1945, he became one of the few artists hired by the WAAC on a full-time, salaried basis.

His original assignment was to go to Wales to record the bombed area around Swansea. This was the first time that Sutherland had encountered such large-scale destruction; it was also the first time that he was compelled to make destruction the subject of his art. Sutherland's experience of war on the home front combined with the Romantic revival impulse of his prewar work in a series of evocative and emotionally charged renderings of Britain's landscape of devastation.

In 1941, the WAAC assigned Sutherland to record the effects of the Blitz in London in the immediate aftermath of German bombing raids. He would rush to locations in the city's East End and the area around St. Paul's Cathedral in order to render the sites before any attempts to clear them had been made. Based on his Romantic revival interest in the poignant aesthetic quality of crumbling ruins, Sutherland sought to experience London's wartime reality of blasted-out concrete, twisted metal, and smoldering embers in the manner of a latter-day Romantic landscape. The WAAC acquired nine of his London works from 1941, including *Devastation, 1941, City: Fallen Lift Shaft.*[6] The image portrays the crumbling brick walls of a bombed building along with the twisted metal skeleton of its elevator shaft. This and other works not only exhibit close attention to visual

detail, but also a brooding, somber quality that registers the artist's personal response to the motif. Feeling increasingly uncomfortable and voyeuristic about his role in creating art out of the tragedy of those who suffered daily through the air raids, Sutherland began to use photography as an aid in his work. Taking photos and working from hastily drawn sketches made at the site, he completed his final renderings in the studio.

When raids subsided in London, the WAAC asked Sutherland to go to Cornwall to depict the tin mines there. He became increasingly interested in rendering the human form during this assignment and produced several portrait heads of the miners. In works such as *Waiting Miner at the Meeting of the Tunnels,* Sutherland relied on nineteenth-century traditions of realist painting for his ennobling portrayals of the tin mine workers and their labors underground. His series of works from Cornwall were some of his most acclaimed of the war years.

In November 1944, Sutherland traveled out of England for the first time. He was sent by the WAAC to record the effects of British air raids that had turned the tide against Hitler's advancing forces after the D-Day invasions of the previous June. In works such as *A Flying-Bomb Depot,* Sutherland once again produced mournful images of war's destruction. His portrayal of the depot combines detailed attention to bomb-blast craters, twisted and charred trees, and crumbling bunkers with the artist's emotional response to the motif. His images from the battlefields of France were the last that he produced for the WAAC program.

In 1946, Sutherland painted a large crucifixion scene for St. Matthew's Church in Northampton. The work was inspired by the twisted and tormented bodies of Matthias Grünewald's *Isenheim Altarpiece* of the sixteenth century as well as by the photographs of victims in Nazi concentration and death camps that began to flood the media after the war. His crucifixion scene was his first effort to render the human figure life-size; it was also the first of several subsequent works that he produced on religious themes.

In 1955 Sutherland settled in the south of France. He painted Mediterranean landscapes and continued to do formal portrait work, which he had taken up in the late 1940s. Some of his portraits include those of Somerset Maugham (1949), Sir Winston Churchill (1954), Helena Rubinstein (1957), and Konrad Adenauer (1963). In 1967, he returned to Pembrokeshire. In 1976, a museum devoted to his work opened in Picton Castle, Wales. Graham Sutherland died in London in 1980.

Notes

1. Kenneth Clark, "The Artist in Wartime," *The Listener* (26 October 1939). Cited in Peter Stansky and William Abrahams, *London's Burning: Life, Death and Art in the Second World War* (Stanford, CA: Stanford University Press, 1994), 28–29.

2. Alan Ross, *Colours of War: War Art 1939–45* (London: Jonathan Cape, 1983), 37.

3. Ross, *Colours of War,* 73.

4. See illustration of Paul Nash's Follow the Führer in Ken McCormick and Hamilton Darby Perry, eds., *Images of War: The Artist's Vision of World War II* (New York: Orion Books, 1990), page 56.

5. Paul Nash to the Ministry of Information, 18 March 1941. Cited in Penelope Curtis, *World War Two: A Display of Pictures from the Collection to Mark the 50th Anniversary of the Outbreak of War in September 1939* . Exhibition Catalogue (Liverpool: Tate Gallery, 1989), 14.

6. See illustration of Graham Sutherland's Devastation, 1941, *City: Fallen Lift Shaft* in Peter Stansky and William Abrahams, *London's Burning: Life, Death and Art in the Second World War* (Stanford, CA: Stanford University Press, 1994), unpaginated colorplate.

Bibliography

Curtis, Penelope. *World War Two: A Display of Pictures from the Collection to Mark the 50th Anniversary of the Outbreak of War in September 1939.* Exhibition catalogue. Liverpool: Tate Gallery, 1989.

Darracott, Joseph and Belinda Loftus. *Second World War Posters.* Exhibition catalogue. London: Imperial War Museum, 1972.

Harries, Meirion, and Susie Harries. *The War Artists: British Official War Art of the Twentieth Century.* London: Michael Joseph, Ltd., 1983.

Harrison, Charles. *English Art and Modernism, 1900–1939.* New Haven, CT: Yale University Press, 1981.

Holz, Keith. "Scenes from Exile in Western Europe: The Politics of Individual and Collective Endeavor among German Artists." In *Exiles and Emigrés: The Flight of European Artists from Hitler,* edited by Stephanie Barron and Sabine Eckmann, 43–56. Exhibition catalogue. Los Angeles: Los Angeles County Museum of Art, 1997.

Remy, Michael. *Surrealism in Britain.* Hants, England: Ashgate, 1999.

Ross, Alan. *Colours of War: War Art, 1939–45.* London: Jonathan Cape, 1983.

Sillars, Stuart. *British Romantic Art and the Second World War.* London: Macmillan, 1991.

Stansky, Peter, and William Abrahams. *London's Burning: Life, Death and Art in the Second World War.* Stanford, CA: Stanford University Press, 1994.

Summerfield, Angela. *The Artist at War: Second World War Paintings and Drawings from the Walker Art Gallery's Collection.* Exhibition catalogue. Liverpool: Walker Art Gallery, 1990.

CHAPTER 5

Artists in Italy: Shaping a Fascist Culture of Consensus

The example of Italy during World War II confounds easy assumptions about the nature of the arts in a dictatorial regime. Unlike Hitler and Stalin who enacted policies that narrowly determined what kind of art was to be tolerated or favored under their rule, Benito Mussolini (1883–1945) maintained an open attitude toward various artistic tendencies. He embraced everything from traditional classicism to some of the most vanguard art and architecture of the early twentieth century. Mussolini, or the Duce (Leader, after the Latin word "Dux") as he came to be called, pursued a deliberate policy of inclusion that fostered cultural pluralism. Such policy favorably disposed artists and intellectuals, including those of the avant-garde, toward the regime. Hitler vilified the avant-garde as degenerate, and Stalin's artistic policies blocked them from vital government support. Italian vanguard artists, by contrast, found themselves in a supportive, rather than adversarial, relationship to Mussolini. Their work joined that of traditional and mainstream artists in helping to legitimate the Duce's authority and dictatorial rule.

The Italian futurists, Italy's leading avant-garde literary and artistic movement of the pre–World War I years, were instrumental in shaping Mussolini's early outlook and understanding of the potential role of art and culture in politics. Before and during World War I, the Duce shared with the futurists a commitment to fervent nationalism and militant hostility to the status quo in Italian political and cultural life. More important, the manner in which the futurists blurred the distinction between art and politics and used public spectacle to sway the masses to their point of view provided Mussolini with a blueprint for his own later use of mass culture and the arts to forge a culture of consensus under his command. In the years of World War II, Mussolini enlisted artists across the spectrum of Italian cultural life in a campaign to rally the populace behind a

program of militarist aggression and territorial conquest. Their task was to give form to Mussolini's vision of a fascist Italy built upon—but far surpassing—the greatness of Italy's Roman imperial past.

Italy and Its Art World before World War II

Mussolini first encountered the founder and guiding spirit of the Italian futurists, Filippo Tomasso Marinetti, in 1915. Marinetti's Futurist Manifesto of 1909 heralded the futurists' passionate allegiance to speed, technology, dynamism, and violence as the new and desirable reality of modern, urban life. Italian futurist painters, including Giacomo Balla, Umberto Boccioni, and Gino Severini, filled their canvasses with dynamic prisms of color that emulated the glinting light and metallic surfaces of modern, mechanized society. Their semiabstract compositions attempted to capture not only the look, but also the sensory experience of modernity, including the dizzying changes of perception engendered by trains, cars, airplanes, and other new modes of transportation. True to their name, the futurists looked to the future and scornfully rejected Italy's brilliant Roman and Renaissance heritage, ever present in the country's unparalleled museum collections and the architectural fabric of its cities. Marinetti and his followers regarded such heritage as a moribund past that must be destroyed.

The futurists' hostility to the past was fueled by their hatred for the current political system in Italy, which they saw as corrupt and responsible for the country's lagging stature on the international stage. Marinetti led other futurists in public performances, civil disruptions, and demonstrations in which they agitated for the overthrow of the Italian government. Staged in galleries and on city streets, the futurists' performances blurred the line between art and life by introducing politics into the rarified institutions of art and bringing art out into general public view.

The futurists greeted the outbreak of World War I as a grand and violent cleansing process capable of ridding the country of its political and social ills once and for all. By the time Mussolini encountered the futurists in 1915, he, too, had begun to attract public attention for his antigovernment, prowar stance. In May 1915, Italy joined the Allies (led by Britain, France, and Russia) in the war against Germany and Austria-Hungary, but suffered military setbacks on the Austrian front. Italy thus emerged from World War I defeated on the battlefield; the country was also shortchanged in European postwar treaty negotiations. In 1919, Mussolini founded his political organization, the Fasci di Combattimento (Fasces of Combat), with the support of the futurists and other groups radicalized by Italy's continued humiliation.

Mussolini's fascists took their name from the Latin word "fasces," bundles of rods tied around an axe that were carried as a symbol of power and authority by officials of the Roman Empire. By adopting this emblem for his organization, Mussolini signaled from the start his intent to restore Italy to its ancient Roman

status as a world imperial power. In 1922, in the midst of the country's worsening economic and political crisis, he staged his famous March on Rome. When Mussolini and his armed squads of "blackshirts" entered the Italian capital and threatened to overthrow the government, King Vittorio Emanuele III agreed to appoint him as prime minister.

Mussolini was keenly aware that the arts and intellectual life must play a role in Italy's renewed claim to international superiority. He therefore embarked on a series of measures designed to placate and ultimately co-opt artists and intellectuals for the regime. In an opening speech for the Sette Pittori del Novecento (Seven Painters of the Twentieth Century) group exhibition that took place in Milan in 1923, the Duce announced the following to the country's artists:

> I declare that it is far from my idea to encourage anything like an art of the State. Art belongs to the domain of the individual. The State has only one duty: not to undermine art, to provide humane conditions for artists, and to encourage them from the artistic and national point of view.[1]

Mussolini's restrained art policy owed much to Margherita Sarfatti, organizer of the Novecento group and exhibition. Sarfatti, a Jewish feminist and political theorist, began an affair with Mussolini in 1913 that lasted until the early 1930s. She also served as an art critic and columnist for Mussolini's journal, *Il Popolo d'Italia* (The People of Italy). Sarfatti maintained that Italy's great cultural traditions had predisposed the country to world preeminence in the past. Its artists and intellectuals, she also believed, would restore Italy to that standing once again. The role of the state, as echoed in Mussolini's speech, should be to provide artists and intellectuals with material support without dictating the form and content of their work. Such official safeguarding of creative freedom and autonomy, Sarfatti insisted, was crucial to the fostering of Italian genius and the recovery of Italy's international standing.

In its early years, Sarfatti's Novecento group became the standard-bearer for a return to order in Italian culture and society after the upheavals of World War I. Unlike the futurists, who adamantly rejected the cultural past, Novecento artists drew inspiration from Italian artistic tradition. Their work paralleled that of Giorgio de Chirico and Carlo Carrà's mysterious and enigmatic Pittura Metafisica (metaphysical painting), which was similarly beholden to earlier Italian stylistic tendencies. Novecento and Pittura Metafisica artists rejected the facetted color planes and semiabstract compositions of the futurists in favor of a return to the use of illusionistic space, figural solidity, and carefully modeled form derived from classical Roman and Renaissance art.

A positive reappraisal of Italy's architectural past accompanied the return to order in painting. It was formalized in 1924 with Mussolini's plan to restore Rome's imperial monuments. The Mausoleum of Augustus, the Theater of Marcellus, and the Pantheon were among those buildings whose iconic presence was to be enhanced anew by the demolition of generations of buildings that had risen up around them. Such structures testified to Italy's ancient greatness

when its empire stretched from the British Isles and Western Europe to Asia and North Africa. Given back their previous glory, they functioned as symbols of a new Italy poised to reclaim its position of political and cultural world power. With these restoration projects, the Duce also made clear his intention to use the high arts—including Italy's architectural monuments of the past—as mass propaganda for the regime.

After a campaign of intimidation and murder of his political adversaries, Mussolini formally declared dictatorship in 1925. The following year, he abolished the legal powers of the Italian parliament and suppressed all political parties except the Partito Nazionale Fascista (National Fascist Party, or PNF). He also exhorted Italy's artists to match ancient Rome's glorious precedent with a new culture of fascist achievement:

> We mustn't remain solely contemplatives. We mustn't simply exploit our cultural heritage. We must create a new heritage to place alongside that of antiquity. We must create a new art, an art of our time: a Fascist art.[2]

As Italy began to feel the effects of the Great Depression in the late 1920s, the government stepped in to centralize the economy and provide needed support for the country's artists. In 1929, Mussolini established a Ministry of Corporations that placed all professions and industries, including the arts, under state control. The ministry instituted a Two Percent Law (formalized in 1942, but already in place in the early 1930s), which required that two percent of all construction costs for public buildings be reserved for the commissioning of decorative art works. The government and the Fascist Party also became the major sources of patronage for artists and took an active role in staging some of the many internationally renowned art exhibitions, including the Venice Biennale, that were regularly hosted on Italian soil. As the threat of a second world war began to loom on the horizon, Mussolini's government attempted to use its control over the arts to shape a fascist culture of national revolution and renewal designed to assert Italy's authority to the world.

Italy's Artists in World War II

Soon after Adolf Hitler's appointment as German chancellor in 1933, Mussolini began to court Germany as an ally and trading partner that might help strengthen Italy's national standing in Europe. Thus began a history of admiration, emulation, and rivalry that characterized Hitler and Mussolini's relationship throughout the World War II era. For his part, Hitler patterned his scheme for world domination on the precedent of Rome's ancient empire. He charged his state architect, Albert Speer, with remaking Germany's capital, Berlin, into a city of world conquest that would surpass in scale and awe-inspiring grandeur Rome's Pantheon, Colosseum, and other imperial structures. Like Hitler in Germany, Mussolini used rallies, parades, and martial pageantry to foster a sense of

national identity, belonging, and allegiance among the Italian populace. Admiring Hitler's imperialist ambitions, Mussolini also soon embarked on his own plan to reconstitute the Italian empire through war and military conquest.

Hitler imposed a coherent Nazi artistic culture in Germany through confiscation and destruction of modernist art works (which he branded "degenerate") and the persecution of artists whose work did not conform to the dictates of the regime. The creation of a similarly coherent fascist culture in Italy was complicated from the start by Mussolini's commitment to a pluralistic art policy. Though Mussolini refrained from naming any style the official art of the state, his support for modernist tendencies in art and architecture nonetheless underscored the marked difference between his dictatorship and that of Hitler and Stalin, where such work was either prohibited or deprived of necessary government patronage.

Mussolini's connection to vanguard artists was long-standing. In 1919, he formed his fascist movement with the help of Marinetti and the futurists. The futurists, who preached artistic revolution and radical cultural change, were drawn to Mussolini's fascist revolution as the political embodiment of their project. The futurists continued to enjoy the Duce's support into the 1930s, when Enrico Prampolini, Fortunato Depero, Giacomo Balla, Tato (Guglielmo Sansoni), Gherardo Dottori, Tullio Cralli, and others launched the "Aeropittura" (aeropainting) phase of futurist art. Building on their favored themes of speed, technology, and dynamism, the futurist aeropainters produced works that celebrated Italian achievements in aerodynamics and flight. In his *Portrait of the Duce* of 1933, Dottori connected those achievements to Mussolini himself. Rendered in a futurist style of facetted color planes, Dottori's portrait depicts Mussolini's famous bald head and chiseled jaw encircled by a halo of hovering aircraft. Marinetti, on the occasion of a 1934 exhibit of futurist Aeropittura in Hamburg, Germany, took the opportunity to highlight the differences between Italian fascism and German Nazism by denouncing Hitler's intolerance for modernism and repressive artistic policies.

Mussolini also supported the work of the rationalists, Italy's most vanguard school of architects. The rationalist movement made its formal appearance in 1926 with the founding of Gruppo 7 (Group 7), an affiliation of young, avant-garde Milanese architects headed by Giuseppe Terragni. The rationalists' approach to architecture embraced the latest in modern design. Their buildings were characterized by expansive uses of glass, unornamented façades, and an overall aesthetic of modular repetition dictated by modern construction techniques. Rationalist works looked similar to those of Walter Gropius's Bauhaus in Germany, Le Corbusier in France, and other exponents of the 1920s international modern movement in architectural design. Gruppo 7, however, insisted upon creating a distinctly Italian version of international architecture by grounding their aesthetic approach in the values of order, balance, and symmetry associated with classical Roman architecture of the past.

In 1933, Terragni began work on what many scholars have come to regard as one of the most outstanding architectural monuments of the fascist regime. His

Casa del Fascio (House of Fascism), erected between 1933 and 1936 in Como, Italy, served as the provincial headquarters of the National Fascist Party. Terragni based his design on Mussolini's contention that fascism was a "house of glass": clear, honest, transparent in its workings, and committed to a direct relationship between the leadership and the people. The Casa del Fascio groundplan was a perfect square with sides twice as long as the building's height. With an aesthetic form dictated by its steel supporting structure, the building comprised a grid of streamlined, unornamented interior and façade walls made of polished marble and punctuated by vast expanses of glass. Terragni designed the Casa del Fascio's interior meeting room to open out through a glass wall into the building's central atrium, or courtyard. The atrium, in turn, was separated by another glass wall from the piazza or square located outside. Providing an unimpeded view between meeting room, atrium, and piazza, Terragni's transparent glass walls symbolized Mussolini's ideology of transparent relations between the public and its fascist leadership. Terragni included 18 doors on the ground floor of the structure that could be thrown open in order to allow the masses to enter the building during ceremonial occasions. Balconies on the front façade of the Casa del Fascio allowed leaders to address crowds inside and outside the building at the same time.

The Italian art world became more contentious as Italy moved closer to war. In 1934, a competition for the design of the Palazzo del Littorio (Palace of the Lictors, or Roman imperial officials) in Rome brought to the surface growing tensions between modernists, on the one hand, and more reactionary cultural forces, on the other. The National Fascist Party (PNF) sponsored the competition, which called for the creation of a large piazza crowned by a permanent museum to the fascist revolution. The Palazzo del Littorio was also intended to include a shrine honoring "martyrs" of the fascist regime, headquarters for the PNF, and offices for Mussolini. One of the most prestigious official architectural projects ever undertaken by Mussolini's fascist government, the contest drew entries from more than 600 of Italy's architects, including several outstanding representatives of the rationalist school.

As the Palazzo del Littorio competition began to unfold, controversy broke out in the Chamber of Deputies between those in the fascist government who favored the work of the rationalists and those who called for an art and architecture grounded in the monumental traditions of classical Rome and the Italian Renaissance. Among the rationalists' most vociferous detractors was Roberto Farinacci, member of the fascist grand council. To Farinacci and others who shared his views, the rationalists' work was fundamentally foreign-inspired, unItalian, and inadequate for the task of lending appropriate grandeur to the fascist regime. Despite Farinacci's opposition, the rationalists, along with traditionalists and architects from other stylistic camps, were awarded prizes for their entries when the first rounds of the competition ended in a stalemate between contending groups.

With Mussolini's invasion of Ethiopia in 1935, Italy's fascist government began to move closer—politically and culturally—toward the Nazi regime. Mussolini

issued a Declaration of Empire after the Italian conquest of Ethiopia's capital, Addis Ababa, on May 9, 1936. In the ensuing climate of nationalist triumphalism, the Duce abandoned his previous position of tolerance for the Jews and began to adopt Hitler's anti-Semitic policies. Reactionary elements within the fascist government and art world also began to gain the upper hand. This changing political and cultural landscape made itself felt in the events surrounding Italy's participation in the Paris World's Fair of 1937.

Mussolini initially declined to participate in the Paris World's Fair, due to economic sanctions imposed on Italy by the League of Nations in response to the Ethiopian campaign. The Duce was also embroiled in the Spanish Civil War, which began in July 1936. In October 1936, Italy and Germany formed a Rome-Berlin "Axis" alliance, later to be joined by Japan. The Axis helped to topple the Spanish Republican government by sending tens of thousands of Italian and German troops to Spain to fight on the side of the rebel insurgent General Francisco Franco. Military campaigns and international sanctions thus greatly strained Italy's resources during this period. By 1937, however, and emboldened by his Declaration of Empire, Mussolini began to look on the Paris World's Fair as an opportunity to announce to the world Italy's resurgence as a world imperial power.

Rationalist architect Giuseppe Pagano handled the interior installations of the Italian pavilion for the Paris World's Fair, while Marcello Piacentini, a stylistic moderate and Italy's most powerful architect of the 1920s and 1930s, designed the structure itself. Pagano and Piacentini's treatment of the Italian pavilion avoided the extremes of either modernist or traditional styles in an effort to project Italian fascism to the world as a coherent and inclusive cultural and political revolution. Clad in ivory-colored cement, the temporary building consisted of a five-story tower connected by a gallery to a two-story horizontal pavilion. The gridlike rectilinearity and arrangement of arcades on the exterior of the structure echoed, in a less austere form, Terragni's Casa del Fascio of 1933–1936. Moderate in size and style, the Italian pavilion appeared dramatically more modern and understated than the heavily ornamented, monumental, and bombastic Soviet and German pavilions positioned across from it on the opposite bank of Paris's Seine River.

Mario Sironi, lead artist of the 1920s Novecento group, created the large-scale mosaic titled *Fascist Work*, which served as the centerpiece of the Italian pavilion's Hall of Honor. Created in the wake of the Ethiopian campaign and Mussolini's Declaration of Empire, the mosaic equated the productive and triumphant world of ancient Rome with the "Fascist work" that had made Italy an empire once again. At the center of the composition, Sironi rendered a large-scale, female personification of Italy attired in a tunic of classical antiquity. Smaller vignettes or scenes surround the figure of Italy. They feature symbols of the Roman Empire (including the Roman eagle and a classical column), images of work, family life, and the military, as well as mythological figures representing the ancient, Roman, and Christian periods of Italian history. Italy's raised left hand points to the words: "Credere, Obbedire, Combattere" (Believe, Obey, Fight). The slogan,

combined with a compositional structure in which the figure of Italy towers over all that surrounds her, asserts Italian civilization from Roman antiquity to its fascist present as a productive social, political, and cultural system in which individuals derive their purpose from—and willingly subordinate themselves to—the monumental authority of the state. Below the figure of Italy appears a laborer raising his spade in salute. Endowed with the bald head and chiseled profile of the Duce himself, the laborer represents Mussolini as supreme worker and patriot of the regime. Sironi includes a halo of light around Mussolini's head, conferring on the dictator the status of the divine.

The rest of the Italian pavilion contained portraits of the Duce and the Italian king, along with murals, stained glass windows, and photographs that documented the achievements of the fascist regime. While Sironi's *Fascist Work* presented a celebratory image of the Italian nation under Mussolini, his art, nonetheless, did not fail to escape criticism from conservative detractors. Farinacci was among those who condemned Sironi's characteristic style of figural distortion and crude handling of form as too beholden to non-Italian artistic tendencies such as German expressionism. More ominous, however, was the experience of Corrado Cagli, a Jewish artist and fascist supporter who painted murals for the main floor of the Italian pavilion's tower. Cagli's images honored the history of Italy's civilization by depicting great Italians throughout time, culminating in a portrait of Mussolini. While the fair was still underway, the Italian foreign minister ordered Cagli's murals destroyed as a harbinger of Italy's soon-to-be formalized anti-Semitic policy.

In 1937, Hitler unveiled his infamous Degenerate Art Exhibition in Munich. The show contained over 600 works of modernist art that had been forcibly rounded up from collections around Germany. Paintings, sculptures, and drawings were held up for public pillory in what was intended to represent the formal eradication of "degenerate" modernism from German artistic culture in the Third Reich. Afterwards, many works from the show were either destroyed or sold abroad in order to provide funds for Hitler's growing war machine. Reactionary critics in Italy took note of the degenerate art show and attempted, ultimately unsuccessfully, to stage a similar defamatory exhibition in Italy. Italy's Ministry of Popular Culture was nonetheless reorganized in 1937 and began to take a harder line against the country's modernist artists.

In autumn 1938, the fascist regime issued its Manifesto of Racial Scientists, formally installing a series of laws against Italy's Jews. Italy's anti-Semitic policies included barring Jews from schools, from marrying non-Jewish Italians, and from entering the civil professions. Margherita Sarfatti, Mussolini's former lover and the Jewish art critic who had inspired his early art policy, emigrated in 1939 to avoid the climate of anti-Semitic persecution that now came to define the Duce's fascist regime.

In May 1938, Hitler made a state visit to Rome in order to cement his cultural and military alliance with Mussolini. The Duce treated Hitler to a sumptuous spectacle of fascist parades in his honor. The Nazi leader was also taken on a tour of his favorite Roman imperial monuments, including the Colosseum. Though

Hitler sought alliance with Italy, he nonetheless regarded Mussolini and the Italian people as racial inferiors. Mussolini, on the other hand, grounded claims to Italian superiority not in race, but rather in the brilliant history and culture of his country, which stretched back to the origins of Western civilization. In order to impress this superiority on Hitler during his visit, Giuseppe Bottai, Italy's Minister of Education, accompanied the Nazi leader to the Mostra Augustea della Romanità (The Exhibition of Augustan Rome). The show featured casts and copies of sculpture fragments from throughout the European reaches of the ancient Roman Empire. It also included plaster casts and temple reconstructions that brought to life the Rome of Julius Caesar and Augustus. Photos, meanwhile, presented images of fascist restoration and building projects, parades, and demonstrations. Mussolini's words "Italians, let the glories of the past be superceded by the glories of the future!" adorned the entryway to the exhibit, reminding visitors—including Hitler—of Italy's long history of greatness and its ongoing project of imperial renewal.

Hitler's visit to Italy coincided with mounting anti-Semitic restrictions in the Italian art world. Corrado Cagli, Roberto Melli, and Antonietta Raphäel Mafai were among those Jewish artists who now found their work banned from exhibition. Anti-Semitic attacks also began to mount in the Italian art press against modernist artists and architects—whether they were Jewish or not. Telesio Interlandi, a pro-Nazi cultural critic, denounced Marinetti, de Chirico, Carrà, Terragni, and other modernists as "Jewish," "Bolshevik," and "degenerate" in his Roman journal, *Il Tevere*. Marinetti responded in December 1938 by leading a large protest demonstration in Rome. As testament to the shameful acceptability of anti-Jewish sentiment across the spectrum of Italian cultural life during this period, Marinetti did not, however, denounce anti-Semitism in and of itself. In his published statements, he took issue only with equating modernism with Judaism. For reactionary critics like Interlandi and Farinacci, modernism and Judaism were equally un-Italian and both were bent on destroying Italy's artistic and cultural traditions.

With Hitler's march into Poland and the outbreak of World War II on September 1, 1939, Italy remained neutral fearing itself no match for French and British naval domination of the Mediterranean Sea. Within Italy, the founding of two national prize competitions summarized the profound political polarization that gripped the country's art world as the world war began to unfold. Farinacci, Italy's long-outspoken opponent of modernist art, established the Premio Cremona (Cremona Prize) and annual exhibit in 1939. He required competing artists to produce overtly propagandistic, pro-fascist works dedicated to such topics as: "Listening to the Duce's Speech on the Radio" or "Italian Youth of the Fascist Movement."

Giuseppi Bottai, the moderate Minister of Education who had accompanied Hitler on his visit to the Exhibition of Augustan Rome, remained steadfast in his commitment to a restrained government art policy. He founded a countercompetition, also in 1939, called the Premio Bergamo (Bergamo Prize). The Premio Bergamo typically held open-theme exhibitions in which artists were allowed to

select their own subject matter. The exhibit was also surprisingly open in terms of which artists were allowed to participate. For instance, works by Renato Guttoso and Giacomo Manzù, members of Italy's growing antifascist resistance movement, made their way into the Premio Bergamo during this period. Guttoso and Manzù belonged to the Milan-based, antifascist Corrente group, which was founded in 1938. Manzù's sculpted relief titled *Crucifixion* from 1939 condemned fascist brutality. Unlike the celebratory images of fascism promoted at Farinacci's Premio Cremona exhibits, Manzù's work portrays a pot-bellied man, dressed in a loincloth, fascist helmet, and sword, idly looking on as the nude, tortured body of another man dangles by one arm from a cross.

Emboldened by Hitler's victorious march into France, Mussolini broke with neutrality by declaring war against France and Britain on June 10, 1940. When Hitler initiated his assault against the Soviet Union on June 22, 1941, Italy declared war on the Soviet Union. On December 11, 1941, four days after the Japanese bombed Pearl Harbor, Mussolini also went to war against the United States.

The Italian government had no formal war art program, although some artists who served at the front produced works based on their experiences. The Milan journal *Corriere della Sera* began to feature war paintings on its front cover. Some were done by artists at the battlefront, such as Marco Casadei, but many were generated by home front artists who worked from eyewitness reports and photographs. Alfonso Artioli's drawings and paintings captured the harsh conditions and bitter cold confronted by Italian troops who joined Hitler's forces on the Russian front in winter 1942. Little is known about Italy's soldier-artists, however, beyond the works they produced during this period.

The last and most ambitious building project of Mussolini's regime was the plan for the Esposizione Universale di Roma (Universal Exposition of Rome, or EUR) of 1942. An outstanding example of fascist *romanità* (the cult of ancient Rome), EUR was in the planning stages as early as 1935. After Mussolini's Declaration of Empire in 1936, the EUR evolved into its intended form as the largest world's fair ever held. Billed as an "Olympics of Civilization," the EUR of 1942 was to demonstrate the universal and timeless validity of Italian world preeminence. Visitors from around the globe would be treated to displays tracing the course of 27 centuries of Western civilization, beginning with Rome's Empire of the ancient world and concluding with Mussolini's Fascist Empire of the present day. Located to the south of the capital city, EUR was to be joined to Rome by roads and rail lines. Those access routes, in turn, were to connect EUR to the ancient Roman port of Ostia. Providing a symbolic link between Rome and the sea, roads passing through EUR were to evoke once again the glorious days of the Roman Empire when Italy exercised uncontested domination of the Mediterranean.

Rationalist and traditional architects participated in the design of the EUR. The huge complex was to include temporary structures and a core of permanent buildings intended to remain after the closing of the world's fair. Work was halted on the project after Italy declared war on France in June 1940. By then,

however, several of the principal structures were completed, most of which were by rationalist architects. The most important building, the Palazzo della Civiltà Italiana (The Palace of Italian Civilization), occupied the summit of a hill overlooking the EUR complex. Designed by rationalist architects Ernesto B. La Padula, Giovanni Guerrini, and Mario Romano, the Palazzo synthesized modernity and monumentality, rationalism and classicism into a new style of fascist imperialism. Tempering the rectilinear, streamlined, machine-inspired forms of earlier rationalist buildings, the Palazzo architects incorporated into their work the overtly classical element of the Roman arch. A cubic structure slightly taller than it was wide, the Palazzo's façade was regularly perforated on each of its six floors by Roman arches. The arch motif symbolized the architectural heritage of imperial Rome. Its emphatic repetition vertically and horizontally across the façade of the Palazzo also symbolized the continuity and endurance of Roman civilization itself.

Rationalist architect Adalberto Libera, who designed the EUR's Palazzo dei Ricevimenti e Congressi (Palace of Reception and Congress) also modified his earlier, more austere modernist style for the project. The front portico of his otherwise wholly modernist building included marble columns reminiscent of those seen on the Roman Pantheon. Similar to La Padula, Guerrini, and Romano's handling of Roman arches on the exterior of their Palace of Italian Civilization, Libera excluded capitals and sculpted ornament from his structure's columns. The EUR's rationalist architects evolved a style of "stripped down" classicism that joined tradition and modernity into an imposing imperial architecture of world domination.

All work on EUR was abandoned with Italy's entry into World War II in 1940. In July 1943, the Allied forces of Britain, Canada, and the United States began their assault on the Italian peninsula. On July 25, 1943, Mussolini was forced to resign as prime minister and arrested. The Fascist Party was also dissolved, bringing an end to the fascists' 21-year rule. Soon after Italy surrendered to the Allies, however, German troops swept in, rolling back the Allied advance. On September 15, 1943, Hitler's forces rescued Mussolini from captivity, and he began to exercise authority once again in German-occupied areas of the country. Jews and members of the Italian resistance, among them some of Italy's artists and architects, were rounded up and sent to concentration and death camps. Renato Guttoso, member of the antifascist Corrente artists' group, was among those who produced images documenting Nazi atrocity on Italian soil. In 1944, some of his drawings were published in a portfolio under the mocking title—in German—*Gott mit Uns* (God with Us). Allied forces eventually defeated the German divisions in Italy and forced them to capitulate in May 1945. Mussolini, who attempted to flee to Switzerland, was captured by the antifascist resistance and executed on April 28, 1945.

In the aftermath of World War II, Italian artists and architects continued to work in a variety of different styles. Most, however, avoided overtly nationalist themes and the classical monumentality that had become so intimately associated with Mussolini's Fascist Empire. The Venice Biennale of 1948, which

took place during the beginnings of the Cold War, claimed to restore Italy's ties to the European modernist art scene, suggesting that the country had been denied modernist art and architecture under fascist rule. As the examples of futurist Aeropittura and rationalist architecture demonstrate, however, Mussolini, far from suppressing modernist work, had, on the contrary, allowed it to flourish. Though some artists, such as Renato Guttoso and Giacomo Manzù, aligned themselves with the antifascist resistance, many more eagerly embraced Mussolini's support and produced works that celebrated the regime's history and achievements. Though often associated with a freedom of expression antithetical to dictatorial control, modernist art and architecture proved as well suited as any other style to the project of building Italy's fascist culture of consensus during the World War II years.

Italian Artist Biographies

Giorgio de Chirico (1888–1978)

Giorgio de Chirico was born in 1888 in Vólos, Greece, to ethnic Italian parents. From 1903 to 1905, he studied at the Higher School of Fine Arts in Athens where he learned to draw and paint. In 1906, he enrolled at the Akademie der bildenden Künste (Academy of Fine Arts) in Munich, Germany. In March 1910, he rejoined his mother and brother in Milan, Italy. De Chirico's first important work *Enigma of an Autumn Afternoon,* was painted in 1909–1910. Unlike his futurist contemporaries who scornfully rejected Italy's cultural and historical past, de Chirico filled his canvasses over the next decades with images that presented a sustained—and unsettling—meditation on Italy's past and present, its classical heritage and the pressures of a modernizing world.

In *Enigma of an Autumn Afternoon,* a male and female couple dressed in classical tunics walk across an otherwise deserted piazza located next to the open sea and bounded by a Roman temple façade. At the center of the piazza stands a sculpted human form, now missing its head and arms, placed on a high pedestal. As the couple moves across the square, the woman steadies herself, her right arm wrapped around the shoulders of her companion and her grieving face buried in her left hand. A ship's sail begins to collapse on the horizon. Cast shadows suggest the approach of twilight. Combined with the piazza's sculpted monument now in fragments and a nostalgic orange glow that bathes the all-but-abandoned square, such imagery evokes a feeling of loss and melancholy. De Chirico's spare, almost abstract handling of the piazza's architectural geometries lend the setting a static and strangely modern feel, despite the antique style of the structures, sculpture, and figures within it. In these and other works during this period, de Chirico juxtaposed a sense of time passing and time frozen, of imperial grandeur and its disappearance, that provided a brooding and contemplative contrast to the brash dynamism of contemporary futurist art.

De Chirico's fame in the international art scene began to grow while he was in Paris between 1911 and 1915. He exhibited and sold some of his canvasses in Paris's prestigious Salon d'Automne (Autumn Salon) during this period. De Chirico also befriended the influential poet and critic Guillaume Apollinaire who, in a 1913 review, was the first to use the term "metaphysical" in relation to de Chirico's uncanny and mysterious imagery. Apollinaire also introduced him to the Parisian avant-garde, including Pablo Picasso and André Derain, who became admirers of de Chirico's work.

When Italy entered World War I in 1915, de Chirico was called up for service in the Italian army. He fulfilled his military duty in Ferrara, Italy, where he continued to paint. The reality of war prompted de Chirico and many others of his generation to question the impact of technological progress and modernity on contemporary life. In one work titled *Disquieting Muses* of 1917, he registered his skepticism about the modern world in a composition featuring three dressmakers' mannequins who appear as stand-ins for human beings. Isolated from one another, the mannequins occupy a steeply receding wooden platform. Illuminated by a melancholy orange light, de Chirico's *Disquieting Muses* suggest the sterility and alienation of a modern world in which the artificial and mass-manufactured begins to replace the authentic and the human in everyday experience. De Chirico made contact during the war years with the anarchist, antiwar Dada movement based in Switzerland and contributed to their Dada journal. Suffering from a nervous condition, he was admitted to a military hospital in 1917, where he met Carlo Carrà for the first time. The two soon became collaborators in the development of the Pittura Metafisica (metaphysical painting) movement.

At the end of the war, in May 1918, de Chirico and Carrà exhibited their Pittura Metafisica together in Rome. Nine months later, de Chirico had his first solo exhibit at Rome's Galleria Bragaglia. He also began to contribute to *Valori Plastici* (Plastic Values), a journal that disseminated Pittura Metafisica to an international audience. His work achieved special fame during the postwar "return to order" in the Italian art world. His long-standing interest in memory and history of the Italian cultural past made him an early exponent of the avant-garde's resurgent interest in classical tradition.

In 1924, de Chirico returned to Paris, where he and his work were celebrated by the surrealist movement founded by André Breton that same year. Devoted to the writings of Sigmund Freud, the surrealists used their art to explore dreams and the workings of the inner psyche. Breton was among those who regarded the enigmatic, dreamlike juxtapositions of de Chirico's work as revelatory of the unconscious mind. Though de Chirico's connection to the surrealists was limited, he contributed an account of a dream to the first issue of the group's newly launched journal, *La Révolution Surréaliste* (The Surrealist Revolution), in 1924. De Chirico traveled back and forth between Rome and Paris over the next few years.

By the late 1920s, de Chirico's work became more invested in themes of mythology, the classical past, and portrayals of the human figure. In *Gladia-*

tors of 1928–1929, he featured the legendary trained fighters of ancient Rome equipped with their helmets, shields, and lances. True to his enduring interest in the strange and incongruous, de Chirico portrays the fighters not sparring with one another in an arena, but, rather, inexplicably—and uncomfortably—packed together in a small, claustrophobic room.

In 1933, de Chirico contributed a mural to the controversial Milan Triennale. Organized by Mario Sironi, leader of the 1920s Novecento movement, the Triennale showcased Sironi's attempt to foster a genuinely fascist art rooted in the rediscovery of the classical world. He invited de Chirico, Gino Severini, Carlo Carrà, Corrado Cagli, Enrico Prampolini, and Fortunato Depero, along with several other artists representing a variety of schools of art, to contribute murals to the display. De Chirico's, titled *Italian Culture,* featured a large white horse and a depiction of the Roman Colosseum. Critics attacked the show for the cacophony of styles and subject matters addressed by the invited artists, only some of whom addressed themes relating to the fascist revolution. De Chirico's mural was among those destroyed when the exhibit was over.

In the mid-1930s, de Chirico began to produce his *Mysterious Bathers* series, a dozen or more paintings that he regarded among the most important of his career. Rooted in his childhood memories of public baths in Greece, the series portrays male bathers in enigmatic settings. In one work, titled *Visit to the Mysterious Baths* of 1935, de Chirico depicts nude men sporting the tightly curled hairstyle and idealized torsos of classical antiquity. They wade in artificial channels of water carved into an arid landscape and interspersed with elevated dressing cabins. Occupying the banks of the channels are two men, one seated and one standing, dressed in the suits, ties, and heavy shoes of contemporary fashion, whose hair and facial features mirror those of their nude counterparts. The clothed and unclothed figures also share blank, expressionless faces that suggest nothing of their relationship to one another. The figures, moreover, sit and move like automatons or sleepwalkers, enhancing the overall dreamlike quality of de Chirico's mysterious image.

Several of the *Mysterious Bathers* paintings were unveiled to the public at the Rome Quadriennale exhibit of 1935. They were also exhibited in New York during de Chirico's extended stay there between 1935 and 1938. De Chirico enjoyed several well-received displays of his art in the United States. American critics reserved special praise for his works devoted to classical subject matter.

De Chirico returned to Italy in 1938 just as the fascist regime began to impose its anti-Semitic policies. He became fearful for his Jewish wife, Isabella Pakszwer Far. He also found himself under increasing attack by reactionary critics who denounced his enigmatic imagery as "Jewish," "Bolshevik," and "degenerate." De Chirico and his wife arranged to spend extended periods of time in Paris. He nonetheless continued to receive public commissions in Italy and to exhibit his work there. Many of his paintings during this period avoided the mysterious quality of his earlier imagery. De Chirico instead began to devote his art to depictions of horsemen in landscapes and portrait commissions. One commission was for a likeness of Mussolini's daughter, which he produced in 1942.

In the postwar years, de Chirico's prominence in the Italian art world waned dramatically. He took to copying motifs and compositions from his earlier works and became outspoken in his hostility to the latest developments in modern art. He continued, however, to work in the areas of theater design, illustration, lithography, and sculpture throughout the rest of his career. In the late 1960s, he produced bronze sculptures based on figures from his paintings. Giorgio de Chirico died in Rome in 1978.

Adalberto Libera (1903–1963)

Adalberto Libera was born in 1903 in Villa Lagarina, Upper Adige. With the outbreak of World War I, he and his family moved to Parma, where he received his degree in architecture. In 1926, he became active in Gruppo 7 (Group 7), a circle of young architects based in Milan. Gruppo 7's manifesto of 1926 founded the Italian rationalist movement in architecture.

In 1927, Libera, along with other practitioners of rationalism, participated in the Weissenhof Settlement Exhibition in Stuttgart, Germany. The Weissenhof exhibit, sponsored by the German Werkbund and organized by Ludwig Mies van der Rohe, brought together architects from around the world to demonstrate the latest in architectural design. Contributors produced proposals for apartment complexes, houses, and other structures, all featuring a similar vocabulary of flat roofs, unornamented façades, and modern construction techniques based on the use of steel, glass, and concrete. Libera presented a project for a hotel in the mountains. Given the strong aesthetic similarity between the structures, despite the different national origins of their architects, the style of building on display at Weissenhof heralded the birth of what came to be known as the International Style of modern architectural design.

In 1928, Libera set up architectural practice in Rome, where he also helped to establish the Movimento dell'Architettura Razionale (Movement of Rationalist Architecture, or MAR). In that same year and with the help of Gaetano Minnucci, he organized the First Exhibition of Rationalist Architecture in Rome. In 1930, Libera also served as secretary general of the Movimento Italiano per l'Architettura Razionale (Italian Movement for Rationalist Architecture, or MIAR). He organized the Second Italian Exhibition of Rationalist Architecture, held at Pier Maria Bardi's Gallery in Rome and inaugurated on opening day by Mussolini. The goal of the display was to present rationalism as the best architectural style for the fascist regime. It exhorted Mussolini for greater support while castigating the achievements of rationalism's traditionalist adversaries. Libera circulated a statement on behalf of MIAR that defended its aggressive strategy on the following grounds:

> This Exposition is not an end in itself, but rather the occasion for MIAR to take decisive action. We cannot continue with a pacific and purely defensive response. In that case too many years would separate us from a certain victory. The moment

has come to explain our reasoning without regard to people or interests and to say a great truth openly: If the renewal of Italy is taking place in the political-economic-social field through the Fascist Revolution, little renewal is occurring in art and nothing in architecture. We Rationalist architects, as Italians and as Fascists, cannot and must not permit the architecture which has only the decaying aspects, the cadaverous forms, be passed off as Fascist architecture.[3]

The show included a "Panel of Horrors," featuring caricatures of traditional architecture produced by some of the best-known Italian architects of the period. MIAR's polemical posture resulted in angry responses from conservatives who condemned the rationalists as negatively "internationalist," "un-Italian," and beholden to pernicious "Bolshevik" interests.

Mussolini's support for the rationalists, despite the controversy engendered by their MIAR exhibit, was evident in the selection of Libera and Mario de Renzi to design the temporary façade for the Mostra della Rivoluzione Fascista (Exhibition of the Fascist Revolution) held in 1932. Celebrating the 10-year anniversary of Mussolini's March on Rome, the exhibit was the largest official display organized by the regime to date. The fascist government saturated the country with posters and advertisements and provided transportation for ordinary citizens to attend the show. Records document some 4 million visitors to the Exhibition of the Fascist Revolution over the course of its two-year run. Libera and de Renzi's façade consisted of a red cube buttressed by four giant symbolic fasces clad in sheet metal. Libera also collaborated with the theater designer Valente on a shrine to the "martyrs" of the fascist revolution, which served as the culminating room of the exhibition. Circular in plan, the shrine was ringed by black banners bearing the names of those who had died for the fascist cause. In the center of the circular space appeared a giant metal cross. Libera and Valente's use of Christian imagery symbolically recast the fascist state in the guise of the sacred and divine.

In 1934, Libera participated in the Palazzo del Littorio competition for the creation of a National Fascist Party headquarters in Rome. He increased the scale of his martyrs' shrine for the 1932 Exhibition of the Fascist Revolution and incorporated it into his plan for the Palazzo del Littorio complex. His proposed structure consisted of a huge office block, arranged in a gigantic arc that pointedly echoed the façade of the Roman Colosseum nearby. Libera's plan also included a freestanding vertical building designed in the form of the fasces to occupy the plaza in front of the office block and martyr's shrine. The structure was intended to provide a towering podium from which the Duce would be able to address the assembled masses.

Libera's was one of the few buildings to be realized for the colossal 1942 Universal Exposition of Rome (EUR). He designed the Palazzo dei Ricevimenti e Congressi (Palace of Reception and Congress) in accordance with the synthesis of modernist and traditional styles of architecture that defined the plans for the world's fair overall. Libera's structure consisted of a compact, symmetrically organized floor plan housing an auditorium inside and an open-air theater on

Adalberto Libera, Palazzo dei Ricevimenti e Congressi. © Scala/Art Resource, NY.

the roof. Located at the center of the building was a cubic reception hall covered by a sleek, cross-vaulted dome of bowed sheet metal. For the rear façade, Libera used a modernist curtain-wall of glass. For the front, however, he incorporated regularly spaced, load-bearing granite columns. True to the style of "stripped classicism" characteristic of the EUR complex overall, Libera eliminated the traditional capitals and ornament from his Palazzo columns.

Libera also designed the "rainbow arch of peace" that became the most widely advertised emblem of the EUR. A single tapered semicircle of unreinforced concrete soaring 50 meters into the sky, the arch's graceful span was to crown one of the main access routes to the fair. Though never built, Libera's rainbow arch was prominently featured on posters and other promotional materials for the fair. When Eero Saarinen proposed a similar arch for the 1954 "Gateway to the West" competition in St. Louis, Missouri, Libera threatened the Finnish American architect with a lawsuit for appropriating his design. The arch was eventually constructed, however, and stands today in St. Louis as a proud symbol of the city.

After World War II, Libera spent three years of self-imposed isolation in northern Italy. In 1947, he resumed architectural practice in Rome. Most of Libera's postwar projects were in the area of housing. After Rome was chosen to host the Olympic Games, Libera joined a team of architects designing the Olympic Village in 1959–1960. From 1953 to 1962, he taught as a professor of architecture at the University of Rome. Adalberto Libera died in Rome in 1963.

Mario Sironi (1885–1961)

In 1885, Mario Sironi was born in Sassari, Sardinia. His family moved in 1886 to Rome, where he was brought up. In 1903, he enrolled in the Accademia di Belle Arti (Academy of Fine Arts) in Rome. There he met artists Gino Severini, Umberto Boccioni, and Giacomo Balla, who later formed the core of Filippo Tomasso Marinetti's futurist movement. In 1906, Sironi spent time in Paris with Boccioni and made trips to Germany where he saw works by the German expressionists. From his early years, Sironi, like many of the Italian futurists, was drawn to left-wing circles, including those that espoused Marxist and anticapitalist views. Accepted by Marinetti as one of the futurist group in 1915, Sironi began to experiment with futurist approaches to painting, took part in their performances, and showed his work in futurist exhibits.

When Italy declared war on Austria in 1915, Sironi enlisted along with several other futurists in the Lombard Battalion of Volunteer Cyclists for the purpose of doing military reconnaissance work. He later trained in the Corps of Photoelectrical Engineers and was made an officer in 1917.

As the revolutionary agendas of the futurists and the fascists began to merge in the immediate postwar years, Sironi found himself drawn toward Mussolini's political movement. Sironi's style and sensibility began to diverge, however, from that of the futurists. Joining the call for a "return to order" in the Italian art world, he rejected the futurists' use of facetted color planes and celebration of urban modernity. Employing more traditional pictorial strategies of spatial coherence and figural solidity, Sironi's work turned instead to the negative side of city life and the continuing oppression of the working class. In images such as *Urban Landscape with a Truck* from 1920, he depicts a desolate urban periphery populated by tenements and factories. Sironi's use of somber brown and black hues in the work underscores the miserable plight of the workers condemned to live there. In 1921, Margherita Sarfatti arranged for Sironi to become the lead caricaturist for Mussolini's newspaper, *Il Popolo d'Italia*. After the Duce's accession to power, the newspaper became the regime's official publication. Sironi served as *Il Popolo d'Italia*'s illustrator until 1943.

Sironi joined Sarfatti's Novecento group at its founding exhibit in 1922 and soon became the movement's leading artist. He developed a number of images of artists and intellectuals, which were featured in Novecento exhibitions well into the 1930s. Drawing on traditions of Italian Renaissance portraiture, Sironi's portrayals served as a visual manifesto of Sarfatti's ideas regarding the leadership role of artists and intellectuals in the reform of Italian society.

By the late 1920s, however, Sironi's views on art began to diverge from those of Sarfatti. Breaking free of the emphasis on naturalistic classicism that had become associated with the Novecento style, Sironi began to incorporate into his art a loose brushwork derived from his studies of German expressionism. His treatment of form also became deliberately crude and unpolished. In works such as *Man With a Spade* from 1928, which was purchased by the government Confederazione dell'Agricultura (Confederation of Agriculture) in Rome, Sironi

also looked to the precedent of Etruscan art, the mosaics of Ravenna, Masaccio, and Italian Duecento and Trecento painters as sources of inspiration. In a brooding, dark palette, Sironi developed images of workers, often rendered seminude and attired in simple loincloths, that blurred their historical specificity, as well as their class identity. Sironi came under attack from conservative critics who regarded his style as "un-Italian" and too beholden to foreign, especially German, influence. For others, his images of workers accorded well with fascist ideology by promoting the myth of a classless society under Mussolini's dictatorial rule.

Sironi's propagandistic usefulness was recognized by Mussolini himself, who put him in charge of a series of official press exhibitions. These exhibits performed a dual role of acknowledging the importance of mass media to the fascist regime, while also showing to the world Italy's achievements in photography, journalism, film, radio, and advertising. With architect Giovanni Muzio, Sironi created pavilion installations for the Italian press exhibits in Cologne, Germany (1928); Barcelona, Spain (1929); and Monza, Italy (1930). As an indication of his growing stature in the Italian fascist art world, Sironi was one of 16 artists honored with a retrospective of his work at the First Rome Quadriennale held in 1931.

In 1932, Sironi was a key organizer of the Mostra della Rivoluzione Fascista (Exhibition of the Fascist Revolution), an extravagant display for the commemoration of the tenth anniversary of Mussolini's March on Rome. The exhibit involved the participation of some 20 artists and architects, mostly from the Novecento, futurist, and rationalist stylistic camps. Combining architecture, sculpture, and photographs in dizzying, montagelike displays, the Exhibition of the Fascist Revolution charted the origin, violent struggles, and triumph of the fascist regime. An estimated 4 million people visited the show over the course of its two-year run. Sironi, who designed several of the rooms, heralded the integration of arts and architecture at the Mostra della Rivoluzione Fascista as an example of fascist modernism.

In the early 1930s, Sironi gave up easel painting, which he now regarded as elitist and out of touch with the masses. He turned instead to producing large-scale murals. In his "Manifesto of Mural Painting," published in Alberto Savinio's journal, La colonna in December 1933, he described mural art as a genuinely public art rooted in Italian tradition. Unlike easel paintings, which were enjoyed principally by those wealthy enough to buy them, murals were meant for public space and had the capacity to communicate to the masses. From their connection to the people, murals, Sironi maintained, could best express the ideals of the fascist revolution: "From mural painting will arise the 'Fascist style,' " he wrote in his manifesto, "with which the new civilization will be able to identify."[4]

In 1933, Sironi tested his ideas about muralism and fascism at the Milan Triennale. As organizer, he invited contributions by several leading artists, including Giorgio de Chirico, Gino Severini, and Carlo Carrà from various camps including the Pittura Metafisica, Novecento, and futurist movements. Sironi refrained from specifying any particular style or subject matter, in the (erroneous) belief that a coherent fascist art would arise spontaneously from their ef-

forts. Critics condemned the exhibit for its resulting disunity and the failure of many of the artists to address themes relating to fascist revolution. The Milan Triennale murals, including Sironi's *Labors and Days,* were destroyed after the closing of the exhibit.

Sironi came under increasing attack from Roberto Farinacci and other critics who condemned his work for its modernist experimentalism. After 1933, Sironi withdrew from public debate and declined to show his work in state or commercial galleries. He continued to undertake public commissions, however, and produced work in the media of relief sculpture, murals, mosaic, and stained glass.

In 1937, Sironi created a large-scale mosaic titled *Fascist Work* as the centerpiece of the Hall of Honor for the Italian pavilion at the Paris World's Fair. Working in his controversial style of figural distortion derived from archaic Italian art and German expressionism, Sironi produced a work that served as unabashed propaganda for the Italian fascist regime. In the wake of Mussolini's Declaration of Empire in 1936, Sironi's *Fascist Work* featured a large-scale female personification of Italy at the center of the composition. Surrounding Italy appeared smaller images of work, study, and family as well as symbols of the Roman Empire, including the Roman eagle and a classical column. Below the figure of Italy, Sironi rendered Mussolini in the guise of a worker with his sleek, bald head surrounded by a halo of divine light.

After World War II, Sironi retreated from public view under criticism for his prominent role in the fascist regime. He returned to easel painting and produced a large body of work, most of which was devoted to portrayals of the human figure and urban scenes. Retrospectives of his art were staged in 1962 and 1973. Mario Sironi died in 1961 in Milan.

Giuseppe Terragni (1904–1943)

Giuseppe Terragni was born in Meda, near Milan, in 1904. In 1917 he enrolled in the Istituto Tecnico (Technical Institute) in Como, where he studied physics and mathematics. After graduation in 1921, he attended the Scuola Superiore di Architettura (Superior School of Architecture) in Milan. During his years of study, Terragni developed interests in painting, architecture, and architectural theory. In 1926, he began to publish articles on the state of contemporary architecture. In that same year he became a founding member of Gruppo 7 (Group 7), the first organized association of the Italian rationalist movement in architecture. Terragni was generally recognized as the leader of Gruppo 7, which included Luigi Figini, Gino Pollini, Sebastiano Larco, Ubaldo Castagnoli, Guido Frette, and Carlo Enrico Rava. Other young, avant-garde architects subsequently joined the association, including Adalberto Libera.

In 1927, Terragni established an architectural practice in Como, where he executed several important and groundbreaking projects. With the engineering assistance of his brother Attilio, he designed a large apartment block called No-

vocomum overlooking Lake Como. Novocomum consisted of reinforced concrete, large expanses of glass, and boldly cantilevered floors that extended out from the façade wall and appeared to hover weightlessly in midair. Terragni also painted the unornamented exterior of Novocomum in bright hues of orange, red, green, yellow, and blue. The local citizenry denounced the structure for its failure to harmonize with the more traditional architecture of its immediate surroundings. Some, claiming that the building looked more like an ocean liner than a place of human habitation, reacted strongly—and negatively—to Novocomum's industrial, machine-inspired aesthetic. Construction on the project was halted several times before Augusto Turati, Secretary of the National Fascist Party (PNF), intervened on Terragni's behalf.

Terragni exhibited his Novocomum project in 1931 at the Second Italian Exposition of Rationalist Architecture organized by the Movimento Italiano per l'Architettura Razionale (Italian Movement for Rationalist Architecture, or MIAR) held in Rome. Rationalist architects used the exhibit to castigate the work of more traditional architects and to establish their bid for rationalism as the state architectural style. Terragni's Novocomum quickly became an icon of the rationalist movement. It was featured prominently in newspaper reports on the controversy that resulted from the show's polemical agenda.

Along with Enrico Arrigotti, Terragni designed the room devoted to the fascist struggles of the year 1922 at the spectacular Exhibition of the Fascist Revolution staged in 1932. Terragni was also commissioned in 1932 to design the Casa del Fascio (House of Fascism) for the provincial headquarters of the PNF in Como.[5] The resulting structure is now regarded as one of the most important examples of symbolic architecture produced under the fascist regime. Terragni's bold, modernist design consisted of a perfectly square ground plan. With façades twice as long as the height of the structure, exterior walls of the Casa del Fascio were given over almost exclusively to glass. Combined with glass walls enclosing PNF offices on the interior of the building, Terragni's emphasis on structural transparency allowed for unimpeded visual access between the masses assembled outside the Casa del Fascio and PNF representatives working inside. The symbolism of the Casa del Fascio design gave visual expression to Mussolini's fascist ideology. The Duce famously described fascism as a "house of glass," with an unmediated and transparent relationship between the leadership and the public it claimed to serve.

In 1934, Terragni, working in collaboration with the Milanese Group, entered the national competition for the design of the Palazzo del Littorio in Rome, a complex intended to function as the PNF headquarters. In addition to Terragni, the Milanese Group included architects Antonio Carminati, Pietro Lingeri, Luigi Vietti, engineer Ernesto Saliva, and painters Marcello Nizzoli and Mario Sironi. The group submitted two plans to the competition, prompted by the emerging struggle between modernist and traditional architects as they vied with one another to define the new building style of the fascist regime. The first plan, Project A, adapted rationalism to the demands of traditional, monumental architecture. Project B, by contrast, comprised an emphatically modernist design of

glass and steel. Terragni explained the Milanese Group's strategy in submitting the two designs:

> The idea was to emphasize with one project [Project A] the primary characteristics of *a contextual response interpreted intelligently in a modern way*, thereby leaving it to the other project [Project B] the task of establishing the highest degree of modernity possible through the union of our energies and our ideas [emphasis in the original].[6]

The Milanese Group's Project A forecast the synthesis of the modern and monumental, rationalism and tradition that defined the evolution of fascist imperial architecture in the final years of the regime. It consisted of a large, curved, windowless façade designed to harmonize with—and form a "contextual response" to—the façades of the Colosseum and the Basilica of Maxentius located nearby. The façade was to be covered not with glass and concrete, but rather with panels of red porphyry, the stone associated with Roman emperors in the imperial past. A single opening, located high above ground level at the center of the vast, curved façade, was to be reserved for a balcony. The design of the structure as a whole concentrated attention on the balcony, which was intended for the Duce and his ceremonial addresses to the assembled masses. The Milanese Group was awarded prizes for their submissions, but neither of their projects was adopted, in the end, for construction of the Palazzo del Littorio.

In the mid-1930s, Terragni completed several apartment houses in Milan in collaboration with architect Pietro Lingeri. In 1938, Terragni and Lingeri received a commission to create a structure in Rome devoted to the revered Italian poet and author of *The Divine Comedy,* Dante Alighieri (1265–1321). Approved by Mussolini, the commission came from Rino Valdameri, a Milanese lawyer and director of the Accademia di Belle Arti di Brera (the Brera Academy of Fine Arts) in Milan. Fascist cultural authorities envisioned the Danteum as part of the larger preparations underway for the spectacular celebration of Italian civilization that was to unfold at the world's fair of 1942, known as the Esposizioni Universale di Roma (EUR). The structure was to be located on the site originally intended for the Palazzo del Littorio in the heart of Rome.

The Danteum was to include a study center. It also featured a symbolic use of architectural form designed to initiate visitors into the spiritual journey and transformation described by Dante in his *Divine Comedy.* Dividing the structure into three sections corresponding to the three parts of Dante's text—the Inferno, Purgatory, and Paradise—Terragni and Lingeri arranged the rooms of the Danteum in a spiraling, ascending order. Emerging from darkened and compressed spaces of the "Inferno" below, visitors were to ascend through rooms that became progressively lighter and more open. Through the manipulation of light and space, Terragni and Lingeri created a ritual reenactment of the *Divine Comedy's* story of gradual spiritual enlightenment. The Danteum also took on explicitly propagandistic meaning as commentators linked the structure's theme of spiritual salvation and transcendence to Dante's prophesy of the return of

empire to Rome, now fulfilled under Mussolini. Entering the Danteum's realm of "Paradise" was thus likened to Italy's attainment of salvation under the Duce's dictatorial rule.

In 1940, Terragni also received a commission to design a Casa del Fascio for the city of Rome. Neither the Danteum nor the Rome Casa del Fascio came to fruition, however. With Italy's entry into World War II in 1940, Terragni was called up for military service in the Balkans. In July 1941, he was sent to the Russian front as an artillery captain. After the Battle of Stalingrad in 1942, he experienced a nervous breakdown and was returned to Italy in January 1943 for hospitalization in Pavia. Terragni died in Pavia in 1943, apparently having committed suicide.

Notes

1. Benito Mussolini, speech at the opening of the Sette Pittori del Novecento exhibit (26 March 1923). Cited in Emily Braun, *Mario Sironi and Italian Modernism: Art and Politics under Fascism* (Cambridge: Cambridge University Press, 2000), 1.

2. Benito Mussolini, speech (5 October 1926). Cited in Jeffrey T. Schnapp, "Epic Demonstrations: Fascist Modernity and the 1932 Exhibition of the Fascist Revolution," in *Fascism, Aesthetics, and Culture,* ed. Richard J. Golsan, 1 (Hanover, NH: University Press of New England, 1992).

3. "Communicato MIAR, nr. 4," (26 January 1931). Cited in Richard Etlin, *Modernism in Italian Architecture, 1890–1940* (Cambridge, MA: MIT Press, 1991), 385.

4. Mario Sironi, "Manifesto of Mural Painting," (December 1933), in *Art in Theory, 1900–1990: An Anthology of Changing Ideas,* ed. Charles Harrison and Paul Wood, 407–9 (Oxford: Blackwell, 1992).

5. See illustration of Guiseppe Terragni's *Casa del Fascio* in Richard Etlin, *Modernism in Italian Architecture,* 1890-1940 (Cambridge: MIT Press, 1991), page 444, plate 243.

6. Giuseppi Terragni to the Milanese Group (25 October 1934). Cited in Richard Etlin, *Modernism in Italian Architecture, 1890–1940* (Cambridge, MA: MIT Press, 1991), 432.

Bibliography

Affron, Matthew, and Mark Antliff, eds. *Fascist Visions: Art and Ideology in France and Italy.* Princeton, NJ: Princeton University Press, 1997.

Apollonio, Umbro, ed. *Futurist Manifestos.* Boston, MA: MFA Publications, 2001.

Berghaus, Günter. *Futurism and Politics: Between Anarchist Rebellion and Fascist Reaction, 1909–1944.* Providence, RI: Berghahn Books, 1996.

Braun, Emily, ed. *Italian Art in the 20th Century: Painting and Sculpture, 1900–1988.* Exhibition catalogue. London: Royal Academy of Arts, 1989.

———. "Political Rhetoric and Poetic Irony: The Uses of Classicism in the Art of Fascist Italy." In *On Classic Ground: Picasso, Léger, de Chirico and the New Classicism,*

1910–1930, edited by Elizabeth Cowling and Jennifer Mundy, 345–58. Exhibition catalogue. London: The Tate Gallery, 1990.

———. *Mario Sironi and Italian Modernism: Art and Politics under Fascism.* Cambridge: Cambridge University Press, 2000.

de Grazia, Victoria. *The Culture of Consent: Mass Organization and Leisure in Fascist Italy.* Cambridge: Cambridge University Press, 1981.

Doordan, Dennis P. *Building Modern Italy: Italian Architecture, 1914–1936.* New York: Princeton Architectural Press, 1988.

———. "Political Things: Design in Fascist Italy." In *Designing Modernity: The Arts of Reform and Persuasion, 1885–1945,* edited by Wendy Kaplan. Exhibition catalogue. New York: Thames and Hudson, 1995.

Etlin, Richard A. *Modernism in Italian Architecture, 1890–1940.* Cambridge, MA: MIT Press, 1991.

Ghirardo, Diane. "Italian Architects and Fascist Politics: An Evaluation of the Rationalists' Role in Regime Building." *Journal of the Society of Architectural Historians* 39 (May 1986): 109–27.

Kostof, Spiro. "The Emperor and the Duce: The Planning of Piazzale Augusto Imperatore in Rome." In *Art and Architecture in the Service of Politics,* edited by Henry A. Millon and Linda Nochlin, 270–325. Cambridge, MA: The MIT Press, 1978.

Schnapp, Jeffrey T. "Epic Demonstrations: Fascist Modernity and the 1932 Exhibition of the Fascist Revolution." In *Fascism, Aesthetics, and Culture,* edited by Richard J. Golsan, 1–37, 244–53. Hanover, NH: University Press of New England, 1992.

Stone, Marla Susan. *The Patron State: Culture and Politics in Fascist Italy.* Princeton, NJ: Princeton University Press, 1998.

CHAPTER 6

Artists in Japan: Relating Tradition and Modernity to the Art of "Holy War"

Though Japan was a major combatant in World War II, the facts concerning its artistic culture during those years remained hidden away for decades in the traumatic aftermath of the country's military defeat. We now know, however, that Japanese government and military authorities sponsored an extensive war art program to which hundreds of artists contributed in the 1930s and 1940s. Dozens of paintings from this program were confiscated by the American military after the war and stored in Washington, D.C. until they were returned in 1970 to the National Museum of Modern Art in Tokyo. Beginning in the 1990s, some of these images made their way into public exhibitions for the first time since 1945. Scholars are conducting research into how these works were produced, the lives of the artists who were responsible for creating them, and what role the government envisioned for war art in shaping public perception of Japan's Holy War.

Virulent nationalism and government repression of dissent defined Japanese society during the World War II years. Unlike Germany during the same period, however, Japan imposed stringent control over the arts only in the later years of the conflict. In 1943, authorities compelled Japanese artists for the first time to join a centralized, government-regulated art agency and took charge of exhibits and the rationing of art supplies. Even then, the kind of imagery allowed by the Japanese government, which included unidealized portrayals of combat, starkly diverged from the sorts of heroic pictures regularly on offer in German and Soviet war art exhibitions of the 1940s.

Until 1943, a thriving system of private patronage contributed to a vibrant and relatively pluralistic range of artistic production in Japan. Nonetheless, as the government and military became important sources of patronage and support for art in the 1930s and 1940s, Japanese artists felt increasing pressure to

demonstrate the relevance of their work to the war effort. Heated debates ensued as government officials, artists, and critics questioned what style of art was best suited to the task, an issue complicated by the fact that Japanese traditions of art had long since become intertwined with Western styles. Such debates brought to the surface long simmering questions about the nature of Japanese culture and society in a modernizing world dominated by Western values.

Japan and Its Art World before World War II

The influx of Western art and culture into Japan began in the mid-nineteenth century. In the 1850s, Japan was forced to abandon its feudal isolation by the United States, France, Russia, and other foreign powers that demanded trade access to the country's ports. The Meiji emperor, who ruled Japan from 1868 to 1912, introduced a series of reforms designed to establish Japan as a world power on equal footing with its Western rivals. The imperial government abolished the country's feudal system, established democratic political institutions, and allowed an entrepreneurial middle class to flourish. Newspapers, railways, European clothing fashions, and other Western trappings further recast daily life.

In the 1870s, the Meiji government set up educational institutions, including Tokyo University in 1877, that were staffed by foreign instructors brought in to impart Western learning, including Western artistic techniques, to Japanese students. Students were schooled in the exacting draftsmanship, use of perspective space, and precision of detail that characterized Western realist painting of the nineteenth century for the purpose of building skills in industrial design and the development of technology.

The arrival of Western culture in Japan sparked fears about the nature of Japanese national identity. Traditional styles of painting were introduced to Japan from China in the seventh century, reworked in the Japanese context, and, over the course of time, came to be regarded as genuinely Japanese. *Nihonga*, a term which means Japanese-style painting, was adopted in the 1880s, as was the term *yōga*, or Western-style painting, in the midst of growing debate over what constituted authentically Japanese art.

Nihonga works typically consisted of intimate nature studies of landscapes, animals, flowers, and sacred imagery imbued with literary, religious, and philosophical meaning. Strong tradition and timeless values prevailed over innovation and transience in *Nihonga* subject matter and its portrayal. Working in delicate washes of mineral pigments and ink on silk or paper, *Nihonga* artists attempted to capture the inner essence of the motif rather than its external appearance. Unlike the oil on canvas medium and enframed rectangular support used in much Western art, *Nihonga* generally adhered to traditional formats of screens or hanging scrolls designed specifically to complement Japanese architectural interiors.

In 1887, the Ministry of Education authorized the founding of the Tokyo School of Fine Arts for instruction in *Nihonga*. Students at the school became deeply immersed in Japanese artistic tradition, but also explored innovative approaches to *Nihonga* that incorporated spatial perspective, bright colors, and other characteristics adapted from Western art sources.

In 1894, Japan waged war with China and registered its first victory in a program of military conquest and territorial expansion that defined Japanese foreign policy through to World War II. In 1905, Japan acquired further lands in its war with Russia and became the first Asian nation to triumph over a Western power in battle. The Meiji government emerged from the Russo-Japanese war as the leading East Asian power in political, economic, and military terms.

Japan began to look to the arts during this period as an important instrument in forging its national identity at home and abroad. Emulating France, Germany, and other powerful nation-states, the Meiji government sponsored its first annual official art exhibition in Tokyo in 1907. The Ministry of Education Fine Arts Exhibition (Monbushō bijutsu tenrankai, or Bunten, as the exhibits came to be called) included separate sections devoted to *Nihonga* and *yōga*, with a third section featuring sculpture. Bunten took place annually until 1918, at which point they were placed under the direction of the Imperial Academy of Fine Art and renamed Teiten (Teikoku Bijutsu-in tenrankai, or Exhibition of the Imperial Academy of Fine Art). The exhibits were well attended and brought social prestige to the artists whose works were selected for display. At the same time, however, Bunten and their Teiten successors became associated with a restrictive officialdom (or *gadan*, meaning art establishment) against which younger avant-garde artists increasingly sought to rebel.

Japan's more liberalized political climate in the early 1920s allowed for the proliferation of vanguard art groups, exhibits, and publications independent of official sanction. Younger Japanese artists began to adapt European developments, including expressionism, Dadaism, surrealism, and constructivism, to new modes of art-making that expanded the boundaries of what was considered "art" by Japan's mainstream art world.

Such openness to new international tendencies rapidly declined, however, in the wake of the Great Kantō Earthquake of 1923. The disaster leveled the capital city of Tokyo, killing some 100,000 and injuring tens of thousands more. Rumors that communists, Koreans, and Chinese were poised to use the earthquake as a pretext to further destabilize Japanese society led to the formation of vigilante groups that murdered suspected subversives by the thousands. Military police also used the catastrophe as an opportunity to round up socialists, anarchists, and other dissidents, including several artists who had gravitated toward radical left-wing political activity. In 1925, a Police Peace Preservation Law was enacted that made it a crime to engage in protest gatherings and other forms of antigovernment behavior.

Japan's Artists in World War II

In 1926, Hirohito became Japan's emperor (and remained so until his death in 1989). His rule inaugurated the Shōwa period (1926–1989); it also solidified the ascendancy of militarist authoritarianism in Japan and the fateful erosion of its democratic political structures on the eve of World War II. As Japan began to feel the effects of the New York Stock Market crash of 1929 and worldwide Depression in the early 1930s, the Shōwa emperor sought the solution to Japan's economic turmoil in a renewed drive for territorial expansion. Hirohito and the military allied themselves with the country's conservative rural population who looked on big business, modern art, and urban culture as fruits of a Western materialism that now threatened Japan's survival as a nation.

In 1931 Japan's military provoked the so-called Manchurian Incident when Japan seized Manchuria from China and placed it under military occupation. Denounced by the international community for its actions, Japan withdrew from the League of Nations in 1933.

Following the Manchurian Incident, the Japanese government began to turn its attention to the arts as a valuable propaganda tool in rallying public support for its imperialist aims. In 1935, authorities initiated fitful attempts to centralize control of the arts. Education Minister Matsuda Genji reorganized the Imperial Academy of Fine Art and Teiten in 1935 in an effort to encourage the production and display of patriotic works. Most successful artists still operated outside the government system, however, and independent, avant-garde art groups continued to form and flourish thanks to a still viable private art market.

By 1936, Japan was one of the first nations to recover from the debilitating effects of the Great Depression, due in large measure to its escalating production of war technology and armaments. In November 1936, Hirohito signed the Anti-Comintern pact with Germany and Italy in a mutual defense agreement against the Soviet Union. Emboldened by economic recovery and the security of its international alliance, Japan began full-scale war on China. Shanghai fell to Japanese troops in July 1937, followed by China's capital, Nanjing, in December, where tens of thousands of Chinese were brutally raped, tortured, and killed.

In 1937, the Ministry of Education published a tract titled *The Cardinal Principles of the Nation,* for use in the nation's schools. The *Principles* provided a rationale for what became known as the East Asia Co-Prosperity Sphere, to be realized through Japan's military conquest of its East Asian neighbors. The tract reasserted the divinity of the emperor and the unquestioned authority of the state. The *Principles* also contained demands for the preservation of racial purity and the rejection of Western culture in Asia, including Western values of individualism, materialism, and rationalism. The publication legitimated Japan's imperialist designs as a divinely sanctioned Holy War aimed at restoring East Asia's harmony with nature, a harmony that had been undermined by generations of Western contact.

In spring 1938, Japan's prime minister, Konoe Fumimaro, enacted the State Total Mobilization Law that overturned the last vestiges of parliamentary democracy in Japan and instituted rule by imperial decree. Crackdowns on politically dissident artistic works ensued. Ishikawa Tatsuzō's antiwar novel *Living Soldiers* was banned in 1938, followed by Kamei Fumio's antiwar film *Fighting Soldiers* in 1939. Avant-garde artists, particularly those associated with the surrealist movement, were put under police surveillance, suspected of ties to communism.

In 1938, Japan signed a cultural exchange treaty with Germany. Cultural authorities staged a classical art exhibit in Berlin on the eve of Hitler's march into Poland in 1939. Hitler visited the show, which featured 125 Japanese works from the fifteenth to the eighteenth centuries. The following year, Japan signed a Tripartite Pact in which Germany and Italy recognized Japan's claim to a Greater East Asia Co-Prosperity Sphere. The cosignatories also pledged to assist one another against the imminent threat of the United States' entry into the war.

In 1939, Japan's Army Information Section founded an Army Art Association for the purpose of hiring artists to do large-scale patriotic canvasses designed to inspire public support for the war effort. Some 300 artists served in the military during this period. Many traveled to the front with combat troops. Their paintings and drawings of the war campaign appeared regularly in home front displays. Hirohito frequently previewed works from such exhibitions in his Imperial Palace, heightening media attention to the shows and contributing to their propaganda function. War art images were also widely illustrated in journals and disseminated in postcard form. In 1940, the military government extended its control over public media and the arts with the establishment of the Cabinet Information Bureau, modeled on Hitler's Propaganda Ministry in Germany.

In January 1941, Japan's leading art periodical *Mizue* (Watercolor) printed a transcript of a roundtable discussion between three military bureaucrats of the Army Information Section and two civilians, one of whom was the nationalist art historian and critic Araki Hideo. Titled "The National Defense State and the Fine Arts: What should Artists do?," the transcript captured the extent to which Japanese nationalist views on the arts had begun to mirror those of Nazi Germany. The group assailed the impact of modern, avant-garde art as the product of insane and degenerate minds in thrall to Western individualism and commercialism. Current tendencies of abstraction and surrealism in particular threatened to render art irrelevant, the roundtable warned, in Japan's current struggle. They called instead for an art supportive of Japan's war aims, easily understood by the masses of Japanese people, and rooted in the values and aspirations of the Japanese "race."

Matsumoto Shunsuke,[1] a leader in Japan's modernist avant-garde, published a rebuttal to the roundtable, which appeared in the April edition of *Mizue*. Matsumoto defended the artist's right to free, creative expression, independent of any propagandistic purpose. Such expression, he maintained, was fundamentally patriotic and essential to the health and growth of Japan as a world cultural leader.

Matsumoto's words fell on deaf ears, however, with the escalation of militarist xenophobia prompted by the U.S. embargo on oil shipments to the island country in 1941. Japan depended on imports—almost all coming from the United States—for 90 percent of its oil supply. The United States aimed to halt Japanese expansion into French Indochina, which Japan had seized when given the opportunity after France fell to Hitler's invading forces in 1940. Japan responded to the U.S. embargo with the December 7, 1941, attack on Pearl Harbor in which more than 4,500 U.S. military personnel were killed. The United States then entered the war, as Japan continued its swift and brutal march into the Philippines, Thailand, Guam, Hong Kong, Borneo, Singapore, Timor, Bali and other expanses of East Asia. Japan's war artists captured these events for home front consumption.

The experience of war raised the question of whether the nonnaturalistic pictorial flatness and delicate, calligraphic style of *Nihonga* was up to the challenge of representing modern, mechanized warfare. Artists such as Kikuchi Keigetsu and Yasuda Yukihiko avoided the problem by using *Nihonga* to appeal to Japanese artistic tradition and the country's militarist history as a source of national pride. Working in traditional screen and hanging scroll formats, they produced images of samurai warriors and other exemplary figures from Japan's past as models for wartime resolve and loyalty to the emperor and nation.

Others, such as Arai Shōri, Katsuda Tetsu, and Ezaki Kōhei,[2] were among those artists who attempted to adapt *Nihonga* to the portrayal of Japan's current war effort. Arai Shōri rode one of the fleet carriers that launched the attack on Pearl Harbor in December 1941. He produced a series of *Nihonga* paintings titled *Pearl Harbor Attack Task Force,* which were confiscated after the war and placed in the U.S. Air Force Art Collection. One work in the series portrays navy men preparing squadrons of bomber planes for liftoff. Another captures the jubilant cheers of the soldiers on ship deck as one of the planes soars into the sky. Arai adapts the fine line and mineral pigment washes typically used in *Nihonga* for describing plants and animals of the natural world to the depiction of Japan's war machine. The planes and propellers in Arai's Pearl Harbor paintings take on the fluttering delicacy of butterfly wings, strangely at odds, some critics objected, with the steely precision of advanced technological warfare.

Katsuda Tetsu and Ezaki Kōhei confronted similar problems when they attempted to depict actual combat scenes in the *Nihonga* style. Katsuda's *Divine Soldiers Descend on Menado* commemorates the bloody Malay Campaign of 1941–1942. Japanese paratroopers descend from the heavens in billowing white parachutes, undeterred by the barbed wire ground barriers set up as defense against their advance. The danger and extremity of armed combat appear far removed from the work's delicate grace and aura of spiritual calm. In his depiction of the Japanese invasion of Guam in December 1941, Ezaki Kōhei also uses *Nihonga's* flat color and fine line to portray infantrymen, who look more like insubstantial cartoon caricatures than vigorous warriors, taking up combat positions on the beach. The works of Arai, Katsuda, and Ezaki illustrate the tension between *Nihonga* and documentary illustration. More importantly, they

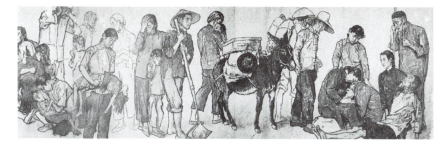

Jiang Zhaohe, *Refugees*, 1943.

André Masson, *The Resistance*, 1944. © 2005 Artists Rights Society
(ARS), New York / ADAGP, Paris.

Henri Matisse, *Cover of Jazz*, 1947. © 2005 Succession H. Matisse, Paris / Artists Rights Society (ARS), New York.

Adolf Ziegler, *The Four Elements*, 1937. © Mary Evans / Weimar Archive.

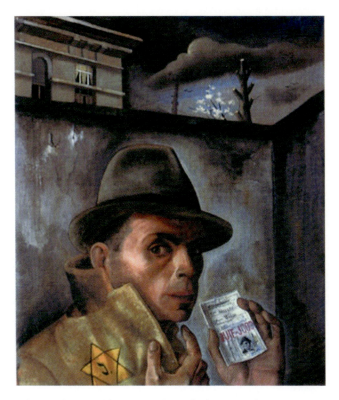

Felix Nussbaum, *Self-Portrait with Jewish Identity Card*, 1943. © 2005
Artists Rights Society (ARS), New York / VG Bild-Kunst, Bonn.

Henry Moore, *Tube Shelter Scene*, 1941. © Tate Gallery, London / Art Resource, NY.

Giorgio de Chirico, *Visit to the Mysterious Baths*, 1935. © 2005 Artists Rights Society (ARS), New York / SIAE, Rome.

Mario Sironi, *Fascist Work*, 1936. © 2005 Artists Rights Society (ARS), New York / SIAE, Rome.

Aleksandr Deineka, *The Defense of Sebastopol*, 1942. © Scala / Art Resource, NY.

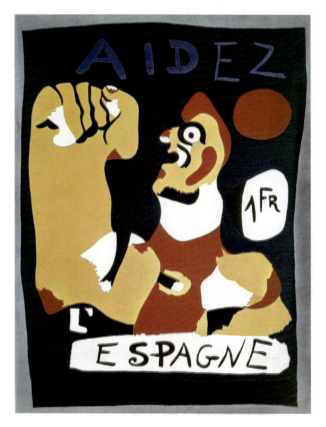

Joan Miró, *Aidez l'Espagna*, 1937. © The Image Works / Topham Picture Point.

Salvador Dalí, *Soft Construction with Boiled Beans: Premonition of Civil War*, 1936. © Philadelphia Museum of Art, Pennsylvania / Bridgeman Art Library, London / Superstock.

Thomas Hart Benton, *Score One for the Subs*, 1943. © Navy Art Collection, Naval Historical Center.

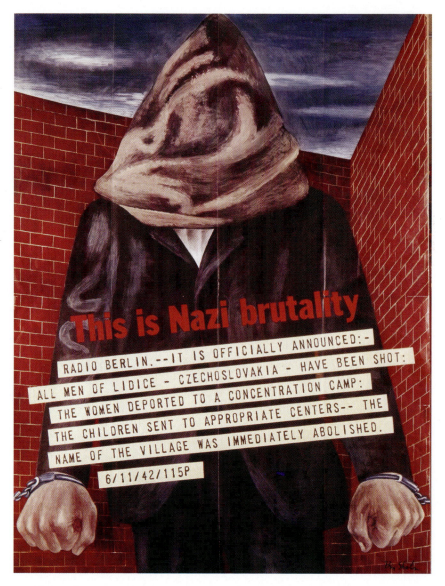

Ben Shahn, *This Is Nazi Brutality*, 1942. © Snark / Art Resource, NY.

suggest a deeper crisis as Japanese culture and tradition confronted the realities of Western modernization and technological warfare during these years.

More successful were those artists who turned to Western techniques of pictorial realism in their efforts to capture the war experience. Western realism had been introduced into Japan in the nineteenth century, not on the basis of its aesthetic value, but rather because of the technological applications of realism's exacting draftsmanship and its greater precision in capturing the "real" world. In an era when the fine arts competed with documentary film and photography in shaping public opinion, the alleged truth-value of realist painting served an important propagandistic purpose for Japanese military authorities. That purpose overshadowed any potential misgivings about realism's suspect "foreign" origins. Realist works presented the Japanese people with images that appeared to tell the truth of war. Subject to military censorship and control, however, such images highlighted only those aspects of the conflict that would sustain public support for the government's war effort.

Most acclaimed and prolific among the realist war art painters was Fujita Tsuguji. Fujita became an official war artist in 1938. He traveled to the battlefront to witness the unfolding campaign. On returning to his studio, he typically worked from combat photographs and used live models in developing his large-scale, oil on canvas portrayals of the war. Such works presented the illusion of documentary truth while providing the public with positive and uplifting images of Japan's military triumphs.

Usaburo Ihara and Miyamoto Saburō were among the many war artists who emulated Fujita's example. Usaburo painted the meeting at which Sir Mark Young, British governor of Hong Kong, signed over Hong Kong to Japanese General Taikaishi Sakai after the loss of 4,000 men in Allied efforts to defend the island. Using photographic realism, Usaburo portrays Young slumped down in a chair, exhausted and humiliated in the presence of the Japanese victors. Miyamoto similarly portrayed the *Meeting of Commanders Percival and Yamashita* (1942). Emphasizing the commanding presence of Yamashita and the squirming discomfort of a defeated Percival, the work presents the Japanese public with a triumphal view of the moment in 1942 when British forces surrendered to the Japanese in Singapore. In 1943, *Meeting of Commanders Percival and Yamashita* won the Imperial Art Academy prize.

With defeat in the battles of Midway and Guadalcanal in 1942, Japan began to suffer its first military reversals. In 1943, Japan's Ministry of Education took complete control over the art world for the first time with the establishment of the Patriotic Society of Japanese Art. Headed by the fervent nationalist and *Nihonga* artist Yokoyama Taikan, membership in the Patriotic Society was compulsory for all artists. In 1938, Taikan delivered a speech to a group of visiting Hitler Youth on the subject of "The Spirit of Japanese Art," which was broadcast in Japan and Germany and published the following year. He encouraged artists to join in the patriotic struggle for the annihilation of the United States, Britain, and other Western powers by raising funds for the war effort through sales of their work. In the wake of mass mobilization for war, the Cabinet Information

Bureau in 1944 placed all exhibition activity under control of Taikan's Patriotic Society. The Shin-Bunten (meaning "New Bunten," which the Teiten were renamed after they came under Ministry of Education control in 1937) were replaced by war art exhibitions in 1944. Art supplies were rationed and only one art magazine, *Bijutsu* (Fine Arts), also subject to government control, was allowed to remain in circulation.

Beginning in 1943, the acclaimed realist war art painter Fujita began to produce and exhibit works that presented frank images of death, destruction, and Japanese combat defeats. While some critics saw these images as deplorably negative and unpatriotic, military officials sanctioned Fujita's new paintings as important instruments for inflaming public outrage over the losses and securing their continued support for the war effort.

Other works, particularly those that heroized Japan's kamikaze pilots, encouraged patriotic identification with the bloody self-sacrifice and martyrdom of those trying to defend the nation in the closing months of the war. The term kamikaze means "divine wind" and derives from an historical legend about a typhoon that saved Japan from Mongol invasion in the thirteenth century. Kamikaze pilots were generally young recruits, brought in only towards the end of the conflict in 1944, who demonstrated their devotion to the emperor and Japan's Holy War by running suicide-bombing missions against enemy navy ships. The military government rewarded them for their service by posthumous commemoration as national deities in the state's Shintō cult of the war dead. In a painting of 1944–1945, Iwata Sentaro depicts a group of young kamikazes awaiting their orders at the airbase in Tachikawa. Iwata's young recruits wear the white cloth of the samurai around their necks in emulation of the selfless loyalty of Japan's samurai warriors of the past. They will take the samurai's ceremonial sword they wear at their side to their deaths.

Japan refused demands for unconditional surrender stipulated in the Potsdam Declaration drawn up by U.S. President Harry Truman, British Prime Minister Winston Churchill, and Soviet Premier Joseph Stalin in Potsdam, Germany, on July 26, 1945. The United States dropped two atomic bombs, the first on Hiroshima on August 6, 1945, which resulted in 90,000 immediate deaths. The second was dropped on Nagasaki three days later, killing another 50,000, with tens of thousands dying thereafter from radiation poisoning. From the time of its invasion of Manchuria in 1931 up until its brutal, mushroom-cloud defeat in 1945, Japan's war dead numbered 3 million in military troops along with an additional 500,000 of its civilians.

Amidst the rubble of war's aftermath, Japan quickly began to rebuild its arts institutions. In 1945, the Ministry of Education reorganized its annual government-sponsored exhibits and provided an important forum for debates on Japan's new postwar cultural identity. Japanese-style, *Nihonga* artists who had resisted the cultural impact of the West in their work found themselves increasingly isolated after 1945. Many in the art world began to regard *Nihonga* conservatism as complicit in militarist conformity of the World War II years. Though a frail national economy made travel to the West difficult well into

the 1960s, younger Japanese artists took advantage of traveling displays and publications in order to follow Western art trends and begin the process of reshaping Japanese culture as part of an internationalized contemporary art world.

Japanese Artist Biographies

Fujita Tsuguji (1886–1968)

Son of an army doctor, Fujita Tsuguji studied *yōga* under Kuroda Seiki at the Tokyo School of Fine Arts. Graduating in 1910, he continued his studies with Wada Eisaku, who had spent several years studying abroad in France. In 1913, Fujita went to Paris in an effort to absorb the latest lessons of the European avant-garde. He became best known during the 1920s for his paintings of female nudes that combined Western modern aesthetics with the light washes of pigments and delicate draftsmanship associated with traditional Japanese art. Fujita traveled widely throughout Europe and South America, returning to Japan in 1933. In 1936, he published a book of essays, in which he exhorted artists to assert their Japanese national identity in exhibits at home and abroad. He also founded the New Production School Association in 1936, which included many artists who eventually became government war art painters.

In 1938, Fujita traveled as an official war artist to the battlefront in central China at the behest of the Imperial Navy Information Office. The following year he helped found the Army Art Association, which sent patriotic painters to the front. The government-regulated press publicized the images and exploits of Fujita and other Army Art Association artists. Their works were also put on public display in war art exhibitions and purchased for installation in government ministries.

Renouncing French modernism's earlier influence on his art, Fujita instead turned to another form of *yōga* for his war imagery, this time the mode of realist painting. In his *Battle on the Bank of the Halha, Nomonhan* of 1941, a large-scale (140 cm by 448 cm) oil on canvas work, Fujita portrays a battle between Soviet and Japanese troops that took place in Manchuria in 1939.[3] Rendered in a realist style, the work depicts dozens of Japanese soldiers with their rifles and bayonets at the ready advancing over the steppes toward a Soviet tank. Fujita traveled to Manchuria after the engagement to see the site where the battle had taken place. He relied on combat photographs, however, for his portrayal of soldiers in action and also used the services of live models who staged mock military charges for him in the garden of his Tokyo studio. Though 50,000 Japanese troops died at Nomonhan (the Soviets lost 9,000), Fujita's work highlights not defeat, but rather the determination, perseverance, and superior numbers of the Japanese troops in their confrontation with the enemy. In 1941, the work was shown at the Second Holy War Art Exhibition sponsored by the Army Art Association.

For his painting titled *Pearl Harbor on 8 December 1941* (1941–1942), Fujita again relied on documentary photographs as the basis of his work. The image presents an aerial view of a successful bombing raid on a U.S. battleship in Pearl Harbor. The work was exhibited in the Great East Asia War Art Exhibit of 1942, when Japanese patriotic fervor was still high in the wake of the country's earlier battlefront successes. Fujita was a prolific painter who regularly and rapidly turned out patriotic war art. Government authorities honored him for his service by appointing him a life member of the Imperial Academy of Art in 1941. Numerous other artists emulated Fujita's example. Like Fujita, they produced realist *yōga* oil paintings that presented the Japanese public with reassuring records of historic events that appeared to confirm Japanese superiority and triumph in battle.

The Japanese military suffered a series of reversals in its war campaign from 1942 onward. Fujita, whose *Battle on the Bank of the Halha, Nomonhan* and *Pearl Harbor on 8 December 1941* had set the standard for positive war art imagery, now adapted his work to Japan's changing fortunes. Maintaining a realist style, he introduced innovations into his subject matter during this period that sparked critical controversy by deviating from the heroic portrayal of war characteristic of his earlier work. In *The Yasuda Unit's Desperate Struggle: The New Guinea Front* (1943), Fujita depicts the defeat of Japanese Captain Yasuda's troops in 1942 at the hands of Allied forces in New Guinea.[4] In an image that draws little distinction between victors and vanquished, Fujita graphically portrays war as a tangle of mutilated bodies, dead and dying, in a muddied landscape dotted with palm trees. Such a frank depiction of war's carnage has few parallels in German and Soviet war art of the period.

Some Japanese critics charged Fujita with lack of patriotism for his less-than-triumphal paintings. Military officials, on the other hand, appear to have supported Fujita's sobering imagery as a measure of documentary realism necessary to bolster flagging public support for the war. Such works served propagandistic efforts in the late war years by engendering popular anger and a will to persevere. Fujita's frank realism also legitimated the suicidal martyrdom of the country's kamikaze pilots as a sacred military duty in defense of the nation.

After Japan's defeat in 1945, Fujita faced condemnation for his role as a nationalist war painter and complicity in an art world system that had oppressed many artists during the war years. He eventually immigrated to France, converted to Catholicism, and devoted his work to religious imagery. Fujita Tsuguji died in 1968.

Kikuchi Keigetsu (1879–1955)

Kikuchi Keigetsu was born in 1879 the son of a village official in Nagano Prefecture. In 1892, at the age of 13, he began studying painting with Kodama Katei. In 1896, he continued his studies in Tokyo, eventually enrolling in the private studio of master painter Kikuchi Hōbun, whose daughter he married in 1906. Keigetsu gained attention in the years before World War I when several of

his works won awards at prominent exhibitions, including the Bunten. He began to emerge as a major *Nihonga* artist, known for his austere imagery, exacting use of line, and preference for historical themes.

In 1910, Keigetsu began to work as Kikuchi Hōbun's teaching assistant at the Kyoto Municipal Special School of Painting. Contact at the school with other prominent artists and exposure to courses in art history and anatomy invigorated Keigetsu's work. His art began to explore scenes of contemporary life, fairy-tale imagery, and decorative bird and flower genres.

From 1918 onwards, Keigetsu regularly served as a judge of Bunten and Teiten exhibits, thus becoming a fixture of the *gadan*, or art establishment. In 1922 and 1923, Keigetsu traveled in Europe, where he was attracted not to the contemporary art scene, but rather to Europe's fine collections of Renaissance painting and ancient Egyptian sculpture. His travels inspired him to pursue further research into Japan's past artistic traditions.

After the reform of the Teiten in 1935–1936 and the institution of the Shin-Bunten in 1937, Keigetsu began to distance himself from the official art world. His work continued to appear in private art exhibitions, however, and addressed themes appropriate to the country's nationalist sentiment. Several of his works, including *Welcoming the Imperial Carriage* from 1943, depict Japan's military heroes of the past as models for current patriotic behavior.[5]

Composed of vivid pigments on silk, *Welcoming the Imperial Carriage* adheres to the traditional *Nihonga* format of the hanging scroll. The work portrays the fourteenth-century samurai warrior Kusunoki Masashige, who had long been mythologized as a supreme example of selfless devotion to the imperial throne and the Japanese nation. Keigetsu portrays the warrior's historic meeting in 1333 with the Emperor Go-Daigo in Hyōgo.

Because of Go-Daigo's godlike divinity, Keigetsu adheres to the reverential conventions of artistic humility that prevented portrayal of the emperor's likeness. Keigetsu merely suggests the emperor's sacred presence through the inclusion of his carriage and the entourage of warriors who attend him in the far background of the composition. Similarly, few war art images from the 1930s and 1940s contain representations of Emperor Hirohito. Unlike Hitler's and Stalin's ubiquitous portrayal in German and Soviet art of the period, Hirohito's pictorial absence from Japanese war art asserted his nonetheless authoritative control as a divine, omniscient presence in all aspects of Japanese life.

In *Welcoming the Imperial Carriage,* Keigetsu's samurai warrior kneels, presses his hands to the ground, and bows his head in a gesture of profound deference and fealty to Go-Daigo. Through the use of brilliant, flat color, and crisp, calligraphic line, Keigetsu focuses attention on Kusunoki Masashige's sword, arrows, and richly patterned samurai armor. Such idealized images of the selflessly loyal samurai proliferated in Japan during the war years as a model of militarist courage and unquestioning submission to the emperor and the state.

In the postwar years, Keigetsu's *Nihonga* art fell out of favor among a Japanese art public who now saw such works as contributing to Japan's disastrous nationalist fervor in World War II. Kikuchi Keigetsu died in 1955.

Matsumoto Shunsuke (1912–1948)

Born in Tokyo in 1912, Matsumoto Shunsuke contracted cerebrospinal meningitis in 1925 at the age of 14, a condition that rendered him deaf. He turned to reading literature and by 1929 had decided to become an artist. He enrolled in *yōga* courses at the Pacific School of Fine Arts, where he befriended a number of avant-garde artists. In 1932 he formed an avant-garde association with a group of his friends called the Red Bean Society. After 1936, he began to publish, along with his wife, Matsumoto Teiko, an influential magazine of essays and drawings called *Zakkichō* (Notebook). The magazine maintained an open editorial policy of running contributions by traditional as well as avant-garde artists and writers interested in the latest European tendencies of surrealism and abstraction.

Matsumoto became increasingly alarmed by the extreme nationalism that began to permeate the Japanese art world as the war years progressed. In 1941, he penned an essay titled "The Living Artist" that was published in the art journal *Mizue* (Watercolor) in April of that year. His essay responded to the roundtable discussion "The National Defense State and the Fine Arts: What should Artists do?" published in *Mizue* in January 1941. The discussion, which took place between three military bureaucrats of the Army Information Section and two civilians supportive of the nationalist cause, railed against modern art as a negative Western influence. The roundtable called upon artists to surrender their egoism and submit their work to serving Japan's wartime propaganda interests by expressing and celebrating the Japanese "race."

In "The Living Artist," Matsumoto championed the cause of artistic freedom against the use of art for propaganda purposes. He claimed that notions of artistic freedom were, contrary to the conclusions of the roundtable, not a foreign import but a value deeply rooted in Japanese tradition. Matsumoto countered the roundtable's prescriptive brand of patriotism with his own vision of patriotic duty. Modern artists, too, served the nation in ways equally important to those of the military and political leadership. They performed a vital role, Matsumoto insisted, crucial to the health and growth of Japanese culture. By absorbing and recasting foreign artistic trends as their own, modern artists paved the way to Japan's ascendancy as the leader of a genuinely universal culture. Matsumoto argued: "Even if we control Asia militarily, if Asian people do not come to Japan in search of culture, but rather run off to Europe and America, it will be impossible to establish essential national defense at a high level...we must digest Europe and overcome it."[6]

Though Matsumoto exhibited with vanguard abstract and surrealist artists, his own work remained figurative and less formally innovative. Scholars have likened his art to the socially critical work of the German artist George Grosz, as well as the French painter Georges Rouault, and the Japanese-American oil painter Hideo Noda. In his work *A Painter* of 1941, Matsumoto portrays himself standing resolute before a backdrop of the city of Tokyo, arms at his sides, and gazing out from the canvas.[7] Behind him his wife and a child are depicted turned away from the viewer. Matsumoto uses a somber palette of earth tones

for the work, with pigment applied in broad gestural strokes reminiscent of European modern art. Depicting himself standing before the urban landscape subtly counters nationalist assaults on the degeneracy of Western urban culture. Choosing to identify his familial bonds as that between a husband, wife, and child, Matsumoto's work also challenges propaganda efforts of the period that promoted the state and national collective identity as the "family" of the Japanese people.

Despite his attempt to couch his dissenting views in patriotic terms, Matsumoto's publication possibilities dwindled after the appearance of "A Living Artist." Military authorities sought greater control over the art press by reducing the number of art magazines permitted to circulate in the country from 38 to 8. Matsumoto thereafter turned exclusively to painting. In spring 1943 he and seven other *yōga* painters formed the New People's Painting Association, which refrained from producing patriotic imagery. The association held three shows before folding in 1944 when the Patriotic Society of Japanese Art began to regulate the country's exhibitions.

After the war, progressive artists who had faced similar repression during the war years revered Matsumoto. He became a prominent advocate for the formation of a national artists union independent of authoritarian government control. Matsumoto Shunsuke died in 1948 at the age of 36.

Yokoyama Taikan (1868–1958)

Yokoyama Taikan was born in 1868, the eldest son in a samurai family from Mito in Ibaraki Prefecture. At age 10, Taikan and his family moved to Tokyo when his father was appointed to the Ministry of the Interior. Taikan enrolled in the Tokyo English School, where he took courses in drawing. In 1889, he entered the Tokyo School of Fine Arts and later served as an instructor there. He became a member of the Japan Art Institute in 1898. Founded by the famed *Nihonga* artist, Okakura Tenshin, the institute became a center for instruction in *Nihonga* that sought to incorporate formal innovation into Japan's artistic traditions.

Some of Taikan's early works demonstrate innovative approaches to *Nihonga*. He became known around the turn of the century for his "hazy style" of representation in which he abandoned the delicate line of *Nihonga* in favor of subtle and evocative washes of pigment. In his landscape images *Misty Moon* (ca. 1900) and *The Cuckoo* (1904), Taikan uses veils of color to suggest trees, water, and the soft atmospheric effects of cloud and mist.

Between 1899 and 1909, he and his colleague Hishida Shunsō traveled and exhibited in India, the United States, and Europe. By 1909 Taikan was back in Tokyo, where he began to exhibit his works in the annual government-sponsored Bunten and to serve as a juror on the selection committee.

When reform of the Bunten threatened to open the exhibits to more modernist tendencies, Taikan withdrew in 1914 and turned his attention to revitalizing

the Japan Art Institute after its virtual collapse in 1904. He organized a regular exhibition at the institute that vied with the Bunten and became a bastion of artistic tradition dedicated to the superiority of Japanese culture. Taikan rejected Western traditions of pictorial realism and increasingly turned away from formal experiment in *Nihonga* art. He became an outspoken nationalist ideologue in the 1920s who advocated the preservation of Japanese art and spiritualism against the corrosive effects of Western individualism and material values.

Characteristic of Taikan's nationalist spiritualism during this period is his work titled *Spring Dawn over the Holy Mountain of Chichibu* from 1928. Commissioned by the Shintō shrine at Chichibu, the work, rendered in the traditional format of the hanging scroll, depicts the sacred and majestic mountains of Chichibu enshrouded in a misty veil of clouds. In such works, Taikan used landscape as a nationalist metaphor for the timeless divinity of Japan. In 1930, Taikan was among those artists selected to represent the nation at a Japanese art exhibition held in Rome, where 14 of his works were put display.

During the war years, Taikan's nationalist leanings became more outspokenly xenophobic. He lectured to a visiting group of Hitler Youth on the superiority of Japanese art and culture in 1938. In 1940, for the 2,600th anniversary of Japan's founding, he exhibited 20 of his *Nihonga* paintings, including 10 views of Mount Fuji and 10 seascapes. Taikan dedicated the proceeds from the sale of his work to buy fighter planes for the war effort. In 1943, he headed the Patriotic Society of Japanese Art, which imposed stringent controls over all Japanese artists. Membership in the Patriotic Society was compulsory for those who wished to continue exhibiting their work.

After the war, military occupation authorities questioned Taikan about his role in the war effort. He attempted to ingratiate himself with U.S. General MacArthur by presenting one of his paintings of Mount Fuji to MacArthur's wife as a gift. Little more is known about his postwar activities. Yokoyama Taikan died in 1958.

Notes

1. Japanese names traditionally present the surname or family name first, followed by the first or given name. The first full reference to an artist's name in the text will follow Japanese order. All subsequent references to an artist will use the family name (thus "Matsumoto Shunsuke" becomes "Matsumoto"). Some artists, however, adhere to a Japanese custom in which they are designated by their first name, known as the "artist name." In those cases, all subsequent references to an artist will use the first, not the family name (thus "Kikuchi Keigetsu," mentioned later in the text, becomes "Keigetsu" after the initial reference).

2. These artists produced works that were among those confiscated by U.S. forces at the close of World War II and placed in the U.S. Air Force Art Collection. Their paintings and several other works discussed in this chapter are difficult to find in histories of twentieth-century Japanese art. For illustrations, see Ken McCormick and Hamilton

Darby Perry, eds., *Images of War: The Artist's Vision of World War II* (New York: Orion Books, 1990).

3. See illustration of Fujita Tsuguji's *Battle on the Bank of the Halha*, Nomonhan in Bert Winther-Tamaki, "Embodiment/Disembodiment: Japanese Painting during the Fifteen-Year War,' *Monumenta Nipponica* 52.2 (1997): 150.

4. See illustration of Fujita Tsuguji's *The Yasuda Unit's Desperate Struggle: The New Guinea Front in Bert Winther-Tamaki*, "Embodiment/Disembodiment: Japanese Painting during the Fifteen-Year War,' *Monumenta Nipponica* 52.2 (1997): 175.

5. See illustration of Kikuchi Keigetsu's *Welcoming the Imperial Carriage* in Ellen P. Conant, *Nihonga. Transcending the Past: Japanese-Style Painting*, 1868-1968 (St. Louis, MO: St. Louis Art Museum, 1995), figure 139.

6. Matsumoto Shunsuke, "A Living Artist," *Mizue* 437 (April 1941). Cited in Bert Winther-Tamaki, "Embodiment/Disembodiment: Japanese Painting during the Fifteen-Year War," *Monumenta Nipponica* 52.2 (1997): 170.

7. See illustration of Matsumoto Shunsuke's *A Painter* in Mark Sandler, "The Living Artist: Matsumoto Shunsuke's Reply to the State," *Art Journal* 55, no. 3 (Fall 1996): 80, figure 1.

Bibliography

Brown, Kendall H. "Out of the Dark Valley: Japanese Woodblock Prints and War, 1937–1945." *Impressions* 23 (2001): 65–85.

Clark, John. "Artistic Subjectivity in the Taisho and Early Shōwa Avant-Garde." In *Japanese Art after 1945: Scream Against the Sky*, edited by Alexandra Munroe, 41–53. Exhibition catalogue. New York: Harry N. Abrams, 1994.

Conant, Ellen P. *Nihonga. Transcending the Past: Japanese-Style Painting, 1868–1968*. Exhibition catalogue. St. Louis, MO: St. Louis Art Museum, 1995.

Dower, John W. *Japan in War and Peace: Selected Essays*. New York: New Press, 1993.

Mason, Penelope. *History of Japanese Art*. New York: Harry N. Abrams, 1993.

Rimer, J. Thomas. *Paris in Japan: The Japanese Encounter with European Painting*. Tokyo: Japan Foundation, 1987.

Sandler, Mark H. "The Living Artist: Matsumoto Shunsuke's Reply to the State." *Art Journal* 55, no. 3 (Fall 1996): 74–82.

———. "A Painter of the 'Holy War'; Fujita Tsuguji and the Japanese Military." In *War, Occupation, and Creativity: Japan and East Asia, 1920–1960*, edited by Marlene J. Mayo and J. Thomas Rimer, 188–211. Honolulu: University of Hawaii Press, 2001.

Tipton, Elise K., and John Clark, eds. *Being Modern in Japan: Culture and Society from the 1910s to the 1930s*. Honolulu: University of Hawaii Press, 2000.

Weisenfeld, Gennifer. *Mavo: Japanese Artists and the Avant-Garde, 1905–1931*. Berkeley: University of California Press, 2002.

Winther-Tamaki, Bert. "Embodiment/Disembodiment: Japanese Painting during the Fifteen-Year War." *Monumenta Nipponica* 52.2 (1997): 145–80.

CHAPTER 7

Artists in the Soviet Union: Defending Communist Utopia

After Adolf Hitler's appointment as German chancellor in 1933, the Soviet Union braced itself for war against the Nazi regime. Joseph Stalin (1879–1953) imposed ever-greater dictatorial control over all aspects of Soviet life in the early 1930s, including the arts. Assuming power in 1924 after the death of the Russian revolutionary leader, Vladimir Lenin, Stalin ruthlessly purged the government of his political adversaries. He also centralized the economy, rendering the nation's artists dependent on government commissions and official approval for their work and livelihoods. In 1934, in a move to clarify further the state's expectations of its artists, the regime declared socialist realism the official art of the Soviet Union. Socialist realism rejected the geometric abstraction and other formal innovations prized by the Russian avant-garde of the 1920s. It demanded instead that artists adhere to a traditional, realistic style of representation and portray themes designed to rouse patriotic nationalism among a Soviet citizenry confronted by hardship and impending war.

The Union of Soviet Socialist Republics (USSR, or Soviet Union) fought alongside the United States, France, and Britain to defeat Germany in 1945. During the Cold War of the 1950s, however, this World War II alliance collapsed. The United States and the Soviet Union emerged as the two competing superpowers of the postwar order. As anticommunist fervor grew in the capitalist West, politicians and commentators sought to discredit the Soviet Union by drawing negative parallels between the dictatorial regimes of a vanquished Germany and the still powerful Soviet Union. Some pointed to the fact that Soviet socialist realism, with its adherence to a style of illusionistic realism and resistance to modernist innovation, resembled the art of Nazi Germany. Such correspondences in the realm of culture served as proof, Western critics argued, of the similarity between Stalin and Hitler's dictatorships.

Important differences between communism and Nazism and between the arts and their function in the Soviet Union and Germany thus became blurred during the Cold War. In Nazi Germany, artists who did not comply with a prescribed style of illusionistic realism and themes ennobling of Hitler's regime were persecuted and driven into exile. In the Soviet Union, some artists perished in the many brutal purges that took place throughout the World War II era. They were not, however, persecuted because of their art but rather on the basis of political affiliations or other nonartistic activities that Stalin construed as hostile to his rule. Moreover, after German troops invaded the Soviet Union in 1941, Stalin fostered greater popular support of his government by easing restrictions on artists and allowing for a greater plurality of artistic styles.

Some of the greatest ideological differences between the two dictatorial systems can be gleaned from how state-approved artists in each country approached the representation of the human form. In Nazi Germany, many artists devoted their work to depictions of idealized nudes that served as examples, through their physical perfection and distinctly German facial types, of Aryan (German) racial superiority. Paintings and sculptures also reinforced traditional gender roles between men and women, with men frequently portrayed as heroic warriors and women as sexualized and submissive keepers of the home and hearth. In Soviet society, by contrast, few artists devoted their work to the rendering of the nude human body. Socialist realist works instead emphasized working class identity through attributes of clothing that celebrated the various workers' professions and military service. Attention to regional types of facial features and attire also made vivid the many ethnicities that constituted the vast Soviet empire. Furthermore, according to the Bolshevik Revolution's promise of women's emancipation, socialist realist artists depicted men and women as equals working side by side on farms and in factories to build the new Soviet society.

For all of their differences, however, Nazi and Soviet art gave visual form to the dominant myths of their respective dictatorial regimes. In Nazi Germany, artists propounded Hitler's myth of a timeless and triumphant master race of racially pure Germans. Under Stalin, Soviet artists painted and sculpted images that supported the leadership's myth of a utopian worker's paradise of the future. Rendered with an exacting naturalism of detail, the "realism" of Soviet socialist realist art stood in stark contrast to the hardship, deprivation, and war that marked the reality of the World War II era. Such works were used by the leadership to give the Soviet people a notion of a better communist future worth working toward and defending in peacetime as well as war.

The Soviet Union and Its Art World before World War II

The origins of socialist realism are rooted in traditions of nineteenth-century Russian realist art, in particular the work of a group of painters known as the

Peredvizhniki (Wanderers), whose lead artist, Ilya Repin, was much admired by Stalin. Named for their travelling, or wandering, exhibitions, the Peredvizhniki sparked controversy for their unflinching portrayals of the impoverished and downtrodden lives of Russia's peasantry. Their images condemned the excesses of aristocratic privilege in a country where some 85 percent of Russians (52 million people) were serfs—peasants enslaved to work the lands owned by the country's landholding elite. As the peasant population continued to swell after 1861 (to some 100 million by 1905), so too did the scarcity of food and civil unrest.

The outbreak of World War I in 1914 accelerated the radicalization of the Russian masses. In March 1917, strikes and riots broke out throughout the country led by workers and soldiers who formed themselves into self-governing soviets (or councils). The soviets demanded the toppling of the tsar (emperor) and an end to the Russian monarchy's abusive regime. In the months of upheaval that ensued, Vladimir Lenin, as leader of the Bolshevik Party, rose to the forefront of events that culminated in the October Revolution of 1917. The October Revolution overthrew the Romanov dynasty, which had ruled Russia for 300 years.

Lenin called together an All-Russian Congress of Soviets. By January 1918, the new revolutionary regime had been transformed into a one-party state headed by the Bolsheviks, who soon changed their name to the Communist Party. Lenin based his political program on the economic theory and historical vision of Karl Marx and Friedrich Engels, whose *Communist Manifesto* of 1848 demanded social and economic justice for exploited workers the world over. Lenin's socialist program entailed the institution of a "dictatorship of the proletariat" in revolutionary Russia in which the working class, under the leadership of the Communist Party, assumed control of economic and political power in the country. Lenin envisioned socialism as a necessary stage on the way toward realizing a genuinely communist (egalitarian and classless) society of the future.[1]

Lenin considered the arts important to the task of forging a new Communist Party mass politics. He vested cultural authority in the Commissariat of Enlightenment (NarKomPros). Formed in 1918 and placed under the leadership of the writer and party leader, Anatoly Lunacharsky, NarKomPros oversaw education, propaganda, and the arts. Lunacharsky dismantled the tsarist art world, beginning with the nationalization of museums and private art collections and the closure of the imperial art academies and studios located in Moscow and Petrograd. He also elevated avant-garde artists, who had been marginalized and excluded under the tsarist regime, to leadership positions in the Soviet Union's newly reorganized schools and academies. Kasimir Malevich, founder of suprematism, and Vladimir Tatlin, head of the constructivist movement, were the most outstanding among a generation of Russian avant-garde artists whose geometric abstractions began to remake the look of Soviet society in its arts, architecture, clothing, and design. Within the context of the October Revolution, the Russian avant-garde assumed political significance as a radical, forward-looking artistic movement poised to sweep away all visual vestiges of the past and usher in the new communist society of the future.

Support for the avant-garde waned quickly, however, particularly within the government, on which the avant-garde was largely dependent for its support. In 1922, Pavel Radimov, a former member of the Peredvizhniki, founded the Association of Artists of Revolutionary Russia (AKhRR), which repudiated the formal experiments of the avant-garde and advocated instead a return to realist styles of representation. The AKhRR laid the groundwork for the evolution of socialist realism and soon garnered important patronage from Soviet trade unions and the Red Army leadership.

The AKhRR's founding declaration announced the group's intention to depict in their work "the life of the Red Army, the workers, the peasants, the revolutionaries, and the heroes of labor." Promising to "provide a true picture of events and not abstract concoctions discrediting our Revolution in the face of the international proletariat," the AKhRR rejected what it described as the elitism and unintelligibility of avant-garde art to the masses. They also distinguished their work from that of the Peredvizhniki, whose paintings had dwelled on the deprivations of peasants and workers under the former tsarist government. AKhRR artists inaugurated instead an art of "heroic realism" characterized by a romantic idealization of proletarian life and rendered in a realist style. Such work was to be based on artistic tradition of the past in order to build the "future art [...] of a classless society."[2]

With the death of Lenin in January 1924, Stalin moved to consolidate power under his rule as General Secretary of the Communist Party. He rooted out his political enemies and subjected them to "show trials," or highly publicized proceedings, in which the accused invariably confessed (regardless of innocence or guilt) to various crimes against the state. Defendants faced harsh punishment including life sentences in the Soviet Union's infamous Gulag system of forced labor camps, or death. The public nature of these show trials ensured that they would serve as important lessons for the populace at large.

In 1929, Stalin declared an end to Lenin's New Economic Policy of limited market capitalism that had been in place since 1921. This change in policy, coinciding as it did with the New York Stock Exchange collapse of that year, shielded the Soviet Union from the worst effects of the international economic crisis of the Great Depression. The Soviet economy was now subject instead to centralized state planning as part of Stalin's drive to accelerate the development of the economic foundations necessary for the realization of communism. The impact of this economic policy change on the art world was swift and decisive. While artists continued to be legally free to work independently or to belong to any number of different artists' organizations, it nonetheless became economically vital to align one's work with the interests of the state, which now became the sole source of patronage. Many more artists thus gravitated toward the AKhRR during this period as an artists' organization that had already proven its ability to secure significant government support.

In 1929, Stalin introduced his First Five-Year Plan, which called for the forced collectivization of agriculture and the placing of all farmland under state control. The plan also stipulated an increase of 120 percent in industrial output by 1934;

Stalin soon doubled that goal. The drive toward rapid industrial development entailed massive government investment in heavy industry and the curtailment of consumer goods and services. Such policies instituted the chronic shortage of necessities that became a way of life for the masses of ordinary Soviet citizens under Stalin.

Beginning in 1932, a series of party reforms were introduced to further centralize control in the hands of fewer and fewer individuals at the top of the Soviet bureaucracy. In the realm of the arts, a parallel move was enacted when the Central Committee of the All-Union Communist Party issued its "Decree on the Reconstruction of Literary and Artistic Organizations." This decree dissolved all artists' groups, bringing to a close the virulent in-fighting among avant-garde and realist artists' organizations that had simmered throughout the 1920s. Placed in their stead was a single union. All artists were compelled to belong to the union if they wished to have continued access to commissions and exhibitions. In 1932 Stalin proclaimed the First Five-Year Plan a triumph of socialist construction, completed a full two years ahead of schedule.

Soviet Artists in World War II

With Hitler's appointment as chancellor of Germany in 1933, Stalin turned his attention toward national defense against the Nazi threat. Given Hitler's avowed hostility toward communism and the Soviet Union, Stalin moved to strengthen his ties to France, England, and other Western powers. El Lissitzky, Sophie Lissitzky, Vavara Stepanova, and Aleksander Rodchenko, all leading Soviet avant-garde artists of the 1920s, became involved in producing photomontages and graphic design for *USSR in Construction,* a propaganda journal (in circulation from 1930 until mid-1941) created to promote a favorable image of the Soviet Union abroad. Their celebratory photographs and montages of some of the Soviet Union's many vast construction projects and modernizing advancements were part of an aggressive foreign policy. The journal sought to garner international respect by showcasing Soviet achievement and projecting to the world the country's ability to defend itself against aggressors.

In 1934, the Soviet Union gained admission to the League of Nations, which had been established in 1919 to further international cooperation in the aftermath of World War I. Stalin also redirected the Soviet economy toward a massive military buildup that worsened the living standards of the country's citizenry. During this period, government-supported art within the Soviet Union legitimated sacrifice and hard work in the present for the building of communist utopia. This kind of art, known as socialist realism, was installed as the official art of the Soviet Union in 1934.

Stalin's cultural commissar, Andrei Zhdanov, defined socialist realism in a speech that he gave before the 1934 Congress of Socialist Writers, held in Moscow. Though his comments were directed first and foremost to literature, they

were also understood to apply to the visual arts. Socialist realism, according to Zhdanov, rejected the expressive individualism and formal complexity of modernist, avant-garde art in favor of coherence and clarity of content deemed more accessible to the masses of Soviet citizens. Socialist realist artists, while adhering to lifelike representation, were not, however, merely to provide an objective recording of the world. As "engineer[s] of human souls," socialist realists were to develop an art realistic in form and socialist in content—imbued, in other words, with visual clarity and a higher didactic purpose that pointed beyond the here and now. In Zhdanov's words: "Soviet [art] should be able to portray our heroes; it should be able to glimpse our tomorrow. This will be no utopian dream, for our tomorrow is already being prepared for today by dint of conscious planned work."[3]

Socialist realist artists thus drew upon the realities of Soviet construction as the subject matter for their art, but cast those realities within the mythic space of the promised future. An example of socialist realist art during this period is the work of Serafima Ryangina, who was a member of the AKhRR from 1924 until its dissolution in 1932. Her painting *Higher and Higher* of 1934 speaks to the egalitarianism of men and women in the Soviet system by depicting a male and female worker dressed in overalls together ascending an electric pylon. They engage in socially useful work, contributing their labor to Stalin's industrial project for the supply of energy to the country. Smiling, healthy, and with windswept hair, Ryangina's workers show no sign of the real-life hardships and perilous work conditions endured by the masses of the Soviet people during this period. Their effortless—indeed joyous—climb up the pylon positively transforms the male and female worker through purposeful, collective labor and their contribution to the building of a better future.

From the beginning of the First Five-Year Plan in 1929 to the inauguration of socialist realism in 1934, the Soviet political and cultural system underwent rapid and traumatic change. While Stalin instituted ever greater degrees of centralized control over all aspects of Soviet life, he also held himself and the leadership less and less beholden to the Soviet masses on whom Stalin continued to base his legitimacy. He lowered a shroud of secrecy over his actions and the operations of the government. The Communist Party also stepped up the activities of its secret police, heightening a culture of paranoia and surveillance that encouraged the people to inform on one another for alleged misdeeds. This transformation from an open to a closed system of governance was given tangible form in the debates that unfolded during this same period concerning plans for the reconstruction of Moscow.

Discussions about the redesign of Moscow had been underway since the October Revolution in 1917. Buoyed by the success of the First Five-Year Plan in the early 1930s, the government turned its attention to the evermore acute need for housing and urban development. Moscow was to serve as a model of such development and a projection to the world of communist achievement. The First Five-Year Plan had allowed the Soviet Union to begin to catch up to its capitalist rivals in the area of industrial production. With the reconstruction

of Moscow, Stalin planned for the Soviet system to surpass the capitalist West with the splendor of its modern, efficient, and beautiful urban spaces.

The signal achievement of the Moscow reconstruction effort was a new Metro that linked together various parts of the city in an underground railway system. The first lines of the Metro came into use in the mid-1930s. Stations were models of theatrical splendor profusely and differently decorated with mosaics, marble, chandeliers, and sculpted reliefs. Riders entering the Metro enjoyed the latest in clean and efficient transportation to and from their everyday places of work and home. The Metro also transported them into a fantasy world of Baroque palaces, Egyptian temples, and other far-flung places and times that were evoked by the various styles of architecture used in each station. In retrospect, the theatrical quality of the Metro stations serves to underscore the fundamentally unreal and illusory nature of Stalin's ambition to transform the city as a whole into a shining example of Soviet progress.

Some new monumental buildings did, indeed, appear, including the luxurious Moscow Hotel located near Red Square. The crown jewel of the reconstruction effort—the new Palace of the Soviets—never came to fruition, however. All work on the project came to a halt in 1942 after the invasion of German forces. The history of the Palace's planning nonetheless reveals important aspects in the development of Stalinist architecture and its relationship to the changing nature of Stalin's dictatorial rule during this period.

The competition for the design of the Palace of the Soviets went through five separate phases between 1930 and 1935. It was intended to border a new square opposite the Kremlin (the seat of the Soviet government). To make room for the project the Church of Christ the Savior was demolished. A major monument of the tsarist era, the church was built in 1832 to commemorate Russian victory over Napoleon's invading forces. The Council for the Construction of the Palace issued a general brief that spelled out the basic character and intended function of the Palace structure. The height of the Palace was unspecified, though it was to possess a monumental façade and two large auditoria in addition to smaller scale theaters. It was also to be fully modernized with capacity for wireless broadcasting and film projection. In the early phases of the design process, the structure was intended to express the power of the peoples' soviets, to provide open and large-scale gathering places for them, and to facilitate the active participation of brigades, delegations, and collectives in the decision-making processes of the regime.

All possible schools of architecture, from traditional to avant-garde, submitted entries for the Palace design. Well-known foreign architects, including Walter Gropius of Germany and Le Corbusier of France, were also invited to participate. The Council for the Construction of the Palace solicited public response to the various entries by posting blueprints in shop windows throughout Moscow and taking the plans into the factories and workplaces. Le Corbusier's plan was the most vanguard. His entry called for the elimination of the old city and the installation of a structure composed of the most modern materials of steel and glass. Le Corbusier's Palace was to be emphatically nonhierarchical

with no central core or ceremonial entryway. His plan envisioned instead a horizontal dispersal of auditoria and theaters. Each of these gathering places was to be open to the exterior through the use of glass walls. The structure as a whole was thus intended to articulate in built form the ideology of egalitarianism and open, debative democracy that had been enshrined in the formation of the peoples' soviets at the time of the October Revolution in 1917. Le Corbusier's plan, ultimately dismissed from consideration, fell prey to growing hostility toward the modernist avant-garde in general in the early 1930s. Chosen instead was the work of Boris Iofan, who emerged during this period as Stalin's state architect.

Iofan's design for the Palace of the Soviets responded to Le Corbusier's avant-garde vision with a structure that instead spoke to Stalin's growing imperial ambitions in a formal language of tradition and monumentality. Rejecting the horizontality, openness, and democratic symbolism of Le Corbusier's plan, Iofan proposed instead a vertically oriented structure clad in heavy masonry that would render the interior functions of the Palace no longer visible to public view. Like traditional monumental architecture of the past, the building as a whole was to be symmetrically organized and include a large, centrally located ceremonial entryway. Echoing both art deco and neoclassical architectural styles, the façade design featured heavy, regularly-spaced, vertical piers, which added to the structure's monumental grandeur.

Iofan's initial plan for the Palace called for a three-tiered lower platform surmounted by four circular towers of diminishing size, stacked one atop the other. The whole was to be crowned by a statue of a worker holding aloft an illuminated red star, the symbol of the Soviet Union. In 1933, however, the political leadership intervened in the project and demanded one significant revision: that the figure of the worker be replaced by a colossal statue of Lenin—100 meters tall—for whom the entire structure, soaring to a height of 415 meters, was to serve as a pedestal. Now envisioned as a monument to Lenin instead of to the Soviet working people, the final approved version of Iofan's Palace poignantly revealed the extent to which the egalitarian utopianism of the early revolutionary regime was eclipsed under Stalin's dictatorial authority. Stalin's dictatorship vested power in the leadership and reduced the people to a homogeneous, politically insignificant mass.

The mid-1930s saw tangible improvements in the lives of the Soviet people, including the greater availability of food, a dramatic improvement throughout the empire in education and literacy rates, and an official sanctioning—for the first time—of leisure activities. In an ironic reversal of the October Revolution's aim to eliminate class hierarchies, Stalin and the leadership now emphasized a programmatic "embourgeoisement" of Soviet society in support of the regime's claim to success not just in farming and industry, but also in the realm of culture.

In 1936, NarKomPros (the Commissariat of Enlightenment) was replaced by the All-Union Committee for Art Affairs (KDPI), which now answered directly to the Party Central Committee. The KDPI oversaw commissioning of works for major exhibitions. Museum directors and staff were given bonuses for in-

creasing the numbers of visitors to exhibitions through arranging organized tours and other outreach programs. Workers were now expected to acquire culture as proof that the proletariat had become the country's new elite. In 1937, Olga Yanovskaya obligingly portrayed finely attired workers attending a theater production in her painting titled *Stakhanovites in Box at the Bolshoi Theater*.[4] In paintings of 1936 and 1937, Sergei Gerasimov and Arkadi Plastov emphasized leisure and plenitude in their joyous and convivial portrayals of collective farm festivals. Yuri Pimenov's painting titled *New Moscow* of 1937 depicts the communist "new woman." With a fashionable, short, bobbed haircut and stylish dress, she enjoys the ultimate (and virtually unattainable) luxury of a car, which she drives through the streets of Moscow's newly constructed city center.

Such images of pleasure and plenitude contrasted dramatically with the redoubled brutality that came to define Soviet life as the threat of war with Germany loomed evermore ominously on the horizon. In 1937 and 1938, Stalin unleashed the Great Purge, a round of state terrorism in which some 7 to 8 million people were arrested and 3 million killed. The major target was the leadership. Scores of top party officials and Red Army leaders were accused of treasonness collusion with Germany among other crimes, subjected to widely broadcast show trials, and put to death.

In 1937, the Soviet Union was invited to participate in the Paris World's Fair, an international display including the latest achievements in the arts and technology from 44 nations around the globe. As Stalin's state architect, Boris Iofan oversaw the design and construction of the Soviet pavilion. Iofan's pavilion was intended in part to counter growing international alarm over show trials and other brutal measures of repression within the Soviet Union that were then making their way into the Western press. Under the growing threat of world war, signaled by the outbreak of the Spanish Civil War, Germany's remilitarization of the Rhineland, and the formation of an alliance between Germany, Italy, and Japan in 1936, the Soviet pavilion was also a pointed warning to potential invaders. Stalin's words, inscribed on the interior wall of the pavilion, insisted on the Soviet Union's commitment to peace and its readiness to defend itself against militarist aggression:

> We will resolutely pursue the politics of peace with all our force and by every means. We do not desire one jot of another's land but we will not concede one inch of our own. We are in favor of peace and will defend the cause of peace. But we fear no threats, and we are ready to respond with blows to the blows of the warmongers.[5]

Showcased inside the pavilion were a scale model of the Palace of the Soviets, socialist realist paintings and sculptures, as well as commemorative statues of Lenin and Stalin.

Working in a less imposing style of streamlined, modernized classicism, Iofan's pavilion stood directly opposite that of Nazi Germany on the fair grounds. Matching the German pavilion in size and monumentality, Iofan's structure

consisted of a series of staggered blocks that created a dynamic, forward- and upward-surging profile for the building. The whole served as a pedestal for a colossal sculpture titled *Worker and Collective Farmworker* created by the Soviet Union's most prominent sculptor of the period, Vera Mukhina. Rendered in stainless steel and towering over 10 meters high, the male and female pair embodied the dynamic utopianism of communist ideology. Using Iofan's staggered block pavilion as a launch pad, the two surge upward and forward, their windblown draperies emphasizing the majestic unfolding of their movement in space. Woman and man, farm laborer and industrial worker, they together symbolize the triumph and future-oriented aspirations of proletarian collectivism. Their hands, bearing the hammer and sickle of their respective professions, join spontaneously to form the hammer and sickle symbol of the Soviet regime. Contrary to the reality of Stalinist dictatorship, Mukhina's sculpture presented the world with an image of Soviet communism as egalitarian, optimistic, productive, and, most importantly, ruled by the proletariat for the proletariat.

By 1937, the early, proletarian phase of Stalin's revolution had, despite the image projected by Mukhina's sculpture, evolved into its imperial, autocratic aftermath. Stalin reshaped his dictatorial regime as a new empire surpassing that of Russia's old tsarist order. Banned since the revolution, hierarchical ranks were reintroduced into the Red Army, the wearing of insignia and elite uniforms appeared for the first time since the fall of the tsarist regime, and party leaders' portraits began to be carried like religious icons in festivals and parades.

A "Stalin cult" also began to emerge during this period, eclipsing earlier emphases in socialist realist art on the portrayal of "the people." Aleksander Gerasimov, Stalin's court painter, was central to the development of Stalin's mythic cult of personality. In 1937, at the height of the Great Purges, Gerasimov turned his efforts to the production of honorific portraits of Stalin. His most famous, *Stalin and Voroshilov in the Kremlin* from 1938, depicts Stalin and his Commissar of Defense, Kliment Voroshilov, walking together along a rain-soaked path at the Kremlin. Grey clouds part in the sky allowing a halo of light to illuminate Stalin's face as he gazes magisterially off into the distance. In a calculated inversion of the facts, Gerasimov rendered Stalin slightly taller than Voroshilov (who was in reality taller than Stalin) infusing this "realistic" scene with a hierarchical organization of figures called for by the Stalin cult. Gerasimov was rewarded for his efforts with the Stalin Prize for artistic achievement in 1941.

Though his image became more omnipotent as the nation's imperial leader, artists nonetheless stressed over and again Stalin's identity as a "man of the people." In Vasili Efanov's *An Unforgettable Meeting* of 1936–1937 and Grigori Shegal's *Leader, Teacher and Friend (Comrade Stalin at the Congress of Collective Shock-Workers)* of 1937, Stalin, bathed in a sacred aura of light, smiles beneficently into the faces of workers who swoon in his presence. Portraits of Hitler typically emphasized his stern, remote, and commanding presence. Images of Stalin, by contrast, stressed a kind paternalism and proximity to the masses of Soviet people, which bore no relationship to political reality.

On September 1, 1939, German troops invaded Poland. Two days later, Great Britain and France declared war on Germany, touching off World War II. Over

the next two years, Hitler's forces pushed westward into the Netherlands, Belgium, Luxemburg, and France. They also attempted to take Britain through a campaign of sustained aerial bombardment. On June 22, 1941, two years after the outbreak of World War II, Hitler turned his attention eastward and launched Operation Barbarossa, the German offensive into the Soviet Union. Whole factories and other vital resources were evacuated east, as were Soviet elites, museum collections, art schools, and the country's better-known artists. In his painting titled *The Partisan Madonna*, Mikhail Savitsky depicted a woman nursing her child as she and other peasants hurriedly harvest their fields in advance of the German troops. Vladimir Gavrilov, in *For One's Native Land*, also captured the desperate eastward flight of the Soviet people, carrying their meager belongings and trudging over a forbidding snow-covered landscape.

In an effort to rally the population to the national cause, Stalin eased a number of restrictions including those that had been placed on the church. He also advocated a more inclusive policy that allowed for state sponsorship of artists whose work did not necessarily adhere to the standards of socialist realism. Many artists spared military service lent their talents to developing camouflage, posters, and propaganda materials for the war effort.

Hundreds of other artists, including some from the Red Army's Grekov Studio for War Painting were attached to troops at the front. Named after the soldier-artist Mitrofan Grekov, the studio was established in 1934 for the purpose of training soldiers how to draw and paint. Works by Red Army and other war artists were featured in war art exhibits held throughout the Soviet empire. Landscape painting and older traditions of Russian art eclipsed by socialist realism were also revived during this period. In January 1942, a Moscow exhibit titled "The Landscape of our Motherland" worked in tandem with heroic war art imagery to rally the Soviet citizenry to the country's patriotic defense.

On September 4, 1941, the Germans laid siege to Leningrad. Over the next 15 months and spanning the severe winter of 1941–1942, countless Leningrad citizens starved to death as German troops bombarded the city and cut off food and other vital supplies. In the midst of the siege, artists produced works— with only the most primitive of supplies at their disposal—for an exhibit titled "Leningrad in the Days of the Patriotic War." Aleksander Deineka was among them. Deineka came to prominence in the 1920s for his modernist approach to painting and graphic illustration, an approach once again accepted under the more lax Soviet art policies of the war period. In addition to documenting the Leningrad siege, he also completed decorative pieces for new Metro stations that continued to be opened in Moscow despite the war. Artistic production under such harsh conditions came to be regarded in and of itself as patriotic evidence of the Soviet Union's unbroken resolve to endure.

On July 2, 1942, the Black Sea port of Sebastopol fell to the Nazis after an eight-month siege. Deineka painted one of the most celebrated Soviet images of the World War II era in commemoration of the navy's attempt to repel the German invaders. In his *Defense of Sebastopol, 1942,* Deineka depicts white-clad sailors of the Black Sea fleet engaging German forces in face-to-face, armed combat. The port city erupts in flames as enemy bombers streak through the

sky above, and a German tank rolls along the beachfront. Deineka's image emphasizes the heroism and physical prowess of the bloodied Soviet sailors who fearlessly confront their technologically superior adversaries.

The tide of war turned against German forces at the battle of Stalingrad in 1942. Hitler's troops began their offensive against the Soviet city on August 22, 1942, in an effort to cut off one of the Soviet Union's major oil supply routes. War artists Dimitry Obozhenko and Boris Ugarov depicted the fierce house-to-house fighting, aerial bombardments, and snow-covered battlefields of the conflict. By late summer, the Soviet Red Army began to wage a successful counter-offensive, soon aided by the onset of the harsh Soviet winter for which the German troops were ill prepared. To commemorate the Soviet Union's decisive victory at Stalingrad, Stalin's court painter, Aleksander Gerasimov, painted a work titled *Hymn to October,* which showed Stalin as the great leader exhorting his troops on to triumph. As German troops began to be routed from Soviet soil, Gerasimov was able to return to Moscow from his eastern retreat in late 1942. Back in the capital city, he completed *Hymn to October,* for which he once again received the prestigious Stalin Prize.

By winter 1943, Soviet citizens began to return to villages and cities ravaged by German forces. Several artists, including Petr Ossorsky, devoted their work to capturing the material and psychological trauma of war's aftermath. In his series *Life Lines of the Motherland,* Ossorsky depicts villagers carrying their children and meager possessions back to homes and fields reduced to bombed-out shells and craters. Yuri Pimenov's *Road to the Front* showed the mass devastation visited on Soviet cities by retreating German forces determined to leave nothing behind. Depicting a woman driving through a winter landscape of snow, mud, and rubble, the work pointedly recalls Pimenov's *New Moscow* of 1937. In *New Moscow,* which celebrated the achievements of Stalin's First Five-Year Plan, Pimenov's fashionably attired "new woman" drove a luxurious car through the gleaming, opulent streets of Moscow's redesigned city center. In *Road to the Front,* by contrast, the woman drives a jeep and wears a fur hat and heavy coat against the winter cold. A helmeted soldier accompanies her as the two follow a convoy of Red Army troops. The convoy moves along a muddy road past abandoned tanks and towards the remains of a city reduced to charred skeletal shells of blasted-out façades. By quoting from his 1937 *New Moscow* in *Road to the Front,* Pimenov evoked the optimism of earlier socialist realist works as well as the extent to which their image of socialist utopia had now been degraded through war. Such depictions of postwar devastation were circulated in exhibits intended to sustain popular desire for revenge against German aggression.

In January 1945, the Red Army began its drive into Germany from the east, coordinating its advance with the Allies who pushed into Germany from the west. Several Soviet war artists, including Aleksander Deineka, were sent to Berlin to document the capture of the German capital city. Piotr Krivonogov recorded Soviet forces storming the entryway to the Berlin Reichstag (parliament) building in a successful effort to defeat the last remnants of the German army. Oleg Ponomarenko depicted the symbolic end of World War II in May 1945

when Red Army soldiers raised the Soviet red flag of victory over the sculpted horses and chariot of Berlin's ceremonial Brandenburg Gate.

For the Soviet Union, triumph over Nazi Germany came at the price of the largest death toll of any other combatant in the war. Estimates place the number of Soviet casualties around 27 million soldiers and civilians, or more than 1 in 10 of the country's population, due to the sheer ruthlessness of the German invading forces and their scorched earth policy of destroying all land, livestock, and industry in their path. The Soviet Union also suffered looting of its art collections, some of which has never been recovered.

In 1947, the imperial academy, which had been dismantled following the October Revolution of 1917, was reestablished. Renamed the USSR Academy of Arts, the Academy's first president was Stalin's court artist, Aleksander Gerasimov, who held the post until 1957. Members of the Academy were appointed by the Communist Party leadership and the institution was funded by and answerable to the government's centralized Committee for Art Affairs. During his tenure as president, Gerasimov presided over a renewed period of repression in the Soviet art world, exacerbated by the international tensions of the Cold War. He oversaw the reinstitution of socialist realism as the only form of state-approved art. Gerasimov also closed the Museum of Modern Western Art in Moscow and conducted a series of purges that rooted out Western artistic influences. Greater tolerance and openness returned to the Soviet art world only after Stalin's death in 1953.

With the appointment of Mikhail Gorbachev as General Secretary of the Communist Party in 1985, the Soviet Union entered into an unprecedented period of *glasnost* (openness). Many works of the 1920s Russian avant-garde that had languished for decades in archives and vaults made their way into a series of important international exhibitions. Since the collapse of the Soviet Union in 1991, we continue to learn more about Soviet art as additional archival material becomes available and scholarly exchange between Russia and the West grows. Most attention has focused, however, on recovering the history of the Russian avant-garde. Socialist realism, the dominant artistic tradition under Stalin, is only recently beginning to attract scholarly analysis. Long dismissed as propaganda unworthy of serious art historical scrutiny, socialist realism has yet to be fully appreciated for its capacity to lend important insight into the workings of the Stalinist regime.

Soviet Artist Biographies

Aleksander Deineka (1899–1969)

Aleksander Deineka was born in Kursk in 1899. He received his first artistic training from 1915 to 1917 at the Art School of Kharkov in the Ukraine. After the October Revolution of 1917, he worked as a war photographer in Kursk under the auspices of Anatoly Lunacharsky's Commissariat of Enlightenment (NarKomPros).

Between 1919 and 1920, he photographed the civil war that marked the early years of the revolutionary regime as the Soviet Red Army struggled to defeat the last remnants of troops still loyal to the deposed Russian monarchy.

In 1921, Deineka relocated to Moscow where he entered the Moscow Higher State Artistic and Technical Workshops (VKhuTeMas) established under NarKom-Pros as one of the many schools designed to replace the imperial academies after the fall of the tsar in 1917. Training as a graphic artist, Deineka received instruction at VKhuTeMas from leading constructivist and other avant-garde artists who had been elevated to positions of cultural authority under Lenin's revolutionary government. Avant-garde explorations of geometric abstraction and machine-inspired form at VKhuTeMas were directed toward the development of a collectivist aesthetic that emulated the streamlined efficiency of modern industry.

In 1924, Deineka participated in the "First Discussion Exhibition of Associations of Active Revolutionary Art," which showcased the work of the first generation of artists to be schooled under the new Soviet system. Deineka displayed his work as a member of the Association of Three, an artist's group comprised of Deineka, Yuri Pimenov, and Andrei Goncharov. His painting titled *Football* depicted five athletes playing soccer in an open-air setting. True to the Association of Three's desire to wed figurative content with modernist handling of form, Deineka's *Football* uses flat planes of color in the rendering of the athletes' bodies and their surrounding environment. Such works established Deineka's art as an important and widely emulated synthesis of modernist, semiabstract stylization characteristic of constructivism, futurism, and cubism with growing calls in the Soviet art world for a return to easily recognizable subject matter drawn from the lives of Soviet citizens.

In 1925, Deineka became a founder member of the Society of Easel Painters (OSt). He continued to work with simplified forms and flattened pictorial space in a series of images devoted to Soviet industry. Among his better-known paintings from this period are *Before the Descent into the Mine* of 1925, *Building New Factories* of 1926, and *Female Textile Workers* of 1927. Most celebrated was his *Defense of Petrograd* from 1927, which commemorated armed struggle of the civil war era. Dividing the composition into two horizontal tiers, Deineka shows wounded soldiers returning home across an industrial suspension bridge in the upper half of the composition. Below, armed men and women worker-soldiers move in the opposite direction. Without a leader or commanding officer, the worker-soldiers spontaneously come together in ranks on their march to the front. Emphasizing the synchronous motions of their footsteps and the repetitive forms of their rifles, Deineka lends his worker-soldiers the discipline and mechanical rhythm of a well-oiled machine. *The Defense of Petrograd* garnered the support of critics who looked on Deineka's canvasses as an acceptable modernist variant of the more traditional socialist realist art that soon began to dominate the Soviet art world.

Deineka was one of the few Soviet artists privileged to travel abroad in the mid-1930s, during which time he visited the United States. His work represented the Soviet Union at the Paris World's Fair of 1937, where his mural

depicting Stakhanov workers was awarded a gold medal. With the formal institution in 1934 of socialist realism in the Soviet Union, however, Deineka faced increasingly negative criticism and marginalization within the Soviet art world as an artist whose formal innovations were out of step with the socialist realist demand for pictorial realism. His fortunes changed once again, however, when Hitler's invasion in 1941 drew the Soviet Union into World War II.

Under the more relaxed artistic policies of the war years, the Soviet government put Deineka's extensive background in graphic arts and illustration to use. In 1941, he was placed in charge of the design of war posters that were printed by the Iskusstvo publishing house. Teams of graphic artists churned out bold images, which were plastered on walls and hung in windows throughout the Soviet empire, rallying citizens to the nation's defense. Deineka also produced several acclaimed paintings devoted to the war effort, including his *Defense of Sebastopol, 1942.* The work commemorated the heroism of sailors in the Black Sea fleet who attempted unsuccessfully to defeat the German invasion of the Soviet port city. Highlighting the brilliant white of the Soviet sailors' uniforms against a flame and smoke-filled sky, Deineka enhances the drama of the scene by adapting the dramatic contrasts and stark silhouettes characteristic of poster art to the medium of oil painting. Though no match for the Germans' technological superiority, Deineka's Soviet navy men tower over their adversaries and rush headlong into battle using bayonets, grenades, and their own hands against the German aggressors. In 1945, Deineka traveled with Soviet troops to Berlin and produced works commemorating the Red Army's triumph over Hitler's forces at the end of World War II.

In 1947, Deineka was made a full member of the USSR Academy of Arts. With the renewed crackdown on modernist artistic tendencies and the reinstitution of socialist realism as the officially sanctioned art of the Soviet Union, Deineka was required to resign as director of the Moscow Institute of Industrial and Decorative Art in 1948. After Stalin's death in 1953 and the ensuing liberalization of Soviet art policy, Deineka experienced a renewed interest in his art. He was made vice-president of the USSR Academy of Arts between 1961 and 1966. His work inspired a younger generation of Soviet artists who emulated his combination of formal experiment with socially engaged pictorial content. Deineka represented the Soviet Union at the Brussels World's Fair of 1958 with two murals, *Peaceful Construction Sites* and *For Peace throughout the World,* which decorated the Soviet pavilion. In the decade before his death, he received numerous awards and honors including the Lenin Prize and People's Artist of the USSR award in 1964 and recognition as a Hero of Socialist Labor in 1969. Aleksander Deineka died in Moscow in 1969.

Aleksander Gerasimov (1881–1963)

From his humble origins as the son of former serfs, Aleksander Gerasimov became the most powerful artist in the Soviet Union from the 1930s through the

1950s. Born 1881 in the remote village of Kozlov, Gerasimov's populist origins functioned as a major source of his legitimacy as an "artist of the people." He began drawing portraits in a realistic style as a child and was encouraged by a local art teacher to take formal training. In 1903 he went to Moscow to enroll at the Moscow College of Painting, Sculpture, and Architecture. Gerasimov experimented during this early period with the looser brushwork and outdoor scenes typical of French impressionism of the late nineteenth century. He soon gravitated, however, toward the realist paintings of Ilya Repin and other artists of the Peredvizhniki, whose work he appreciated as more "Russian" and untainted by foreign influence.

Graduating in 1915 with qualifications in painting and architecture, Gerasimov began a tour of military service. Thanks to the intervention of an influential patron, he was spared service at the front. Gerasimov was able to continue with his art and began to attract attention for his accomplished portraits of military officers. After he was demobilized in 1918, he returned to Moscow. Disgruntled by the ascendancy of avant-garde artists in NarKomPros and other areas of revolutionary arts administration, Gerasimov returned to Kozlov, where he remained until 1925. Working in his preferred realistic style, he became involved in producing revolutionary public art in Kozlov, including images of Marx and Engels, posters, and banners, as well as stage designs for the local theater, which had been built according to one of his architectural designs. In 1925 he relocated once again to Moscow and the following year began to exhibit with the Association of Artists of Revolutionary Russia (AKhRR).

In 1927, Gerasimov was befriended by Kliment Voroshilov, who replaced the recently purged Leon Trotsky as Stalin's Commissar of Defense. Voroshilov was foremost among the leadership in currying relationships with artists, patterning his patronage of them on the tsarist aristocracy of the past. Gerasimov's portrait of Voroshilov was displayed in the ninth AKhRR exhibition. The following year, in 1928, his equestrian portrait of Voroshilov served as the centerpiece of the tenth AKhRR exhibit, which was devoted to the Red Army and visited by Stalin himself. Voroshilov advised Gerasimov on his 1929 painting of *Lenin on the Tribune,* a work that established Gerasimov as a leading realist painter; it was subsequently put on permanent view at the prestigious Tretyakov Gallery.

In 1933, Gerasimov painted the first of his many portraits of Stalin, depicting Stalin giving a speech at the 16th Party Congress. As a sign of Gerasimov's elite status, he was given the rare privilege to travel abroad in 1934, paying visits to major artistic centers throughout Europe. His writings, which he published on his return, scorned Western avant-garde and contemporary art. He reserved praise only for the works of old masters, which he encountered in Europe's museums. In 1934, he also helped to establish the Red Army's Grekov Studio for War Painting.

Gerasimov became a victim of his own talents in the mid-1930s when he began to produce group portraits of various sectors of the leadership. Several ran afoul of changing political fortunes during the period of the Great Purges. In his 1936 portrait of the *First Cavalry Army,* for example, he included likenesses of army figures who were soon arrested and executed; the work remained unsuitable for exhibit throughout the rest of the Stalin era.

As Stalin began to exercise greater autocratic rule in the mid-1930s, Gerasimov became instrumental in fostering a "Stalin cult" in the visual arts.[6] During the Great Purges, he produced numerous honorific portraits of Stalin, including his famous *Portrait of Stalin and Voroshilov in the Kremlin* of 1938. Though Stalin's Commissar of Defense was in reality the taller of the two men, Gerasimov strategically rendered Stalin with the greater stature. His painting also pointedly underscored the close relationship of Stalin to his military leadership at a time when World War II loomed on the horizon.

Between 1937 and 1939, Gerasimov served as the chair of the Moscow Artist's Union, during which time some of his detractors disappeared (whether or not at Gerasimov's bidding is unknown) in the Great Purges. In recognition of the elite status accorded to artists under the Stalinist dictatorship, the Stalin Prize was instituted in 1939 with an award of 100,000 rubles. In 1941, Gerasimov was one of the first artists on whom the prize was bestowed when he was honored for his 1938 *Portrait of Stalin and Voroshilov at the Kremlin.* Between 1939 and 1954, Gerasimov headed the Executive Committee of the Union of Artists of the USSR, the new nationwide artist's union, which placed him in charge of all artists throughout the Soviet Union.

As part of the artistic elite, Gerasimov was evacuated from Moscow to the east when German troops began to flow over the Soviet Union's western frontier in June 1941. To commemorate the turning of the tide against Hitler's forces at Stalingrad in 1942, Gerasimov painted *Hymn to October,* commemorating Stalin as leader of a victorious Red Army. Gerasimov returned to Moscow in late 1942. In 1943, he was given the nation's highest honor when the Supreme Soviet named him People's Artist of the USSR. He spent the remainder of the war years creating history paintings that documented strategic meetings of the Allies, including his image of Stalin, Franklin Roosevelt, and Winston Churchill at the 1943 *Tehran Conference of the Three Allied Powers* (1945) and the *Moscow Meeting of the Foreign Ministers of the Three Great Powers* (1945).

In 1947, Gerasimov was appointed president of the newly founded USSR Academy of Art. He remained president of the Academy until 1957. During his time as president, Gerasimov presided over a new wave of repression in the Soviet art world as "foreign" modernist influences were once again weeded out and socialist realism reinstalled as the official art of the Soviet Union. With the thaw in Soviet art policy after Stalin's death in 1953, Gerasimov lost his leadership position in the Soviet art world, but continued to take part in exhibitions. A retrospective of Gerasimov's works was put on display at the USSR Academy of Art in 1963. Aleksander Gerasimov died that year in Moscow.

Boris Iofan (1891–1976)

Stalin's state architect, Boris Iofan, was born in Odessa in 1891. He began his studies at the local school of art. In 1914, Iofan left Russia to begin architectural training at the Regio Istituto Superiore di Belle Arti (Higher Institute of

Fine Arts) in Rome. After receiving his degree in 1916, he entered architectural practice in Rome before returning to the Soviet Union in 1924.

Between 1928 and 1930, Iofan worked with his brother, Dimitry Iofan on developing a mass-housing complex in Moscow that incorporated constructivist ideals of collective, self-sustaining arrangements of living space. The project consisted of 500 units in 11-story housing blocks interspersed with courtyards, shared laundry facilities, a cinema, and a supermarket. The structure was largely modernist in design. It incorporated neoclassical elements, however, including heavy vertical piers on the façade that signaled, even at this early date, Iofan's growing interest in more traditional forms of monumental architecture.

In 1931, Iofan entered the competition for the design of the Palace of the Soviets, a structure intended as the centerpiece of Stalin's massive project to transform Moscow into an example of socialist construction.[7] The structure was to serve as a place where the people, as represented through their soviets, or governing councils, could actively participate in the decision-making processes of the regime. The project changed, however, in accord with profound political changes that transformed the Soviet Union in the early 1930s into an increasingly repressive regime under Stalin's iron-fisted rule.

Iofan's design for the Palace was one of many submissions, which included entries by modernist architects from abroad such as Walter Gropius from Germany and Le Corbusier from France. Iofan's plan won out over its more vanguard competitors, however, with a design that incorporated more traditional and monumentalizing elements. Combining art deco and neoclassical architectural styles, the planned façade of Iofan's Palace consisted of heavy, regularly spaced, vertical piers. The structure was, moreover, to be symmetrically organized around a central entryway to the building. Iofan's vision for the Palace contrasted dramatically with that of Le Corbusier, whose asymmetrical and horizontally oriented plan called for opening up the Palace's interior space to the outside through the extensive use of glass. The selection of Iofan's more traditional and masonry-clad solution rendered the interior function of the structure—and the decision-making processes that were to unfold within it—inaccessible to the masses of Soviet citizens in whose name the building was to be constructed.

Iofan's Palace of the Soviets was to tower over its surroundings in the heart of Moscow with a three-tiered lower platform surmounted by four circular towers of diminishing size, stacked one atop the other. In his initial design, he intended for the structure to be topped by a massive sculpture of a worker holding aloft the red star symbol of the Soviet Union. But, as the political leadership began to exert ever-greater control over the populace, it demanded that Iofan modify his plan by replacing the figure of the worker with a sculpture of Lenin. Stalin regularly presented himself to the Soviet people as the legitimate heir to Lenin's revolutionary legacy. By replacing an emblem of the people with one of the leadership, Iofan's final design aptly envisioned the transformation of the Soviet Union from its early years of revolutionary commitment to the masses of Soviet citizens into an increasingly repressive Stalinist dictatorship.

Given his success in the Palace of the Soviets competition, Iofan was chosen to design the Soviet pavilion for the Paris World's Fair of 1937. Stalin used

participation in the fair as an opportunity to demonstrate to the world Soviet achievement in the arts and technology, for which Iofan's pavilion was to serve as a foremost example. Using a streamlined classicism, Iofan's massive structure consisted of a series of staggered blocks that provided a dynamic platform for Vera Mukhina's large-scale, stainless steel sculpture titled *Worker and Collective Farm Worker.* Surging upwards and forwards, Mukhina's male worker and female collective farm worker complete in figurative form the dynamism and forward-looking optimism suggested by Iofan's structure overall. The two figures brandish their implements that together represent the hammer and sickle symbols of the Soviet Union. Mukhina's *Worker and Collective Farm Worker* appear ready to leap into space from atop the Soviet pavilion, carrying their message of the unfolding communist revolution to the world.

The lavishness of Iofan's pavilion was matched by that of Albert Speer, Hitler's state architect, who designed the German pavilion. The two structures, positioned on the banks of the Seine, faced one another across the main axis of the fair. The physical confrontation of the Soviet and German pavilions expressed in architectural form the armed conflict that was beginning to mount between the two nations as the fair got underway. Within the shadow of world war, Stalin also included an inscription on the wall inside the structure, which warned against any attempt to attack the Soviet Union. The display of Soviet prowess in Iofan's pavilion was thus given immediate political urgency as the Soviet Union braced itself for its impending confrontation with Nazi Germany.

Iofan continued to function as the Soviet Union's favored architectural representative abroad. In 1939 he designed the Soviet pavilion for the New York World's Fair. That same year, he was named a member of the USSR's Academy of Architecture. In 1941, he was also awarded the prestigious Stalin Prize and Order of Lenin.

With the invasion of German forces in June 1941, Iofan's work on the Palace of the Soviets soon came to a halt. He returned to the design of the structure on and off over the next several years until 1956, when the project was officially dropped. In 1962, he turned to designing residential architecture once again and began work on a design for the Institute of Physical Culture in Moscow. Boris Iofan died in 1976.

Vera Mukhina (1889–1953)

Born into a merchant family in Riga in 1889, Vera Mukhina attended the Feodosisky High School in Kiev where she began private drawing lessons. By 1910, she was living in Moscow and continued to study at various private art schools. She met the avant-garde artist Lyubov Popova at this time. The two became close friends, traveled, and learned from one another. In 1912, Mukhina went to Paris and studied sculpture at Antoine Bourdelle's studio at the Académie de la Grande Chaumière. She supplemented her training with trips to the Louvre in order to see classical and Egyptian sculpture. On a visit to Italy with Popova in 1914, she also studied the sculptures of Michelangelo; she returned to Russia that same year with the outbreak of World War I.

Through Popova, Mukhina came in contact with avant-garde art circles and began producing stage designs and sets for avant-garde theater productions. After the October Revolution, she became involved in Lenin's Plan for Monumental Propaganda. The plan called on artists to replace old tsarist monuments with new statuary dedicated to the political and cultural heroes of the October Revolution. In 1919–1920, she was founder of the Monolit (Monolith) group of sculptors, who worked together on monumental propaganda projects and entered their work for consideration by Lenin's plan. Mukhina's submissions included sculptures of dissident writers and Bolshevik revolutionaries, which she developed in a figurative, yet semicubist style of geometricizing planes. After working primarily in theater and clothing design in the mid-1920s, Mukhina returned to sculpture by the end of the decade.

In 1927, Mukhina's sculpture *Peasant Woman* was featured in a major exhibition held in Moscow to celebrate the tenth anniversary of the October Revolution. Rendered in a realist style, the work featured a woman dressed in peasant dress and headscarf. Standing erect with her thick, muscular arms confidently folded across her chest and feet firmly planted on the ground, Mukhina's *Peasant Woman* projects an air of unbowing strength and proud self-sufficiency. Critics widely praised the work for introducing a new heroic type into the realm of sculpture.

From 1927 to 1930, Mukhina taught sculpture at the Higher Artistic and Technical Institute (VKhuTeIn). In 1931, she fell victim to a wave of Stalinist repression when she was arrested and exiled for attempting to cross the border illegally. She was able to return to Moscow and resume her career the following year. In 1934, Mukhina participated in the design of the Moscow Soviet Hotel as part of Stalin's plan for the redesign of the capital city.

Mukhina achieved international fame for her stainless steel sculpture, *Worker and Collective Farmworker,* which was placed atop Boris Iofan's Soviet pavilion at the 1937 Paris World's Fair. The work portrays a male worker holding a hammer and a female farmworker with a sickle in her hand surging forward and upward from the top of the staggered blocks that constituted Iofan's pavilion design. Brandishing their implements high above their heads, the workers' hammer and sickle spontaneously come together to form the hammer and sickle symbol of the Soviet flag. Mukhina's sculpture received wide acclaim as a dynamic expression of Soviet ideology. Her work projected to the world an image of the Soviet Union as a productive, optimistic, and forward-looking nation built by and for the working masses. *Worker and Collective Farm Girl* thereafter became an enduring symbol of the Soviet regime and was widely reproduced, including as an emblem on Soviet currency.

Members of the leadership sought Mukhina for her work in producing sculpted portrait likenesses. In 1942, she rendered a portrait bust of Colonel Yusupov, which she carried out at the colonel's hospital bedside. The work, true to the tenants of socialist realism, stresses Yusupov's heroic dignity as a military leader. Mukhina depicts the colonel wearing an eye patch over his left eye and with his right cheek dimpled by a scar. The erect bearing, squared jaw,

Vera Mukhina, *Industrial Worker and Collective Farm Girl,*
1935. © Grego M. Schmid/Corbis.

and expressionless calm that Mukhina imparts to her subject offset such traces
of physical pain and diminished capacity. She further underscored Yusupov's
status as a military leader by including his military insignia on the high collar
of his uniform. Mukhina's planned portrait bust of Stalin was interrupted by the
German invasion and subsequent chaos of the war years.

Less is known about Mukhina's activities in the postwar years. She continued,
however, to receive public commissions and participate in exhibits within the
Soviet Union and abroad. Vera Mukhina died in Moscow in 1963.

Notes

1. Though Marxist-Leninist theory sees socialism as a preliminary stage on the way
to communism, the terms socialism and communism are frequently used interchange-
ably. For concise discussions of the historical usage and definition of socialism and

communism, see Tom Bottomore, ed., *A Dictionary of Marxist Thought* (Cambridge, MA: Harvard University Press, 1983), 87–90, 444–47.

2. "Declaration of the Association of Artists of Revolutionary Russia," in *Russian Art of the Avant-Garde: Theory and Criticism,* ed. John Bowlt, 265–67 (New York: Thames and Hudson, 1988).

3. Andrei Zhdanov, "Speech to the Congress of Soviet Writers," in *Art in Theory: An Anthology of Changing Ideas,* ed. Charles Harrison and Paul Wood, 409–12 (Oxford: Blackwell Publishers, 1992).

4. In the mid-1930s, the Soviet government inaugurated the Stakhanovite movement, named after Aleksei Stakhanov, a miner who in 1934 was reported to have produced 14 times the normal amount of coal in one shift. Workers were exhorted on to the same achievement in exchange for membership in the Stakhanovites and the social prestige the movement extended to its members. The movement was reinforced by a government propaganda campaign designed to extract ever-greater degrees of sacrifice from the citizenry.

5. Joseph Stalin, inscription on the interior of the Soviet pavilion, Paris World's Fair, 1937. Cited in Sarah Wilson, "The Soviet Pavilion in Paris," in *Art of the Soviets: Painting, Sculpture and Architecture in a One-Party State, 1917–1992,* ed. Matthew Cullerne Bown and Brandon Taylor, 106 (Manchester: Manchester University Press, 1993).

6. See, for example, illustration of Aleksander Gerasimov's *Portrait of Stalin* in Boris Groys and Max Hollein, eds., **Dream Factory Communism: The Visual Culture of the Stalin Era** (Ostfildern-Ruit, Germany: Hatje Cantz Verlag, 2003), page 149.

7. See illustration of Boris Iofan's **Palace of the Soviets** in Boris Groys and Max Hollein, eds., **Dream Factory Communism: The Visual Culture of the Stalin Era** (Ostfildern-Ruit, Germany: Hatje Cantz Verlag, 2003), page 238.

Bibliography

Barron, Stephanie, and Maurice Tuchman, eds. *The Avant-Garde in Russia 1910–1930: New Perspectives.* Exhibition Catalogue. Los Angeles: Los Angeles County Museum of Art, 1980.

Bendavid-Val, Leah. *Propaganda and Dreams: Photographing in the 1930s in the USSR and the US.* Exhibition Catalogue. Zurich: Edition Stemmle, 1999.

Bowlt, John, ed. *Russian Art of the Avant-Garde: Theory and Criticism.* New York: Thames and Hudson, 1988.

Bown, Matthew Cullerne. *Art under Stalin.* New York: Holmes and Meier, 1991.

————. *Socialist Realist Painting.* New Haven, CT: Yale University Press, 1998.

Bown, Matthew Cullerne, and Brandon Taylor, eds. *Art of the Soviets: Painting, Sculpture and Architecture in a One-Party State, 1917–1992.* Manchester: Manchester University Press, 1993.

Cohen, Jean-Louis. *Le Corbusier and the Mystique of the USSR: Theories and Projects for Moscow, 1928–1936.* Princeton, NJ: Princeton University Press, 1992.

Fitzpatrick, Sheila. *The Commissariat of Enlightenment: Soviet Organization of Education and the Arts under Lunacharsky, October 1917–1921.* Cambridge: Cambridge University Press, 1970.

Groys, Boris. *The Total Art of Stalinism: Avant-Garde, Aesthetic Dictatorship, and Beyond.* Translated by Charles Rougle. Princeton, NJ: Princeton University Press, 1992.

Groys, Boris, and Max Hollein, eds. *Dream Factory Communism: The Visual Culture of the Stalin Era.* Exhibition catalogue. Ostfildern-Ruit, Germany: Hatje Cantz Verlag, 2003.

Hudson, Hugh D., Jr. *Blueprints and Blood: The Stalinization of Soviet Architecture, 1917–37.* Princeton, NJ: Princeton University Press, 1994.

Khan-Magomedov, Selim O. *Pioneers of Soviet Architecture: The Search for New Solutions in the 1920s and 1930s.* New York: Rizzoli, 1987.

Lodder, Christina. *Russian Constructivism.* New Haven, CT: Yale University Press, 1983.

Margolin, Victor. *The Struggle for Utopia: Rodchenko, Lissitzky, Moholy-Nagy, 1917–1946.* Chicago: University of Chicago Press, 1997.

Solomon R. Guggenheim Museum, State Tret'iakov Gallery, State Russian Museum, and Schirn Kunsthalle Frankfurt. *The Great Utopia: The Russian and Soviet Avant-Garde, 1915–1932.* Exhibition catalogue. New York: Guggenheim Museum, 1992.

Tarkhanov, Alexei, and Sergei Kavtaradze. *Stalinist Architecture.* London: Laurence King, 1992.

Tolstoi, Vladimir Pavlovich, I. M. Bibikova, and Catherine Cooke, eds. *Street Art of the Revolution: Festivals and Celebrations in Russia, 1918–33.* New York: Vendome Press, 1990.

Valkenier, Elizabeth. *Russian Realist Art. The State and Society: The Peredvizhniki and Their Tradition.* New York: Columbia University Press, 1989.

CHAPTER 8

Artists in Spain: Waging a Media War

The civil war that engulfed Spain between 1936 and 1939 announced the growing threat of dictatorship and war on the European continent. General Francisco Franco (1892–1975), backed by armed support from Italy and Germany, waged an ultimately successful campaign during these years to crush the democratically-elected Spanish Republican government. The Soviet Union, meanwhile, was the only country to supply the republic with significant military assistance against Franco's rebel insurgency. The rest of the international community looked on as communism and fascism, democracy and dictatorship faced off against one another on Spanish soil, setting the bloody stage for the events of World War II.

The Spanish Civil War was among the first armed conflicts to be waged not only on the ground, but also in the mass media. Artists, military leaders, and cultural functionaries turned to radio, film, photography, newsreels, journalism, posters, demonstrations, street theater, and exhibitions for propaganda purposes. Their efforts forecast the manner in which such media would be used by major combatants in World War II to rally public support and shape world opinion. The role of mass media in the Spanish conflict also raised serious questions—ones we still grapple with today—about the relationship between the flood of often undigested information made readily available through newspapers, films, and photographs, on the one hand, and genuine knowledge and truth about unfolding events, on the other. Some of the most powerful and enduring works of art produced during the Spanish Civil War, above all Pablo Picasso's painting *Guernica* of 1937, reflect precisely on the issue of war, mass media, truth, and lies.

Spain and Its Art World before World War II

For General Francisco Franco and his supporters, the Spanish Republic's progressive social, cultural, and political policies threatened to destroy all that had made Spain a great power in its illustrious past. Franco promised to restore the strong authoritarian leadership and power of the Catholic Church that had first defined Spain as a leading European nation in the fifteenth century. Through its sponsorship of Christopher Columbus's exploration of the Americas in 1492, Spain had also established itself as a major colonial power during this period. In the realm of the arts, the Spanish court's patronage fostered a rich artistic culture. The country's seventeenth-century master artists Zurbarán, El Greco, and Diego Velázquez commanded admiration throughout Europe.

Spain's fortunes began to change in the seventeenth century, however, marking a period of steady decline that pushed the country to the periphery of world power. From its early history and well into the twentieth century, Spain was a deeply divided society with wealth and power concentrated in the hands of landed oligarchs, the nobility, and the Catholic Church. Masses of poor and exploited laborers and peasantry worked the vast landed estates of the country's semifeudal, agrarian economy.

Limited industrialization began to emerge in the late nineteenth century concentrated first and foremost in the cities of Barcelona, located in the province of Catalonia, and Bilbao and Asturias of the Basque region. Industrialization gave rise to an organized and increasingly militant proletariat. Socialist and anarcho-syndicalist trade unions began to form in the 1880s. They pressed for political change and greater social and economic justice for Spain's workers.

Industry, commerce, and the growth of a small entrepreneurial middle class tied Spain to a modernizing Europe. Such developments brought Spanish artists into contact with the latest artistic tendencies emerging in France, Germany, Italy, and elsewhere. By 1900, Barcelona emerged as a center of the European art nouveau movement, whose major Spanish exponent was the imaginative architect Antonio Gaudí. Gaudí's fantastic turn-of-the-century buildings, including the *Sagrada Familia* and *Parque Güell* among many others, grace Barcelona's streets to this day with their whimsical multicolored façades of molten, plantlike forms. Pablo Picasso, Joan Miró, Salvador Dalí, and other young Spanish artists began to follow impressionism, post-impressionism, fauvism, and other European vanguard artistic trends during the first decades of the twentieth century. Like many artists of their generation, however, Picasso and Miró left behind the relative provincialism of Spain's art world early in their careers. They relocated to Paris, which served at that time as the recognized capital of the international avant-garde.

Decades of corrupt monarchy and military dictatorship came to an end in Spain with the abdication of King Alfonso XIII in 1931. The Spanish electorate voted into power a coalition government made up of socialist, liberal, and moderate workers; members of the middle class; and intellectuals. The Spanish Republic, as the new government was called, introduced sweeping, modernizing

reforms. It pursued a policy of secularizing Spanish society by instituting the separation of church and state. The republic reformed the educational system and enacted progressive labor and agrarian regulations. It also sought to redistribute the nation's wealth in an effort to end class inequity and break the control of the landed nobility and church over the nation's economy.

Most controversially, the republican government agreed to recognize industrially rich Catalonia's long-standing demands for regional autonomy. The Catalan Statute, signed into law in 1932, granted the region its own government, flag, and official use of the Catalan language. Catalonia's success in achieving autonomy prompted a similar movement for independence on the part of the Basque region.

In 1936, the Spanish Republic voted to align the country with the Soviet Union's call for a "popular front" between the Soviet Union and Western democracies against the growing militarist threat posed by Nazi Germany. The landed nobility, the Catholic Church, and military leadership, already inflamed by the erosion of their economic and political privilege under republican rule, now added to their list of grievances the growing influence in Spain of "communist atheism."

Spain's Artists in World War II

In coordination with military leaders throughout the country, General Francisco Franco led the armed uprising against the republic that began on July 18, 1936. Franco committed his "nationalist" insurgency to rolling back the republic's progressive reforms, reinstituting the power of the Catholic Church, and rejecting Catalonia's claim to autonomy. While claiming an official policy of nonintervention in Spain's internal affairs, Germany and Italy nonetheless supplied Franco with bombers, transport planes, and tens of thousands of troops. In the early months of the civil war, Franco's nationalist forces seized control of over a third of the country. By October 1936, they prepared to lay siege to the capital city of Madrid.

The foreign military assistance, order, and coordination of Franco's insurgency contrasted with the lack of international support and disarray that beset early republican attempts to defend the country against the nationalist assault. France eventually sent a few aircraft in support of the republic. Britain, on the other hand, refused any involvement, claiming fears of a wider regional war. Unlike Franco's trained and uniformed military forces, the first defenders of the republic came largely from Spain's untrained and militarily unprepared civilian population—young and old, men and women alike.

In Barcelona, which became the headquarters of the republican defensive effort while Madrid lay under siege, artists immediately engaged in producing posters, banners, and broadsheets exhorting the population to resist the nationalist insurgency. The Sindicato de Dibujantes Profesionales (Union of Profes-

sional Designers, or SDP), founded in Barcelona before the outbreak of the civil war, affiliated itself with socialist and anarcho-syndicalist trade unions. SDP artists Carles Fontseré, Jaume Solà, and Riba-Rovira used their skills as advertising designers to create propaganda posters with bold, eye-catching images and slogans. Their posters stressed the strength and heroism of the working class and exhorted workers to lead the popular defense against Franco's nationalists. The SDP opened a studio where dozens of artists from a broad coalition of leftist groups urgently worked to turn out similar propaganda images that were then plastered on walls throughout the city. As the war progressed, defense councils in Madrid and Barcelona, along with government propaganda agencies, other trade unions, youth and peoples' organizations, employed artists to produce posters, banners, and propaganda materials to rally public support for the defensive war effort. In the chaos of civil war, such media could be quickly and cheaply reproduced for the widest possible dissemination.

News of nationalist mass executions and the mutilation and torture of republican loyalist prisoners soon made its way into the international press. Such reports galvanized an antifascist resistance outside Spain, which attracted to its ranks prominent artists and intellectuals of the day. Authors Ernest Hemingway and George Orwell were among those who came to Spain during the civil war to lend their services to the republican cause and bear witness to unfolding events. Hemingway's novel *For Whom the Bell Tolls* (1941) and Orwell's *Homage to Catalonia* (1938) provided an international readership with vivid testimony to the guerilla warfare and partisan politics of Spain's civil war. Their writings also attempted to raise public consciousness about the imminent threat that an unchecked fascist advance in Europe posed to world civilization.

Among those artists who rallied to the republican cause was photographer Frank Capa, who traveled to Spain in August 1936. Born in Budapest in 1913, Capa's career as a photojournalist began in 1931 when he studied journalism and began to work for a photo agency in Berlin. As a leftist and a Jew, Capa fled Germany for France in 1933 when Hitler came to power. In Paris, he worked for the illustrated journal *Vu* (View) and began to experiment with the new, handheld, 35mm Leica camera.

Arriving in Spain shortly after the outbreak of the civil war, Capa exploited the mobility of the Leica to take photographs in the thick of combat. Such images have since established his reputation as one of the greatest war photographers of the twentieth century. Most acclaimed among his works, and one which has become an icon of the Spanish Civil War, is Capa's photo titled *Falling Militiaman*. The photo captures the instant in which a bullet claims the life of a republican fighter, whose knees buckle, arm swings back, and rifle flies from his hand as he falls backward, collapsing to the ground. Paris's *Vu* magazine reproduced this arresting depiction of combat death in its pages in September 1936; it was circulated again to a readership of 1,600,000 in the popular U.S. illustrated journal *Life* in July of the following year.

Powerful though it is, the question of the photo's impact on public opinion—to what extent it fulfilled Capa's intent of generating sympathy for the republican struggle—remains unanswered. Countering stories of Franco's atrocities that had saturated the news media in the early months of the civil war were now an equal number concerning republican retaliation, including the wanton murder of clerics suspected of collaborating with the nationalists and the burning of churches as hated symbols of the old order. For a public grown apathetic and disillusioned about both sides in the conflict, the seeming truth-value of Capa's *Falling Militiaman* contended with suspicions that the photo may have been deliberately manipulated. Questions began to circulate (and persist to this day) about the image: Was the incident staged? Did Capa retouch the photo to achieve the desired effect? Captions that accompanied the published versions of *Falling Militiaman* did little to alleviate gnawing uncertainties that the photo was incapable of resolving by itself: Who is dying here? Where? When? And who is to blame? In short, the world's unprecedented visual access to the experience of battle in this case offered little guarantee of genuine understanding about the causes and effects of Spain's tragic civil war.

Under continuous siege by Franco's troops and Hitler's Condor Legion of aerial bombers, the republican government fled Madrid in November 1936 and reestablished itself in Valencia. Afraid of jeopardizing his Popular Front alliances with Western democracies in the struggle against Hitler, Stalin reluctantly agreed to send assistance to the republic by late 1936. Communists effectively took control of the republican government and orchestrated the defense of Madrid. The Communist Party also organized the International Brigades, some 60,000 volunteers in the fight against fascism, from around the world. The Brigades, including the Abraham Lincoln Brigade from the United States, began to arrive in Spain by the end of November 1936.

Jesús Hernández, Minister of Instruction, set up literacy programs, cultural missions, exhibits, and summer camps, all of which were used to spread the message of the republic's new war discipline under the communists. Photomontage artist José Renau, Director of Fine Arts during this period, was put in charge of safeguarding Spain's cultural treasures in an effort to counter nationalist claims that republican loyalists regularly engaged in vandalism and destruction of Spain's monuments. Renau also advocated that Spanish artists committed to the republican cause abandon the formal innovations of modernist art as elitist and unintelligible to the masses. He called on them to emulate instead Soviet socialist realism, characterized by clearly legible and affirmative portrayals of popular heroism in the struggle against Franco.

Beginning in fall 1936, Renau also helped to plan Spain's participation in the Exposition internationale des Arts et des Techniques appliqués à la Vie moderne (International Exposition of Arts and Applied Technics in Modern Life, otherwise known as the Paris World's Fair). The fair, situated on the banks of the Seine in the shadow of the Eiffel Tower, opened to the public on May 25, 1937. Forty-four nations constructed temporary pavilions on the site for the display of their

latest achievements in commercial products, technology, design, and the arts. Despite wartime chaos and a chronic shortage of funds, the Spanish Republic looked on the fair as a crucial venue for addressing the world about its current plight. Unlike the other displays at the fair, the Spanish pavilion contained no national products. It was given over instead entirely to films, photomontages, and works of art that functioned together as a large-scale advertising campaign and concentrated plea for international assistance.

José Luis Sert, Catalan by birth and a onetime apprentice to the leading French modernist architect Le Corbusier, was charged with the design of the Spanish pavilion. He produced a modest, necessarily inexpensive, three-story building made from prefabricated modules of glass and asbestos panels attached to a steel frame. The modernist style and unadorned, functional character of Sert's building contrasted dramatically with the Soviet Union and Nazi Germany's bombastic, large-scale, monumental structures, which towered over all the other national pavilions located on the fair grounds.

José Renau produced and installed photomontages on the inside of Sert's pavilion and also attached them to the building's exterior façade. Some of the photomontages highlighted the republic's achievements in education, labor reform, and health care. Others documented nationalist atrocities and the destruction of Spain's cities through aerial bombardment. Renau changed the photomontages periodically throughout the fair, transforming the exhibition space into an urgent news broadcast that regularly issued bulletins to fair-goers about unfolding events in Spain's civil war.

Spanish artists Pablo Picasso, Joan Miró, Julio Gonzáles, and Alberto (Alberto Sánchez Pérez), as well as the U.S. sculptor Alexander Calder, donated their time and effort to create works specifically for the pavilion and its plea to the international community. Their works were reproduced as postcards distributed for sale. The postcards further disseminated the message of the pavilion and helped raise funds for the republic's defense. Most acclaimed among the Spanish pavilion's many donated sculptures, drawings, and paintings was Picasso's mural-sized (12 feet by 25 1/2 feet) work titled *Guernica,* which served as the centerpiece of the structure's ground floor.

Spanish organizers commissioned Picasso to produce a mural for the pavilion in January 1937. He began serious work on the project four months later in the aftermath of the destruction of the cultural capital of Spain's Basque region, the small town of Guernica. For three and a half hours on April 26, 1937, Hitler's Condor Legion dropped incendiary bombs on the town, while machine gunners mowed down civilians as they attempted to flee the resulting firestorm. Guernica was the first undefended civilian population to be destroyed by aerial bombardment in the history of modern warfare. The horrific nature of the attack ignited world indignation. Franco's propaganda office quickly denied any involvement with the event, touching off protracted recriminations and counterrecriminations in the media between nationalists and republican loyalists. The public, meanwhile, was forced to read between the lines.

Alberto Sánchez Pérez, José Renau, José Luis Sert, Exterior of Spanish Pavilion, 1937. © 2005 Artists Rights Society (ARS), New York/VEGAP, Madrid.

Picasso was among those absorbed by such conflicting reports as they poured into French journals and newspapers immediately after the bombing. His painting *Guernica,* rather than focusing specifically on the bombing itself, dwells instead on the unsettling relationship between media reportage and the search for the truth that consumed Picasso's thoughts during these weeks. Using his cubist style of fragmented pictorial form, Picasso fills a claustrophobic interior space with screaming humans and animals, including a woman cradling her dead child in her arms and a horse whose warrior rider has fallen to the ground. The warrior lies prone with his limbs twisted and arm severed from his body; Picasso underscores Guernica's tragic defenselessness through the broken sword the warrior clutches in his right hand.

Several of *Guernica's* figures look skyward in ominous evocation of the death that had rained down from the sky on the small Basque town. But the source of their agony—who is to blame for their degradation—remains unexplained. One figure thrusts its head and arm into the scene through a widow, holding a lamp in its hand. Representing the search for the truth, the figure's lamp, along

with a light bulb suspended from the ceiling of the interior space, sheds light on the chaos of screaming and collapsing figures below. *Guernica's* restricted palette of black, gray, and white suggests the very mass media of photos and newspaper through which Picasso (and the rest of the world) waded in efforts to uncover the truth about what had actually transpired. Horizontal rows of short hash marks that stretch across the body of the warrior's horse in *Guernica* evoke the reams of newsprint that did little to clarify matters in the immediate aftermath of the atrocity.

Franco's nationalists predictably condemned Picasso's *Guernica* as republican propaganda. But Picasso also faced criticism from some republican loyalists, particularly those aligned with the Communist Party, who demanded that the mural be replaced. Insisting that *Guernica* was neither explicit enough about who was responsible for the bombing, nor intelligible enough in its form and content for the masses to understand, the communist left called for a more realist and overtly propagandistic treatment of the event. Recognizing the unparalleled media value of having a major international artist support their cause, organizers of the Spanish pavilion decided, in the end, to leave the mural in place.

Though Picasso donated *Guernica* to the Spanish Republic, he refused to have it returned to Spain after the closing of the fair in November 1937. He insisted that the mural remain outside the country until Spain's democracy was restored. It first toured to Norway and Great Britain in order to raise funds for the republic. The mural then arrived in the United States on May 1, 1939, when it was put on view at the Museum of Modern Art in New York; *Guernica* remained there for the next four decades.

On May 19, 1939, Franco's victory parade marched through the streets of Madrid led by detachments from Hitler's Condor Legion, Mussolini's Italian blackshirts, falangists (Franco's blue-shirted storm troopers), and Spanish nationalist troops. Franco immediately suppressed the Catalan and Basque languages and cultures, rolled back progressive labor and agrarian reforms, and restored the power of the Catholic Church over Spain's educational institutions. Emulating Nazi art policy under Hitler, Franco also rejected modernist tendencies in the arts. He presided over an official return to tradition in painting, sculpture, and architecture in which artists patterned their work on that of Zurbarán, El Greco, Velázquez, and other masters of Spain's artistic past.

Franco's purges wiped out a whole generation of Spaniards, among them the country's most talented artists, intellectuals, and educators. Some 400,000 Spaniards fled into exile, never to return to their native country. Military tribunals condemned tens of thousands more to death. Another 400,000 were interned in prison and labor camps. Many were assigned to massive reconstruction projects, including the 20,000 prisoners who were forced to work on the *Valle de los Caídos* (Valley of the Fallen), a mausoleum for Franco and his supporters. Prison laborers took 20 years to carve the mausoleum, including its massive basilica and monastery, into the hillside of Sierra de Guadarrama. A towering cross, visible for miles, dominated the site located just northeast of Madrid.

Though Franco lent some assistance to Hitler during World War II, Spain remained largely neutral in the conflict and gradually became more isolated from the world. During the Cold War of the 1950s, the United States and other Western powers courted Spain as a bulwark against the Soviet Union. The country's art world became more open to outside influences as a result, and modernist tendencies began to reemerge. Artists such as Antoni Tàpies and Eduardo Chillida began to reintegrate Spain's artistic culture once again into the international avant-garde. Such developments accelerated after Franco's death on November 20, 1975. In 1981, Picasso's *Guernica* finally came home to Spain. It went on public display in Madrid's Prado Museum and has since become among the most prized and celebrated works of Spain's long and illustrious cultural patrimony.

Spanish Artist Biographies

Alberto (Alberto Sánchez Pérez, 1895–1962)

Alberto Sánchez Pérez was born in 1895 into a poor family in Toledo. Moving to Madrid in 1907, he supported himself for several years in a variety of jobs including that of blacksmith, baker, and shoemaker. In 1912, he apprenticed to the sculptor José Estanys, from whom he learned plaster casting. Alberto's first contacts with avant-garde circles came in 1922, when he met the Uruguayan painter Rafael Barradas. He then adopted a neocubist style for his figurative sculptures. In 1925, his work was featured at the Exposición de Artistas Ibéricos (Exhibition of Iberian Artists) in Madrid alongside that of Pablo Picasso and Salvador Dalí. He subsequently received a three-year grant from the city of Toledo, which allowed him to work exclusively on his art. It was during this period that he began to identify himself exclusively by his first name.

In 1925, Alberto helped to found the Primera Escuela de Vallecas (Vallecas School). During regular field trips with students into the countryside, he began to develop an aesthetic based on the geology, textures, and colors of Spain's varied terrain. His sculpted works during this period, including *Bird of my Invention Made in Stones Created by a Blast* (1929–1930) and *Horizon Sculpture, Sign of the Wind* (1930), consist of abstracted natural forms that resemble bleached bones, petrified plants, and weathered rock.

In the midst of the dramatic social, political, and economic changes that ushered in the republican government in 1931, Alberto became politically radicalized. In the early 1930s, he contemplated abandoning art altogether, which he had come to regard as mere self-indulgence under the current conditions of crisis and injustice in Spanish society. Artists, he felt, might better assist Spain's poor and disenfranchised through practical work such as factory labor, rather than making art for a few wealthy collectors.

Alberto continued to engage in debates on the role of art in revolutionary change through the early 1930s. He found himself the center of controversy in

1935 when an article published in José Renau's communist-affiliated journal *Nueva Cultura* (New Culture) attacked Alberto along with other modern artists. The article alleged that the stylistic innovations in Alberto's art, despite his leftism, made his work elitist and difficult for the masses to understand. *Nueva Cultura,* in line with the artistic orthodoxy then in place in the Soviet Union, championed socialist realism as a genuinely revolutionary art. In his published reply, Alberto defended his allegiance to communist revolution, but maintained that such a revolution might also be served by nonrealist, though nonetheless politically committed, art.

After the outbreak of the Spanish Civil War in 1936, Alberto attached himself to the agitprop (agitation and propaganda) division of the Communist Party's Fifth Regiment. He produced stage sets and designs for traveling theater as part of the republican government's misiónes pedagógicas (pedagogical missions). The pedagogical missions were inaugurated in 1933 to combat the nearly 90 percent illiteracy rate of the Spanish populace. Films, lectures, libraries, art works, and theater productions were taken into the small villages and towns of the Spanish countryside and used for educational purposes; with the assistance of Alberto and other artists during the civil war, these missions also took on the propaganda role of rallying the Spanish people to the republic's defense.

In 1937, organizers of the Spanish pavilion at the Paris World's Fair invited Alberto to contribute a work to the display as part of the republican government's appeal to the world for assistance against Franco's rebel insurgency. His sculpture, titled *The Spanish People have a Path that Leads to a Star,* occupied a position in front of the pavilion entryway. Cast in concrete and towering 41 feet into the air, Alberto's work stood as a beacon of hope that beckoned visitors to the pavilion and its story of Spain's achievements and current crisis. Typical of the semiabstract natural forms of his work during this period, Alberto's pavilion sculpture resembles a large-scale petrified cactus painted in earth tones. A snake-like tendril spirals up the sculpture's shaft, past a bird perched on the cactus's branch, and culminates in a starlike shape at the top. The work aptly illustrates Alberto's notion of modernist stylistic innovation wedded to an explicit political content that, in this case, held out hope for the eventual triumph of the Spanish people over fascism. After the closing of the Paris World's Fair in November 1937, the sculpture disappeared in its transit back to Spain.

At the end of 1938, the republican government sent Alberto to the Soviet Union to teach Spanish children who had taken refuge there. He remained in Moscow after the defeat of the republic in 1939. Alberto's modernist sculptures were out of step with the socialist realism sanctioned by the Soviet art world during this period. He found work instead doing costumes and set designs for Russian productions of Spanish plays. After the death of Stalin in 1953 and a thaw in Soviet cultural policy, Alberto was able to return to producing and exhibiting semiabstract sculptures similar to his earlier work. Alberto died in Moscow in 1962. The Fundación Alberto (Alberto Foundation), dedicated to Alberto's life and works, was established in Madrid in 1974 on the eve of Franco's death.

Salvador Dalí (1904–1989)

One of the most prolific painters and sculptors of the twentieth century, Salvador Dalí is also among the best known. His flamboyant personality established his reputation as a leading, though controversial, figure in the surrealist movement of the 1920s and 1930s. Born in Figueres, Catalonia in 1904, Dalí first became interested in painting through his contact with the impressionist painter Ramon Pichot, an associate of Picasso. In 1921, he entered the Real Academia de Bellas Artes de San Fernando (San Fernando Academy of Fine Arts) in Madrid.

Dalí followed the latest developments of European post-impressionism and futurism, but also introduced into his work elements that revealed his abiding admiration for the Spanish masters Velázquez and El Greco, as well as Leonardo and Michelangelo of the Italian Renaissance. His first solo show took place in 1925 at the Galería Dalmau in Barcelona. He became involved in Barcelona's artistic avant-garde during this period, publishing essays in avant-garde journals, designing stage sets, and producing book illustrations.

By the late 1920s, Dalí began to gravitate toward the surrealist movement. Founded in Paris in 1924 by the poet and writer André Breton, surrealism preached a "revolution" of the unconscious mind as a necessary stage on the way to revolutionary political change in contemporary European society. Inspired by the psychoanalytic theories of Sigmund Freud, the surrealists explored dreams as a key to the unconscious. They also tried by various means (including holding séances and ingesting narcotics and alcohol) to liberate their unconscious desires as a source, they believed, of more authentic, uninhibited means of creative expression. The group took its name from Breton's manifesto published in 1924 that described the group's revolutionary aim as one dedicated to wedding dream and reality into a superior, or "sur-reality."

In one of his first surrealist endeavors, Dalí collaborated with the Spanish filmmaker Luis Buñuel. In 1929, the two produced *Un Chien Andalou* (The Andalusian Dog), an experimental film that attempted to simulate the dream experience. After the film's screening in Paris, Breton approached Dalí about becoming a member of the surrealist group. In 1929, Dalí had his first one-man show in Paris at the Camille Goemans Gallery. Breton's preface to the catalogue introduced Dalí to the Parisian art public as a leading member of the group: "With the coming of Dali," Breton stated, "it is perhaps the first time that the mental windows have opened really wide."[1]

In his work titled *The Persistence of Memory* from 1931, Dalí reveals his characteristic surrealist style. Using linear perspective, cast shadows, and exacting detail, Dalí suggests a realistic seaside landscape of sand, cliffs, and water. In the foreground, however, is a gelatinous, sluglike creature, composed of eyelash, nose, and tongue, lying prone on the ground. Draped over the creature is a clock that appears—implausibly, as in a dream—to have melted in the sun. Dalí includes three other clocks in the composition, each rendered with similar exacting detail: one drapes over a barren tree limb, another oozes

over the side of a platform in the left foreground, and a third, beginning to decay, is devoured by a hoard of ants. Such realistic illusionism applied to the dreamlike captured the surrealist ambition to combine reality and dream into a superior surreality.

Dalí became most notorious in the late 1920s and early 1930s for his works that flaunted social and sexual taboos. In *The Lugubrious Game* (1929), also rendered with exacting illusionistic detail, Dalí presents a painted collage filled with images of human sex organs—breasts, penises, and vaginas—as well as various sexual acts, including masturbation and sodomy. Dalí also began to work in assembled sculptures during this period, such as his *Scatological Object functioning Symbolically* (1931), where he explored his fetishistic fascination with women's high-heeled shoes.

Though Dalí continued to exhibit with the surrealists in the 1930s, he ran afoul of Breton and other members of the group when his love of provocation led him to break one taboo too many. Breton and several other surrealists declared their political commitment to the struggle against fascism by joining the Communist Party in the late 1920s. They became enraged when Dalí claimed a fetishistic fascination with Hitler. "I was fascinated by Hitler's soft, fleshy back, which was always so tightly strapped into the uniform," Dalí reminisced years later.

> Whenever I started to paint the leather strap that crossed from his belt to his shoulder, the softness of that Hitler flesh packed under his military tunic transported me into a sustaining and Wagnerian ecstasy that set my heart pounding, an extremely rare state of excitement that I did not even experience during the act of love.[2]

Driven out of the surrealist group for his politically indiscriminate fantasies, Dalí began to establish his reputation in the United States. In 1934, he had a celebrated exhibit at the Julian Levy Gallery in New York. He soon began to collaborate with the fashion designer Elsa Schiaparelli, with whom he created jewelry and women's fashions. Dalí also did a few window displays in downtown New York, in which he adapted surrealist notions of fantasy and desire to the needs of mass advertising and the fashion industry. As a measure of his growing popular appeal inside and outside the U.S. art world, *Time* magazine featured Dalí on its front cover in 1936.

Dalí responded to the outbreak of war in his native Spain with a painting titled *Soft Construction with Boiled Beans: Premonition of Civil War* (1936). In symbolic reference to Spain's self-destruction through civil conflict, Dalí depicts, in his characteristic surrealistic style, a human figure that has torn itself asunder into disconnected and reconfigured parts of arms, legs, breasts, and buttocks. The sense of physical and psychic torture is enhanced by the figure's face, which appears contorted in unbearable agony.

Dalí formally immigrated to the United States in 1940, where he remained throughout World War II. In 1941, the Museum of Modern Art in New York hosted a retrospective of his career. The following year, Dalí published his au-

tobiography titled *The Secret Life of Salvador Dalí*. After World War II, he did sketches for Walt Disney cartoons and, in 1946, designed a dream sequence for Alfred Hitchcock's film *Spellbound*. In 1949, Dalí returned to Spain. Paintings of his later years reflected Dalí's growing interest in atomic physics, science, and Christian mysticism. In 1974, the Dalí Museum was established in his home-town of Figueres in Catalonia; he was buried there after his death in 1989. Salvador Dalí willed his entire estate to the Spanish nation.

Joan Miró (1893–1983)

Joan Miró, the son of a goldsmith, was born in Barcelona in 1893. He began formal artistic training in 1907 at Barcelona's Escuela de Bellas Artes (School of Fine Arts), where Picasso had studied 12 years before. In 1911, suffering from depression and an attack of typhus, Miró retreated to his parents' country house in Montroig, located south of Tarragona, where he developed an interest in nature and the simplicity of rural existence that remained with him throughout his career.

In 1915 he took drawing lessons at the Círculo Artistico de Sant Lluk (St. Luke Artistic Circle). His paintings of these early years, characterized by bold color and prismatic forms, reflected his studies of fauvism and cubism. In 1919, he moved to Paris, where he called on Picasso, whose family he knew from Barcelona. Picasso encouraged Miró and helped him to establish himself in the Parisian avant-garde.

Miró's painting *Harlequin's Carnival* of 1924–1925, represents his break-through to a distinctive style. In a work that plays with the relationship between surface patterning and three-dimensional depth, Miró fills a stark interior space of neutral-colored walls with whimsical, brightly colored biomorphic forms—semiabstract motifs resembling snakes, birds, fish, cats, and insects—that appear to hover on the two-dimensional surface of the picture plane.

André Breton, founder in 1924 of the French surrealist movement in Paris, attempted to recruit Miró for the surrealist group. Breton recognized in Miró's work a surrealist penchant for the dreamlike and fantastic. Although Miró never joined Breton's group, he contributed works to several surrealist exhibitions of the mid-1920s. By the late 1920s, Miró began to experiment with collage and explored the boundaries of art by using unusual, nonart materials.

Miró's works of the early 1930s resonated with the civil chaos that began to engulf his native Spain. From 1934 to 1936, he produced his *Wild Paintings*, a series of images rendered in acid-colored pigments mixed with sand and tar applied to cardboard or paper. Miró filled his *Wild Paintings* with grotesque, demonic human forms engaged in scenes of sexual violence and aggression.

With the beginning of the Spanish Civil War in 1936, Paris became Miró's home in exile. A friend of the architect José Luis Sert from their years together in Barcelona, Miró was approached by the organizers of the Spanish pavilion for the Paris World's Fair of 1937 to produce works for Sert's structure. Taking

over the interior stairwell between the second and third floors on the northeast corner of the pavilion, Miró covered the stairwell wall with a large-scale (18 feet and 1/2 inch by 11 feet and 11 3/4 inches) mural titled *The Reaper* or *Catalan Peasant in Revolt.*

In *The Reaper,* Miró adapts his semiabstract, biomorphic formal vocabulary to the rendering of the head, neck, and arms of a Catalan peasant, whose truncated torso appears to emerge directly from the earth. Painted in red, black, and white, the figure appears in the red woolen cap with curled peak typically worn by Catalan peasants. The image represents El Segador (The Reaper), an iconic hero of Catalan independence, rising up from the earth to do battle against his oppressors with a sickle defiantly held aloft in his right hand.

Miró produced a second version of *The Reaper* as a stenciled print, which was also displayed in the Spanish pavilion. Titled *Aidez l'Espagne* (Help Spain), the semiabstract head and torso of the reaper, again in red woolen cap, appear in bold, sharp-edged, graphic form. Rendered in brilliant yellow, red, black, and white against a blue background, the image served as a design for a French postage stamp intended to raise revenue for the Spanish Republic. In *Aidez l'Espagne,* the reaper raises a powerful, over-sized, clenched, right fist in the gesture that had become the symbol of the Spanish Republican loyalists and their resistance against Franco. Miró expressed his faith in eventual republican victory with a statement handwritten in French at the bottom of the print: "In the present struggle, I see on the Fascist side spent forces, on the opposite side, the people whose immense creative resources will give Spain an impetus that will astonish the world."

After Franco's victory, Miró settled in the village of Varengeville on the Normandy Coast, where he produced childlike paintings filled with abstract stars, birds, and flowers reminiscent of his earlier works inspired by the countryside around his family farm at Montroig. In 1940, he returned to Spain and lived in quiet seclusion under Franco's regime. In 1941, the Museum of Modern Art in New York staged the first major retrospective of his work, which brought him international attention for the first time. In 1944, Miró completed a series of 50 black and white antiwar lithographs titled *Barcelona,* which he had begun in 1939. As Spain's cultural isolation began to dissipate during the Cold War, Miró maintained a prolific career and achieved ever-greater fame outside Spain for his paintings, sculptures, murals, and works in ceramic. He also created posters for political causes such as Amnesty International.

Between 1972 and 1974, several large retrospectives of Miró's art were held in New York, London, and Paris. After Franco's death in 1975, he began to enjoy acclaim in his native country. In 1978 the Museo Español de Arte Contemporáneo (The Spanish Museum of Contemporary Art) in Madrid held a major Miró retrospective. In 1975, the year of Franco's death, the Fundació Joan Miró (Joan Miró Foundation), dedicated to his life and work, was founded in Barcelona. The foundation building was designed by Miró's lifelong friend, José Luis Sert. Joan Miró died in 1983.

Pablo Picasso (1881–1973)

Avant-garde painter, sculptor, and printmaker, Pablo Picasso ranks as one of the most important artists in the history of twentieth-century art. Born in Málaga in 1881, he had his first painting lessons from his father, who was a teacher of drawing at the Escuela Provincial de Bellas Artes (Provincial School of Fine Arts). The family moved to Barcelona in 1895. At age 14, Picasso passed exams to enter senior courses at Barcelona's Escuela de Bellas Artes (School of Fine Arts). He soon became involved with artists and intellectuals of the Catalan modernist movement who regularly congregated at Els Quatre Gats (The Four Cats, in Catalan), a bohemian café in Barcelona. He also associated with anarchist circles during this period, but generally refrained from incorporating any discernible political content into his work.

Picasso began to travel to and exhibit in Paris in these early years, soon gaining international notoriety for his canvases, which were inspired by turn-of-the century symbolism, art nouveau, and the work of Spanish masters such as El Greco. In 1904, he moved to Paris; three years later, he met the French painter Georges Braque. Working together, Picasso and Braque developed cubism, one of the most significant stylistic developments in the history of Western modernism. Building on the lessons of Paul Cezanne's art, Picasso and Braque dismantled the conventions of rational perspective—the naturalistic portrayal of objects in a coherent, three-dimensional space—that had dominated Western art since the time of the Italian Renaissance. In *Desmoiselles d'Avignon* (Women of Avignon) from 1907, one of his first cubist paintings, Picasso applied this aesthetic to the portrayal of nude women in a brothel. The result is a work of savage intensity in which the women, rendered simultaneously from a variety of different perspectives, appear twisted, contorted, and fragmented by the prismatic color planes that define their bodies as well as the space they inhabit.

In 1912, Picasso introduced collage into the avant-garde art scene with works such as his *Still Life with Chair Caning*. He explored the boundary between art and nonart through the use of unusual materials in his work. *Still Life with Chair Caning* incorporates various nonart materials, such as a piece of oil cloth embossed with a chair caning design, scraps of newspaper, and rope, into the high-art format of an oil painting.

Picasso remained in France during World War I, where he was able to continue to paint and produce stage designs for Serge Diaghilev's Ballets Russes (Russian Ballet). He abandoned the formal experiments of cubism and collage and turned to a more traditional, neoclassical form of painting. *Three Women at the Spring* of 1921 is typical of Picasso's art during this period. Unlike the fractured prisms of his earlier semiabstract cubist work, Picasso uses figural solidity and coherent, three-dimensional space in his rendering of *Three Women at the Spring,* a depiction of women dressed in classical garb reminiscent of ancient Greece and Rome.

Picasso soon returned to a more abstract handling of form, and many of his portrayals of the female nude from the mid-1920s onward resumed the troubled

and threatening erotic content expressed in his *Demoiselles d'Avignon* of 1907. André Breton, founder of the surrealist movement in 1924, saw the disturbed sexual subject matter of Picasso's work as an example of surrealism's interest in exploring all forms of psychic repression, including dreams and sexual taboos. Though Picasso maintained his independence from the group, he nonetheless contributed to the first surrealist exhibit in 1925. He also allowed his work, including *Desmoiselles d'Avignon,* to be reproduced in the pages of Breton's journal, *La Révolution surréaliste* (The Surrealist Revolution), which published surrealist art and literature between 1924 and 1929. In 1933, Picasso designed the first cover for the surrealist journal *Minotaure* (Minotaur, named after the half-man, half-bull creature of Greek mythology).

With the election of a Popular Front government in France in May 1936 and the beginning of the Spanish Civil War two months later, Picasso became more politically involved than he had been in his career to date. He produced images that were carried in the streets of Paris during Popular Front demonstrations over France's worsening economic crisis and the spread of fascism in Europe. He also contributed stage sets for revolutionary Popular Front plays. Concerned by developments in his native Spain, he accepted the Spanish Republic's request in 1936 that he serve as director of Madrid's Prado Museum, a role he fulfilled from his exile in Paris. In January 1937, he completed a series of drawings titled *The Dream and Lie of Franco* in which he portrayed Franco as a grotesque polyp; copies were sold to raise money for the republic. While finishing the series, Picasso was approached by organizers of the Spanish pavilion at the Paris World's Fair of 1937 to lend his artistic services to the pavilion's propagandistic purpose.

Picasso's contribution, titled *Guernica,* occupied the long wall of the pavilion's ground floor. Picasso set about the work after hearing and reading reports of the saturation bombing by Hitler's Condor Legion of the small town of Guernica, located in the Basque region on Spain's northern coast. Rather than produce a realistic portrayal of the event, Picasso recycled motifs of women, bulls, and horses—long present in his earlier work—for an allegorical presentation of war's disaster. The figures shout, scream, and collapse in a claustrophobic space while looking skyward towards an unknown and unseen menace. Picasso used a cubist fragmentation of pictorial space in *Guernica* to further enhance the sense of dislocation and destruction to the human body and its surrounding environment caused by the use of ferocious, mechanized warfare.

Like the rest of the world, Picasso poured over news reports in which Franco denied any involvement in the attack and instead accused republican forces of the atrocity. Using a restricted palette of black, gray, and white, Picasso evoked the very media of photos and print journalism through which he learned of the event and its unresolved aftermath. The search for the truth, the desire to shed light on what transpired at Guernica, forms the expressive core of Picasso's painting. One figure, clutching a lamp in its hand, leans its head and arm through a window into the interior space where the calamity unfolds. Combined with the light cast from a ceiling light bulb, the lamp illuminates the figures below, including a screaming horse, a woman clutching her dead child in her

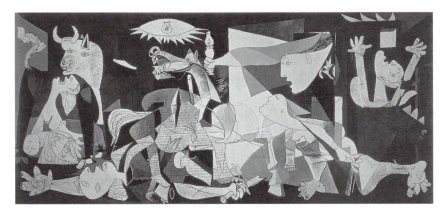

Pablo Picasso, *Guernica*, 1937. © Centro de Arte Reina Sofía, Madrid, Spain/A.K.G., Berlin/Superstock.

arms, and a warrior, who has fallen from the horse and lies prone on the ground with a severed arm and broken sword.

After the closing of the Paris World's Fair in November 1937, the painting traveled in order to raise funds for the republic. It ended up at the Museum of Modern Art in New York in 1939 in connection with a major retrospective of Picasso's work. Following Picasso's wishes, the painting remained there as long as Spain continued to exist under Franco's dictatorial rule.

With Hitler's invasion of France in 1940, Picasso continued to live in his Paris studio and privately pursue his work. After France's liberation in October 1944, he joined the French Communist Party. He produced a number of works supportive of the Communist Party cause and attended several peace conferences that were held during the Cold War. In 1950, he was awarded the Lenin Peace Prize by the Soviet government. Picasso maintained his stature as a major avant-garde artist and prolific painter, sculptor, and printmaker up until his death at age 91 in 1973.

During World War II and the Cold War, Picasso's *Guernica* grew in stature as a timely emblem of creative and individual freedom opposed to the forced conformity and lack of freedom under dictatorial rule, whether fascist or communist. In 1981, *Guernica* came home to Spain and was housed in the Casón del Buen Retiro exhibition hall of Madrid's Prado Museum. Beginning with the Vietnam War of the 1960s and continuing up through global protests of the invasion of Iraq by U.S. and British forces in 2003, Picasso's *Guernica* has become a revered emblem, frequently reproduced and carried in demonstrations, of the international antiwar movement.

Inside Spain, the work continues to be the focus of simmering tensions surrounding persistent Basque separatist demands for political autonomy. The most recent controversy erupted in 1997, when the U.S. architect Frank Gehry completed his extraordinary, titanium-clad Guggenheim Museum located in Bilbao, the industrial capital of the Basque region. Gehry included a special space on

the third floor of the museum for the display of *Guernica* during the museum's opening ceremonies. Requests to have the painting on loan from Madrid were denied by a Spanish government fearful that the painting would remain in Basque hands. Now declared too fragile to travel, *Guernica* is on permanent display at the Museum Reina Sofía in Madrid.

José Renau (1907–1982)

José Renau was born in Valencia in 1907. His father, a painting restorer, taught drawing at Valencia's Escuela de Bellas Artes de San Carlos (San Carlos School of Fine Arts). Renau studied painting at the San Carlos school until 1926. He subsequently worked in commercial advertising and graphic design. In 1928 he had his first solo show at the Circulo de Bellas Artes (Circle of Fine Arts) in Madrid, where he exhibited paintings and prints.

In the late 1920s, Renau became politically radicalized and joined the growing protest movement against Spain's military dictatorship. In 1929, he came across photomontages by the German artist and Communist Party member John Heartfield, displayed in a Valencia bookstore. Heartfield gained international recognition among the left in the 1920s for his politically charged works in which he combined disparate photographic images, taken out of their original context and juxtaposed with one another, to make a critical point. For Heartfield and other photomontage artists of the period, such juxtapositions revealed a deeper truth that lay behind photography's claim to represent "reality." Speaking some years later, Renau described photomontage as "a way of X-raying visual reality. It is the only way," he continued, " to make the spectator visualize absurdity, to make two levels of existence coincide in the same space. This is what I call true realism."[3]

In 1931, Renau became a Communist Party member. He began to publish some of his critical photomontages in which he appropriated and recombined postcard, press, and advertisement photos. Photomontages by Renau, featured in the journals *Orto* and *Estudios* between 1929 and 1937, often employed satire in addressing such topics as abortion rights, religious repression, and social injustice.

Between January 1935 and October 1937, Renau edited the Communist Party-affiliated journal *Nueva Cultura* (New Culture). *Nueva Cultura* condemned the stylistic experimentations of modernist art as elitist and incomprehensible to the masses. The journal advocated instead Soviet socialist realism, comprised of easily legible images and politically directed content, for which Renau's photomontages served as an example. *Nueva Cultura* sold for a low price and served to disseminate the republic's call for resistance to fascism during the Spanish Civil War. Renau designed socially critical covers of the journal and published in its pages his "photo novel" titled *Testigos negros di nuestro tiempo* (Black Testimonials of Our Time). The photo novel functioned like an extended photomontage, as readers were encouraged to draw connections between one photograph and

the next while paging through the journal. Renau's *Black Testimonials* assailed patriarchy, nationalism, and fascism in contemporary Spanish society.

When the Soviet Union took control of the Spanish Republican government in late 1936, Renau became the republic's Director General of Fine Arts. In 1937, he published an article on the "Social Function of the Poster" and wrote admiring articles on the propaganda posters of Soviet Russian artists El Lissitzky and Alexandr Rodchenko. Renau produced a number of his own propaganda posters during this period in which he used his talents as a trained graphic designer to create bold and graphic images and slogans intended to rally support for the republican cause. He also took charge of producing and installing the photomontages that appeared both inside and on the exterior façade of the Spanish pavilion at the Paris World's Fair of 1937. His pavilion photomontages showed the republic's improvements in literacy, schools, hospitals, labor conditions, and help for the young and old juxtaposed with images that told the story of Spain's ongoing destruction by Franco's insurgency.

Renau fled into exile in Mexico after Franco's victory in 1939. Between 1949 and 1966, he worked on a photomontage series titled *The American Way of Life* in which he dissected U.S. capitalism and imperialism. Appropriating and recombining photos from U.S. illustrated journals and newspapers such as *Look, Life, Fortune,* and *The New York Times,* Renau contrasted American icons of liberty and freedom with images of poverty, the Ku Klux Klan, and U.S. military interventions such as the Korean War and the dropping of the atomic bomb on Hiroshima at the end of World War II. He also counterposed images of commercialized feminine beauty seen in U.S. advertising with photos of famine in other countries. With such comparisons Renau implicated the excesses of American consumerism in the suffering of impoverished peoples around the globe. In 1958, José Renau moved to East Berlin, where he died in 1982.

Notes

1. André Breton, "The First Dalí Exhibition," catalogue preface. Cited in Briony Fer, David Batchelor, and Paul Wood, eds. *Realism, Rationalism, Surrealism: Art between the Wars* (New Haven, CT: Yale University Press, 1993), 200.

2. Salavador Dalí, *Journal d'un génie* (Paris, 1964). Cited in Robert Descharnes and Gilles Néret, *Salvador Dalí, 1904–1989* (Cologne, Germany: Taschen, 1993), 104.

3. José Renau, interview by Carole Naggar, December 28, 1977, in "The Photomontages of José Renau," *Artforum* 17 (Summer 1979): 32–36.

Bibliography

Chipp, Herschel B. *Picasso's Guernica.* Berkeley: University of California Press, 1988.

Daniel, Marko. "Spain: Culture at War." In *Art and Power: Europe under the Dictators 1930–45,*edited by Dawn Ades, Tim Benton, David Elliott, and Iain Boyd Whyte, 63–68. Exhibition Catalogue. London: Thames and Hudson, 1996.

Freedberg, Catherine Blanton. *The Spanish Pavilion at the Paris World's Fair.* 2 vols. New York: Garland Publishing, 1986.

Martin, Rupert, and Frances Morris. *No Pasarán! Photographs and Posters of the Spanish Civil War.* Exhibition catalogue. Bristol, England: Arnolfini Gallery, 1986.

Martin, Russell. *Picasso's War: The Destruction of Guernica, and the Masterpiece that Changed the World.* New York: Dutton, 2002.

Naggar, Carole. "The Photomontages of José Renau." *Artforum* 17 (Summer 1979): 32–36.

Oppler, Ellen C., ed. *Picasso's Guernica.* New York: W. W. Norton and Company, 1988.

Tisa, John, ed. *The Palette and the Flame: Posters from the Spanish Civil War.* New York: International Publishers, 1979.

Trueba, Josefina Alix. "Alberto Sánchez." In *Art and Power: Europe under the Dictators 1930-45,* edited by Dawn Ades, Tim Benton, David Elliott, and Iain Boyd Whyte, 111–14. Exibition Catalogue. London: Thames and Hudson, 1996.

Vernon, Kathleen, ed. *The Spanish Civil War and the Arts.* Ithaca, NY: Cornell University Center for International Studies, 1990.

Whelan, Richard. *Robert Capa: A Biography.* New York: Knopf, 1985.

———. *Robert Capa: The Definitive Collection.* London: Phaidon, 2001.

CHAPTER 9

Artists in the United States: Selling War and Peace in the "American Century"

Two vast oceans promised to insulate the United States from the violent spread of dictatorship in Europe and Asia during the early phases of World War II. This false sense of security came to a swift and brutal end on December 7, 1941,when Japan launched a surprise attack on the U.S. naval base at Pearl Harbor in Hawaii. Within a matter of hours, the U.S. fleet stationed there was destroyed, with nearly 3,000 killed and some 1,300 injured. America declared war on Japan the next day. Three days later, on December 11, Germany and Italy—Japan's partners in the "Axis" alliance—retaliated by declaring war on the United States. With Britain under German siege, China rent asunder by Japanese invasion, and France's democratic government driven into exile, the United States found itself called upon to take the lead in the defense against global tyranny.

Unlike other combatant nations such as Germany, the Soviet Union, or Great Britain, the U.S. government displayed only marginal interest in building a war art program. A mass media campaign, including film and advertising as well as photography, painting, and drawing, nonetheless saturated U.S. visual culture during World War II. Movie houses, billboards, illustrated journals, and exhibitions were filled with works designed to rouse American support for the war. The main catalyst for the production of such wartime propaganda was not, however, the U.S. government.

Instead, big business sponsors—anxious to demonstrate their patriotic loyalty—spearheaded such efforts. Corporations sought to win over an American public still recovering from the Great Depression of the 1930s, an economic calamity for which many continued to hold big business responsible. Sponsorship of war-related art and mass media thus served corporate America as an important source of legitimacy in the 1940s.

In 1941, media mogul Henry Luce envisioned the World War II experience as a turning point for the United States' standing in the world. In the pages of his popular *Life* magazine, he declared the dawn of an "American Century" as a war-torn Europe struggled to fend off the Nazi threat.[1] Luce, whose publishing empire was intimately involved in the war campaign, looked forward above all in the "American Century" to a postwar order of American economic, social, and political—as well as cultural—dominance in a world in which U.S. corporate capitalism would play a central role. Many artists active in the war effort thus became involved not only in rallying public support for U.S. entry into the war, but also in envisioning a future world society molded in the image of a distinctly American peace.

The United States and Its Art World before World War II

Hundreds of leading European artists and intellectuals found safe haven in the United States from tyranny during the World War II years. Their presence in New York and other major cosmopolitan centers in the 1930s and 1940s profoundly reshaped the American art world. They and their work helped to erode long-standing American resistance to foreign cultural influence and avant-garde stylistic innovations. Fernand Léger, Marcel Duchamp, and other European artists who formed part of the World War II migration had been first introduced to the American art public over two decades before, on the eve of World War I.

In 1913, a landmark display titled the "International Exhibition of Modern Art" was unveiled in the spaces of Manhattan's 69th Infantry Regiment Armory. The Armory Show, as the exhibit came to be known, featured some 1,300 works by American artists as well as recent paintings, drawings, and sculptures by leading members of the European avant-garde. Léger, Duchamp, Pablo Picasso, and Wassily Kandinsky were among those represented by works ranging in style from cubism and futurism to expressionism and abstraction. The Armory Show constituted a groundbreaking display of the latest tendencies in the international art world. The American response, however, was generally uncomprehending, if not hostile. Critics used terms such as "degenerate" and "insane" to describe the bold, nonnaturalistic use of color and fractured pictorial structures present in the European works on exhibit; some railed against negative "foreign" influence and warned of the works' anarchistic threat to U.S. culture and values.

In the face of such resistance, photographer Alfred Stieglitz nonetheless pioneered efforts in the early part of the century to establish a viable U.S. vanguard capable of rivaling that of France, Germany, Italy, and other European wellsprings of innovative art. Through his journal *Camera Work* and 291 Gallery in New York City, Stieglitz promoted the work of Matisse, Picasso, and Cézanne, as well as tribal arts from Africa and the new medium of photography, which he helped to define as a legitimate and respected art form.

Above all, Stieglitz championed the work of such American artists as Max Weber, Marsden Hartley, and Arthur Dove, whose paintings defied mainstream U.S. taste for conventional figurative and realist art. In the 1920s, Stieglitz added to his circle Georgia O'Keeffe, who became famous for her semiabstract renderings of flowers. Charles Demuth and Charles Sheeler were among those associated with precisionism, one of several modern art movements that began to take off in the 1920s thanks to Stieglitz's trailblazing efforts.

The experimentalism and cultural optimism of the 1920s began to wane by the end of the decade, however. With the New York Stock Exchange crash of 1929, the Western industrialized world was plunged into the Great Depression. The collapse of the U.S. economy spelled the demise of the American art market. War, too, loomed on the horizon, announced by Hitler's appointment as German chancellor in 1933. American artists, whether vanguard or traditional, suddenly confronted a changed set of circumstances in which they were forced to reckon with the relationship between their art and unfolding events.

During the Depression, the American art world shied away from the more exaggerated stylistic innovations that had characterized European as well as American avant-garde art of the 1920s. Artists looked instead to ways in which their work could engage broader, more popular audiences and address the pressing social issues of the day. New artistic movements, such as social realism and regionalism, began to emerge in the early 1930s. Social realists used their art to address political repression, class exploitation, and racial conflict in Depression-era America. The regionalists, by contrast, developed idealized images that promoted the traditional values of America's Midwestern, agrarian "heartland." Social realists and regionalists alike rejected the obscurity and elitism of avant-garde art. They embraced instead more conventional, figurative, and readily accessible approaches to the rendering of subject matter.

Social realists and regionalists were among the many who benefited from job relief programs instituted by Franklin Delano Roosevelt shortly after he assumed the presidency in 1933. Roosevelt ushered in New Deal legislation in agriculture, banking, securities, and labor designed to initiate economic recovery, reverse the country's staggering unemployment rate, and stem the tide of growing social unrest. The Works Progress Administration (WPA) sponsored large-scale construction projects that created, among other things, the country's modern system of dams, roads, bridges, and hydroelectric power plants. Through the Public Works of Art Project (PWAP), the Federal Arts Project (FAP), and the Farm Security Administration (FSA), the New Deal also launched the most extensive federal art program in the nation's history. To this day, Post offices and government buildings around the country contain murals and other works of art that were created under the auspices of the program. More than 40,000 artists—musicians, painters, actors, writers, and photographers—benefited from the WPA over its decade of existence.

By the late 1930s, however, growing discord over government sponsorship of the arts emerged. Conservative congressional critics took offense at several instances in which left-wing artists had used WPA commissions to protest current problems of social and economic injustice. Others opposed to the WPA art

programs cited the negative examples of Germany, the Soviet Union, and Japan, where government sponsorship was used to repress freedom of expression and subordinate the arts to overt propagandistic manipulation. During the Depression, federal arts support had been viewed as an important aspect of economic recovery, the construction of a national culture, and the safeguarding of the American way of life. Under the circumstances of war and dictatorship in the 1940s, however, such support increasingly came to be seen as antithetical to American values and potentially injurious to freedom of expression. By the time Hitler invaded Poland on September 1, 1939, the WPA art programs were all but dead.

In June 1940, France fell to Hitler's invading forces. Two months later German troops launched an assault across the English Channel in what became known as the Battle of Britain. Though the United States had thus far remained out of the war, the Roosevelt administration instituted conscription in September 1940 to ready an army of 2 million combat troops and reserves. Following an appeal from British Prime Minister Winston Churchill for an end to U.S. isolationism, Congress signed into law the Lend-Lease Act of March 1941 that allowed American material support for Britain and its Allies. Roosevelt also imposed a crippling oil embargo on Japan in an effort to halt Japanese imperialist aggression in the Asian Pacific.

America's Artists in World War II

On December 7, 1941, Japan retaliated against the U.S. oil embargo with the destruction of the American naval fleet at Pearl Harbor. On December 8th, the United States declared war on Japan; on December 11th it also declared war on Germany and Italy. Fundamentally unprepared for combat, the United States suffered a string of military defeats in the first six months of 1942. As fear and xenophobia mounted at home, the government ordered, on February 19, 1942, the internment of Japanese-Americans living on the West coast. Deprived of their rights and livelihoods as U.S. citizens, upwards of 110,000 Japanese-Americans remained in hastily established and deplorably maintained concentration camps until the end of the war.

Three days after Pearl Harbor, on December 10, 1941, over 30 national organizations representing over 10,000 artists formed the Artists for Victory association. With WPA art programs all but defunct and in the absence of any plans for a government war art program, members of the association voluntarily pledged their talent and work to further the war effort. Sponsoring patriotic exhibitions throughout the war years, Artists for Victory members also secured commissions from some of the various federal agencies that soon began, despite the lack of any centralized and coordinated effort on behalf of the U.S. government, to seek out artists for wartime propaganda campaigns.

One such agency was the Office of Emergency Management (OEM). Along with the Office of Facts and Figures (OFF) and the Office of Government Re-

ports (OGR), the OEM was responsible for handling war information. Shortly after Pearl Harbor, the OEM's Section of Fine Arts held a national competition in which it invited artists to portray the war; 1,189 artists participated. The OEM purchased 109 of the submitted works for display in a war art show, which was unveiled at the National Gallery of Art in Washington, D.C. in February 1942. The OEM's Section of Fine Arts also appointed eight recognized U.S. artists—George Harding, Richard Jansen, Ogden Pleissner, Howard Cook, Reginald Marsh, Carlos Lopez, Mitchell Jamieson, and David Fredenthal—to create paintings and drawings devoted to the military and wartime industry.

Lack of coordination between the OEM, the OFF, and the OGR led to mounting criticism about the quality and consistency of communication between the government and the public as the war progressed. On June 13, 1942, Roosevelt responded to such concerns by signing an executive order that consolidated all three agencies under a new Office of War Information (OWI). Elmer Davis, a former radio commentator, was appointed OWI director. From the outset, Davis wrestled with the relationship between democratic principles of the public's right to know and the military's desire to manipulate access to the truth. While Davis managed to maintain one of the freest presses of any country involved in World War II, public understanding of events was nonetheless carefully orchestrated to prepare citizens for sacrifice and foster a unified home front. The OWI maintained a "chamber of horrors" to which it consigned combat photographs of dead and wounded U.S. soldiers censored at the insistence of the military. Such works were deemed too demoralizing for the public and contrary to the goal of rallying public support for the war effort.

A policy of carefully calibrated censorship was not enough, however, to guarantee sustained public commitment to the cause. An opinion poll taken in mid-1942 indicated that 3 out of 10 Americans, despite the recent shock of Pearl Harbor, desired a negotiated settlement with the Axis powers. Seeking to counter such lingering isolationism, the OWI turned to the powerful resources of the film and advertising industries to assist the agency in an all-out propaganda effort. Many such industries had already rallied to the war and were eager to prove further their patriotic support.

Major Hollywood film producers, for example, formed their own Motion Picture War Activities Committee shortly after Pearl Harbor. Members of the committee were now asked to head up the OWI's Bureau of Motion Pictures. MGM, Paramount, Fox Movietone, and Universal produced thousands of patriotic newsreels that were monitored by the OWI and seen in theaters across the country by millions of Americans. Moviehouses screened Hollywood films throughout the war years that promoted social harmony at home and the will to fight abroad. Among such efforts, Frank Capra's seven-part series titled *Why We Fight* became required viewing for soldiers and was also released to the general public. Even Donald Duck and Mickey Mouse joined the campaign by taking on military and civil defense tasks in Walt Disney's wartime cartoons.

Like their film industry counterparts, advertising executives voluntarily formed a Graphic Arts Victory Committee to coordinate their work with the

government. Members joined the OWI to develop effective advertising and printed materials for the government's War Loan campaigns. War Loan drives, which exhorted ordinary citizens to invest in the war effort, functioned above all to solidify public involvement in and direct identification with the military campaign. The Department of Treasury organized seven War Loan campaigns during the war and a Victory Loan drive at the war's conclusion.

Many prominent artists, such as the regionalist painter John Steuart Curry, were brought on board to create war bond posters that were mass reproduced and disseminated around the country. In images such as *Our Good Earth, Keep it Ours* (1942) and *The Farm is a Battleground* (1943), Curry adapted his 1930s regionalist imagery of the American Midwest to the current needs of the war effort. By emphasizing the dignity and heroism of the strong American farmer, his works promoted defense of the heartland as a rationale for entering the conflict. Like the American farmer who served his country by doing his job well in the face of adversity, Curry's posters suggested that the American public could similarly demonstrate its selflessness and patriotic service by purchasing war bonds. This marriage of art, advertising, and militarism proved a resounding success, not only in raising funds for the war, but also in bolstering public support for the cause. In December 1943, Ted R. Gamble, the director of war finance for the Treasury Department, boasted to Congress that the War Loan campaigns had proven "the greatest advertising operation in the history of the world."[2]

The War Department, meanwhile, attempted to establish a program—modeled on that of Great Britain—for the purpose of creating a lasting legacy of art commemorating U.S. involvement in World War II. In spring 1942, the Department formed an Art Advisory Committee chaired by George Biddle, a social realist painter who had been instrumental in urging the development of Roosevelt's New Deal art programs of the 1930s. The Art Advisory Committee included Biddle; artist Henry Varnum Poor; David Finley, the director of the National Gallery of Art; Edward Rowan, the director of the Treasury Department's Section of Fine Arts; Reeves Lewenthal, the president of the Associated American Artists; and John Steinbeck, the acclaimed novelist.

The committee selected 23 artists in uniform and 19 civilians to go to fronts around the world. Soldier-artists received their standard commission, while civilian artists attached to the program were paid $3,800 a year plus travel and supply costs. They were deployed in war art units of two to five men each and placed under the command of the U.S. Army Chief of Engineers. Joe Jones, Henry Varnum Poor, Aaron Bohrod, George Biddle, and others traveled to combat fronts in Europe and the South Pacific as part of the program. Biddle spent six weeks sketching in Tunisia and Italy with the U.S. 3rd Infantry Division. Though the program had a meager start-up fund of $33,500 and ran on a shoestring budget, Congress nonetheless axed it in 1943 as a frivolous expenditure. War artists, some of whom were still at the front on assignment, found their commissions abruptly canceled. Several were absorbed into the Army Corps of Engineers and other branches of the government and armed services.

Biddle, who was in Tunisia at the time, was solicited by Henry Luce to contribute his drawings from the front as a war artist correspondent to Luce's *Life* magazine, a lavishly illustrated journal that appeared for the first time in 1936. Biddle's work appeared alongside some of the many lengthy photo essays developed by Luce's staff of war photographers, including those by Margaret Bourke-White. Bourke-White (who covered Moscow under bombardment and the Italian campaign) was among the limited number of photographers granted clearance by the Pentagon to enter combat zones. The documentary quality of photographs, as well as the speed with which they could be produced and transmitted to the home front, made them an especially invaluable—and sensitive—propaganda tool. *Life's* combat photos, as well as their captions, were therefore throughout most of the war required to pass by censors before publication. The aims of the U.S. military and private media thus became indistinguishable as they worked in concert to shape public perception of the campaign. Providing firsthand visual records to an American public hungry for war-front news, *Life's* circulation figures quickly skyrocketed after Pearl Harbor. Its readership numbered in the tens of millions by 1942 and grew as the war progressed.

Abbott Laboratories, an international pharmaceutical firm based in Chicago, also launched a war art program during this period. Abbott hired regionalist painters Thomas Hart Benton and John Steuart Curry to create drawings and paintings depicting the role of the medical industry in the war effort. Curry accordingly produced a book dedicated to medical soldiers in training titled *Paintings of Army Medicine.* In 1943, Abbott commissioned Benton, along with painter George Schreiber, to render images of "silent service" aboard U.S. combat submarines. Such service was dubbed silent because of the Navy's need to keep its maneuvers secret in submarine warfare against the Japanese and Germans. Abbott published and distributed Benton and Schreiber's images in a volume titled *The Silent Service and Marines at War.*

Private industry became vital to the continued production of war art as government support, never large to begin with, dried up in the final years of World War II. Big business representatives also played a more commanding role within the OWI, which continued its loan drives and war propaganda initiatives through 1945. In 1943, growing strain erupted between corporate interests and liberal reformers within the agency. A case in point was the experience of Ben Shahn, a social realist artist and political leftist active in the OWI Graphics Division in New York in 1942 and 1943. During this period, a corporate-dominated OWI rejected several of Shahn's works in which the artist rallied support for the war abroad while also addressing problems of racism and class inequality at home.

Shahn's works reflected particularly on the plight of African Americans in the United States who continued to experience discrimination even though their services—and often their lives—were needed to help win the war. African Americans were treated as second-class citizens and compelled to serve in segregated units throughout the war. The OWI used its censorship authority to shield from public awareness race riots that periodically erupted at military bases in Louisiana, New Jersey, and elsewhere. Rather than avoid the problem,

Shahn was one among many liberals involved with the OWI who looked on the war as an opportunity to begin public dialogue on the problem of race in America. In one work rejected by the OWI, Shahn suggested that equality and unity between whites and blacks in America was needed not only to maintain a unified front against the enemy, but also to realize a genuinely democratic society in the postwar era to come. Titled *A Need for All in Time of War, a Place for All in Time of Peace,* Shahn portrayed a black welder standing beside a white welder, both at a moment of rest, proudly looking off into the distance—and the future—together.

In spring 1943, the OWI turned down another of Shahn's works for its current War Loan campaign. Titled *This is Nazi Brutality,* his image addressed the destruction of the population of Lidice, Czechoslovakia by German forces in June 1942. In the work, a lone and defenseless figure, his head shrouded in a hood and his wrists shackled, stands against a brick wall awaiting an executioner's bullet. With *This is Nazi Brutality,* Shahn pointed to the extremity of Nazi atrocities and Germany's ongoing assault on innocent life, while also bringing to mind the murderous specter of racist intolerance. Price Gilbert, former vice-president of Coca-Cola and member of the OWI, took exception to Shahn's piece and compelled the OWI to reject it on the grounds that it was too shocking for the American public. In April 1943, following this and similar incidents at the OWI, liberal members resigned from the agency in protest.

A series of paintings by illustrator Norman Rockwell were instead adopted, again at Gilbert's urging, for the OWI's War Loan campaign of spring 1943. Titled *The Four Freedoms,* Rockwell's images gave visual form to President Roosevelt's famous "Four Freedoms" speech, which he delivered as a State of the Union address shortly before Pearl Harbor in 1941. The "Four Freedoms"—freedom of speech, freedom to worship, freedom from want, and freedom from fear—quickly became a favored motto for the U.S. government, summarizing its rationale for armed intervention in the struggle against tyranny. In 1942, Artists for Victory sponsored an exhibition devoted to Roosevelt's "Four Freedoms"; the following year, Rockwell produced his famous *Four Freedoms,* which were featured as cover illustrations for the *Saturday Evening Post.*

The *Post,* owned by media giant Curtis Publishing, was one of the first popular journals to depend heavily on revenue from advertising. As the *Post's* most renowned illustrator, Rockwell was instrumental in forging the magazine's commercially successful relationship to America's white middle class. In Rockwell's *Four Freedoms,* parents tuck their peacefully slumbering children into bed (*Freedom from Fear*); a man stands and declaims his views while others respectfully look on (*Freedom of Speech*); people of various faiths fold their hands in silent prayer (*Freedom to Worship*); while a family sits down to a sumptuous Thanksgiving meal (*Freedom from Want*). After the OWI picked up Rockwell's paintings for its spring 1943 War Loan campaign, they were sent on national tour where they helped to raise $132 million in war bonds. The agency also produced a poster of Rockwell's *Four Freedoms* depicted underneath the caption "OURS...to fight for," which sold over 4 million copies. The bountiful, God-fearing, predominantly

white, middle-class world of Rockwell's *Saturday Evening Post* readership thus became synonymous with those American values to be defended and preserved against world tyranny.

In the aftermath of the controversy, Shahn responded to the OWI's rejection of his work with another poster, this time depicting the Statue of Liberty holding aloft a bottle of Coke (in reference to Gilbert's former status as a Coca-Cola executive), under the slogan "The War that Refreshes: The Four Delicious Freedoms." For Shahn and others, the OWI and corporate America's refusal to confront racial and economic injustice maintained the "social harmony" of a status quo wracked by enduring social problems. Feeding the public instead with positive and uplifting images also, and not incidentally, rendered America's citizens oblivious to soaring corporate profits while racism continued and workers were urged to make ever-greater sacrifices in the name of wartime patriotism.

On D-Day, June 6, 1944, Allied forces swept into France, liberating the country from Nazi control. A year later, on May 7, 1945, Germany's defeat was sealed. To break Japan's unrelenting will to fight on, the United States dropped two atomic bombs, one on Hiroshima and the other on Nagasaki, in early August 1945. At least 140,000 Japanese citizens were instantly incinerated with tens of thousands more dying in the following years from radiation poisoning. On September 2, 1945, Japan's Emperor Hirohito declared his country's unconditional surrender.

By war's end, U.S. combat losses numbered upwards of 400,000 soldiers, with over two-thirds of all casualties sustained in the final bloody months of 1944–1945. Roused from its isolationist stance by Pearl Harbor in December 1941, the United States had quickly transformed itself into an industrial giant whose technological superiority proved critical to the defeat of world dictatorship. Social realists, regionalists, and other U.S. artists became directly involved in producing images that forged popular willingness to sacrifice and endure the harrowing conflict. Their work also served the interests of big business and helped to create the conditions under which the United States emerged from the war the richest and most powerful nation on earth.

The direct involvement of regionalists and social realists in using their art to promote political and commercial concerns during the war years had negative consequences for their work after 1945. Leading critics in the art world came to regard the clear legibility and popular appeal of regionalism and social realism as mere propaganda, easily manipulated by nonartistic interests, and not worthy, in the end, of being called "art." Art world attention focused instead on the work of European exile artists, whose challenging explorations of surrealism and abstraction fundamentally reoriented the work of younger American artists during and after the war.

In 1942, Peggy Guggenheim opened her Art of This Century gallery in New York, where she showcased the work of several avant-garde artists whom she had helped escape to the United States. Like Alfred Stieglitz before her, Guggenheim not only showed advanced work by the European vanguard; she also provided exhibition space for younger experimental artists in the United

States. From this productive cross-fertilization emerged abstract expressionism, America's first internationally acclaimed avant-garde art movement. In 1944, the Museum of Modern Art in New York honored Jackson Pollock, abstract expressionism's most prominent representative, with the purchase and display of his painting titled *She-Wolf*. Pollock went on to develop his abstract, mural-sized "drip" paintings of the late 1940s and early 1950s for which he is best known today.

In the early part of the century, the United States was ambivalent about, if not hostile to, the foreign cultural influence of the European avant-garde. By the end of World War II, however, the American art world had come to regard the protection and promotion of such art as important to the self-definition of a free and pluralistic society challenged by fascist repression and intolerance abroad. In the postwar years, avant-garde art also became an important instrument in America's Cold War struggle against communist Russia.

In 1947, the U.S. Information Agency (USIA) harnessed abstract expressionism to its propaganda campaign against Soviet encroachment in postwar Europe. Critics widely proclaimed the "triumph" of American art as the USIA funded the display of works by Pollock and other abstract expressionists in European exhibitions during the early Cold War period of the 1940s and 1950s. Shown in such venues alongside "propagandistic" socialist realism from the Soviet Union, abstract expressionist paintings legitimated U.S. claims to a social order grounded on democratic freedom and the right to individual expression. Corporate America also patronized abstract expressionism and other U.S. vanguard art tendencies as testament to big business's progressive and forward-looking self-image in the postwar era. Such powerful government and business sponsorship assured America's leadership role after World War II in the international avant-garde.

U.S. Artist Biographies

Thomas Hart Benton (1889–1975)

Born in Neosho, Missouri in 1889, Thomas Hart Benton was the son of Missouri lawyer and Congressman, M. E. Benton. In 1907, he enrolled at the School of the Art Institute of Chicago. In 1908, Benton moved to Paris where he studied at the Académie Julian and spent time visiting the city's outstanding museums. Deciding to become an avant-garde painter, he began to explore the latest artistic tendencies of impressionism and post-impressionism. While in Paris, he met the Mexican artist Diego Rivera, whose large-scale murals of the 1920s would have a profound impact on Benton and other artists.

On his return to the United States in 1912, Benton settled in New York where he remained until 1935. In 1916, some of his early paintings were exhibited along with those of other American avant-garde artists in the "Forum Exhibition of Modern American Painters." Alfred Stieglitz was on the organizing commit-

tee for the exhibit, which was modeled on the famed Armory Show of 1913. Benton's paintings during this period were abstract, such as his *Constructivist Still Life* of 1917–1918, which explored the use of faceted color planes familiar to the work of Pablo Picasso, Georges Braque, and other artists of the pre-World War I cubist movement.

In 1918 Benton joined the U.S. Navy where he prepared drawings for official Navy use. Producing realistic renderings of buildings, ships, and machinery for Navy purposes prompted a decisive change in his art. His experience of the war effort and comradeship with ordinary soldiers also changed his political outlook. Leaving behind the elitism of the avant-garde art scene, Benton turned instead toward engaging the world around him and developing images that he hoped would communicate with the common person.

Between 1923 and 1926, Benton labored on his first large-scale series of history paintings titled *The American Historical Epic.* The series illustrated Benton's newfound populism in a narrative of the United States from its colonial days. His works adopt the perspective not of military leaders, politicians, or momentous events, but rather that of the brutal encounters between the European settlers, unnamed Native Americans, and enslaved Africans whose stories constitute the founding legacy of the country. His rendering of human figures and the settings in which they appear take on a figural solidity, sculptural volume, and clarity of spatial relationships absent from his earlier, semiabstract work.

In the mid to late 1920s, Benton's populism led him to depart New York's hectic urban environment for several extended trips through the American South and Midwest in search of the country's heartland. In 1930, he was able to put his research to use in a series of murals titled *America Today,* which were installed at the New School of Social Research in New York City. Panels in the mural cycle consisted of montages of various scenes. Benton devoted several in the series to describing a cross-section of working America—from black cotton pickers in the deep South to white tenant farmers in the Midwest as well as construction workers, coalminers, and steelworkers. Other panels explored the cacophony and frenetic pace of the big city with images of street preachers, radio demagogues, and jazz bands interspersed between portrayals of drinking, dancing, boxing, and other urban leisure pursuits and entertainment.

His work at the New School was followed by other large-scale mural commissions, including a controversial series that Benton completed in 1932 for the library of the Whitney Museum of American Art. Titled *The Arts of Life in America,* the work consisted of four panels devoted to *Arts of the West* (depicting cowboy life on the American frontier), *Arts of the City* (showing a jazz orchestra, dancers, and urban types), and *Indian Arts* (portraying Native Americans hunting and performing ritual dances and music). Controversy arose over the fourth panel titled *Arts of the South,* in which Benton included images of a white preacher, folk musicians, and a sharecropper along with African blacks singing spirituals and gambling. For some, Benton's portrayal of blacks in *Arts of the South* was overly caricatured and demeaning, which led to charges of racism.

A petition began to circulate at the Art Students' League in New York (where Benton was currently teaching) that the murals be destroyed.

In 1934, Henry Luce's *Time* magazine featured Benton's self-portrait on the cover of its December 24 issue. *Time* christened Benton, along with Grant Wood and John Steuart Curry, as leaders of the "Regionalist School" of American art. The editors applauded the regionalists' rejection of foreign modernist influences and branded their engagement with American folkways and agrarian traditions as a new nativism vital to the country's national regeneration during the Depression era. Stung by earlier charges of racism and now identified by *Time* with antiforeigner, antiurban, nationalist sentiment, Benton came under increasing assault from liberals and leftists in the New York art scene as a political and social reactionary. In 1935, he left New York and returned to his home state of Missouri.

Benton continued to produce public murals and took up teaching at the Kansas City Art Institute until early 1941. He was on a lecture tour when news broke about the Japanese bombing of Pearl Harbor. He immediately returned home and began work on a remarkable series of paintings titled *Year of Peril*. Benton adapted his regionalism to the world stage in works that stressed the threat of the continuing spread of fascism and dictatorship to the American way of life. Speaking to a reporter about the series, Benton described *Year of Peril* as his effort to shake the American public out of its isolationist complacency:

> Art is so unimportant alongside life. We are fighting a war for the preservation of democracy, which I happen to believe in. And the artist's function is to either "carry guns" or bring "the bloody, actual realities of this war home to the American people." [3]

In *Exterminate,* the largest painting in the series, Benton portrays two American soldiers disemboweling and driving a bayonet into the heart of a hideous, oversized monster who grasps Japan's red sun flag in its left hand. Behind this grisly personification of Japan stands a larger and equally powerful Hitler-like figure, holding aloft a Nazi swastika in one hand and a flaming torch in the other. Though the American soldiers appear to have thwarted their Japanese enemy, the looming Nazi monster indicates the presence of continued threat.

Year of Peril was put on view at the Associated American Artists' Gallery in New York, where some 75,000 people came to see it. The paintings were then sold to Abbott Laboratories in Chicago, which reproduced them in a propaganda booklet along with a foreword written by Archibald MacLeish. The Office of War Information requested to use the images as part of its propaganda campaign, issuing them in the form of stamps, posters, and postcards to be sold in the United States and abroad to help raise funds for the war effort. The paintings were also featured in numerous newsreels and articles devoted to the series, making Benton's *Year of Peril* canvasses some of the most famous and widely reproduced images of the war years.

In 1943, Abbott Laboratories commissioned Benton to join the submarine crew of the *Dorado* during training exercises, where he witnessed crewmen

practicing the firing of the sub's automatic cannon. He later transformed this experience into a dramatic combat scene portraying the razor-sharp hull of the *Dorado* slicing through the ocean's churning waves. Navy men on deck work like a well-oiled machine, loading cannon, firing tracer shells, and blasting to smithereens an enemy ship that looms on the horizon.

Benton's other works for Abbott Laboratories showed the cramped conditions of life on a submarine including crewmen catching moments of sleep on bunks nestled in between torpedoes. Some of his images also addressed the controversial subject of racial integration in the armed services during World War II. African Americans were restricted to volunteering as officers' stewards on Navy subs, but were trained, as were all crewmen, to assume a variety of tasks in an emergency. In one drawing, Benton captures the quiet dignity of a black crewman at a moment of repose, sitting by himself, reading, and drinking a cup of coffee.

After the war, Benton continued to receive commissions and favorable critical attention for his murals and portrait work. But his art was eclipsed by the rise of abstract expressionism in the postwar years and general public antipathy toward the kind of figurative art for which Benton had become famous in the 1930s and 1940s. His art and its prominent use for propaganda purposes during the war years irrevocably associated Benton's regionalism with nationalist and commercial interests deemed out of favor in the post-World War II art world. He continued to paint up until his last days. Thomas Hart Benton died of a heart attack at age 86 in 1975.

George Biddle (1885–1973)

Recognized as the father of the federal arts projects of the 1930s, George Biddle was born into a prominent Philadelphia family in 1885. His brother, Francis Biddle, served as Solicitor General and New Deal advisor to President Franklin D. Roosevelt. George Biddle attended Groton and later became Roosevelt's classmate when he enrolled at Harvard University. Intending to follow in his family's footsteps, Biddle studied at Harvard Law School.

Biddle later passed the bar exam in Pennsylvania, but decided to pursue a career in art instead. He enrolled at the Pennsylvania Academy of Fine Arts and, in 1911, sailed for France, where he continued his studies at Paris's Académie Julian. In subsequent years, Biddle returned to Europe for visits in order to keep himself abreast of the latest European artistic tendencies.

During World War I, Biddle served in the U.S. Cavalry in France. After the war, he traveled to the South Seas, during which time he took up work in pottery and sculpture. In the 1920s, he began to travel in Latin America. While in Mexico in the late 1920s, he came into contact with the Mexican artist Diego Rivera. He was deeply inspired by Mexican President Alvaro Obregon's government-sponsored art program in which artists such as Rivera were hired to decorate public buildings with large-scale murals. Rivera's murals, whose

style incorporated lessons from Italian Renaissance art as well as pre-Columbian Mexican works, communicated to the Mexican people the spirit of the Mexican Revolution, the country's past history, and its aspirations for the future. For Biddle, the Mexican mural program demonstrated how art could assume a positive social function. He abandoned the nudes and landscape studies that had dominated his art of the 1920s and turned instead to themes that engaged contemporary social and political issues.

Government support for the arts in Mexico also demonstrated how art could flourish and help to build a national culture. Such support provided Rivera and other artists with financial security and allowed them the creative freedom to pursue their work without being subject to the whims of the art market. Back in the United States, and at the height of the Depression, Biddle pursued establishing a similar program in the United States. On May 9, 1933, he wrote to his former classmate Franklin Roosevelt, shortly after Roosevelt assumed the presidency. Pointing to the Mexican example, Biddle suggested to Roosevelt that U.S. artists could help the president express the aims of his economic recovery program by producing works of art illustrating the goals of the New Deal. Though some states had long had their own art programs, what Biddle proposed amounted to the first federal endeavor of this kind. Such a program, he argued, would put artists back to work, create lasting monuments to Roosevelt's presidency, foster social engagement between artists and the public, and help to forge a national culture.

Roosevelt expressed interest in the plan. Biddle went to work with the Treasury Department, which had custodial authority over all federal buildings. His most willing supporter in the federal bureaucracy was Edward Bruce, who eventually became director of the Public Works of Art Project (PWAP) and the Treasury Section of Fine Arts. In addition to the Federal Arts Project and the Farm Security Administration, the PWAP and section programs provided economic support for upwards of 40,000 artists over the course of 10 years, resulting in paintings, drawings, sculptures, photographs, plays, books, and other creative endeavors that left an indelible stamp on U.S. culture during the Depression era.

In 1936, Biddle and several other artists were engaged to decorate the Justice building in Washington, D.C. Biddle's contribution created controversy, however, with the conservative Commission of Fine Arts, which served as presidential advisor on art for the nation's capital. Titled *The Sweatshop of Yesterday can be the Life Ordered with Justice Tomorrow,* Biddle's five-panel mural contrasted downtrodden workers and the dilapidated tenements in which they lived with a healthy, well-housed, and happy family. The Commission of Fine Arts found the work disturbing and discordant with the neoclassical restraint of the architecture and decorative programs of the nation's capital. They demanded, unsuccessfully, that Biddle change his mural on charges that the form and content of his work were inappropriate to represent the nation in its Justice building. Biddle accused the commission of censorship and denounced its members for attempting to dictate what was and was not appropriately "American" in the arts.

In 1936, Biddle joined the American Artists' Congress (AAC), a Popular Front artists' organization aligned with the Soviet Union in the struggle against the spread of fascism in Europe. Among its nearly 400 founding members, the AAC included many of the most recognized artists then working in the United States. They dedicated themselves to the fight against war and fascism abroad while militating for continued government support for the arts at home. The American Artists' Congress also approved Biddle's call to boycott Nazi Germany's international art exhibition planned as part of the Olympic Games, which were held in Berlin in 1936.

Throughout the 1930s, Biddle was a prominent social realist painter, whose work addressed not only class oppression, as in his Justice Department murals, but also racial discrimination. In the early 1930s, his work protested the plight of the Scottsboro Nine, a group of African Americans who were wrongfully convicted of rape in 1933. In a work titled *Spirituals* from 1937, Biddle rejected stereotypical and caricatured portrayals of African Americans. Rendered with sensitive dignity, his image shows a group of African Americans, differentiated from one another by facial expression and skin color, joining together in song.

During the World War II years, the New Deal art projects that Biddle had fought to establish in the 1930s were systematically dismantled. Moreover, no centralized federal war art program was installed after the attack on Pearl Harbor in December 1941. In spring 1942, however, the War Department invited Biddle to chair its Art Advisory Committee. The committee selected 23 soldier-artists and 19 civilians to produce drawings and paintings based on direct experience of the front. In a memo dated March 1, 1942, Biddle informed the artists of their mission. Their work, he insisted, was to go beyond the mere documentary capacities of film and photography. Their paintings and drawings should instead synthesize human experience of the war and serve as a lasting testimony to America's involvement in the struggle:

> In this war, there will be a greater amount than ever before of factual reporting, of photographs and moving pictures. You are not sent out merely as news gatherers. You have been selected as outstanding American artists who will record the war in all its phases and its impact on you as artists and human beings. The War Department Art Advisory committee is giving you as much latitude as possible in your method of work, whether by sketches done on the spot, sketches made from memory, or from notes taken on the spot, for it is recognized that an artist does his best work when he is not tied down by narrow technical limitations. What we insist on is the best work you are individually capable of and the most integrated picture of war in all its phases that your group is capable of. [...] Express if you can—realistically or symbolically—the essence and spirit of war. [...] We believe that our Army's Command is giving you an opportunity to bring back a record of great value to our country. Our Committee wants to assist you to that end. [4]

Units of two to five war artists were placed under the command of the U.S. Army Chief of Engineers. Soldier-artists received their standard commission; civilian artists were paid $3,800 per year plus travel and supply expenses. In

April 1943, they were dispersed to one of the 12 active fighting fronts around the world, including Europe, Alaska, and the South Pacific. Biddle traveled to Tunisia where he joined the U.S. 3rd Infantry Division as part of the North Africa campaign. He followed the conflict into Italy, spending a total of six weeks sketching Allied advances that pushed the Germans up the Italian peninsula. Biddle's painting, titled *German Prisoner on Monte Casino,* shows the aftermath of a bloody encounter in which the Allies broke through entrenched enemy lines. A German prisoner dressed in green fatigues stands with his hands raised in surrender. Around him is a landscape strewn with the dead and dying, pockmarked by artillery shells, and dotted with broken and defoliated trees. In *War Orphans, Italy* (1944), Biddle depicted the care-worn faces of three children left without parents by the conflict. Biddle was in the middle of his commission when Congress voted in July 1943 to slash the budget and abandon the War Department's art program. He was thereafter picked up as a war artist correspondent for Henry Luce's *Life* magazine, to which he contributed during and after the war. In 1944, Biddle published his autobiographical *Artist at War,* in which he incorporated several of his drawings completed at the front.

After World War II, Biddle assumed teaching positions at various institutions including Columbia, the University of California, and the American Academy of Rome. He also published several more books and articles, including *The Yes and No of Contemporary Art* (1957). George Biddle retired to Croton-on-Hudson in New York State, where he died in 1973.

Margaret Bourke-White (1904–1971)

Margaret Bourke-White was born in New York City in 1904. Her earliest interests were in biology and technology. In 1921, she enrolled at Columbia University, where she took to supporting herself and paying for her studies with work as an amateur photographer. She also took courses at Columbia's affiliated Clarence H. White School of Photography. In her sophomore year, she transferred to the University of Michigan in order to pursue studies in zoology. In 1926, she enrolled at Cornell University where she completed her undergraduate degree in 1927. By then, Bourke-White had become an admirer of Alfred Stieglitz's photography. She moved to Cleveland with the intention of becoming an industrial photographer.

By 1928, Bourke-White had her own studio and began publishing her work in local journals. She quickly became sought after by industrial clients for the manner in which her photos celebrated the clean, machine-tooled beauty of modern technology. Bourke-White received commissions to photograph smoke stacks at the Otis Steel Company in Cleveland, hydroelectric generators at Niagara Falls, and plow blades at the Oliver Chilled Plow Company in South Bend, Indiana. In each case, she exploited unusual vantage points, dramatic perspectives, and contrasts of light and shadow in her photography in order to emphasize the rhythmic patterns of mass-produced objects. Her work cap-

tured the general sense of optimism and faith in technology that accompanied America's industrial boom of the 1920s.

In 1929, *Time* magazine editor-in-chief, Henry Luce, brought Bourke-White to New York to help him launch *Fortune* Magazine, which he envisioned as a new kind of business journal that would make extensive use of photographic illustration. Working for Luce, Bourke-White helped establish the new genre of the photo essay, in which photographs, instead of explanatory text, assumed a primary role in communicating narrative information. The enormous popularity of such essays was instrumental in building Luce's unrivaled media empire in the 1930s and 1940s. The first issue of *Fortune* appeared in January 1930, with Bourke-White's photographs used in the lead article. Bourke-White herself became something of a media icon through her work for *Fortune*. She was thereafter lionized in the press and much in demand on the lecture circuit. She opened her own studio in the new Chrysler building in New York City, where she did her work for *Fortune* and also took on additional contracts for advertising clients.

In spring 1930, *Fortune* sent Bourke-White to photograph Germany's industrial recovery from the devastation of World War I. She then traveled to Soviet Russia for the first of several trips there in order to capture Stalin's First Five-Year Plan for the Soviet Union's rapid industrial and technological modernization. Her photographs recorded dam and bridge construction at Dnieperstroi, farmers at work on a large collective farm in Rostov, bustling industrial ports, and factory production. Bourke-White's work did much to foster a positive image of the Soviet Union as a country— unlike Depression-era America— where industry boomed and people worked. In 1931 she produced her first book of photographs, titled *Eyes on Russia*. In 1934, more of her photos from the Soviet Union were released in a second book, titled *U.S.S.R. Photographs*.

In 1934, Bourke-White's photography turned away from the abstract geometries of modern technology as she began to focus her attention instead on people and their plight in the Great Depression. She produced a photo essay for *Life* titled *The Drought* on the devastated lives of Midwest farmers caught by the ravages of the Dust Bowl in the early 1930s. Her work brought her into the orbit of social realism during this period as she worked to refine her own art of social conscience.

In 1936, Luce invited Bourke-White to work for his new illustrated journal, *Life*. Her work appeared on the cover of the first issue, to which she also contributed the lead photo essay. Her name appeared on the masthead of *Life* throughout her remaining career.

Bourke-White also collaborated with the southern novelist Erskine Caldwell during this period. Together they published *You Have Seen their Faces* (1937), which combined photos with text on the subject of Depression-era life. The two married for four years between 1939–1942. They also published *North of the Danube* (1939), about life in Czechoslovakia before the German takeover, and *Say, Is this the USA* (1941), about life in the United States.

In May 1941, Bourke-White returned to Moscow with Caldwell. In June, a month after their arrival, Germany invaded the Soviet Union. The only ac-

credited foreign photographer in the Soviet capital at the time, Bourke-White provided exclusive photographic coverage of the invasion. Some of her most spectacular images were taken from the roof of the U.S. embassy, where she captured the enemy bombing of the city. With the assistance of a U.S. presidential envoy, Bourke-White also gained access to a camera-shy Joseph Stalin. Her remarkable portraits of Stalin were taken back to the United States in a diplomatic pouch and published in *Life* magazine. She was also able to provide exclusive photographic coverage of the eastern front as Germany pressed into the Soviet Union and its satellite territories. In fall 1941, Bourke-White returned to the United States where she went on lecture tours about her experiences.

After Pearl Harbor, Bourke-White became the first woman accredited as a war photographer by the U.S. Armed Forces. She was also the first woman authorized to fly in combat missions. Bourke-White was attached first to the U.S. Army Air Force in England. She then covered the Allied advance into Italy and Germany. In the midst of an assignment, her submarine suffered a torpedo attack, and Bourke-White was rescued in the waters off North Africa. Her photographs of the Allied campaign were used jointly by the U.S. Air Force and *Life* magazine. On March 1, 1943, *Life* capitalized on Bourke-White's celebrity as a female war photographer by publishing an exposé titled "*Life's* Margaret Bourke-White goes on a Bombing Mission."

Bourke-White published three photo books of her wartime experiences: *Shooting the Russian War* (1942), *They Called it 'Purple Heart Valley'* (1944), and *Dear Fatherland, Rest Quietly* (1946). She is best known today for her harrowing photographs of Nazi concentration and death camps. In 1945, she traveled with General George Patton's army into Germany where she photographed camp victims at the moment of their liberation. In *Prisoners at Buchenwald* (1945), her camera captured the mixture of joy and despair that filled the hollowed eyes and sunken cheeks of a group of Buchenwald's male camp inmates. The flash of Bourke-White's camera floods over the faces of the newly liberated men, who emerge from their primitive bunks into the light. An enduring testimonial to the inmates' suffering, Bourke-White's photographs pierced the morbid gloom of Nazi atrocity. Her work also exposed that atrocity to the court of world opinion as her images were immediately released and circulated in the pages of *Life* magazine.

After the war, Bourke-White continued to use her photography to promote social justice around the world. In 1946–1948, she documented the independence and partition of India. She also interviewed and photographed the Indian nationalist leader, Mohandas Gandhi, shortly before he was assassinated in 1948. In 1949–1950, she was in South Africa to document the abuses of the country's segregationist apartheid system, as well as worker exploitation in the South African diamond and gold industries. In 1952, after the Korean War armistice was signed, Bourke-White went to Korea to cover the continuing guerilla war below the demilitarized zone.

In 1957, Bourke-White produced her last assignment for *Life* magazine. In 1963, she released her autobiography titled *Portrait of Myself*. Suffering from Parkinson's disease, Bourke-White was forced to abandon photography in her

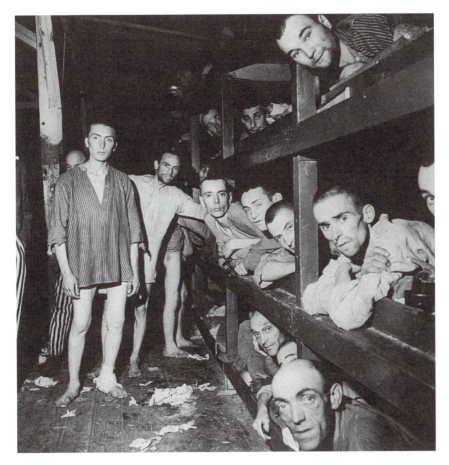

Margaret Bourke-White, *Prisoners at Buchenwald,* 1945. © Margaret Bourke-White/Getty Images.

last years. Margaret Bourke-White died in her home of Darien, Connecticut, at age 67 in 1971.

Norman Rockwell (1894–1978)

Norman Rockwell was born in New York in 1894. While still in high school, he studied part-time at New York's Chase School of Fine and Applied Arts. He demonstrated a talent for drawing and determined at an early age that he wanted to be a professional illustrator. His models were the acclaimed illustrators Howard Chandler Christy, Howard Pyle, and J. C. Leyendecker, whose work had helped to popularize the new media of illustrated journals and newspapers at the turn of the century.

In 1910, Rockwell was accepted at the Art Students' League in New York where he studied illustration. Three years later, at the age of 18, he accepted a

post as art editor and illustrator for the new Boy Scouts of America magazine, *Boys' Life*. In 1925, he began creating his enormously popular Boy Scout calendars with sentimental and patriotic themes, which he continued to produce for the next 50 years.

Rockwell also illustrated other children's magazines, but had his sights set on working for *The Saturday Evening Post*. George Horace Lorimer, editor of the *Post*, aspired to tap into and define the American mainstream with his journal. In 1916, Rockwell produced his first cover for the *Post*, followed by 322 more covers that were published over the next 47 years. Rockwell's gentle comic narratives and penchant for describing the lives and behaviors of ordinary "folk" in his illustrations became central to the *Post's* growing success over the next several decades.

During World War I, Rockwell served in the Navy beginning in 1917. He was assigned to paint camouflage on airplanes. When his talent became evident to his superiors, he was returned to the home front and commissioned to produce portraits of army officials. He resumed his work for *The Saturday Evening Post* at war's end.

In the 1920s, Rockwell began to study avant-garde art. In 1923, he traveled to Paris with the intention of readjusting his realist style to incorporate some of the latest tendencies in vanguard art. Lorimer of *The Saturday Evening Post* discouraged such stylistic changes and urged Rockwell to maintain his popular and accessible approach to illustration. Rockwell found his earlier interest in the "American Scene" affirmed by a general retreat from the stylistic innovations of the European and American vanguard that began to define the U.S. art world in the late 1920s and 1930s. He accordingly abandoned avant-garde experiment in his art and resumed production of the sentimental imagery for which he had become known.

Such work assured Lorimer of a thriving readership. By 1929, the *Post* enjoyed a subscribership of nearly 2 million, with many millions more readers. In most cases, Rockwell retained the original works of art that he produced for the *Post*, while the magazine had copyright over their reproduction and distribution. By contrast, such corporate clients as Ford Motor Company, Sun-Maid Raisins, Hallmark Cards, and General Electric, for whom Rockwell produced commercial illustrations during the period, often retained his original works. Unlike most artists, he lived through the Depression shielded from the financial hardships of the decade by his thriving reputation in commercial illustration.

In the mid-1930s, Rockwell began to use photography as an aid. This allowed him to work with nonprofessional models, which he chose for their special physical characteristics and behaviors. He took to assembling props and models for a composition, engaging a photographer to photograph the arrangement, and using the resulting photos as sources for his illustrations. Rockwell then typically rendered the composition in charcoal. He occasionally photographed these studies in turn and applied color to them directly. In other cases, studio assistants helped transfer the charcoal study to canvas.

In 1941, Rockwell dedicated his work to the war effort. In that year, he created the fictional soldier, Willie Gillis, who appeared on the cover of 11 issues

of *The Saturday Evening Post* throughout the conflict. Rockwell also produced images for the government that assisted in rallying public support. In 1942, for example, he created the poster *Let's Give Him Enough and On Time.* The image depicts a bloodied soldier on the front lines, who has almost run out of ammunition. The work formed part of the government's effort to encourage home front sacrifice in the factories to speed production of war matériel. In 1943 Rockwell created another poster, this time to encourage increased coal production, titled *Mine America's Coal.* The work contains a portrait of a Pennsylvania coal miner. Two blue stars pinned to the miner's shirt indicate that he has two sons at the front. Such images were intended to remind American workers of the soldiers and the patriotic cause for which they were working. In these and other wartime works, Rockwell's illustrations and paintings took on a greater graphic simplicity. Using strong compositions derived from advertising, Rockwell sought to relay the patriotic message of his images with a direct clarity.

Rockwell's most famous war-era achievements were his four paintings that illustrated President Roosevelt's "Four Freedoms" speech of 1941. He originally produced one of the works in the series, titled *Freedom from Fear,* as a cover for *The Saturday Evening Post* in 1940. Commemorating the Battle of Britain, *Freedom from Fear* portrays parents tucking their slumbering children into bed. Rockwell intended the work to remind *Post* readers of the safety enjoyed by American families while others feared for their lives in a war-torn Europe. After he completed the next three canvasses in the series, *Freedom to Worship, Freedom of Speech,* and *Freedom from Want,* the U.S. government adopted all four as the centerpiece for its War Loan drive in spring 1943.

Rockwell also gained fame during World War II for his image of *Rosie the Riveter,* which was produced and distributed as a poster in 1943. The work portrays a red-haired, strong-armed Rosie, her skin smudged with grease and dirt, perched on a narrow wooden box. Taking a break from her labors, Rosie uses the box as a makeshift seat while eating her lunch. Behind her, an American flag unfurls while she uses a dog-eared copy of Hitler's *Mein Kampf* (My Struggle) as a footrest. With her pneumatic drill still resting in her lap and her goggles and welding visor pushed back on her head, Rosie's lunch break, Rockwell's image informs us, will be brief. Images such as these acknowledged and celebrated maximal production and the strong presence of working women in America's home front war effort.

Rockwell devoted the majority of his successful career to the portrayal of ordinary people and the fashioning of a patriotic, sentimentalized vision of American life. After the war, however, he turned to creating portraits of the famous. In 1960, he rendered a likeness of John F. Kennedy during his presidential campaign. When President Kennedy was assassinated in 1963, *The Saturday Evening Post* ran the portrait as a memorial on its front cover. This, in fact, was the last cover produced by Rockwell for the *Post;* his contract with the magazine came to an end in that year.

In the mid-1960s, Rockwell began to work for *Look* magazine. His images took on a more socially critical caste as he used his art to protest the problem

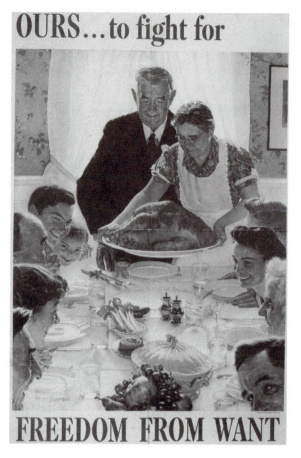

Norman Rockwell, *OURS…to fight for,* 1943. © MPI/Getty
Images.

of racism in America and champion the civil rights movement. In January 1964,
Look reproduced his painting titled *The Problem We All Live With* on the subject of
the federally-mandated desegregation of the schools. The work portrays Ruby, a
diminutive African American girl, whose right to attend a school in New Orleans
was challenged by racial hatred. Dressed in a white dress and carrying her school
books in her hand, Ruby is escorted by four federal marshals into her school.
They pass by a wall splattered with tomatoes suggesting the fury of segregation-
ists who protested Ruby's arrival and the principle of racial egalitarianism she
had come to represent.

In succeeding years, Rockwell continued to use his work to support social
justice issues. In 1966, he began to produce posters in support of the Peace
Corps. At the height of the Vietnam War, he refused a commission to create
recruiting posters for the Marines based on his strong opposition to America's
involvement in the conflict.

In the last years of his life, Rockwell set up a trust for his paintings, studio,
and archives in what later became the Norman Rockwell Museum in Stock-

bridge, Massachusetts. In 1977 Gerald R. Ford awarded him the Presidential Medal of Freedom. Norman Rockwell died in Stockbridge in 1978 at the age of 84.

Ben Shahn (1898–1969)

In 1898, Ben Shahn was born in Kovno, Lithuania, to a family of Jewish craftsmen. His father was a socialist and intellectual, who published politically dissident philosophical pieces in the Yiddish press. The family immigrated to New York City in 1906 in order to escape the pogroms and anti-Semitic repression imposed on Jews in tsarist Russia.

Between 1913 and 1917, Shahn worked as an apprentice in a Manhattan lithography shop. In the evenings he attended high school in Brooklyn. In 1916, Shahn studied at the Art Students' League. After taking courses in biology at New York University and City College, he enrolled in the National Academy of Design in 1923. He subsequently traveled through Europe and North Africa.

Shahn returned to New York in 1925, where he shared a studio with the photographer Walker Evans. Shahn continued to experiment during this period, searching for a personal style that was modernist, but not derivative of European models. He also became politically radicalized and looked for ways in which to create an art of social relevance. Shahn had his first solo exhibit in 1930 at the Downtown Gallery in New York.

Shahn's reputation as a leading social realist painter was established in 1932 when he exhibited two paintings at the Museum of Modern Art in New York (from a group of 23 works he had produced on the subject) titled *The Passion of Sacco and Vanzetti*. Nicola Sacco and Bartolomeo Vanzetti were Italian anarchists involved in antiwar activities during World War I. The two were found guilty of murder and executed in 1927. Their case became a cause célèbre among liberals and political leftists, Shahn included, who believed in Sacco and Vanzetti's innocence and saw their execution as government retaliation against their politically dissident views. Shahn refused an offer from a wealthy patron to purchase the works before the opening of the Museum of Modern Art exhibition, which would have prevented his canvases from being shown to the public.

Shahn became friends with the Mexican artist and onetime Communist Party member Diego Rivera. In 1933, he assisted Rivera in creating his mural for the Radio City of America (RCA) building in New York. Rivera took the opportunity of the RCA commission to herald the benefits of Soviet-style socialism over the chaos and depredations of American capitalism during the Depression era. When Rivera added a portrait head of Lenin to the mural, the Rockefeller family (who had commissioned the work) ordered Rivera's work destroyed shortly before it was completed. Shahn joined other artists and intellectuals in protesting the mural's removal as yet another instance of political repression in the United States. Though Shahn was never a Communist Party member, he nonetheless believed deeply in causes of social justice. In the early 1930s, Shahn produced

works for the labor movement and also lectured and exhibited at the Communist Party-affiliated John Reed Club in New York.

In the mid-1930s, Shahn joined the leftist Artist's Union and worked on its journal, *Art Front.* He also became involved in Roosevelt's New Deal art programs when he went to work for the Farm Security Administration (FSA) between 1935 and 1938. Shahn, as part of an FSA commission, used photography to document the plight of agricultural workers during the Depression. In 1936, along with 400 other leading artists, he joined the American Artists' Congress, which was dedicated to the struggle against war and fascism and to continued government sponsorship of the arts. In November 1940, Shahn won a commission from the Treasury Department to do a pair of murals for the social security building in Washington, D.C. Addressing the theme *The Meaning of Social Security,* Shahn's murals contrasted images of unemployment, child labor, and old age with the benefits of work, family, and social security.

In 1942 and 1943, Shahn produced work for the war effort under the auspices of the New York branch of the Graphics Division of the Office of War Information (OWI). He faced repeated rejection of his efforts, however, on charges that his images were not appealing enough to be reproduced and disseminated for factory production and war loan drives. The OWI turned down his image *This is Nazi Brutality,* for instance, on charges that the work was too violent and potentially injurious to civilian morale. The poster depicted the execution of a man in Lidice, Czechoslovakia, a town that had been destroyed by the Germans. Shahn produced another work, which was also rejected, titled *A Need for All in Time of War, a Place for All in Time of Peace.* Advocating racial egalitarianism as important not only to the war effort, but also to America's postwar peace, Shahn depicted two welders, one white and one black, standing side by side, looking off into the distance together. The OWI rejected the work on grounds that "it didn't mean anything."[5]

After leaving the OWI in 1943, Shahn produced a number of sensitive paintings, including *Italian Burial Society* (1943), *Concentration Camp* (1944), and *Italian Landscape II: Europa* (1944), some of which were based on previously censored photographs of war destruction in Italy.

Shahn's welders poster was later picked up by the national labor union, the Congress of Industrial Organizations (CIO). The CIO retitled it *For Full Employment After the War, Register–Vote* for use in the presidential election campaign of 1944. Shahn had made posters for the CIO since it was founded in the late 1930s. In July 1943, the CIO formed a Political Action Committee (CIO-PAC) in response to the passage of the antilabor Smith-Connally Act. The Act was designed to end wartime strikes and limit the amount of financial support unions could contribute to political campaigns. In 1944, Shahn became the CIO-PAC's chief artist of its graphics division. Shahn's *For Full Employment After the War* envisioned a postwar order of peace, prosperity, and social egalitarianism for all. The CIO used the poster to urge its 5 million members, as well as those of other unions, to throw their support behind Roosevelt in the 1944 presidential election campaign.

Shahn left the CIO-PAC in 1947. He turned instead to illustrating articles on social justice issues for *Fortune, The New Republic, Harper's Weekly,* and *The Nation.* The Museum of Modern Art in New York honored Shahn with a retrospective of his work in 1947. His art, previously little-known outside the United States, also began to grow in popularity in Europe. His images of the postwar years, which he produced and exhibited as posters, ads, and prints, protested nuclear testing, the Vietnam War, and continuing racial discrimination. Many of his works also began to focus on questions of his Jewish identity in the aftermath of the Holocaust. In 1954, the Museum of Modern Art in New York organized another major exhibit of his work, which was sent, along with abstract expressionist pieces by Willem de Kooning and others, to represent the United States at the 27th Venice Biennale. In 1956, Shahn held the Charles Norton Chair of Poetics at Harvard University. During this period, he also published his views on art in his book titled *The Shape of Content* (1957).

Given his political and social activism and his history of collaboration with the Communist Party and union groups, Shahn was one among many American citizens who became the target of Cold War hysteria. In 1959, he was called before the House Un-American Activities Committee (HUAC) to explain the inclusion of his work in a recent exhibit in Moscow. Shahn refused to answer the questions of the committee claiming they were infringing on his freedom. He also voiced his belief that such Cold War witch hunts did little more that tarnish the United States' confident image abroad as a defender of free expression and democracy. Shahn produced a print in 1960, in which he included the following words to summarize his response to HUAC's actions:

> I have the right to believe freely, to be a slave to no man's authority. If this be heresy so be it. It is still the truth. To go against conscience is neither right nor safe. I cannot…will not…recant. Here I stand. No man can command my conscience.[6]

Ben Shahn died in New York in 1969.

Notes

1. Henry Luce," The American Century," *Life* (17 February 1941): 61–63.

2. George H. Roeder, Jr., *The Censored War: American Visual Experience during World War Two* (New Haven, CT: Yale University Press, 1993), 83.

3. "Thomas Hart Benton Painted These Powerful War Pictures," *P.M.* 2 (5 April 1942): 6–7. Cited in Cécile Whiting, *Antifascism in American Art* (New Haven, CT: Yale University Press, 1989), 115.

4. George Biddle, memorandum, 1 March 1942. Cited in Col. H. Avery Chenoweth, *Art of War: Eyewitness U.S. Combat Art from the Revolution through the Twentieth Century* (New York: Michael Friedman Publishing Group, Inc., 2002), 116.

5. Frances K. Pohl, *Ben Shahn: New Deal Artist in a Cold War Climate, 1947–1954* (Austin: University of Texas Press, 1989), 14.

6. Pohl, *Ben Shahn*, 174.

Bibliography

Biddle, George. *Artist at War.* New York: The Viking Press, 1944.

Blum, John Morton. *V was for Victory: Politics and American Culture during World War II.* New York: Harcourt Brace Jovanovich, 1976.

Chenoweth, Col. H. Avery. *Art of War: Eyewitness U.S. Combat Art from the Revolution through the Twentieth Century.* New York: Michael Friedman Publishing Group, Inc., 2002.

Guilbaut, Serge. *How New York Stole the Idea of Modern Art: Abstract Expressionism, Freedom, and the Cold War.* Translated by Arthur Goldhammer. Chicago: University of Chicago Press, 1983.

Larson, Gary O. *The Reluctant Patron: The United States Government and the Arts, 1943–1965.* Philadelphia: University of Pennsylvania Press, 1983.

Roeder, George H., Jr. *The Censored War: American Visual Experience during World War Two.* New Haven, CT: Yale University Press, 1993.

Whiting, Cécile. *Antifascism in American Art.* New Haven, CT: Yale University Press, 1989.

Conclusion: Remembering World War II

On April 18, 1945, the famed American war correspondent Ernie Pyle died from enemy fire on an island off the coast of Japan. This happened four months before the conflict in the Pacific faced its decisive end in a mushroom cloud of atomic warfare. Pyle chose to experience World War II not from the safety of the war room or dispatch office, but rather down in the trenches with those who faced death minute by minute, hour by hour. From 1940 onward, he covered combat fronts in Italy, France, North Africa, and the Asian Pacific. Knowing in April 1945 that the war in Europe was rapidly drawing to a close, Pyle composed a short commemorative newspaper column on the horror of what he had seen and experienced. His words provided a sober and admonitory counterpoint to the victory celebrations that were soon to unfold back home. A draft of Pyle's column was found on him at the time of his death:

> And so it is over. The catastrophe on one side of the world has run its course. The day that had so long seemed would never come has come at last. [...] in the joyousness of high spirits it is easy for us to forget the dead. [...] there are so many of the living who have burned into their brains forever the unnatural sight of cold dead men scattered over hillsides and in the ditches along the high rows of hedge throughout the world. Dead men by mass production—in one country after another—month after month and year after year. Dead men in winter and dead men in summer. Dead men in such familiar promiscuity that they become monotonous. Dead men in such monstrous infinity that you come almost to hate them.[1]

What work of art could do justice to the enormity of such mass death? How and in whose name should such an event be memorialized? And where, by whom, and for what purpose should such memories be preserved? In the im-

197

mediate aftermath of World War II, most wanted to put their experiences behind them, to get on with life, and to not look back on the carnage and ordeal of those bitter years. As time passed, however, the events of World War II became configured in various—and at times controversial—artistic attempts to remember those who fell, why they fell, and how.[2]

In 1952, the Japanese-American sculptor Isamu Noguchi became embroiled in the complexity of postwar international relations between Japan and the United States when he was asked to help memorialize those who were killed by the dropping of the atomic bomb on Hiroshima in August 1945. Born in the United States, Noguchi spent his childhood in Japan before returning to America for his studies. Like thousands of other Japanese-Americans, he was interned in 1942 following the U.S. government decree for Japanese-Americans' forced detention in the wake of the attacks at Pearl Harbor.

In 1950, at the age of 45, Noguchi returned to Japan as an internationally acclaimed artist recognized for his evocative, abstract sculptures. While in Japan, he was solicited by Hiroshima's mayor to help construct a Peace Park located near the epicenter of the atomic blast. Noguchi designed railings for two bridge entryways into the memorial complex. Titled *Shinu* (To Die) and *Ikiru* (To Live), Noguchi's graceful concrete bridge railings incorporate semiabstract forms that evoke, on the one hand, ribs of a ship used to ferry the dead to the afterlife, and, on the other, round disks reminiscent of Japan's national symbol of the rising sun. Noguchi also designed an immense memorial arch for Peace Park that was to have an underground repository listing the names of all those who were killed by the U.S. bombing of Hiroshima. This part of the project never came to fruition, however, because questions began to be raised about the propriety of having an American artist (albeit of Japanese descent) create a memorial to America's attack on Japan.

Noguchi's experience aptly demonstrates the manner in which war monuments—including those to World War II—are distillations of passion, memory, and politics. The feelings they evoke and the times they attempt to recall cannot outrun the political imperatives of the moment in which such memorials are conceived and realized. In 1954, the U.S. Marine Corps unveiled its large-scale memorial in Arlington National Cemetery. A monument to the marines' service in World War II, the memorial also became embedded in Cold War struggles of the 1950s between the United States and the Soviet Union.

Sculpted by Felix de Weldon, the 78 foot bronze statue replicates a wartime event photographed by Associated Press photojournalist Joe Rosenthal. Rosenthal captured five U.S. marines and one sailor together raising the American flag on the small, Japanese-held Pacific Island of Iwo Jima before the conclusion of a bloody battle that ultimately claimed the lives of 6,821 Americans and 20,000 Japanese. The triumphal Marine Corps memorial honored the marines' valor in the Asian-Pacific war. Speeches and commentaries at its unveiling made plain, however, the extent to which the memorial also served current political needs by symbolizing the United States' unity of purpose and patriotic resolve to prevail in its Cold War confrontation with the Soviet Union.

Decades after the conclusion of World War II, a national monument devoted to the victims—rather than the victors—of World War II was unveiled in Washington, D.C. A combined study center and exhibition space, the United States National Holocaust Museum opened to the public in 1993. The structure commemorates those killed in Nazi Germany's horrific acts of mass murder that claimed 11 million lives in the final phases of World War II. Plans for the Holocaust Museum took shape beginning in 1978 under President Jimmy Carter and in the midst of sensitive negotiations regarding U.S. support for Israel in the ongoing Middle East crisis. Designed by architect James Ingo Freed, the museum takes its place alongside the Vietnam Veteran's memorial and museums dedicated to African American and Native American experience that also now occupy the Washington Mall. Along with these other memorials and buildings, Freed's museum and the inhumanity to which it speaks contrasts with the confident heroism of the Marine Corps memorial at Arlington, as well as that of the Washington, Jefferson, and Lincoln Memorials, which predate the Holocaust Museum in the mall's commemorative space.

In the early stages, plans for the content of the Holocaust Museum generated controversy. Questions were raised and debated concerning who would and should be commemorated in the museum's space. Was it to represent first and foremost the 6 million Jews who fell victim to Nazi genocide? Or was it also to explore the lives and experiences of the 5 million others—including communists, homosexuals, and gypsies—who were also gassed and incinerated in Nazi death camps? In the end, the meaning of the Holocaust became less the preserve of any single community of interest. The museum's Holocaust memory was rendered instead more permeable to other forms of remembering and other needs, particularly those of the U.S. government and its effort to enlist the events of the Holocaust in the definition of American democratic ideals. The museum now provides a more expansive view of the victims of Nazi atrocity and is visited by tens of thousands of people each year.

The creation of a national monument dedicated explicitly to America's role in World War II had to wait much longer. On May 29, 2004, a full 60 years after the United States led its Allies to triumph over the Axis powers of Germany, Italy, and Japan, the World War II Memorial was unveiled. Designed by Friedrich St. Florian, it occupies a position between the Lincoln Memorial and the Washington Monument on the national mall. The World War II Memorial is the first work to be placed on the central axis of the mall since the Lincoln and Washington monuments were built over a century ago. Roger Durbin, a World War II veteran, set the project in motion when he asked his congressperson in 1987 to work for the creation of a memorial to those Americans who had fought and died in the conflict. After 17 years of lobbying, Congress approved the plan and appropriated funds for the memorial's construction.

St. Florian's design consists of 50 flattened pillars representing the states and territories of the nation in 1945. Adorned with sculpted bronze wreaths, the pillars are arranged in two semicircles flanking two 43-foot, arched entry pavilions representing the European and Pacific theaters of the war. Each arch has

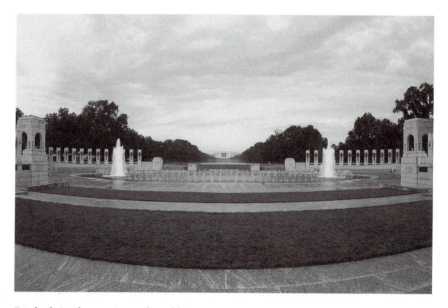

Friedrich St. Florian, National World War II Memorial, view from across Seventeenth Street, Washington, D.C. Final architectural admission, 2000. © Daniel J. McLain/Getty Images.

a 10-foot wide bronze laurel wreath suspended from a bronze ribbon. Bronze eagles hold the ribbon in their beaks while perched atop supporting columns. The memorial encircles the Rainbow Pool and its newly restored fountains. Freedom Wall, decorated with 4,000 gold stars, occupies the western side of the memorial plaza. Each star represents 100 of the 400,000 Americans killed in World War II combat. Inscribed on a low stone panel in front of wall are the words: HERE WE MARK THE PRICE OF FREEDOM.

Construction of the World War II Memorial faced opposition from the National Coalition to Save Our Mall and several congressional leaders who opposed altering the mall's existing commemorative configuration. Others supported the project, but opposed St. Florian's design. Such objections were overridden by those who believed that a monument to America's role in the "Good War" was long overdue. The May 2004 dedication ceremony drew a crowd of 100,000 people, among them World War II veterans, President George W. Bush, and former presidents Bill Clinton and George Bush.

Long in planning and execution, the World War II Memorial's appearance at this point in our nation's history prompts reflection on what lessons the "Good War" offers us today. Situated at the heart of our national mall, the memorial symbolically occupies the center of our national consciousness. What significance should we now draw from a monument to the tragic and triumphant events of a war fought over a half-century ago? How does the memorial invite us to see the United States' role in the world of 1945 and in its current role? How do the values that then led the country into war against dictatorship compare and

contrast with those that now guide our use of military force in Iraq, Afghanistan, and the global war on terrorism? The strength of the World War II Memorial will be proven through the extent to which it not only evokes memory of our past involvement in a world at war, but also, and more importantly, by how it shapes our nation's present and future commitment to forging a world at peace.

Notes

1. Ernie Pyle, handwritten draft for a newspaper column found on him the day of his death, April 18, 1945. Cited in James Tobin, *Ernie Pyle's War: America's Eyewitness to World War II* (New York: The Free Press, 1997), 3–4.

2. For some of the many sources on memorials to World War II, see Bruce Altshuler, *Isamu Noguchi* (New York: Abbeville Press, 1994); Albert Boime, *The Unveiling of the National Icons: A Plea for Patriotic Iconoclasm in a Nationalist Era* (Cambridge: Cambridge University Press, 1998); Edward T. Linenthal, *Preserving Memory: The Struggle to Create America's Holocaust Museum* (New York: Viking Press, 1995); Karal Ann Marling and John Wetenhall, *Iwo Jima: Monuments, Memories, and the American Hero* (Cambridge, MA: Harvard University Press, 1991); Nicolaus Mills, *Their Last Battle: The Fight for the National World War II Memorial* (New York: Basic Books, 2004); Andrew M. Shanken, "Planning Memory: Living Memorials in the United States during World War II," *Art Bulletin* 84, nr. 1 (March 2002): 130–47; and James E. Young, *The Texture of Memory: Holocaust Memorials and Meaning* (New Haven, CT: Yale University Press, 1993).

Index

About the Author

BARBARA MCCLOSKEY is an associate professor of art history at the University of Pittsburg. She is the author of *George Grosz and the Communist Party: Art and Radicalism in Crisis, 1918 to 1936.*